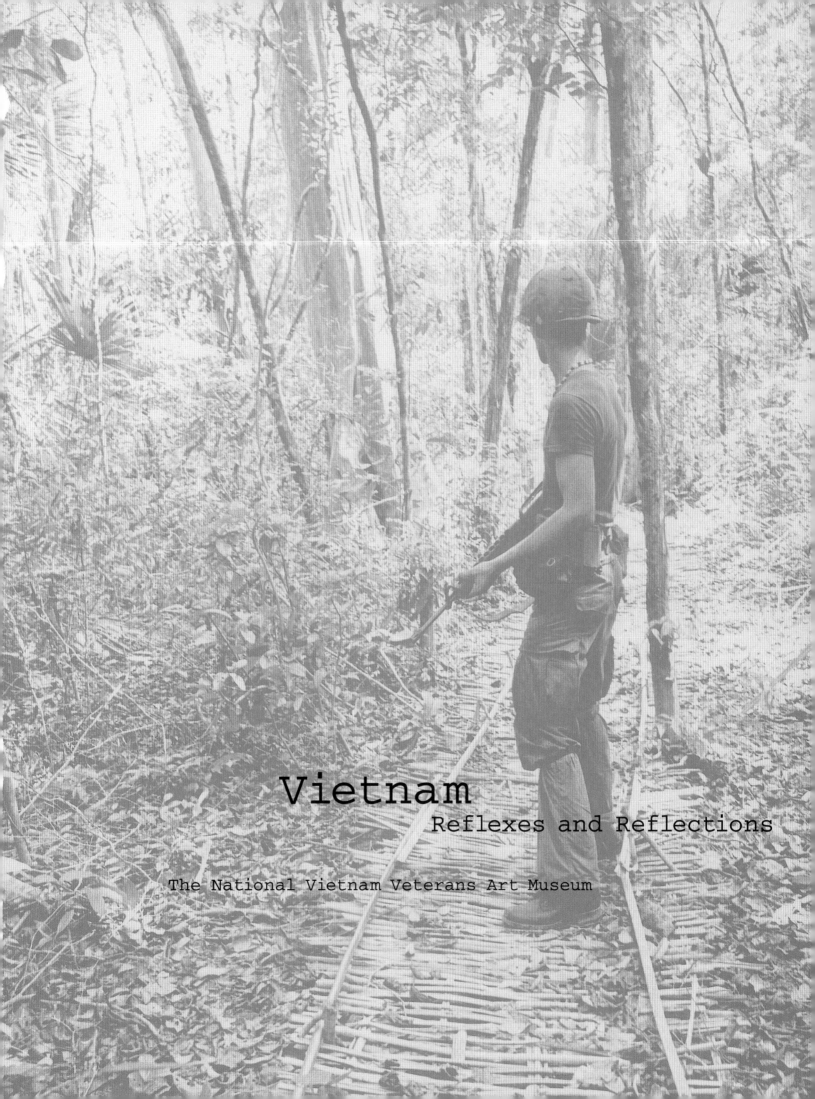

Vietnam
Reflexes and Reflections

The National Vietnam Veterans Art Museum

Vietnam

The
National
Vietnam
Veterans
Art
Museum

Reflexes and Reflections

Edited by Eve Sinaiko

Foreword by Sondra Varco

Essays by Anthony F. Janson and Eve Sinaiko

Collection photographed by Michael Tropea

Harry N. Abrams, Inc., Publishers

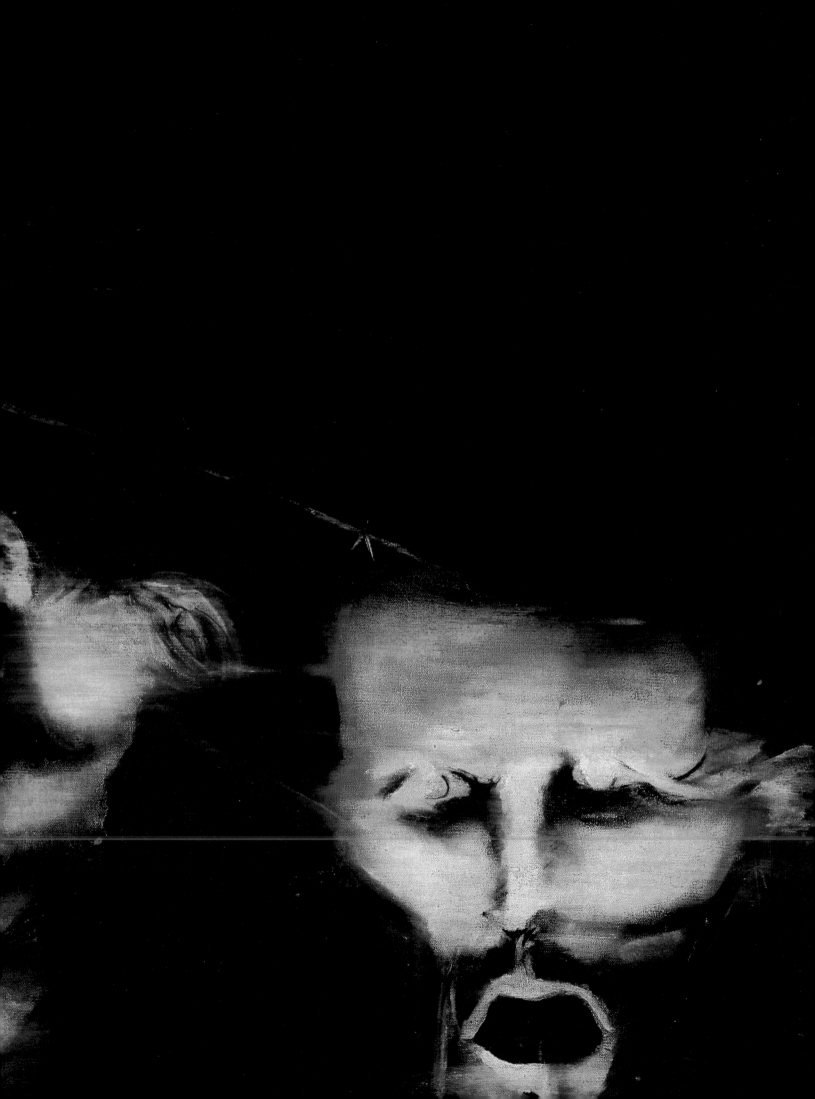

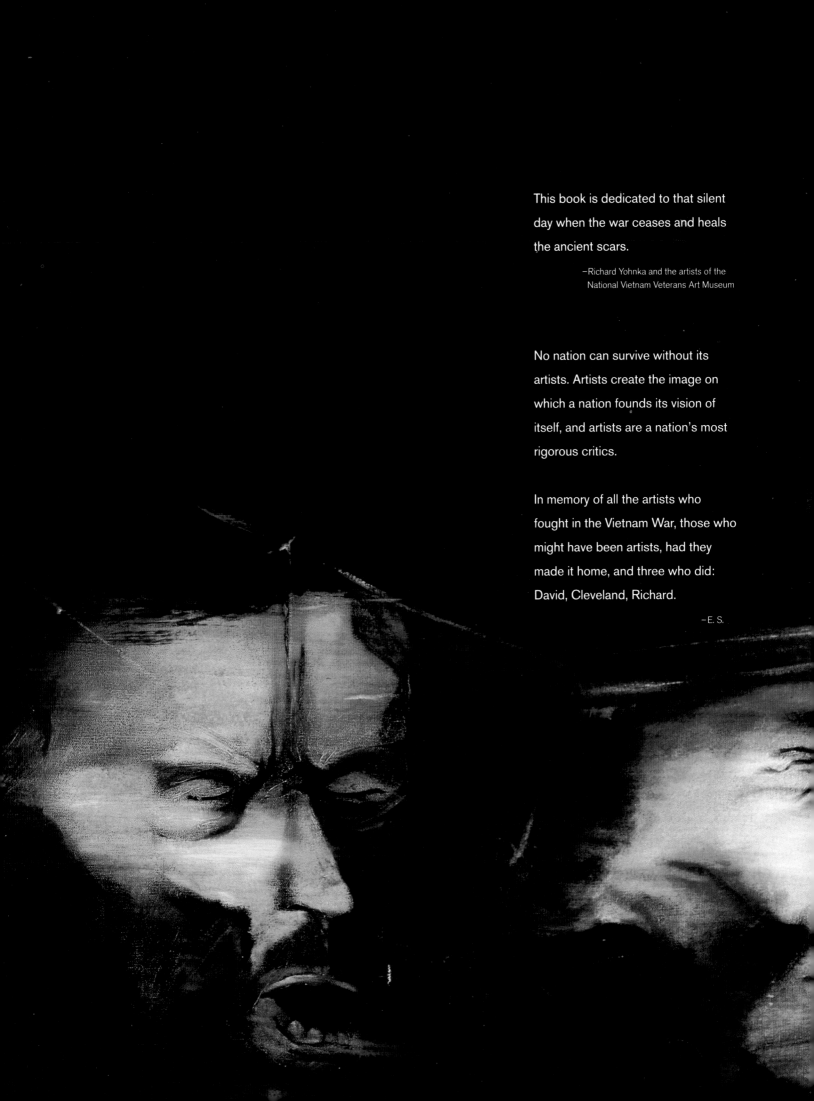

This book is dedicated to that silent day when the war ceases and heals the ancient scars.

—Richard Yohnka and the artists of the
National Vietnam Veterans Art Museum

No nation can survive without its artists. Artists create the image on which a nation founds its vision of itself, and artists are a nation's most rigorous critics.

In memory of all the artists who fought in the Vietnam War, those who might have been artists, had they made it home, and three who did: David, Cleveland, Richard.

—E. S.

Editor: Diana Murphy

Designer: Judith Hudson

Picture research and permissions:

Roxana Marcoci, Barbara Lyons

Map design: Christine Edwards

Library of Congress Cataloging-in-Publication Data

Vietnam : reflexes and reflections : the National Vietnam

 Veterans Art Museum / edited by Eve Sinaiko; essays

 by Anthony F. Janson and Eve Sinaiko; collection

 photographed by Michael Tropea.

 p. cm.

 Includes bibliographical references and index.

 ISBN 0–8109–3945–2 (clothbound)

 1. National Vietnam Veterans Art Museum. 2. Art,

 American. 3. Vietnamese Conflict,—1961–1975. Art and

 the conflict. 4. Art—Illinois—Chicago. I. Sinaiko, Eve.

 II. Janson, Anthony F. III. National Vietnam Veterans

 Art Museum.

 N8260.V54 1998

 704'.355'0973—dc21 98–2956

Printed and bound in Japan

On the endpapers: David Smith. Untitled, detail (see no. 167)

On page 1: R. Dean Sharp. Untitled (see no. 157)

On pages 2–3: John Plunkett. *Gimme Some of That

Good-Time Lock and Load* (see no. 138)

On pages 4–5: Richard Yohnka. *Echoes* (see no. 180)

Text on pages 63–64 copyright © 1998 James Dale Elder, Jr.

Reprinted by permission

Text on pages 92–93 copyright © 1998 Grady Estle Harp.

Reprinted by permission

Harry N. Abrams, Inc.

100 Fifth Avenue

New York, N.Y. 10011

www.abramsbooks.com

Contents

We had been told, on leaving our native soil, that we were going to defend the sacred rights conferred on us by so many of our citizens settled overseas, so many years of our presence, so many benefits brought by us to populations in need of our assistance and our civilization.

We were able to verify that all this was true, and, because it was true, we did not hesitate to shed our quota of blood, to sacrifice our youth and our hopes. We regretted nothing, but whereas we over here are inspired by this frame of mind, I am told that at home factions and conspiracies are rife, that treachery flourishes, and that many people in their uncertainty and confusion lend a ready ear to the dire temptations of relinquishment and vilify our action. I cannot believe that all this is true and yet recent wars have shown how pernicious such a state of mind could be and to where it could lead. Make haste to reassure me, I beg you, and tell me that our fellow citizens understand us, support us and protect us as we ourselves are protecting the glory of the empire.

If it should be otherwise, if we should have to leave our bleached bones on these desert sands in vain, then beware the anger of the Legions!

> — Marcus Flavinius,
> Centurion in the 2d Cohort in
> the Augusta Legion,
> to his cousin Tertullus in Rome,
> 2d century A.D.

Foreword

The National Vietnam Veterans Art Museum has its origins in the Vietnam of the 1960s. Young American men and women left their homes and took an oath that says, in part, "against all enemies, foreign and domestic." Few of them understood the serious implications and complexities of that oath at the time. These young people soon found they had neither time nor opportunity to be young. They were "trained to be soldiers" and sent to the other side of the world. Very shortly they were literally in a jungle.

At the same time, in that jungle on the other side of the world, there were other young men and women who had taken a similar oath and left their mothers' homes.

These soldiers were mirror images of each other and were trained to kill each other. They used rifles, knives, grenades, and so on to do that job. They slept in mud, heat, and monsoon rains. Often they barely got enough to eat; to survive they tried to stay awake for long periods, and often they wore their clothing until the jungle rotted it off their bodies.

In this horror and isolation from the safe and the familiar, amazing things happened to them. They were given overwhelming responsibility, unasked for and undesired, and coped with it in many ways as they were reintroduced to themselves through adversity.

They have told me that some break under this pressure, a few literally go insane. Others manage to get through it, though they will never be the same again. Still others develop a fire in their mind that consumes them, and they ingeniously hold onto it for a later time, vowing to themselves that if they live they will fulfill a destiny.

It was from these men and women and these circumstances that the seeds for this collection were sown. The art comes out of many varied experiences. It was made by Marines who spent their entire tours in the jungle, suffering incredible casualties (one in four names on the memorial wall in Washington, D.C., is that of a Marine). It comes from pilots and door gunners who continuously risked their lives flying in and out of battles to drop off troops and pick up wounded. Often, they say, they had to balance themselves, as well as the helicopters, as their feet slid on the blood-splattered floor. It comes from Special Forces troops, trained assassins

who had to go it alone to accomplish their deeds. The collection also includes work by soldiers barely larger than twelve-year-old children who searched the deep underground tunnels of the enemy forces, and by Airborne troops who were secretly dropped into Laos and Cambodia and when seriously injured were left for dead. Represented as well are a surgeon who kept IVs running in dead men in order that other nearby wounded would not give up the fight to stay alive; nurses who held screaming men cradled in their arms as they died, wishing they could save them; and a prisoner of war who was kept in solitary confinement for five years and brutally tortured. These are the men and women of the National Vietnam Veterans Art Museum. They are people of incredible strength and integrity who experienced that strange spontaneous insight that comes to some who participate in war. They had a passion to tell the story of those who did not insulate themselves from the experience. It is not for the faint of heart. They have given us images that refuse to die, made from memories that are extraordinarily vivid and devoid of moralism.

These artists are full of incongruities. Some tell me they feel their bodies are empty halls echoing only sorrow. Many are angry that so much courage, bravery, and sacrifice went unrecognized. They say they built fortresses around themselves against the world. Then they made the art work that tells the story and shows that they individually confronted, firsthand, the darkest side of themselves.

They made the art, and then hid it away. Most trusted no one to tell their stories to. Very few nonveterans had the courage to listen to their stories.

My first encounter with the art of Vietnam veterans came in 1979, when at Joseph Fornelli's studio a drawing caught my attention. It was an image of a mother with a child sculpted to her hip (see no. 54). I did not know at the time that Joe was a Vietnam veteran. I knew him only as a local artist. I wanted to buy the drawing, but for a long time he would not sell it to me and would not tell me why. We had already been friends for several years, and another year passed before he told me he had made the drawing in Vietnam. He said he had over

a hundred such pictures from the war, some done with c-ration coffee and river water. He told me he drew to keep his sanity and to record his experiences.

It took me another year to convince him to let me take a few of the drawings to some galleries in Chicago in hopes of organizing an exhibition of the works, so that people could learn about this problematic war through his art.

At the time Vietnam was not an open subject. Gallery owners were intrigued by the drawings, and several praised them, but they considered them too controversial, too political to exhibit. Some were afraid of attracting antiwar protesters. Yet the art itself was not political at all: they were reacting to the word — Vietnam.

In 1980 a curator at the Museum of Contemporary Art in Chicago told me she had heard that a small group of veterans were trying to mount a show at an alternative gallery called N.A.M.E. At the gallery I learned that a Chicago policeman, a former Marine, and a former soldier were trying to persuade three other former veterans, all students at the American Academy of Art, to show their work. The gallery director was willing but concerned about security, so the policeman offered to get some of his off-duty police buddies to stay in the gallery while the work was on display.

I was anxious to meet this group. I contacted the policeman, and on one hot August night in 1980 Joe Fornelli and I went to meet the officer at a run-down chicken restaurant in a deteriorated Chicago neighborhood. Sitting in a booth at 1:00 A.M., we exchanged very tense conversation and photographs of our artists' paintings. After looking at these I felt more strongly than ever that this American history in art must be preserved and exhibited.

The policeman told me they were calling themselves the Vietnam Veterans Arts Group. They were going to hold the show at N.A.M.E., and one of them, Ned Broderick, a former Marine, had come up with the title *Vietnam: Reflexes and Reflections*. The men were cautious and ambivalent, but curious to see the reaction of the public to their art. Joe and I decided to participate and help them.

We wanted to find other veteran artists, so we put advertisements in magazines and newspapers we thought guys their age would read – art publications as well as *Hot Rod News, Sports Illustrated,* and *Shotgun News.* Eleven artists responded from several states, all of them combat veterans.

We opened the exhibition in October 1981. We had no idea what to expect of an audience, and I had no idea what to expect from the artists. One piece of art in the show, a door painted to look like the entrance to a whorehouse, seemed "Vietnam unreal" to the group. So the off-duty policeman handed his revolver to the artist, who then shot some holes in the door. Right in the gallery! Nobody was arrested, but I wondered what kind of craziness I was getting involved with. However, the art was very powerful and haunted me, so I stayed.

N.A.M.E. was a storefront gallery. We hung curtains of camouflage material; using surgical tape, some of the artists partly taped over the gallery name on the front window so that it read "N.A.M." At the opening, instead of the usual white wine and cheese, we served warm beer and army-surplus c-rations, food the soldiers ate in Vietnam. Two thousand people came to the opening, and over the next five weeks about 350 people visited the gallery daily. There were no protests.

The success was far beyond what we had anticipated. We kept the gallery open seven days a week, fourteen to sixteen hours a day. In addition to the paintings, sculpture, and other work, we had an audiovisual presentation set up in a corner of the gallery, showing slides taken by GIs of everyday life as a soldier in the war. Late in the evenings, groups of Vietnamese refugees and immigrants came with interpreters to talk to the artists and look through the thousands of slides for pictures of a home village or city or – more important – lost relatives who had served in the South Vietnamese army. When any were found, we printed copies to give them. Families of veterans came forward to express their appreciation for being given a glimpse of their sons' experiences (we had no women in the group until 1995). Veterans came with their wives and children to show them "what Vietnam was really like."

It was encouraging to see that so many people wanted to know about the war. The artists had been very reluctant to show their work or discuss the war. Also, the memories the exhibition stirred were difficult for them. The most surprising aspect of the first show was that they found other veteran artists who were making work relating to their experiences. Until this point each one had been convinced that he was the only one giving serious treatment to this subject. As the exhibition gained attention from the press and public, more artists came forward. They took strength from each other, and I acted as a buffer between them and the world when it was necessary. But interest by now went well beyond the art community. A new and intense curiosity on the part of the general public to know more about the Vietnam War was finding an effective source of satisfaction through the viewing of the art.

We began to receive offers of shows from private galleries, only to find that we would have to "modify" the exhibition – that is, to remove art that might be offensive or disturbing to viewers. We were on one occasion asked if we had any art that was not so depressing or any paintings of generals saluting troops in formation. Of course, we did not. We kept to our original philosophy of allowing the artists free expression and turned down the offers.

Not all exhibition spaces were so timid. In the spring of 1983, not long after the dedication of the National Vietnam Veterans Memorial in November 1982, we were invited to bring the collection to an experimental gallery called the Washington Project for the Arts. There, too, it was a great success, and many artists had the opportunity to meet each other for the first time. Just an hour before the opening reception, a Maryland artist named Ulysses Marshall heard about the exhibition on the radio while driving home from work. He went home, got his art, and brought it to the gallery. With the help of the other artists, paintings were moved around to make room for his work. New artists often joined the Vietnam Veterans Arts Group in this spontaneous fashion. The WPA show led to an invitation to display the work in the rotundas of the House of Representatives and the Senate. By now we had thirty-two artists.

Art critics came to see the work intending to stay a few minutes and ended up staying for hours. Interviews with the artists were constantly taking place. And the critics talked about the apparent lack of use for art-school techniques. Some critics spoke of feeling unsettled by these outsiders who seemed to be challenging notions of subject and style. The show received rave reviews. This was important to the artists, as it gave them confidence and credibility.

Later that year the Lyndon Baines Johnson Memorial Library paid the cost of bringing part of the collection to Austin, Texas. They later offered to buy the collection. We decided not to let it out of the hands of the artists. By now the project had momentum and we were aware that we could keep it traveling. With the help of a core group of artists and friends in Chicago, we kept it going.

Between 1983 and 1992 the collection traveled to over thirty sites in the United States. During this time we acquired art by artists from Australia, North and South Vietnam, and even one from Cambodia. Sometimes we were invited to cities by veterans' groups who raised the money for shipping and display costs themselves; sometimes we went to university galleries and local museums. We were operating largely by word of mouth. Between shows the collection was usually stored in the basement of my home or in a Chicago warehouse.

At each site new artists came forward, clutching a painting, sculpture, or drawing unearthed from an attic, garage, or basement. Though many works were sadly damaged, Joe Fornelli used his conservation expertise to repair them.

We hung as much art in each space as was possible, trying always to give each artist some representation. Though there was often great variation in the quality of the work, we felt that because the experience was valid, so was the art.

Later in the 1980s corporate sponsorship would have been easier to obtain, but always at the price of censorship or "editing." Instead, we charged borrowing galleries what fees we could and paid the rest of the operating costs ourselves. We were also supported by the extraordinary generosity of some individuals, usually veterans. On one unusual occasion, during the exhibition at New York's Lincoln Center, we ran out of money for food and hotel rooms. A significant amount was then given to me by one of our newer artists. I later found out that he had emptied his extra pair of cowboy boots of marijuana, sold it in Central Park, and presented me with the profits!

By the early 1990s the Vietnam Veterans Arts Group had nearly one hundred artist members and over five hundred art works, as well as thousands of slides of the war. We knew we had something very important to care for, and we continually struggled for funding. We needed a permanent home for this amazing collection. We wanted to be able to display the works all the time, to do conservation, and to provide research and study materials to those studying the war.

In 1993, while we were searching Chicago for a site, two local real-estate developers, Sheldon Baskin and Jerry Fiat, offered to build us a beautiful temporary gallery space, rent free, in a building they were renovating in an area of the city that was undergoing redevelopment. There we were able to exhibit the art and work hard at finding a permanent home for it. In the fall of 1995 the City of Chicago gave us a three-story abandoned warehouse on Indiana Avenue and a generous grant to renovate it. The Vietnam Veterans Arts Group became the National Vietnam Veterans Art Museum and opened in August 1996, sixteen years almost to the day after the late-night meeting when a few of us sat in the fast-food chicken restaurant and first talked about the art of the war. In this permanent facility we are able to accommodate school groups and veterans' groups, to display a great portion of the collection and many artifacts of the war, and build an archive of documents given to us by veterans. We continue to accept new work, though necessarily our acquisitions are now juried.

I have been asked, "Why build a museum to a war that was lost?" I have been told, "Artists can't be killers." The responses to such comments are in the art. These artists have the ability to live with many kinds of emotions, and they explore and reveal a struggle from

which they have emerged with a more comprehensive account of who we are as human beings. They have a discontent with what is easy. This museum to a lost war is filled with work done by men and women who experienced what most of us will never have to face. It is an extraordinary tribute to dignity and identity created from an atmosphere of deception and indignity.

What this collection means to the general viewer, or reader, is for each individual to decide. Here is what Michael Brostowitz, a former Marine, wrote about his first visit to the museum:

One Sunday afternoon I relived a large section of my past. Previously I had allowed only small fragments to surface and only if they were not too painful, or no one else was there, I would deal with them . . . kind of. That afternoon I endured more of me than in all my other times. . . . I came to realize that this occurred because this art was made by a group of artists who shared the same passions that I held. Even better was the fact that what I had felt troubled by and unable to grasp emotionally they constructed in a tangible form that I could see, read, and feel, just as it had been engraved in my mind. This group of spiritual guides created a medium for me, all of us . . . to accept the facts of our lives, like it or not.

Originally, this art was not created for the eyes of others, but only for the artists themselves. These artists take an extraordinary step forward by asking the viewer to reexamine the nature and function of art. They tell you to forget what you have seen in typical combat art, for it bears no relation to the realities of war.

The works of art in this museum, and this book, do not allow the viewer to be neutral: they demand a response. For the artists the Vietnam War is never solved. Many have said they do not want to forget, as to do so would lessen the sacrifices made by so many.

Wars usually unite societies, and certainly generations, but this one did not. Twenty-five years after its end I can attest that the artists and the viewers of this art are still grieving. The issue for veterans is not whether the war was right or wrong; the fact is that it happened, and this is the art specific to that experience. It is a compelling account of brave men and women who fought other brave men and women, and who have something in common only with each other. As Jim Gray, one of the poets whose work is included in our archive, has written:

We went to Vietnam,
And some of us came back.
That's all there is . . .
Except for the details.

Sondra Varco
Executive Director
The National Vietnam Veterans Art Museum

In the United States, in the first years after the Vietnam War, its veterans were an invisible population. Americans of every political persuasion were sick of the subject – the ugly news on television every night, the divisive arguments and protests, and especially the war itself. It is difficult in retrospect to recall just how thoroughly veterans were silenced, all but erased by a culture that desired ardently to forget the war as soon as possible. But this imposed silence is a salient aspect of veterans' postwar experience, and it deeply informs the art and writing in this book.

When their tours of duty ended, American soldiers returned from the field with little preparation and no welcome. Flying from "the War" to "the World" virtually overnight, sometimes directly from battle sites, they changed into civilian clothes and rejoined civilian life with shocking abruptness, and in a silence ringing with animosity. America was sharply divided politically between critics and supporters of the war, and veterans were themselves a battleground between the two positions. From the left they took the brunt of blame for the war itself; from the right, they were bitterly chastised for failing to win it. Most responded by withdrawing from the public debate. It was in this climate of high but suppressed emotion that some veterans began, almost secretly, to create art about their experiences (a few had been able to make art in Vietnam). The early works in the collection of Chicago's National Vietnam Veterans Art Museum were thus made entirely for private purposes and were often hidden away.

Editor's Note

In 1982 the national memorial to Vietnam veterans now known as the Wall was dedicated in Washington, D.C. It was conceived by a veteran and funded without government support. Though at first some veterans disliked the Wall's design, which reminded many of the foxholes they had lived in, it was a dramatic success as a monument and marked a turning point in America's attitude toward them. By the early 1980s an influx of South Vietnamese refugees to the United States included many veterans of the South Vietnamese armed forces, adding to the veteran population. Vietnam War veterans had begun by this time to appear as figures in popular culture, commonly represented in films and television programs as psychotic or pitiful killers, warped by their experiences and driven by unspeakable memories. After the advent of the Wall veterans remained stereotyped in pop culture, but by the late 1980s their representation had altered. They now began to figure in films and television as silent, long-suffering heroes whose experiences (stoically unmentioned) were a crucible of manhood from which they had emerged strong and tested, baptized by fire, dauntless and unsung, but . . . troubled by dreams.

Both the Crazed Vietnam Vet and this more sympathetic and romantic figure struck most veterans as false and offensive. Both were cheap clichés and implied that veterans were psychologically damaged. Though the Vietnam War was no longer unmentionable, the perspective of veterans themselves remained largely unexpressed. By about 1990 discussion of the war had for the most part faded from public discourse, relegated to classrooms and the books of specialists. Americans expressed a desire for reconciliation and closure concerning Vietnam.

Throughout these years artists who were veterans explored their memories in painting, sculpture, drawing, and other media. Very little of this work was exhibited publicly; some was displayed under the dismissive rubric of "art therapy." But the work continued to be made.

To most veterans it is obscene to speak of closure concerning an experience so powerful and important, so significant both to their own lives and to the body politic. In addition to the memoirs and military histories

published by veterans of every war, Vietnam veterans have turned with an extraordinary wealth of creativity to the arts as an arena, perhaps all the more so because other spheres of expression were long closed to them. Many have written fine novels and poetry (some are noted in the bibliography), and as this book attests, they have painted, crafted, and constructed forceful works of visual art. Some twenty-five years after the war they continue to speak with myriad voices. And though the artists represented in this book are anything but monolithic in their views of the war or their political opinions, they are unanimous in their passionate desire to speak for themselves. The two critical essays on the oeuvre of the National Vietnam Veterans Art Museum have therefore been placed after their own words and art.

The artists' statements should be seen as the principal commentary on the art. The statements themselves are a mixture of recent writing and extracts from older manuscripts, culled from the archives of the museum: letters, memoirs, unpublished novels, transcripts of conversations. Some of the documents were written in Vietnam during the war, others immediately after and in the intervening years. Very few were written for this publication. Selecting them was a collaborative effort between the artists, the editor, and the museum's executive director, and an attempt has been made to present a range of voices, points of view, aspects of the war experience, and means of expression. Marines based on the North Vietnamese border had different experiences from sailors stationed offshore, or from helicopter pilots, or clerks in Saigon, or field officers, or tunnel rats. Above all, every artist interprets experience differently. If there is relatively little political commentary in these texts, it is due to no deliberate editorial decision; politics in the narrow sense of the word is not the central concern of most artist veterans. In the broader sense, all art is political, and open to the viewer's interpretation.

It has not always been possible to assign dates to these texts, and not all of the statements refer directly to the making of art. It is for the reader to explore the ways in which art and writing together convey the variety and depth of the war experience of one group of men and women.

A note on nomenclature: Some place-names in Vietnam have changed since the end of the war. Vietnam itself is no longer divided into North and South but is the Socialist Republic of Vietnam. During the American war the southern state was the short-lived Republic of Vietnam, and before that the French colony of Indochina. Its capital city was Saigon, now renamed Ho Chi Minh City in honor of the founding leader of the Communist independence movement that won the war. To maintain the historical immediacy of the artists' narratives and fidelity to the time of which they speak, the place-names of the period have been retained in this text. The map on the following page reflects this decision and indicates the political realities of the period of the American war in Vietnam, commonly dated from about 1963 to 1975. There and throughout the book the names of villages, firebases, and other military sites have been made as consistent as possible. During the war military place-names changed from year to year, and many were spelled in more than one way. An attempt has been made to render these place-names accurately, but no doubt errors have crept in. Each artist's dates of service refer to the period he or she was in Vietnam, not the full term served in the armed forces. Rank is not given, and the degree of descriptive detail about the service itself has been determined by each artist individually. Unless otherwise noted, all works are in the collection of the National Vietnam Veterans Art Museum.

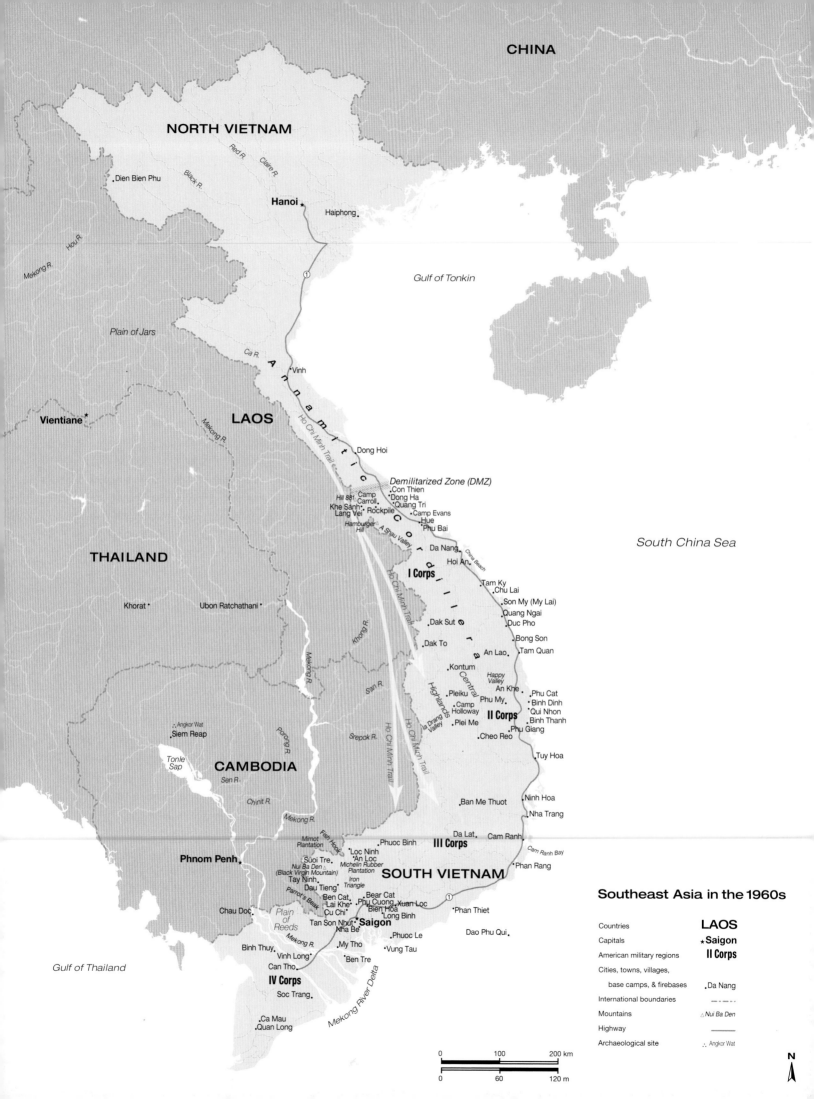

CHINA

NORTH VIETNAM

Dien Bien Phu

Red R.

Claire R.

Black R.

Hou R.

Mekong R.

Hanoi ★

Haiphong

Gulf of Tonkin

Plain of Jars

Ca R.

Vinh

LAOS

Vientiane ★

Mekong R.

Dong Hoi

Demilitarized Zone (DMZ)

Con Thien

Dong Ha

Hill 881 Camp Carroll

Quang Tri

Khe Sanh Rockpile

Camp Evans

Lang Vei

Hue

Hamburger Hill

A Shau Valley

Phu Bai

THAILAND

Da Nang

China Beach

I Corps

Hoi An

South China Sea

Tam Ky

Chu Lai

Son My (My Lai)

Khorat

Ubon Ratchathani

Quang Ngai

Dak Sut

Duc Pho

Bong Son

Dak To

An Lao

Tam Quan

Khong R.

Kontum

Happy Valley

An Khe

Ho Chi Minh Trail

San R.

Pleiku

Phu My

Phu Cat

Binh Dinh

Qui Nhon

Camp Holloway

Binh Thanh

Srepok R.

Ia Drang Valley

Plei Me

II Corps

Phu Giang

Mekong R.

Cheo Reo

Tuy Hoa

Porong R.

.: Angkor Wat

Siem Reap

Tonle Sap

Sen R.

CAMBODIA

Chinit R.

Ban Me Thuot

Ninh Hoa

Nha Trang

Da Lat

Cam Ranh

Phuoc Binh

III Corps

Cam Ranh Bay

Mekong R.

Fish Hook

Loc Ninh

Mimot Plantation

An Loc

Phnom Penh ★

Suoi Tre

Michelin Rubber Plantation

Phan Rang

Nui Ba Den (Black Virgin Mountain)

Tay Ninh

Iron Triangle

SOUTH VIETNAM

Dau Tieng

Parrot's Beak

Ben Cat

Bear Cat

Lai Khe

Phu Cuong

Xuan Loc

Chau Doc

Cu Chi

Bien Hoa

Long Binh

Plain of Reeds

Tan Son Nhut

Saigon

Nha Be

Phuoc Le

Phan Thiet

Mekong R.

My Tho

Vung Tau

Dao Phu Qui

Binh Thuy

Vinh Long

Ben Tre

Gulf of Thailand

Can Tho

IV Corps

Mekong River Delta

Soc Trang

Ca Mau

Quan Long

Southeast Asia in the 1960s

Countries	**LAOS**
Capitals	★ Saigon
American military regions	**II Corps**
Cities, towns, villages, base camps, & firebases	. Da Nang
International boundaries	– – – –
Mountains	△ Nui Ba Den
Highway	———
Archaeological site	.: Angkor Wat

0 100 200 km

0 60 120 m

N

The Artists

Little is known of this artist. An American soldier recalls how these works were found:

During my second tour in Vietnam, I was the American operations officer in a combat division in I Corps. Sometime around the end of summer 1969 we moved our headquarters to a small airfield in Phan Thiet, overlooking the South China Sea. From there we ran some large operations with heavy casualties on both sides, but many more were company-size combat patrols. The reconnaissance teams often fought hard and took heavy losses, but their mission was to discover the location of the main North Vietnamese and Viet Cong forces. So if they could, they avoided contact with small enemy patrols and followed them back to their camps.

On one occasion a patrol of six men turned a bend in a rain-soaked trail in deep mountain forest and found themselves face to face with three North Vietnamese or Viet Cong soldiers. It was a routine engagement; we had hundreds of them. The Americans killed the Vietnamese, gathered their equipment for intelligence, left the bodies to the care of their comrades, and were extracted back to Phan Thiet.

The equipment lay around headquarters for a few hours as the war flowed on to more urgent matters. That evening, we opened the packs and found the usual soldier stuff, common to all armies – except in one. That pack held a sheaf of mildewed papers with delicate watercolor and pen sketches and a pocket watercolor kit similar to the one I carried at the time. Many of the paintings were quick sketches; others were more finished camp scenes. The artist had clearly used every scrap of paper he could find: rice paper, pages of old newspapers and magazines, and thin, lined notepads. We sorted through the sketches for those of intelligence value and shipped a large batch of the best to Nha

Anonymous North Vietnamese or Viet Cong artist

Served in Vietnam, probably
North Vietnamese Army, ca. 1969

1 Untitled. ca. 1969. Watercolor on paper, 9 x 5½ in.

From a letter, 1984:

Artists reflect what we are; we are the mirrors.... It was while serving in Vietnam that I began to perceive things in a significantly different manner. Perhaps the reality of sudden death opened new avenues of thought for me. Certainly my experiences recuperating in an army hospital from a serious leg wound have added a great deal to the imagery in my work....

Following my years in the army, images appeared and reappeared in my work and began to form a symbolic language. The core of my work is the image of the bone as structure and strength. Some of these recurring images are related to memories of a man I came to know in the hospital. Both Harris and I were recovering from similar leg wounds. Mine healed; his never did. But these pieces are about more than broken bones and bleeding soldiers. My work is not about specific events but rather about situations — the circumstances, conditions, and environments that affect the individual.

... Although many people see violence and pain and anger in my work, my thoughts on these pieces are filled with feelings of warmth and gentleness and regret. In much of my work there is a certain sadness and humility and a seriousness free of satire. If the glass is broken, it has been cared for and bandaged. If it remains whole, it represents the strength of the bone and at the same time the fragility and elegance of crystal....

The *Damaged Bones* are a personal memorial to unknown victims. In a military situation, everything appears to be uniform, the same. There are no individuals in the army. But in reality the differences are subtle. The surface appears very rigid and tense, but dig down a bit and the underlying structure is much different.

During basic training, Fort Ord, California, August 1967

Michael Aschenbrenner

Born Pomona, California, 1949
Served in Vietnam, Army, 1st Battalion, 327th Infantry Regiment, 101st Airborne Division, A Shau Valley and Phu Bai, forward observer, 1968

6 Three *Bone Units* of eighteen from the series *Damaged Bones: Chronicles 1968.* 1980–82. Left: glass, twigs, fabric, plaster, and paint, 30 x 4½ x 3½ in.; center: glass, wire, steel hooks, twigs, gauze, and plaster, 33 x 4½ x 3½ in.; right: glass, twigs, wire, and fabric, 31 x 4½ x 4 in.

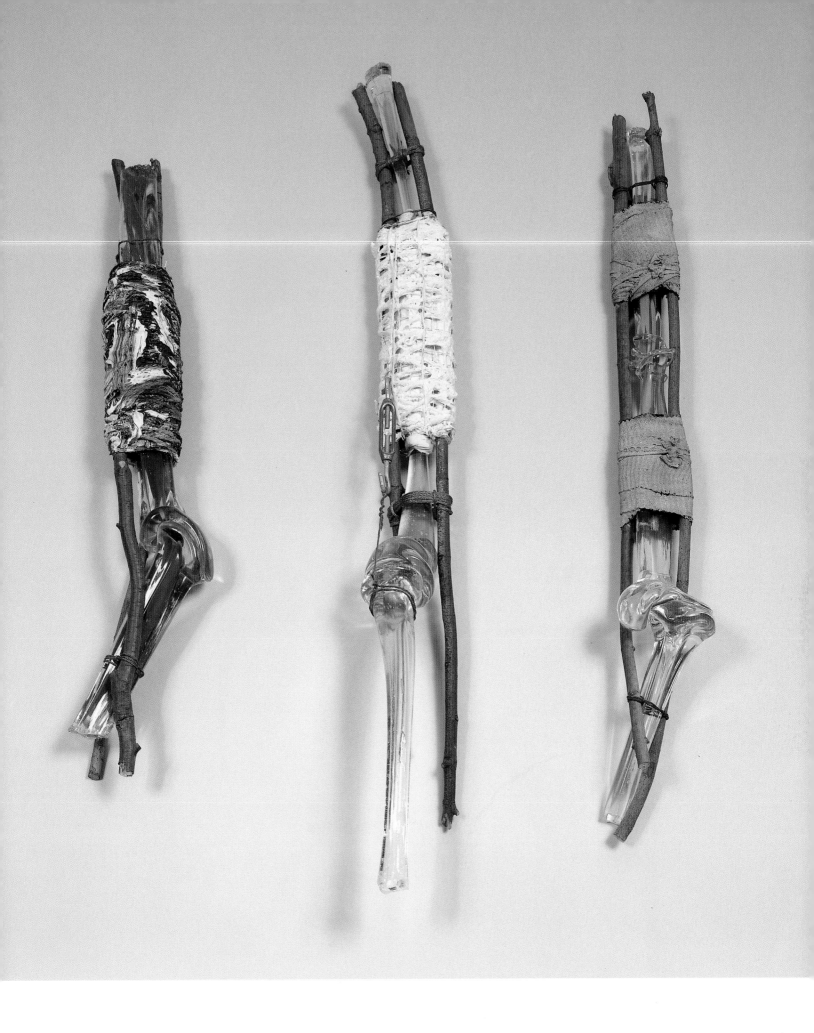

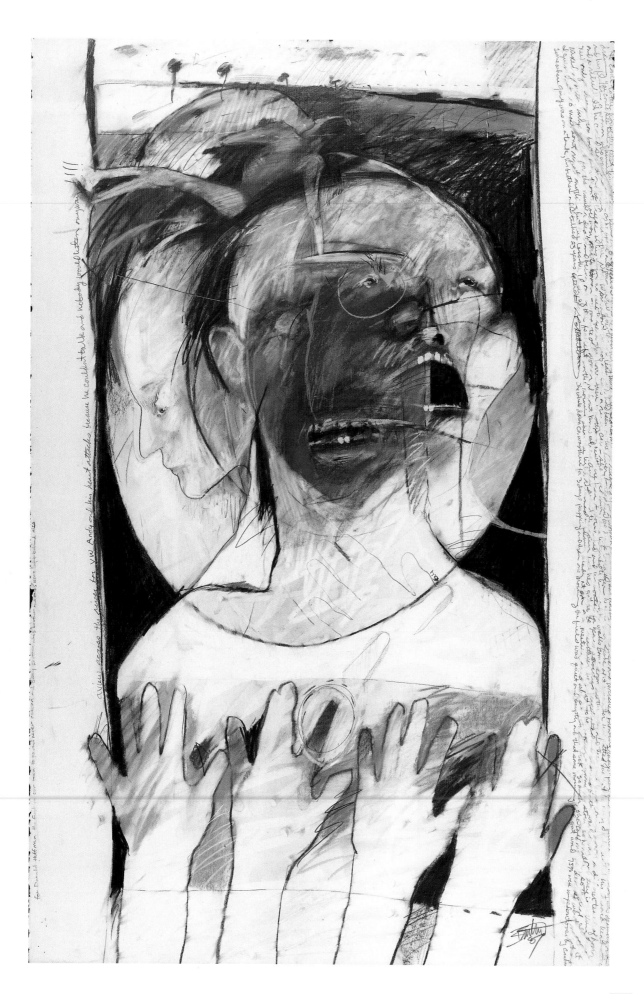

Inscription on the painting:

For Donald Huffman the first in our town to go and never return and Gary Britton whose brother and folks were left behind also.

A View Across the River for VVet Andy and His Heart Attacks Because He Couldn't Talk and Nobody Would Listen Anyway!!!!

He came to the house . . . he'd never met my third wife. I'd not met his second a young woman who sat nearby and watched knowing Andy's "plug" had been pulled and the story was draining and draining. You could see him gaining strength as he spoke and thru all our tears I remembered he had been on the river boats. When we drank together he never spoke of it no matter how potted we got, he never spoke until his second heart attack and his finding a woman who was too young during the Nam to know about the pros and cons and really care – she loved him, she listened to him and his walls came down all the way and they just kept coming down as did our tears of horror and a relief that he could say it and be free. His . . . no need to speak the horror there is nothing new there. Fear to rot naked and unabated for years atrocities perpetuated and endured both. War is war and there is nothing there new only transition from boy to old man and girl to woman – woman to old woman. I don't know where Andy went to again, but he's got to be healthier, he's got to be happier. Funny

his story is so horrible, so typical I had it mixed up with Larry's except for the number dead and being one of the few left in the morning when the light returned. Funny a lady at an AA meeting said "Why do vets say 'fuck' so much?" She told me we deserved what we got. I guess so. Most don't regret anything but the loss, the lonely years. His whole darn Co. was there for 3 days prepping and then one morning the field was quiet and empty and that same morning we got word that 75% were wiped out over in Cambodia. Somewhere Gary was on a tank, his brother and I talked 25 years after and cried.

From a letter, 1995:

Somewhere between Vietnam and a bottle of whiskey my nightmare began. With scratches of line and bursts of color I have tried to rid myself of that nightmare and its long-reaching effects. I have tried to draw a map for myself from the past to the present, from sickness and anger to peace and health. Every day I have to work because the truce I have with darkness is delicate and peace requires constant maintenance.

At the 160th Signal Group, Long Binh, 1970

Richard Bartow

Born Newport, Oregon, 1946
Served in Vietnam, Army Signal Corps,
Long Binh Air Base, clerk-typist, 1970

7 *A View Across the River for VVet Andy and His Heart Attacks Because He Couldn't Talk and Nobody Would Listen Anyway!!!!* ca. 1989. Watercolor, graphite, colored pencil, and pastel on paper, 40 x 26 in.

From a memoir, 1991:

In 1966, on my eighteenth birthday, I registered for the draft. I never looked at a map to see where Vietnam was, but I started paying a lot more attention to the nightly news. Things were beginning to heat up over there, and I watched it all on television. I was scared, but very curious about what it was really like. I wasn't drafted until 1969, so like many others I watched older friends go off to Vietnam. Some came back with severe wounds; some didn't come back at all. None were talking. They had changed; they had all changed. They seemed quiet and bitter. I didn't understand it until I had gone and returned: they were deeply hurt from watching close friends die, having to kill other human beings, and then coming home, where the only people who cared were those who hated us. I didn't really have an opinion about the war before going. It wasn't the way I thought it would be from watching World War II movies as a child, and that confused me. Those who were shot were supposed to fall to the ground without pain or blood, and simply go to sleep forever. Those who survived were supposed to return from war as heroes, with dignity, respect, and honor. After watching some of my friends go to Vietnam, then come back without parades, forever forgotten and forever changed, I had serious doubts about being drafted. But something made me go, against my better judgment. After all, men are supposed to go off to war. I had to see what it was really like, and I couldn't let my family think I was a coward.

In the old imperial city of Hue there were sandbags and barbed wire surrounding the schools. There were soldiers with machine guns guarding the children as they played. There were women and children begging in the streets as we drove by in trucks. There were no young Vietnamese men without uniforms. There were hundreds and hundreds of houses made out of scraps of wood from ammunition crates and the cardboard from c-ration boxes. There were piles of rubble that had formerly been beautiful mansions in what was once a great city. There were mass graves where the North Vietnamese Army had executed thousands of civilians during the Tet offensive of 1968. I could only imagine what these people had been through. I started crying for them, instead of for myself.

I was taken into the jungle on a resupply helicopter to join the Delta Raiders, who were already on a combat mission. The bird's-eye view of the distant mountains was breathtaking; flat, plush green rice paddies ran right up to a wall of triple-canopy, jungle-covered mountains. Mountain streams and rivers ran everywhere, and waterfalls. I could hardly believe there was a war going on in such a wonderful place. Aside from occasional bomb craters, the view was spectacular: it was a dream world made of every kind of green. No artist could ever do it justice.

Once I was with the company, my reason for being in Vietnam changed. I still cared about the South Vietnamese people, but they seemed very far away. Our immediate problem was the survival of one another: these scruffy-looking characters with eyes that seemed to look through you. The only thing that mattered at all was the ground I was standing on and those standing there with me. It was basic and tribal, a primitive state of mind.

Near Firebase Ripcord, July 1970

Ray Blackman

Born Bartlesville, Oklahoma, 1948
Served in Vietnam, Army, 2d Battalion,
501st Infantry Regiment, 101st Airborne
Division, northern I Corps, rifleman,
1970–71

There were no front lines in Vietnam, so at dusk the company would form a large circle and face outward. It was so dark in the jungle at night that you couldn't see the men posted to either side of you. Sometimes waiting for something to happen was harder than being in a firefight.

On my second day in the field we headed down from the mountains; by early afternoon we had reached a beautiful river and started working our way upstream. A light observation helicopter passed over our heads at treetop level. We heard a loud *crack-crack-crack* and the chopper burst into a ball of flame and fell from the sky. There was a firefight. . . .

The next day we killed a lone NVA soldier and that night we set up an ambush around his body. My position was about two feet in front of him. He didn't look real, but I know he was. I wondered if he had a wife and children. We had been trained to think of the NVA as our enemy and not human beings, but I couldn't help it. He was lying there all full of holes and his family didn't even know yet that he was dead. . . .

When I got home from Vietnam, everyone was still doing the same things; it was as though time had stood still for them. Things that I had enjoyed a year earlier seemed boring and childish. There were men dying in the jungles of Vietnam, and no one seemed to care. It made me very angry. When I tried to explain my feelings, I was cut off cold. The war was something bad that I guess everyone thought would go away if they kept silent.

I never really had nightmares about my experiences, but when it's quiet and I lie in bed, I think of Vietnam.

8 *Combat Assault*. 1986. Pencil on paper, 11 x 14¼ in.

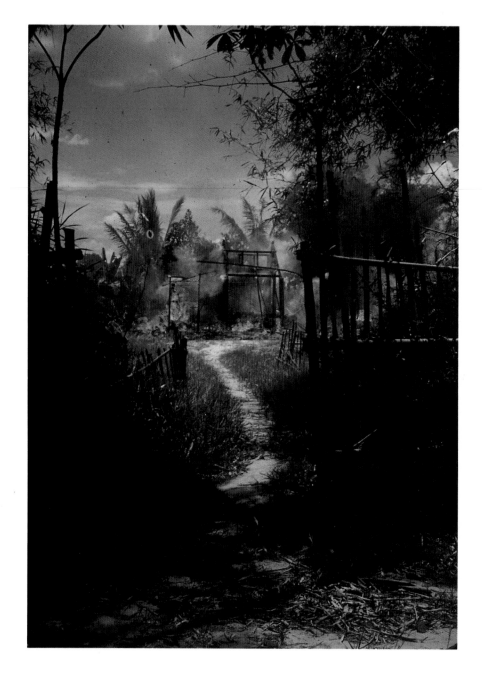

9 *Search and Clear, Ap Pho Burning, Street Without Joy.* May 1968. Color photograph, 11 x 8 in.

I was drafted in 1967 after two years of college, eligible because I was not in the upper half of my freshman class. I spent my junior year abroad at the University of Hue.

I went into the field with the 1st Cav. Airmobile, line infantry, on January 1, 1968, and fought at Bong Son, Hue, Route 1-A (which the French had called the Street Without Joy), Khe Sanh, the Mini Tet at Cua Viet, the National Preserve west of Hue, and the A Shau Valley. I participated in about 150 air assaults in three hundred days and came out of the field on Thanksgiving Day, 1968. My photo of the burning village was taken during the Tet offensive. Because I was involved in constant tactical movement I never stayed in one place very long, but I saw the diversity of both the terrain and the cultures in Vietnam. The burning village represents the destruction of both in the spring and summer of 1968.

Gerald Boldenow

Born Hammond, Indiana, 1947
Served in Vietnam, Army, 5th Cavalry
Regiment, 1st Air Cavalry Division,
I Corps, M-60 machine gunner, 1968

10 *Flag No. 7.* ca. 1982. Watercolor on
paper, 30 x 23 in.

From a letter, 1995:

The ship that carried me to Vietnam was
brand-new, but parts of it were from World
War II: the life rafts and its one five-inch gun,
which was disabled. We smoked the vintage
Lucky Strike Green cigarettes we found in
the life-raft survival kits. We were unable to
do anything warlike, but we were considered
wonderful bait. During the day we would lie
just off the beach of North or South Vietnam,
China, or Siberia, trying to excite the Commu-
nists into talking about us, in order to pin-
point their radio transmission sites. By sunset
we would try to be back out at sea, watching
the silent, flickering lights of artillery duels in
the mountains.

Ten years after I was discharged from
the Navy I thought Vietnam was just a fuzzy
memory and that I had emerged unscathed
from the war, except for a tendency toward
gallows humor. The Russian invasion of
Afghanistan in 1979 was the catalyst for the
start of my work. In retrospect I feel that the
fuel driving my art is the slow release of
pent-up feelings from post-traumatic stress
from my service in the war. I started painting
fragments of flags then.

Paul Bouchard

Born Providence, Rhode Island, 1946
Served in Vietnam, Navy, USS *Ramsey,*
South China Sea, boatswain's mate,
1968

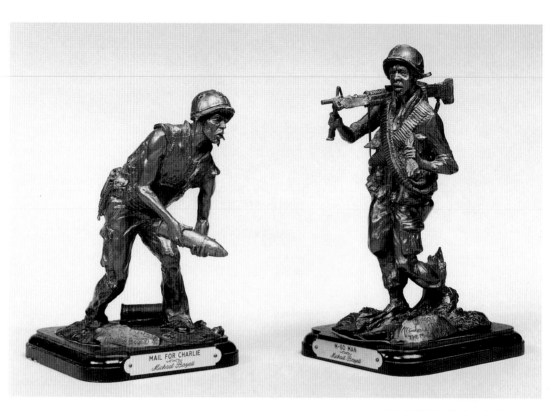

11 Left: *Mail for Charlie*. 1980. Bronze, 7¾ x 3½ x 4½ in.; right: *M-60 Man*. 1980. Bronze, 6¾ x 4½ x 4½ in.

In Vietnam, 1968

Michael Boyett

Born Boise, Idaho, 1943
Served in Vietnam, Army, 3d Battalion,
60th Infantry, 9th Infantry Division,
Mekong Delta Mobile Riverine Force,
M-60 machine gunner, 1968–69

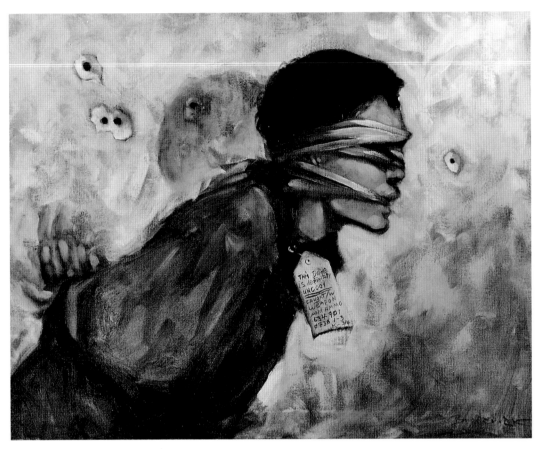

12 *VC Suspect.* 1976. Oil on canvas,
22¾ x 28¾ in.

At Con Thien, Thanksgiving Day, 1966

Ned Broderick

Born Alton, Illinois, 1947
Served in Vietnam, Marine Corps, 3d
Battalion, 4th Regiment, 3d Marine
Division, Quang Tri Province, DMZ,
and Laos, radio operator, 1966–67

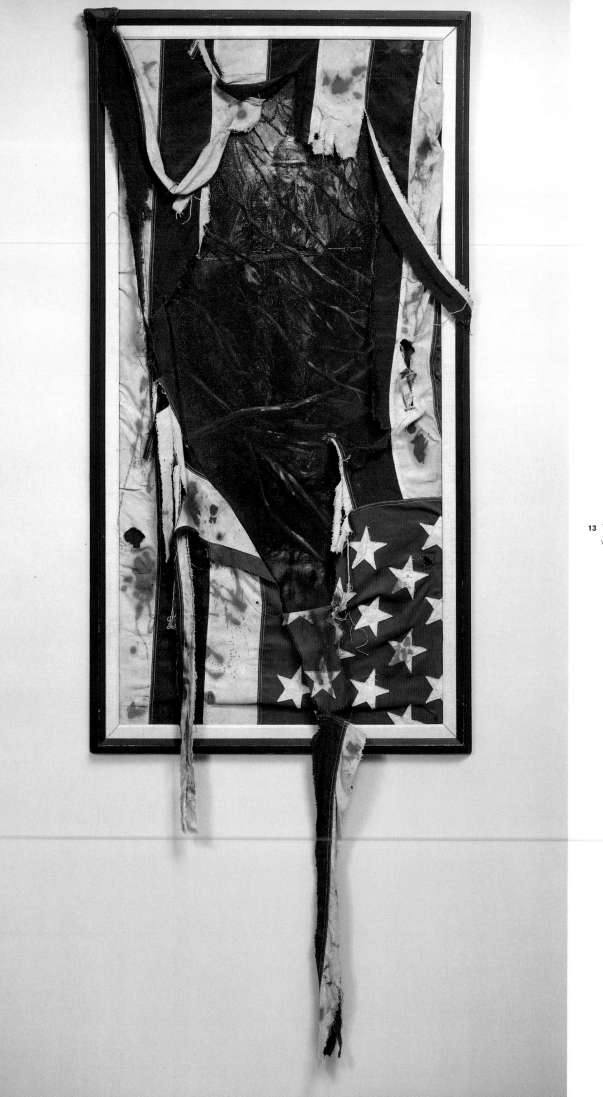

13 *The Wound.* 1978. Oil on hardboard with cotton fabric, 69¾ x 27¾ in.

A recollection, 1996:

In Vietnam I served with a Marine battalion
for nineteen months. We arrived in Vietnam
with 1,250 guys and in six months we were
down to 430. In those days we went directly
from operation to operation, in the DMZ and
at the end of the supply line. Resupply was
ammunition and c-rats; water most of the
time was for drinking only. We wore our uni-
forms until they rotted off our backs; in that
time we had beer twice; we were never in a
building; we never saw an electric light. We
slept on the ground or in holes in the ground.
During the monsoon, five months long, we
got wet and stayed wet until summer. We saw
people die in every conceivable way; all that
was war was with us and with our enemy as
well, whose lives I came to see as a mirror
image of our own.

I saw Marines give up their lives to
save others, not because they had to or were
ordered to, but because they were who they
were. On Operation Hastings I saw a small
group of Marines throw themselves into a hasty
blocking force against overwhelming odds
to cover the evacuation of wounded. They
were experienced combat veterans and knew
what they were doing and that they would die.
This type of sacrifice was not uncommon; it
was expected of everyone and never spoken of.

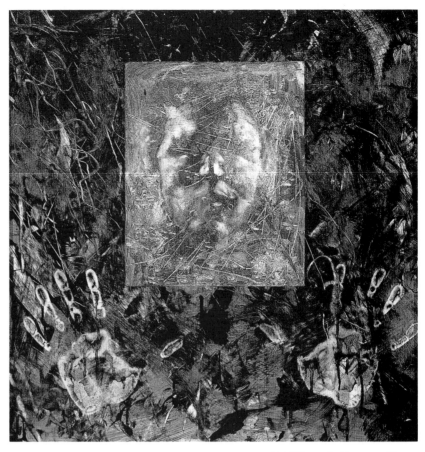

14 *Hi Mom . . . I'm Home.* 1994. Oil on
hardboard, 30 x 30 in.

On Operation Prairie we were fighting
for a long time with very little sleep, low on
ammo and with no food for three days. One
marine found a c-rat can of date pudding while
searching for ammo on the dead. He could
have eaten it himself – no one knew he had
it. But he crawled from foxhole to foxhole,
cutting off paper-thin little bits of cake, until
everyone he could reach had a few crumbs.
The holiest of communions.

Time, since those days, has carried a long
chain of these memories into this present, and
still, with all the suffering and loss and every-
thing that was said of that war over all these
years, I can only think of the days spent in
that company as the great privilege of my life.

1966:

Each face
will lose his name
and time will not defer
But there will always
be the bond
between what we are
and where we were.

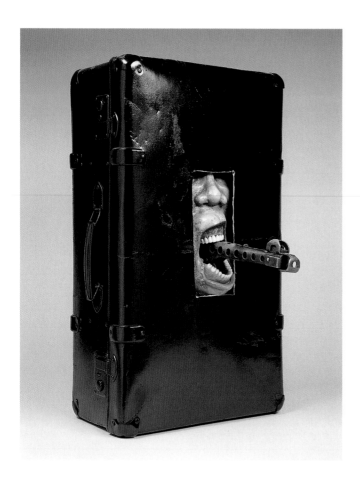

15 *Le Duc Tho Goes to Paris to Discuss the Shape of a Table.* 1995. Leather suitcase, steel submachine-gun barrel, false teeth, oil, and polyurethane resin, 25 x 15 x 19 in.

16 *Round and Round.* 1996. Oil on hard-board with plastic elements, 21 x 21 in.

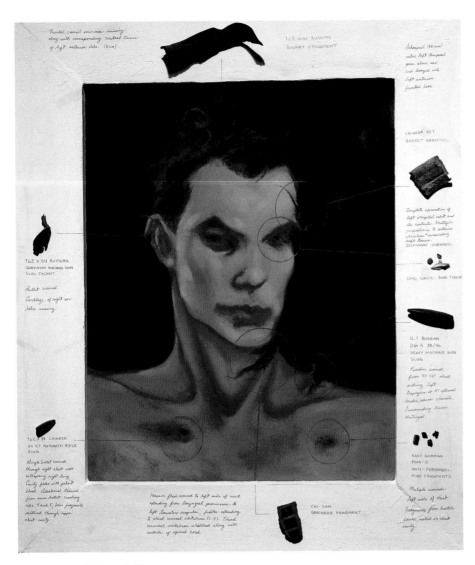

17 *This Is How It Works.* 1996. Oil on canvas with found objects, 26 x 22 in.

Inscriptions on the painting, clockwise from top left:

Frontal cranial eminence missing along with corresponding cerebral tissue of left anterior lobe. (6 cm) / 122 M/M RUSSIAN ROCKET FRAGMENT / Schrapnel (40 mm) enter left temporal area above ear and lodged into left anterior frontal lobe. / CHINESE 107 ROCKET SHRAPNEL / Complete exoneration of left occipital orbit and its contents. Multiple perforations to anterior oblicularis & surrounding soft tissue. SECONDARY SHRAPNEL / SAND, GRAVEL, BONE TISSUE / 12.7 RUSSIAN DSH K 38/46 HEAVY MACHINE GUN SLUG Puncture wound from 50 cal. shell entering left trapezius at RT external border, above clavicle. Surrounding tissue destroyed / EAST GERMAN POM-Z ANTI-PERSONNEL MINE FRAGMENTS / Multiple wounds left side of chest. Fragments from hostile device noted in chest cavity / CHI-COM GRENADE FRAGMENT / Massive flesh wound to left side of neck extending from laryngial prominense to left leavator scapulai, further extending to third cervical vertebrae (c-3). Third cervical vertebrae shattered along with contents of spinal cord. / Single bullet wound through right chest wall collapsing right lung. Cavity filled with patient blood. Additional trauma from same bullet crushing ribs 4 and 5, bone fragments scattered through upper chest cavity. / 762 X 39 CHINESE AK 47 AUTOMATIC RIFLE SLUG / Bullet wound. Cartilage of right ear helix missing. / 762 X 54 RUSSIAN GORYUNOV MACHINE GUN SLUG JACKET

For years I have lived with the pleading screams of dying boys denied the fortune to age into men. The sounds of them crying for God and begging for their mothers have become stronger as I have grown older. It is ironic that as my hearing ability has diminished with age, those silent sounds have become louder and clearer. As I listened to those voices, I eventually accepted the fact that I would have to continue my journey into the realm of the warrior and that I would have no choice but to live in that other dimension just as those before and with me had. Along with the echoes of the past came the conscious mental battle of current times: questioning myself about whether I tried hard enough to answer their pleas. My answer to myself was only to *resolve* never again. At times when I am working out, running, and I reach a threshold of pain, I break through it by imagining that I am running toward their screams, but this time I will not fail.

There was a time, actually a long time in my life, when I buried my deepest feelings somewhere in the ocean of my mind. I did not want to feel or see myself. I was afraid of what I would feel inside, afraid to reexperience the horrors, to relive the violence that I was capable of. I became a Spartan, not allowing myself pleasure although going out of my way to help others. To do otherwise, I felt, would weaken me. Looking back, I see that was very selfish.

It seems forever that my mind has been sharing space with the memories of my fallen brothers and the what ifs. If permitted to live, what else would they have bestowed on society? More than me; certainly more than those who chose to not go then because of moral conviction, but now hide their guilt behind those and other false stories of why not. Because I know fear, I do feel sorry for those who hid behind theirs, but I cannot forgive them. That they must seek from themselves and from the dead. Over the years the dead have watched me, and as I felt their eyes, I vowed I would bear this standard, that I would live my life in such a way as to honor them and their sacrifice. When weakened all I would do was recall the looks on their faces — which mirrored the way they died — how dirty their bodies were, and that they had perished in hell. I could not understand why their surroundings did not fit the ceremony of their deaths. Now I know why I was wrong.

I would also wonder why they were denied the experience of the love of a woman or the birth of a child when they more than anyone else had earned the right to these pleasures.

We lived with those who had the least but shared the most — water, letters, pictures, cigarettes, fear, the safety of the morning sun, the next breath of air, honor, and the idea that you were then, and are now, nothing more than your word.

At the times and places of their deaths, we gathered and looked at their bodies, perhaps envying them but not really wanting to join them. There was a strangeness about them beyond their deaths, in that their souls did not want to leave, but to stay, to protect

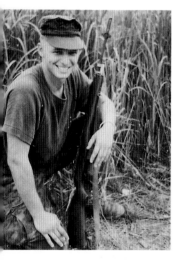

In Quang Nam Province, 1969

Michael Brostowitz

Born Milwaukee, Wisconsin, 1950
Reborn in Vietnam, 1st Battalion,
7th Regiment, 1st Marine Division,
Dodge City, Arizona, Charlie Ridge,
Happy Valley, M-60 machine
gunner and grunt, 1969

and guide us away from the same destination. They did stay and by their deaths did heighten my senses, letting me know when harm was near. There was a trade-off; the payment . . . losing the sensitivity essential for a peaceful soul. Most eventually left me, leaving faces without names, names without faces, voices stirring emotions.

In conclusion of the beginning and the start of the end, we were at the places where their souls left their bodies. There is now a place that has been created that permits the spirits of our fallen warrior brothers to gather. In this place the spirits of the dead shall awaken the souls of the living. I have been there and have felt their presence in greater numbers than in any other place. I thank them and I welcome the beginning of the journey toward peace.

To those who did not, you will never have a clue.

18 *Come a Little Closer.* 1997. Oil on board, 15¼ x 19¾ in.

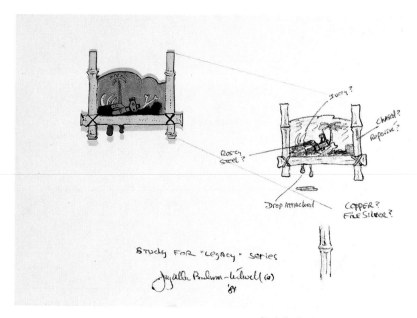

19 Study for the *Legacy* series. 1982. Enamel on copper mounted on paper, with ink and crayon, 6¾ x 8¾ in.

RM3 UNSNSUPPACT DET (Radioman 3d Class, Naval Support Detachment Activity), Binh Thuy, 1968

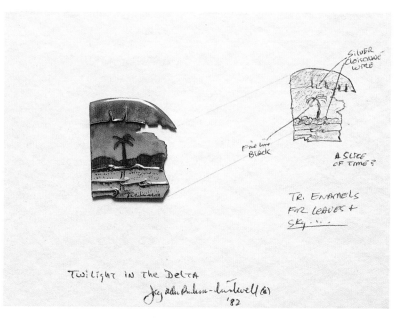

20 *Twilight in the Delta.* 1982. Enamel on copper mounted on paper, with ink and crayon, 6¾ x 8¾ in. Present location unknown

Jay Burnham-Kidwell

Born Wilmington, Delaware, 1946
Served in Vietnam, Navy, Binh Thuy
Naval Support Base, Phong Dinh
Province, Mekong Delta, radio operator,
1967–68

From a letter, 1982:

I was brought up on John Wayne war movies, collected World War II relics, and, with the assistance of mother, God, country, and Walt Disney, was prepared early to enlist.

I was in country December 1967 to December 1968. I landed at Tan Son Nhut airport at 3:00 A.M. in dress blues. The first things I noticed were the heat and the smell of burning shit, garbage, and jungle. After a week in Cholon I was assigned to Binh Thuy, in the Delta.

. . . I watched young men get killed, wounded, mutilated, and driven a bit crazy; become alcoholics and smack addicts. After fourteen years I still have it all inside. It'll never go away. So it goes.

I walked point, stood security, stood radio watch, rode shotgun on helicopter fuel trucks, and got into alcohol and drugs. I watched a lot of people get blown away.

I got home and the freaks gave me shit, the straights gave me shit, and everyone else washed their hands of the responsibility for their own failure. The only people I could talk to for years were veterans.

I was told in art school not to do any "war art." My instructors (with two exceptions) were totally against anything so banal. I still do Vietnam-related work; I probably always will. *Twilight in the Delta* and the *Legacy* study were two attempts to portray slices of the war.

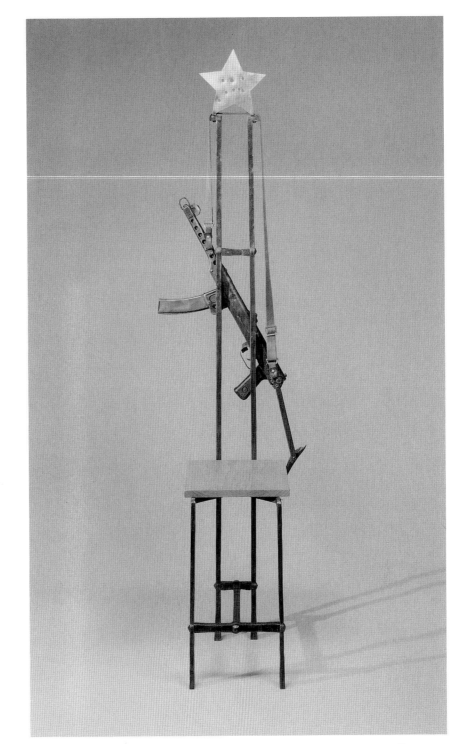

21 *Forgings – Revolutionary Furniture.* 1993. Forged steel, stainless steel, oak, and Chinese submachine gun, 63 x 11¼ x 14¾ in.

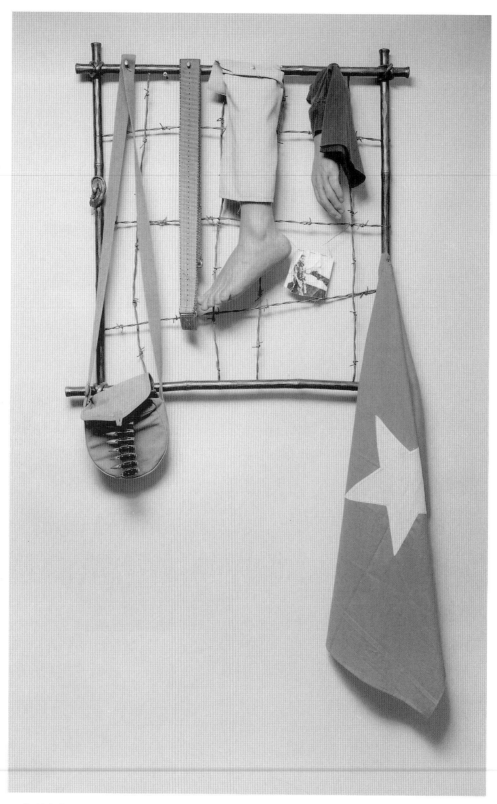

22 *Real Life Souvenirs.* 1993. Forged
steel, cast bronze, vinyl, ammunition/
drum carrier, belt, fabric, barbed wire,
photograph, 36 x 36 in.

Inscription on the photograph:

In America, the grass always seems greener
. . . in the Nam, one can measure the height
of the grass by the elephant's ass.

From two letters, 1966:

Dear Mom,
. . . I have only a few lines to let you know
that I am alright. Due to the circumstances,
I'm unable to write a long letter. For the past
two weeks we've been on a mission whereas
we've lost contact temporarily with the out-
side. Mail has gotten in about three times. To
date this has been the worst operation. We've
hit and been hit by everything. Even the bugs
seem to turn on us. I'm still taking pictures.
By the time I leave here, I should have quite
a few. All of us here are hoping that [Presi-
dent] Johnson okays the sending of more
troops. We can use as many as he can send.
So far Johnson has nixed all proposals for
more troops. We want to end this thing and
go home. Be waiting to hear the news from
home. On the map you can get some idea how
I've been traveling. (Yes, we slipped into Laos.)
 Your loving son, Ray

. . . My little Kodak has caught the only per-
manent thing this place has besides the
smell: the stare in the eyes of the living and
the dead. Those stares and the smell: they
will stay with me when the Nam is only a TV
documentary.
 Ray Burns, Vietnam Vet (Still)

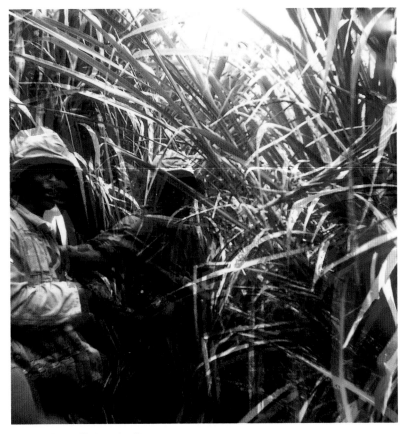

23 Untitled. 1966. Photograph, 10¾ x
 10¾ in.

On a mountaintop, five kilometers
into Laos, 1966

Ray Burns

Born Windsor, Ontario, Canada, 1947
Served in Vietnam, Army, 2d Battalion,
35th Infantry, 3d Brigade, 25th Infantry
Division, Pleiku, fire-team leader and
linguist, 1965–66

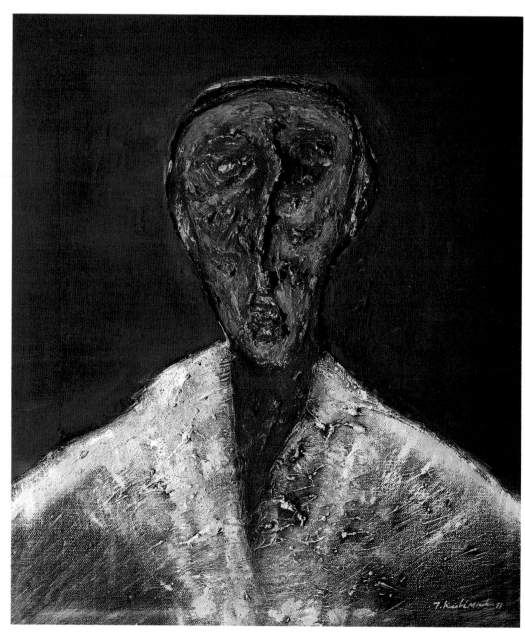

24 *Portrait of a Soldier After War.* 1993.
Oil on canvas, 31 x 26¼ in.

Cao Ba Minh

Born Hai Duong, Vietnam (French
Indochina), 1942
Served in Vietnam, South Vietnamese
Air Force, Saigon and Da Nang,
editorial staff, 1967–75

My works are washed in the blood and tears
of suffering, of annihilation, of brother killing
brother — all the baggage of humanity's
shame. In my youth I was drawn and woven
into the fabric of Vietnam, into a history writ-
ten in shame, not pride.

I left my career as a writer and entered
the world of painting because what I was
compelled to say words will not satisfy. This
portrait, this face of monstrosities, is a vehicle
to expose the kind of wickedness that the
human soul can create and, in turn, suffer.

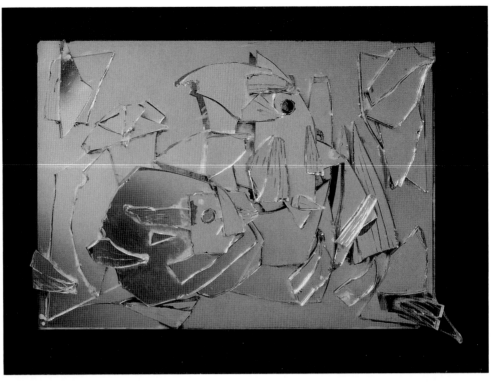

25 *When I Look in the Mirror Each Morning.* 1981. Clear and mirrored glass, 20 x 26⅝ in.

26 *Exhibition of Our Time.* Undated. Oil on canvas with paper collage, 43 x 30¾ in.

Cao states that he considers his art-making during this period an exposition of our time, the ideological era. He depicts somber images of our societal drama, the tragic Vietnam War, and the long dark tunnel with no end.

Cao Ninh

Born Hai Duong, Vietnam (French Indochina), 1944
Served in Vietnam, Army of the Republic of Vietnam, Phu Bai Air Base, years of service unavailable

27 *Exiles on Main Street.* 1971. Oil on canvas, 29 x 34¾ in.

In the village of Gia Le, Thua Thien Province, February 1969

Elgin Carver

Born Birmingham, Alabama, 1947
Served in Vietnam, Marine Corps,
3d Combined Action Group, Phu Bai
and Hue, rifleman, 1969

From a letter:

I was assigned to the 3d Combined Action Group (CAP) in I Corps in South Vietnam. Each CAP comprised fifteen Marines and a Navy corpsman. Each was attached to a South Vietnamese Popular Forces unit, comparable to our National Guard. Each CAP was assigned to a village, for which we provided security and on-the-job training. We had no base and moved constantly from location to location throughout the area. For my first six months in country I never saw the inside of a military base. Among CAP units casualties were high. I did what was required of me and then I went home.

For many years the war seemed to have happened yesterday, seldom out of my mind. Then I woke up one morning and it was far in the past. I don't know why.

I paint but seldom exhibit because I cannot stand the false faces that so many people in the arts seem so determined to wear. I seldom speak with other veterans because of the false faces forced on them by their homecoming. Intellectualizations of artists and war stories should always be suspect.

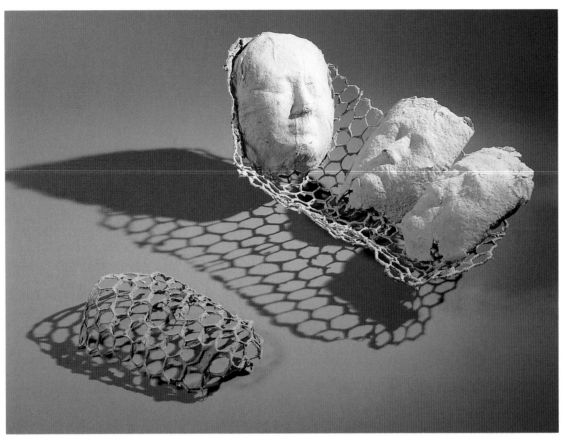

28 *Healing the Wounds of War.* 1990.
Hand-cast paper, ca. 9 x 17 x 18 in.
overall

M̲y mother was an artist. When I was a
child, I loved anatomy – the body in motion –
and I loved art. During the Tet offensive in
1968, our unit treated 496 surgical patients
in thirty-six hours.

At a rice-wine ceremony in a
Montagnard village outside Pleiku,
January 1968

Mary Margaret (Peggy Riddell) Caudill

Born Philadelphia, Pennsylvania, 1942
Served in Vietnam, Army Nurse Corps,
71st Evacuation Hospital, Pleiku,
and 22d Surgical Hospital, Phu Bai,
operating-room nurse, 1967–68

29 Untitled (Phu Cat Air Base). 1968.
Photograph, 8½ x 4⅞ in.

At Phu Cat Air Base, 1968

Douglas Clifford

Born Chelsea, Massachusetts, 1945
Served in Vietnam, Air Force, 460th
Tactical Reconnaissance Wing, Phu
Cat Air Base, Binh Dinh Province,
Central Highlands, aerial reconnais-
sance film-lab technician, 1968–69

As they were for millions of Americans, images of Vietnam were a significant part of my life for several years before I went there. I watched along with my family as the nightly news showed story after story of the war, American GIs, in or out of action, and Vietnamese soldiers and civilians, along with related statistics. The newspapers, weekly newsmagazines, and other purveyors of images were all involved in this effort to show us that war in a land so far away from us. It was an effort not without purpose, for to support the war it was necessary to see it in a certain way: to see how destructive war can be, how terrible is the unleashed strength of a military superpower, how we could identify with American GIs, and how without substance or context were the Vietnamese. It is that last point that struck me so forcefully when I got there in late 1968, about eight months after the Tet offensive, which began the change in the war that led to its conclusion.

Having been trained as a photographer by the Air Force, by the time I went to Vietnam, twenty-three years old and with more than two years of service already completed, I was capable of forming my own images. What I found there, from my first day in country, was in sharp contrast to what I had previously been exposed to: not that war wasn't terrible, because signs of the war's destruction were all around. And the American GI's experience was, after all, now my own. It was the Vietnamese who surprised me. I saw people doing things that everybody does, or at least tries to do – kids selling cold orange soda and Coca-Cola at the roadside, kids chasing chickens, farmers knee-deep in lush green fields tending their rice, women washing and hanging out laundry, and old people doing very little. These were the images we had not previously seen.

It was not, as I had expected, the war for which I was most unprepared. For that I had, in some fashion, been trained. My older brother had spent thirteen months in I Corps in 1967 and come home wounded. Two cousins had gone and come back. There were friends, guys I was stationed with, acquaintances, schoolmates, and others who had gone, and some of them had not come back. There were lots of images to go with that reality.

The other reality, the one that lacked images, was the reality of Vietnam – the country, the place. That reality included the shoreline of the South China Sea, the cordillera of the Central Highlands, where I was stationed, and between the highlands and the sea the rice paddies, rich green in the rainy season and tawny brown when it was dry. The people in this reality were not just soldiers, VC and ARVN, but schoolchildren, farmers, merchants, and the countless others who worked at the bases, providing services, both legitimate and illegitimate, to the United States military. That was the reality to which I had to supply my own images.

I was not a combat soldier as my brother had been. Those guys had a different existence, for which I had a profound respect, but which I had few illusions of trying to depict in photographs. Not only was combat not my own experience, but it was an experience that was being extensively documented.

My photographs, then, are from my environment at the time and show something about Vietnam as a country and the Vietnamese as people. I did not ignore that other reality, that world of GIs and what we were doing there, but I wanted to show it from a different perspective. There was so much to reveal about where we were, what we were doing, who we were doing it with and to and for that the endeavor became a serious avocation for me. As any veteran can tell you, whether in war or nearly war or peace, military life contains stretches of time that are devoted to being ready and standing down after something happens, or just after being ready. I used the time I had to photograph as much as I could.

I tried to present Vietnam as a place where people lived, worked, went to school, and struggled with their lives, in spite of the war. People seem surprised by this and by how the American military presence looked in that context. I wanted to take pictures of little children looking like children; I wanted the landscape to be shown for its beauty: the tropical sunsets were spectacular and with the monsoon came every shade of green, from rice stalks to the grass on the hills; and on some days the Central Highlands rose up through the low cloud cover like a panorama in a Chinese screen painting. The military airplanes were beautiful but terrible, and noisier than can be imagined. Their grace and fluidity were aspects of their capacity for destruction. The resources devoted to the airplanes were overwhelming and the relationship of these machines to the surrounding environment of water buffalo in rice fields and fishing boats trailing nets was absurd. So there were two stories to be told.

I have found that most of us picture soldiers overseas in terms of what they leave at home and what they are doing without. To see a war from the perspective of the land where the war is – the perspective of its people – is an experience not to be underestimated.

My pictures are artifacts of the war. They were shot, processed, printed, and mounted in Vietnam. They owe their existence to Vietnam.

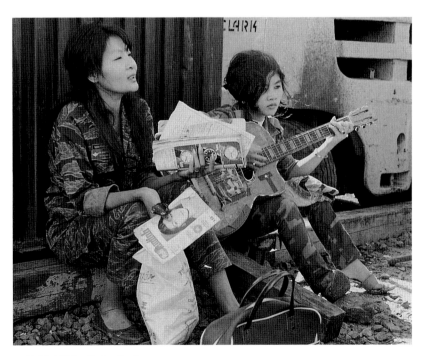

30 Untitled (Pleiku Air Base). 1969.
Photograph, 7½ x 9½ in.

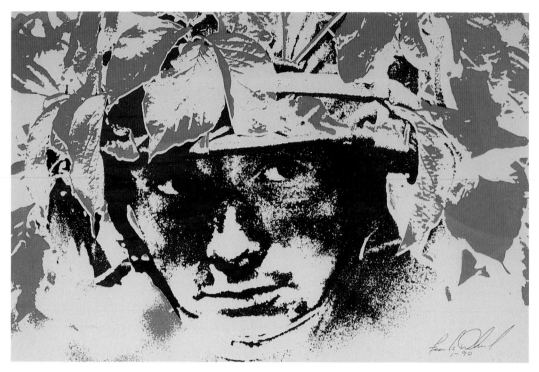

31 *The Green Machine.* 1977.
Screenprint on paper, 13½ x 17¼ in.

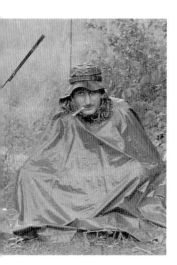

At his command post in the Iron
Triangle during the monsoon, 1970

Frank Dahmer

Born Florence, South Carolina, 1938
Served in Vietnam, Army, II Field
Force Artillery, 2d Battalion, 35th Field
Artillery, 1966–67; Headquarters,
Task Force South, 1969; 2d Battalion,
14th Infantry Regiment, 25th Infantry
Division, 1970; II and III Corps, artillery
forward observer and infantry com-
pany commander

Retro-perspective views
A combat commander doesn't have a best
friend, or any friends. There is no one comrade
who always shares your muddy hole in the
jungle. Commanders have a different concept
of friendship: a respect for those who served
under their command.

Most of my guys were good kids serving
their tour. It's regrettable that I can't remember
their real names. There was never an accu-
rate list of names in a combat unit, only various
scraps of sodden paper. The official morning
report chronicled the daily coming and going
of soldiers, but not who was present for duty.
Called the "foxhole strength," these are the
faces of a unit. I still picture those faces clearly.
I hope I'll never forget them as they were then.
These are faces at the best they ever will be:
bright, young, strong — lights of an era.

I remember one kid, Fritz; his name is on
the Wall. Fritz commanded my third platoon
and sometimes was my second in command.
NCOs like Fritz were known colloquially as
"shake-and-bakes." A bright draftee would be
sent to officer candidate school straight out of
AIT and get an instant promotion to sergeant.
Passing a test, however, did not always ensure
that every shake-and-bake was capable of
leadership.

As the war dragged on, experienced leaders were being devoured faster than they could be replaced. The army's answer was an accelerated program to develop junior NCOs to be combat team leaders. Unfortunately, there is a world of difference between a commander with years of training and combat experience and a junior NCO with less than a year in service. This was the failure of the politically mandated one-year tour of duty. The military was feeding on itself.

Fritz, distinguished at shake-and-bake and ranger school, landed without any experience in the company as a senior NCO. He wasn't a friend any more than any of the others. I was over thirty and on my third combat tour, and he, like most of the company, was still reaching for twenty.

We had a *chieu hoi,* an informer who told us about a large rice cache. This man couldn't pinpoint the location of the cache on a map and could only generally locate the area on the ground. I sent one platoon out to a blocking position. I planned to sweep down the blue line [creek] with the other two, pushing everything into the block. I would lead and Fritz was to bring up the rear.

The first platoon walked straight into a hidden enemy base camp guarding the rice cache and was chopped up badly. The second platoon went in to help them, while Fritz's third platoon swung around to flank the enemy, get more fire forward, and relieve the pressure. An inexperienced point man failed to see the signs of trouble until Charlie opened fire.

We were getting our casualties out, bringing in air support, and beginning to move when Fritz and another guy were shot. With my strongest platoon leader down, the platoon froze. No one gave a command. I moved to the third platoon. When I got to it, the platoon was still in a ditch, waiting for Fritz to tell them what to do. I went in to find the two men, and the platoon followed me. They just needed someone – anyone – up front.

Fritz had done a heroic thing but also a dumb thing. The platoon was his responsibility. He should have sent a couple of scouts ahead. He had learned to lead but he didn't live long enough to learn command.

I made the same mistake. The company was my responsibility. With Fritz gone, had I been hit the company might have also been stopped. What I should have done was to scream and shout, kick ass, and develop a new leader to move the platoon forward. Hindsight. There was so little depth of leadership by this stage of the war. It was my job to take care of these men. They were just kids off the block, good kids.

A soldier will perform miracles for you if he thinks you care. Make an effort to take care of him and he will walk through hell, not because he likes war or wants medals or because of orders, but because he is part of something larger, a unit. He wants to do a good job, as recognized by those around him. He wants to be respected and seen as valuable. I never saw so many good young men sacrifice so much for each other and for their units.

32 *Morning Mission.* 1975. Watercolor on paper, 13½ x 27½ in.

33 Four untitled pairs of photographs from the *Vietnam Retrospective* series. 1966/1987–88. Each pair 5 x 18 in.

In Vietnam, 1966 (Decker is at left)

A fog of enchantment envelops us in times of war. It is a killing fog, in which the best and most noble stirrings of the human heart are perverted. I was twenty years old in 1966, when I recorded my first images of the fog called the Vietnam War. I was forty-three when I really began to develop them. The war I experienced was not glorious or honorable or manly or righteous. With the bullets and the bombs and the bloody carnage came blood-lust, hysteria, and insanity. Time passes; the fog lifts; war is not a team sport, press conferences are not pep rallies. Yet like moths circling an open flame we continue to be drawn to it, fascinated by it. We haven't learned anything.

Keith Decker

Born Oak Park, Illinois, 1945
Served in Vietnam, Army, 1st Medical
Battalion, 1st Infantry Division, east
of Bien Hoa, medic, 1966

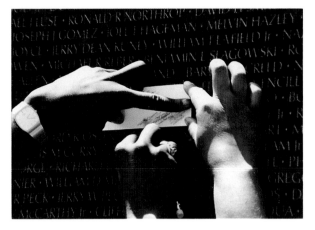

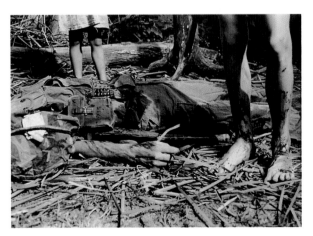

34 *Hill 551*. 1979. Charcoal on paper,
18½ x 21⅝ in.

Dien Trau (Ly Mai Bich)

Born Vietnam, 1952
Served in Vietnam, South Vietnamese
Army, infantry, until 1975; spent five
years in a Vietnamese reeducation
camp, ca. 1975–80

35 *Hot LZ.* April 1970. Color photograph, 16 x 20 in.

In Vietnam, probably at LZ Becky, September 1969

I flew with Apache Troop, a small aerial-reconnaisance unit consisting of four combat platoons and a maintenance section. Scouts flew light observation helicopters at treetop level, trying to draw the enemy out to shoot at them. Weapons were the Cobra gunships that accompanied the loaches providing fire-power once the enemy had been located. Lift consisted of Huey helicopters, which carried the Blue Platoon (infantry recon) out to its mission. Maintenance kept everyone up and flying. It was all related, and we all worked together in order to survive.

When we went on missions I always brought my camera. Fire Support Base David was the 1st Cav Div's most remote outpost in Cambodia. It had been hit during the night and early-morning hours, first with mortars and rockets, then by a ground attack. NVA soldiers had penetrated the perimeter of the camp. Those who had managed to get inside were killed and our mission was to do an aerial recon of the area, locate any NVA near the base, and kill them.

What we saw on approach was the aftermath of a fight for life. We were all used to death and destruction, but this seemed

Arthur Dockter

Born Fargo, North Dakota, 1950
Served in Vietnam, Army, 1st Squadron,
9th Cavalry, 1st Air Cavalry Division,
Tay Ninh and Song Be provinces,
helicopter door gunner, 1969–70

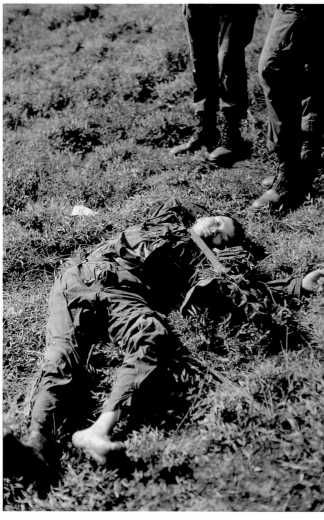

36 *The Living Dead* (LZ David, Cambodia). June 1970. Color photograph, 20 x 14½ in.

different. The rain had washed the blood off the dead NVA and the American soldiers at David seemed exhausted and dazed. Shutting down the helicopters, everyone got out to see what had happened. I began to photograph the dead, amazed at the way they had died. One NVA soldier had been blown in half; his lower torso lay fifteen or twenty yards away from his upper half. He had been carrying several RPG rounds when he was hit by gunfire and one had exploded, ending his life instantly.

The next body looked very young and his eyes were open, as if he were still alive and watching what was going to happen to him. Although his eyes were open, his body was not moving. I kicked his foot for a response; there was none. There was another body nearby, and something there didn't look right. I'd been in Vietnam flying on helicopters for nearly twelve months, watching my friends die, shooting at people with a machine gun and getting shot at, rescuing Ranger teams and other air crews. I had been on a lot of strange missions, but I had never seen anything like this. The man was literally shredded by firepower – blown apart. It was like biology class in high school, when you dissected the frog, only this time it was a human, and now the class was called war. You learned how to kill and how to die. This person had been taught well.

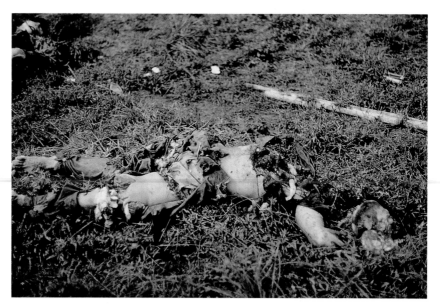

37 *The Dead Dead* (LZ David, Cambodia). June 1970. Color photograph, 14½ x 20 in.

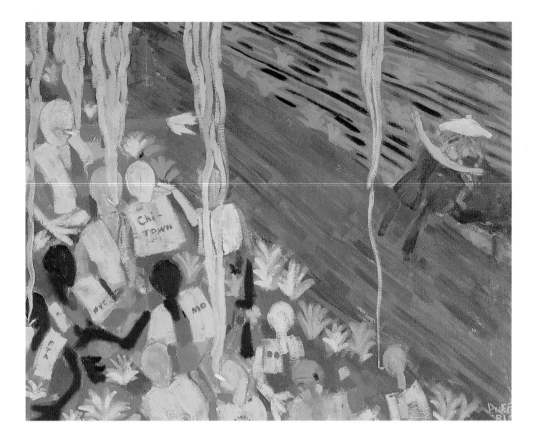

38 *Chi Town.* 1981. Oil on canvas,
25¼ x 31¼ in.

From a letter:

I arrived in Vietnam two weeks before the
Tet offensive in 1968 and came home on
Christmas Day, 1968. Every event within that
time period was charged with extremes: yelling,
explosions, drunkenness, exhaustion. I was
unprepared for the beast I met in Vietnam.
It left me shaken. I hope to reflect this state
in my work. I paint for myself, no one else.

 I still have not dealt with all of my Viet-
nam War experiences — some are much too
difficult to revive. I relived some of them in
the work while I was painting it, so as far as I
am concerned the work is part of the Viet-
nam War, as I experienced it.

From a memoir, ca. 1978:

. . . When I woke up, the first thing I wanted to
know was who had had their heads up their
asses when this goddamn fuckup took place.
Where had Lt. Yonson been? I found out that
he had spent the night in the Fire Direction
Center tent with his crony, Lt. Gore; so the
guns had been fired without supervision. The
gunners on No. 4 had reported the error
shortly after it happened. Then, in the middle
of the night, an emergency radio message
had come from the Command in Saigon, ask-
ing all artillery batteries to check their fire

Duffy (right) with his brother, Dan, at
Firebase Bear Cat, February 1968

Michael Duffy

Born Chicago, Illinois, 1945
Served in Vietnam, Army, 7th Battalion,
9th Artillery, Firebase Bear Cat, Binh
Son Rubber Plantation, Xuan Loc,
and Nha Be, artillery battery executive
officer, 105mm howitzers, 1968

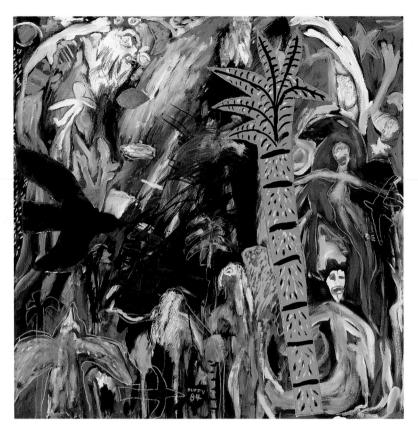

39 *Warring Nations.* 1984. Oil on canvas with canvas collage, 49 x 49 in.

and review the missions fired in the previous half-hour; a military post in Saigon had reported seeing incoming rounds. Yonson and Gore had refrained from waking me at the time, since, they said, nothing could be done until morning anyway.

As the executive officer, I had the responsibility to drive into Saigon as soon as possible to survey the damage. I was to talk to the family and express our deepest sympathy for their loss. This sympathy took the form of monetary compensation. The United States government had a formula to use on these occasions. In the event of an accident in a rubber plantation, we paid the owner (usually French, not Vietnamese) in the neighborhood of $300 per tree destroyed. I was once approached by an owner in a camp north of Vung Tau and asked to sign a document confirming his loss of thirteen rubber trees. I told him no way. Though I suppose it might have been true.

If we killed a farmer's water buffalo, the compensation was perhaps $100. For the loss of a human life, the survivors received a sum near $55. Armed with this good news for the survivors, I left camp with Lt. Limb, a Vietnamese friend.

The drive into Saigon, first on a dusty access road, then on pavement, was about half an hour through beautiful green rice paddies. Beyond our camp there was only one other military installation, a small Navy base defended by a platoon of ARVN troops at Nha Be. Military traffic was light; most of the armed forces took the other road, from the Long Binh ammo dump and Bien Hoa, the gigantic base where our orders were issued.

As we drove closer to Saigon, the rice paddies gave way to lots filled with trash, the garbage the Americans left behind, which became the treasure of the Vietnamese. They scavenged for beer cans, nails, lumber, anything in short supply. Lt. Limb watched the scavengers as we passed. "I think," he said, "you should tell this family that the shell was VC."

"Why?" The idea did not appeal to me.

"Do you think," he said gently, "that we will get out of this neighborhood alive, if they know where the shell came from?" I thought about this proposition; as we entered the city it began to make sense.

We wound through the narrow streets of lower Saigon. Women and children stood in the doorways of their living quarters, watching us. I was glad that Lt. Limb was with me, so they could see that I had a friend who was one of them. Children yelled, "Number One GI! Number One GI!" Translated into English this meant, "Throw candy! Throw candy!" but I didn't have any.

At first glance the house seemed unharmed. But it had no roof: our shell had fallen toward the rear of the shelter and scored a direct hit on the family's sleeping area. They were an ARVN soldier's wife, his daughter of twelve, and a nine-year-old son. A crowd gathered as we got out of the jeep. While I surveyed the damage, Lt. Limb spoke in Vietnamese to the survivor, a grandfather. I assumed he was explaining that the round had been Viet Cong. The old man was grateful that we had taken the time to come and speak to him; he wanted to show us the bodies.

I had seen plenty of Vietnamese bodies on the road during the Tet offensive, but I was still not prepared for this. They were in a room on a table under a sheet, which was covered with flies. The old man pulled away the sheet, and I saw three charred bodies. With their contorted faces they looked like figures of clay, fired in a kiln with a matte black glaze. Their teeth were still white.

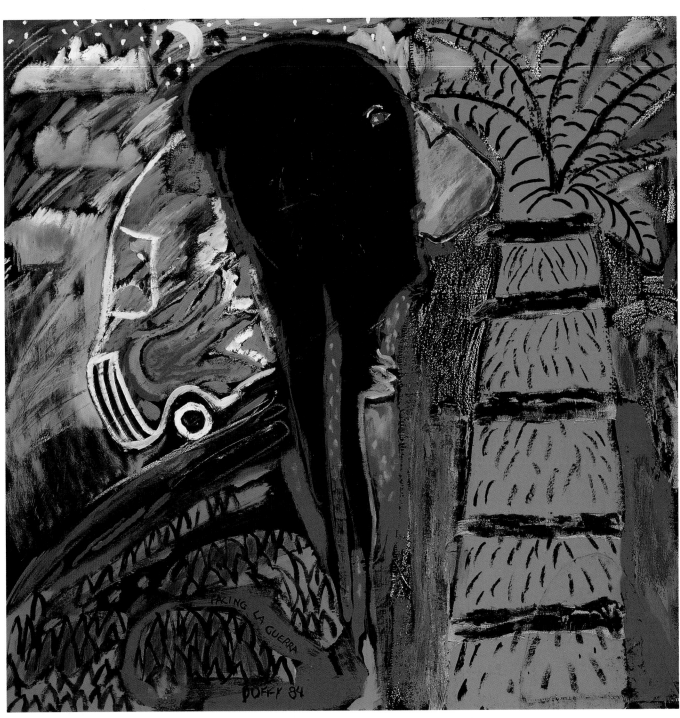

40 *Facing La Guerra.* 1984. Oil on
canvas with stitching, burlap, and tar,
49 x 49 in.

41 *Guardian.* 1979. Wrought iron, wood, paint, bones, copper wire, tacks, lead, and feathers, 12 x 18 x 18 in.

In Khorat, Thailand, 1970

William Dugan

Born Salem, Massachusetts, 1947
Served in Thailand, Air Force, Khorat
and Udorn, morgue laboratory
technician, 1970–71

I was an Air Force lab tech and did autopsies and bagged bodies in Thailand. I also did the same thing for a while when I got back to the States. Yes, *Back in the World, Again* is about how it felt to come back. The pieces of bone, brass, shells, braided in the creature's hair and hanging from its belt, are the tokens, mementos, souvenirs, transitional objects of our life. We all carry tokens with us to strange places for magical protection.

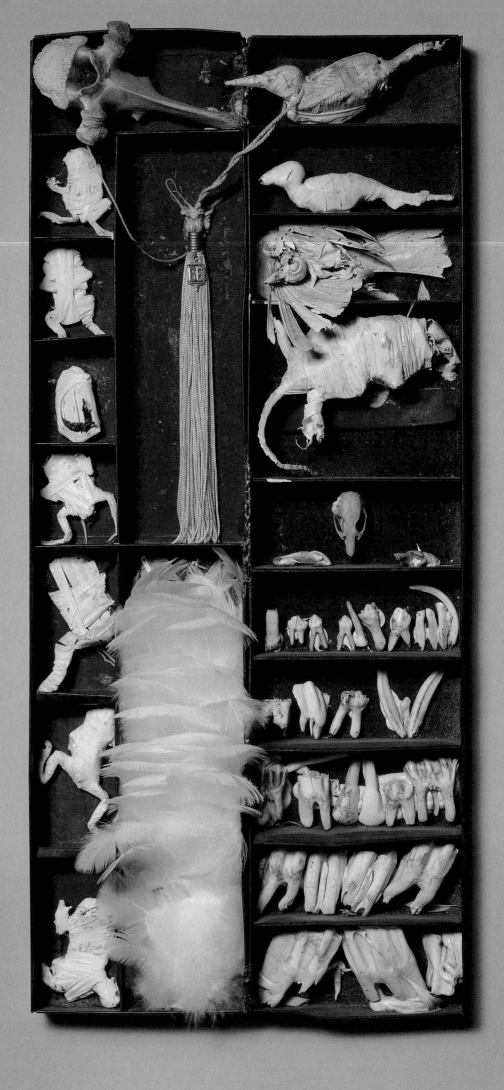

42 *Clean White Things in a Dirty Box.*
1977. Steel, wood, bones, fabric,
feathers, nylon tassel, Teflon tape,
bird, frog, and rodent remains,
24 x 11 x 1½ in.

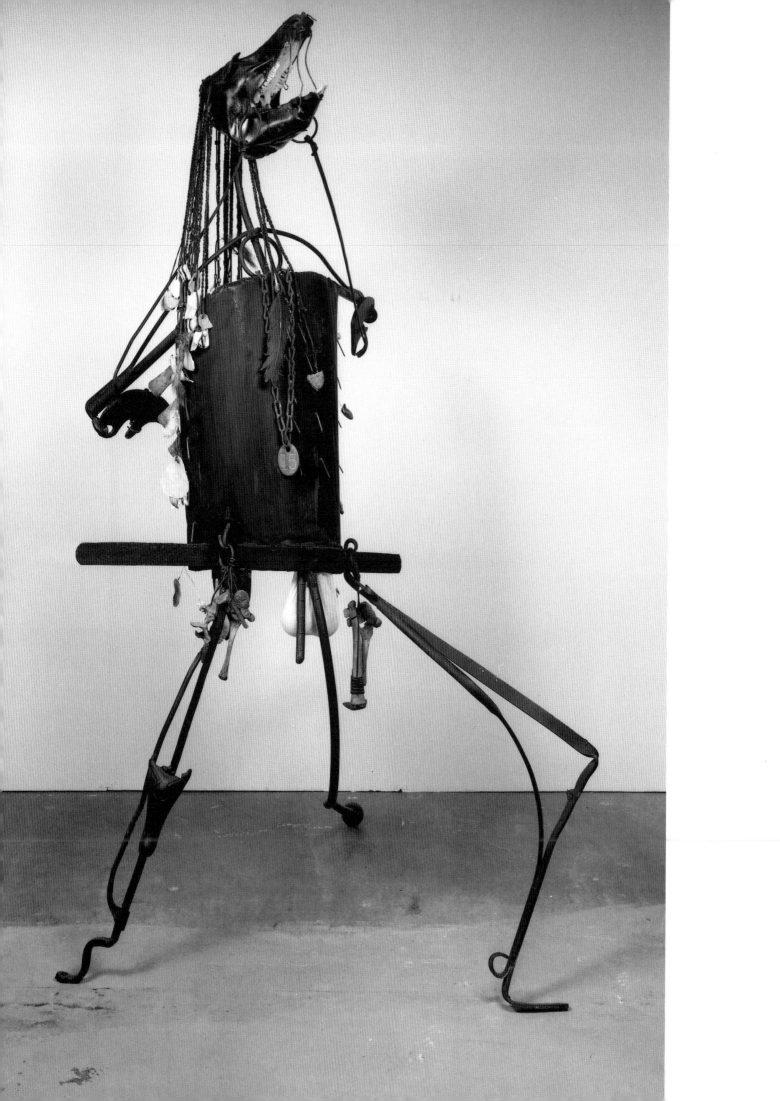

In 1975, when I was in graduate school, someone ran over a squirrel in front of me on the road one day. I stopped, picked it up (it was dead), and carried it to the studio. Then I skinned and cooked it on a wood fire and ate it. I tanned the skin. After that I picked up lots of road kill and started printing the skins and incorporating the bones and other parts into sculpture. I made homages to the animals — honorable burials. Needless to say, lots of folks thought I was strange and it was real hard to get in shows. I still use animal parts in my sculptures, drawings, and prints.

I'm So Short, My Head Hurts reflects the language used during the war and the excitement of going home. I didn't know I would carry this with me for so long. If the base of the sculpture is touched the helmet vibrates, somewhat like having a loose brain stem.

Yes, going to Southeast Asia influenced my life and my art.

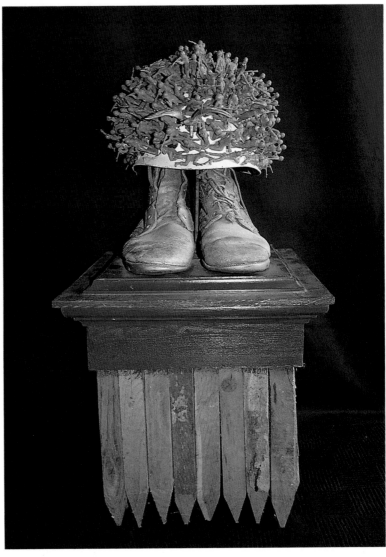

44 *I'm So Short, My Head Hurts.* 1996.
Combat boots, plastic soldiers, wood,
paint, helmet, 32 x 15½ x 15½ in.

43 *Back in the World, Again.* 1979.
Scrap iron and brass, hog skull,
leather, bone, nails, beads, shells,
ceramic, 84 x 48 x 48 in.

The photographs are by Rus Elder,
the text by his brother, Dale.

45 Untitled. 1968 or 1969. Color
photograph, 11 x 14 in.

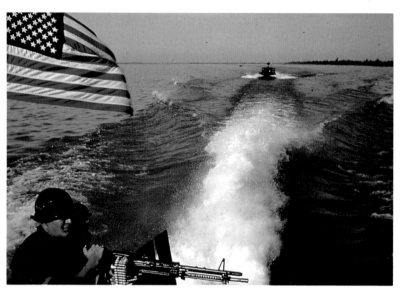

46 Untitled. 1968 or 1969. Color
photograph, 11 x 14 in.

In Da Nang, 1969

Rus Elder

Born Macomb, Illinois, 1935
Served in Vietnam, Navy, Saigon,
Mekong Delta, and Da Nang, combat
cameraman, 1967–69

From *Tyger, Tyger,* a novella:

1.

The army teaches you to do what you're told to do, even if you get blown all to hell for doing it. In fact, it is better to get blown all to hell than not to do what you are told. Those who cannot adapt to this system are either broken physically and mentally or are made squad leaders. Each new day seems to make less sense. I still remember rolling out of my bunk in basic training and rushing to roll call. Those names linger with me yet:

Ball, Harold S.
Bone, Theodore E.
Brassica, Napus I.
Crotch, Rothmille N.
Domet, Conley A.
Ennis, Paul P.
Eulation, Marvin P.
Frealy, Ignatz P.
Fyte, Leo N.
Gassim, Orville R.
Gorge, Henry N.
Hardon, Warren R.
Hooker, Francis
Long, Richard S.
Max, Clive
Neas, Herman
Oins, Gerald R.
Orne, Oscar P.
Peters, Morton T.
Rouse, Arthur A.
Shunne, Rex E.
Small, Richard, Jr.
Smarm, Richard
Thomas, Timothy I.
Torris, Clay
Urvics, Cedrick S.
Wanton, Lester M.
Wanton, Morles R.

All present and accounted for, and even listed this way I still don't seem to fit, somehow. My name leaps off the page at me and I feel a strong urge to strike it from the register....

2.

The A-1E had crashed while strafing enemy positions at the base of the mountain on the other side. Two of them working different sides of the mountain had roared toward its summit from a self-created valley of fire, destined to touch for an instant two hundred feet above the crest. The napalm that this one carried had left its signature on the mountainside, a charred ellipsis. Using an axe, the older of the soldiers began to chop a hole in one of the wings that still lay whole among the wreckage. The flier's body had been removed the day before by men from the unit that insecurely held the top of the mountain. All that was left were a few fingernails, a ring, and some bits of burned flesh. To the one using the axe, this wilderness was a place of fearful peace. Unlike the tranquil woods at home, the jungle here seemed to ignore them, harshly. They hurried; both were anxious to be done and gone. It was necessary to jam the breeches of the 20mm cannons in the wing because otherwise the enemy would take and use them, mounting them on a piece of wood and shooting at anything that flew over.

They short-fused the charges and headed for cover. Neither saw the tiger until he was upon them. The soldier carrying the axe was taken full on and found himself

"Just below An Khe Pass, Central Highlands, October 1965. Look tough, don't I!"

James Dale Elder, Jr.

Born Bloomington, Illinois, 1944
Served in Vietnam, Army, 85th Ordnance Detachment, Qui Nhon, Central Highlands, Da Nang, and Saigon, explosive ordnance disposal specialist, 1965–66

looking down the tiger's throat for an instant; the other soldier was knocked away by the tiger's passing flank. Scrambling to a sitting position a few feet from the edge of the path, he managed to dig the .45 out of its holster only seconds before the blast shook the hillside and rained bits of dirt and metal on him. He sat in shock for several minutes, unable to move, until he became aware of yet another presence. A young Vietnamese boy of about fifteen had come silently up the trail and now stood only a few feet away, peering ahead into the smoky clearing. His dark young eyes seemed to be intently examining something at its edge, as if he were undecided about it. He wore only short pants and his bare feet had made no noise on the smooth path. The movement of the soldier's arm made him turn and they gazed into one another's eyes for a moment. The young boy moved his own arm to bring his strange-looking pistol to bear on the sitting soldier. The slug from the .45 caught the boy in the middle of his young brown chest and lifted him off the path. The soldier scrambled to the clearing. The tiger was gone; his friend was not. Half dragging, half carrying him, he managed to get him the two miles up the mountainside. He had four neat, very deep puncture holes in his skull.

3.

He lay rigid, listening. Moonlight shone through the tent's opening. There was no sound but the breathing and small sleeping noises of the others in the tent. He sat up carefully. He removed the .45 automatic from beneath his pillow and pulled back the mosquito netting. He moved quietly to the tent's open doorway and stood in the shadows, listening again. There was something, a faint sound; it was coming from another compound across the road. He could see the barbed wire of both perimeters sparkling in the moonlight. He

held his breath in order to hear it better. It was a guitar, he decided. He could not hear the tune clearly, but it seemed familiar. The tempo was wrong, too slow. It should have been a cheerful tune, but the cadence made it sluggish and sad. He recognized it now and began to hum it lowly to himself, but words came that were not the old words. They shuffled through his mind:

Your son's comin' home in a body bag
Doodah, doodah.
Your son's comin' home in a body bag
Oh, doodah day.

He returned to his bed and lay on his side beneath the mosquito netting with his .45 still in his hand. Two large gray rats came through the door of the tent and began to search for food. Their presence comforted him and he finally dropped off to sleep.

4.

He was the last off. He stopped in the middle of the apron, halfway between the plane's gangway and the fence that contained the people who had come to meet him and the others. The others had already scurried across the remaining fifty yards that separated him from the gate. He turned and looked back at the DC-3, sitting silent on the gray concrete. It was newer, but the same type of plane he had flown in when traveling by Air Vietnam. Slow and obsolete, it had seemed out of place even there. He turned back toward the terminal. Only three people were left behind the fence. They stood close together. He could not see their faces clearly. One of them waved. A feeling of loneliness and desolation swept over him. They were strangers, though they didn't realize it.

Between a laugh and a tear lies a whiter shade of pale.

The briefing in Saigon was merely perfunctory; the trip by prop to Da Nang an eternity.

The first month went by like forever. Everything, not just the venue, was completely foreign. The sights and smells were like nothing ever experienced before. The absence of other Americans spawned feelings of long-distance loneliness.

The cheap, crumpled, sweaty suits had shown their faces and elaborately detailed plans, written in disappearing ink or some other spooky shit. Word in Saigon had been to do as they say; get what they wanted and just forget about the cost. These people held the real power and could deliver anything from Chicom weapons to the finest dope in all of Southeast Asia. Biggest problem was figuring out whose side they were on.

It seemed as if they were the anointed ambassadors of the lunatic fringe, who controlled the government back in the World. Was this the twilight's last gleaming?

Even in the brief period of a month, the toll was heavy. . . . Thirty days and what stories could be told, if only they could. The world had turned upside down and inside out. Its colors were red and green, up and down. The loss of reason had been accomplished with infinite ease.

Maybe the mirror was reflecting the growing insensitivity. Silent tears had molted into a cancerous cynicism. Life no longer held any meaning. Death rode in the shotgun seat on every mission. Whatever feelings had existed were replaced with callousness dashed with a touch of sadism. Deaths and injuries created an unfathomable void, echoed in the mirror's tale.

The mission was everything. The mission was nothing. The only reality was the void.

Emotions faded into a haze of despair. A psychological aging process invaded every pore. Infrequent tears and even fewer laughs defined the parameters of one's existence.

Survival was defined in terms of seconds, minutes, and hours. There was no room for feelings of a human kind. All the fantasies of glory were blown apart in the blink of an eye.

A child's dreams lay smashed and broken. Dreams of redemption could find no plausible source. Alibis wore thinner with every passing day. Labels existed, but none were flattering.

Once a child, now in a man's role, dispensing democracy and justice as ambassador of the land of the free and the home of the brave. Try whispering the word "democracy" to a kid, who couldn't vote or drink, while he lies dying in the mud.

What the fuck happened? Was it just some cruel joke? Did anyone really believe in this?

Tell me, mirror, all about that revolution. Tell me how we're goin' to change the world. Tell me how we're goin' to make it better. Tell if we'll live to see tomorrow.

But the mirror only kept its silence, reflecting the blackness of the soul. It either had no answers or was part of the hoax. For all the years ahead it would only stare back in wonder, holding tightly to its secrets. For it knew what no one else would ever see or hear: It knew the undeniable truth.

47 *This Land Was Their Land.* 1995. Color photomontage, 18 x 26 in.

Edward J. Emering

Born New York, New York, 1945
Served in Vietnam, Navy, Special
Operations, MACV, Da Nang, 1966–68

Our cause was not clear to the people over there or here. With no cause and no purpose and no welcome home, we suddenly had no country either. The scar that war left on this country is obviously obnoxious to everyone, and so Vietnam vets are a cause for embarrassment. . . . After the Americans accept us for being Vietnam vets, they'll have to accept us for what we did there. I would like to inform Mr. and Mrs. America that when I came home I hated you. I saw how you treated your youth. I watched Joe Blow Jr. bleed to death there and here.

I never heard John Wayne or a movie director say "cut" after my combat scenes. A lot of your sons are dead in Cambodia, reported as missing in action.* My biggest crime is that I can't remember their names. No war can be glorious when young men get trashed to keep a few fat capitalists in good cigars.

I went to Vietnam as a medical corpsman with ten weeks of training; five weeks of that was learning how to make beds and wash hands. I was nineteen years old, naive and ready to save the world from Communism. The medic training was a gas. It started out as basic first aid and progressed to basic first aid. I'll tell you this: I was nervous. . . . So Vietnam became on-the-job training. I was assigned to an assault helicopter company. My job as a medic was to be on call. We went by helicopter, ambulance, or jeep; or we ran.

In Vietnam I used to drop people because they became too heavy to carry, and I watched a lot die because I wasn't God. This is not an apology or a confession; it is a worm that has crawled into my head to live and serve as a reminder not only on Veterans Day but every day of my life.

A poem:

If I forget, who will warn my sons;
if we forget the carnage
over boundaries
invisible
save for the mapmakers
and their offspring
the mapreaders.

In Vietnam, October 1970

Randolph Evans

Born Peoria, Illinois, 1950
Served in Vietnam, Army Medical
Corps, 8th Medical Detachment,
155th Assault Helicopter Company,
Ban Me Thuot, Central Highlands,
and Cambodia, medic, 1970

From a memoir:

A Big Green Joke
High-school graduation . . . at least the Army is twenty-six days away. . . . That night, standing alone, Rock Island Railroad tracks, the sixties, what a time to be a teenager: Vietnam, civil rights, KKK, student protests, riots, assassinations, Cuba, Russia, missiles, hippies, dead beatniks . . . at least the Army will save me.

Now the Army of Chicago, represented by massive stone walls, is pondering the fate of this new recruit, who may not be good enough to get in. Pleading to the Sergeant of the Army of Chicago: "Please let me in. I have nowhere else to go." First the Recruiter of the Army of Peoria had me cornered, and now this motherfucker had me cornered. And before him, the judge; before him, the police; before them, a handful of citizens from the community I called home. Let me in; I promise to be a Good Soldier.

On a bus to a plane, to the Army of Missouri: raw recruits with no sleep and everything a big green joke. Three years of this shit? Never. Too crowded on a bus to a plane to the Army of Georgia, basic training, mean motherfuckers, ugly, big, running at you shouting. Graduate basic, on a bus to a plane to the Army of Fort Sam Houston Texas. Not bad: no yelling; I promise I'll be a good medic trainee. Ten weeks bored to tears: hand washing, bed making, basic first aid, advanced basic first aid, nobody serious. Big joke.

Orders, Vietnam, thirty days leave. Tears at airport, goodbye forever Randolph Evans of Chillicothe, Illinois, you are a trained trooper on your way. You don't know shit, but the Army of Stateside has told you everything they know about World War II.

Gateway to the Pacific, sign above our heads, Oakland.

Inside, huge hallways, dim lights, maps on wall, rows of telephones (last chance to call home). Where is Bien Hoa? It's pronounced "Ben Waaa"; that's where we go. Time for sleep, no sleep, just wait. Dawn roll

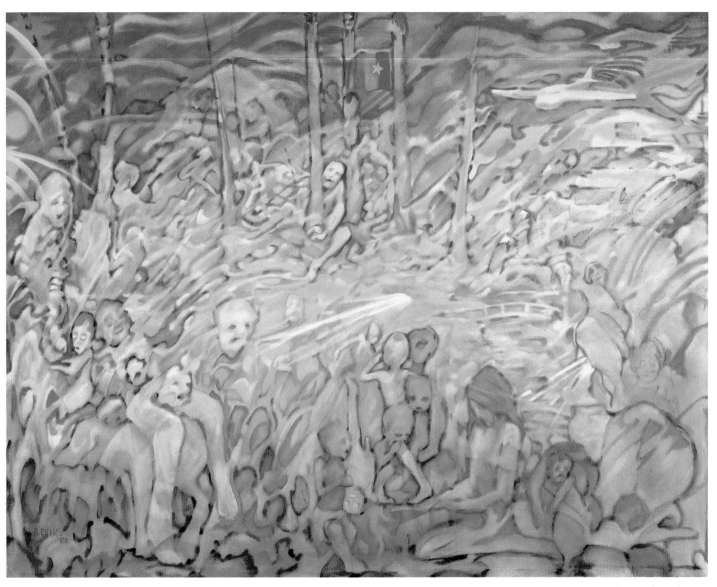

48 *Orphans Burning.* 1980. Oil on canvas, 48 x 61 in.

*call, fall in fall out, ship out. Big fucking jet,
flying into sunset, darkness twenty-two
hours, ocean under us, stop in Japan to take
a piss. Then off again, smaller talk, little
laughter, then the silence, then the circling.
Look out windows: 250 faces crowding the
glass. Darkness outside, little parachutes,
smoking little flares, descending, illuminating
the ground, silence. Instructions: walk to exit.
Darkness, piss smell.*

> *Humidity like a blanket, instantly on the
skin: home for a year.*

Vietnam, 90th Replacement Battalion, Bien
Hoa, Republic of Vietnam, January 1970.
Assigned to the First Aviation Brigade for the
duration. Town of Ban Me Thuot, whorehouses,
bars, military compounds surrounded by
Special Forces, compounds saturated with
U.S. military troops.

> Rockets and mortars used as harassment
at night; in the day we fly away and take the
war somewhere secret like Cambodia. The
Eighth Med's daily routine: sick call, cold, hang-
over, v.d., suicide, insanity, self-inflicted gun-
shot, tapeworm, rat bite, mortar fragments.

We had a three-quarter-ton truck, one
ambulance, one jeep, and the opportunity to
fly into any landing zone the pilot had the balls
for. On emergency Medevacs we picked up
ARVNs and civilians blown to hell. I spoke no
Vietnamese, so I couldn't tell them they had
been fucked by capitalists for the last time.
An unwritten law forced us to throw dead
bloody cadavers (citizens of the Republic of
Vietnam only) out of the helicopter. For medics
of the 155th, flying was volunteer duty; we
had eight medics, four on flight status. Most of
the men in our company died in their chop-
pers, crushed from the sudden weight and
drop from the air. The first person I knew per-
sonally who was crushed into a compact
cube with nothing to hold onto went from 6' 2"
to 36" square.

> Sometimes Chinooks would bring us
bagged bodies and we'd take them to Graves
Registration: Americans who'd gotten their ass
kicked somewhere; this is the Army of the
Nineteen-Year-Old. I met the men of Graves
Registration: a big name, a small building. I
didn't stay for the whole show; I didn't get
past the water-hose treatment – I stayed for
positive identification and puked ten steps
out the door.

> The gunships were Falcons; elite
C-models, which carried guns; H-model Stage-
coaches, which carried guns and people; slicks
flown by people who would re-up to get out
of the field, second-tour door gunners. The
Vietnamese got the new helicopters, ours were
old; sometimes they just fell out of the sky.
To simulate the damage done to an aircraft
when it falls out of the sky, pick up the head
and throw it against a boulder until the thin
walls of the skull cave in. Note the wet spots
in the dust around little mud balls; note the
people running, note gooks like ants around
sugar, note confusion, note death, note MIA.
Mrs. Johnson of Rockford: he is dead, we left
him there.

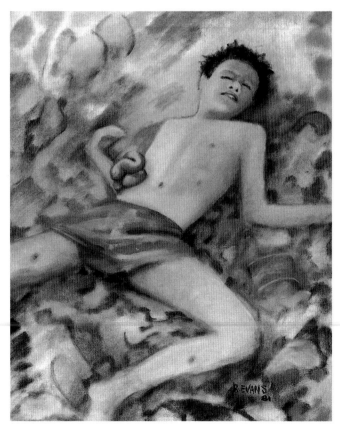

49 *Long Before His Time.* 1981. Oil on
canvas, 30 x 24 in.

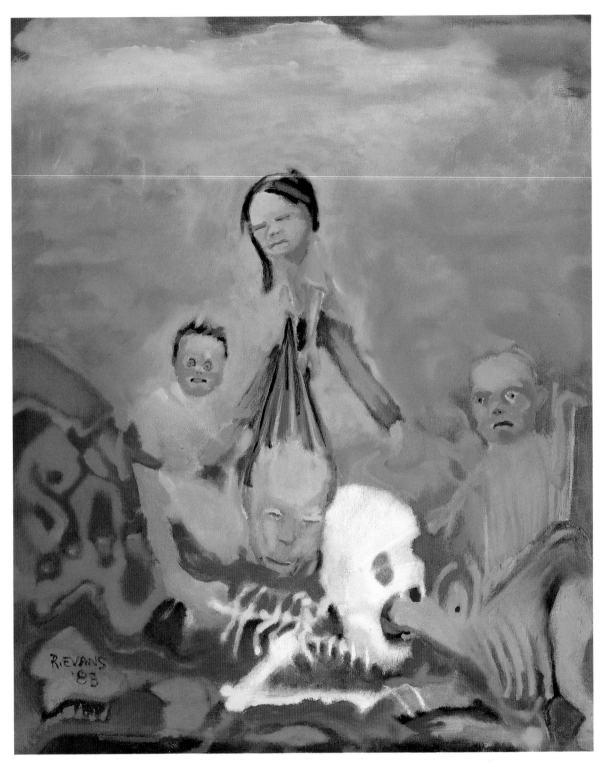

50 *Madame Sihanouk's Offspring
and Their Nanny.* 1983. Oil on canvas,
48 x 39 in.

Problem with that boy? Problem child? Send him to war. Where I was, the lifers were fat, lazy, ugly, and stupid, getting rich off the blood of my friends.

We drank rice wine in grass huts while bare-assed children played outside. They killed a chicken and gave us gold bracelets. We gave them cigarettes and good booze. The North Vietnamese Army killed them.

And I am here. The faces of the children of Vietnam, they are more than thirty years old by now, if they lived.

I knew some young people once, right out of high school, who would risk their lives for people they didn't know, because duty and conscience required it. How are they now? Where are they? I really miss them, in spite of their various forms of insanity, which used to scare me, but which I now understand.

Hey one-eye, bloody blond-haired boy, teeth exposed, no lips, chin gone, hair matted: when I discovered you were dead, I pried your fingers from my forearm. When I put that tube down your throat it was to put air in your lungs. I

breathed for you, but you were dead already, or going through the motions of death. I'm glad you died; you would have hated the way you looked.

Hey little boy, five or seven, where did you end up? Where were your parents when that truck ran over you?

Remember the guy who kicked the door down to get us into the underground hospital in time? Well, he died two weeks later, or so I was told. Deathland, Stinkland, Vietnam, how could a few million American teenagers possibly save you?

Two GIs running down the road, on fire. From the air I saw the explosion and the jet fuel burning; the flames took their breath. We buzzed them several times, but the major wouldn't land; we shot up the village instead. Shortly after this I started staring at the sun: it was supposed to cause blindness. I had seen enough.

I quit the army, but I forgot to tell anyone.

* Legally, no American troops were supposed to be in Cambodia or Laos. The United States government did not officially acknowledge their presence in those countries.

51 Left to right: *I Don't Mind Dying, But I Hate to See the Children Cry*; *See Ya Koreeya*; *Ned's Chickens*; *Gizzards of Boz.* 1994. Oil on canvas, 40 x 32 in. each

52 *Dare to Enter*. 1965. C-ration coffee
and Chinese watercolor on vellum,
16½ x 14¼ in.

In his hooch at Bien Hoa, 1965

Joseph Clarence Fornelli

Born Chicago, Illinois, 1943
Served in Vietnam, Army, 501st Assault
Helicopter Company, Bien Hoa,
helicopter crew chief and door gunner,
1965–66

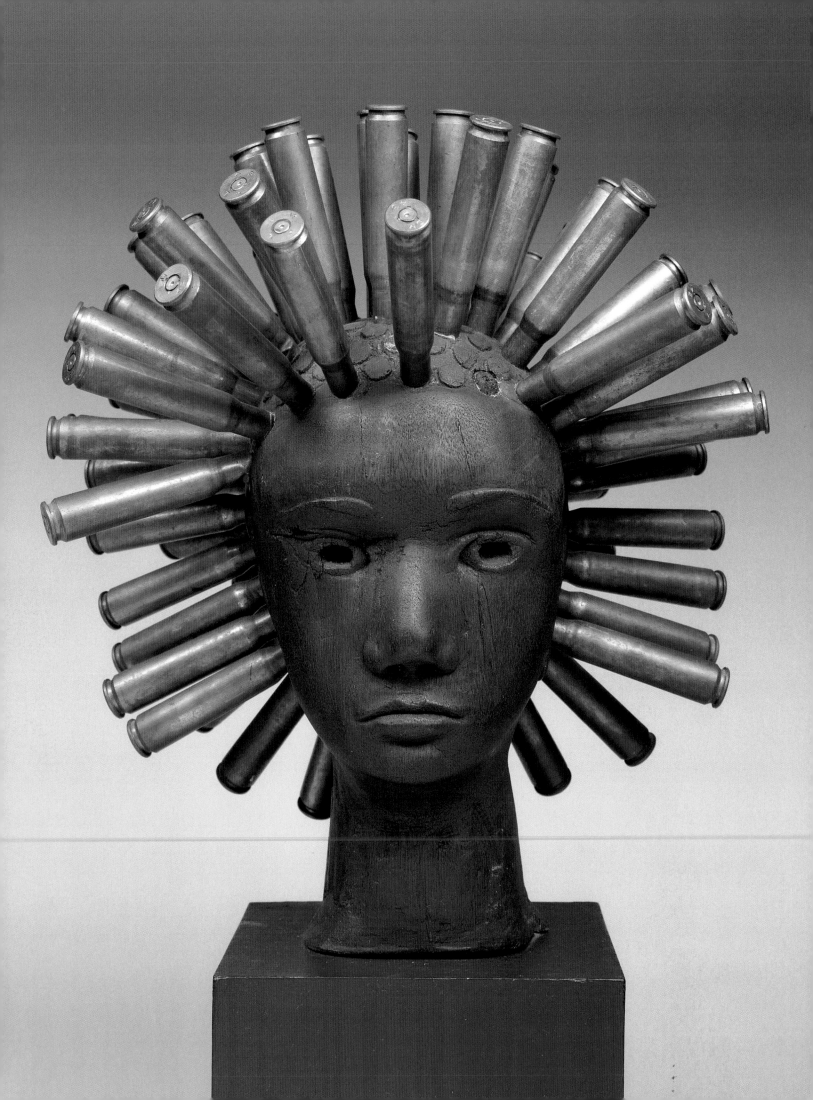

From a conversation:

The spirit is unwordable, unpaintable.

I did the sculpture and drawings in Vietnam, during the war. Later, I used to have a kind of shrine in my studio, a collection of artifacts from another time: my helmet, some shells, other things the GIs carried. I can remember my head shaved so it would fit inside the helmet... and these shells, the tracers on them left a beautiful yellow-orange trail after you fired them. The Zippo lighter, my flack-jacket cover... the gun I had smelled of the oil and cleaning bath; it stunk. That old gun had seen some fighting. Later I traded it to an Air Force guy for five gallons of ice cream....

In the 1800s Indians wore a shirt or vest during some mystical ghost dances they did to protect themselves from death before they went into battle; and I'll be damned, a lot of them didn't get killed. What I'm saying is, a warrior — any warrior — has something happen when he puts on his battle clothes — you feel that it gives you a kind of magical power, makes you invisible or gives you strength inside. So something takes over that as a rational person you know is ridiculous. But if you thought that way in combat you'd be dead. You're so vulnerable.... You know, there is a certain strange high, an excitement about somebody shooting at you and you at them. I'm telling you, it's something that puts your nerve endings outside your body; and the air that touches your body — you know about it, you can feel it, you can smell it. This atmosphere is very oppressive. It's hard to breathe and pushes on your shoulders. This heavy air, the heat, the humidity of Vietnam, is something you don't know. It's the kind of air you can feel touching your body and pushing at you.

Recently, someone was talking to me about how cruel the ancient Romans must have been, when killing became a sport to them; watching people die in arenas was a pastime. Hard to understand? The world was doing it again in the 1960s. I came back from Vietnam to see people eating dinner on their TV trays while they watched the carnage: the new Colosseum.

54 *Mother and Child*. 1965. Map ink on vellum, 11½ x 4 in.

55 *Metamorphosis*. 1965. Map ink on vellum, 14 x 11¼ in.

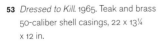

53 *Dressed to Kill*. 1965. Teak and brass 50-caliber shell casings, 22 x 13¼ x 12 in.

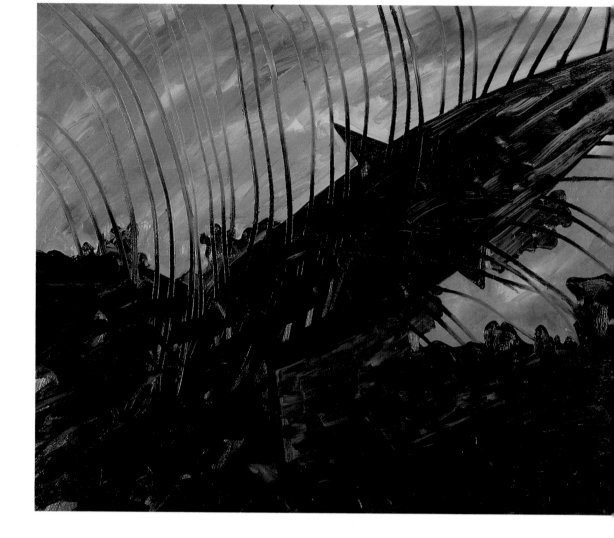

In the town of Ubon Ratchathani, Thailand, 1965

Rupert Garcia

Born French Camp, California, 1941
Served in Thailand, Air Force, 8th Air
Police Squadron, Ubon Ratchathani
Air Base, air-base ordnance security,
1965–66

In 1965–66 I was stationed at a secret air base in Thailand. My job was security. I guarded pilots, jet fighter bombers, helicopters, information, money, ordnance, myself and other GIs, and the host country's personnel. The paradoxical aesthetics of war profoundly fascinate and puzzle me: the sculptural components of machines of destruction, the fire of consumption, the evidence of death and destruction — the absurdity of war, the beauty-and-beast of war, the good-guys-and-bad-guys of war.

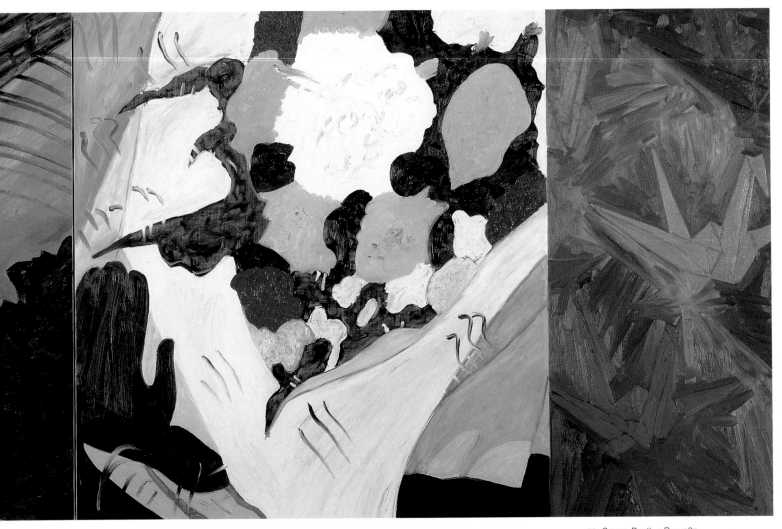

56 *Guerra, Death, y Paz.* 1987.
Oil on linen, three panels, 50 x
142½ in. overall

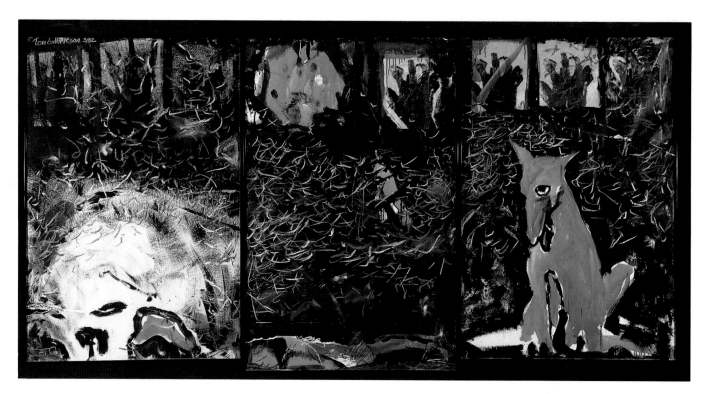

57 *Night Life (Guardians of the Secret).* 1982. Oilstick, enamel, and collage on paper, three panels, 39 x 24 in. each

In a guard tower on the perimeter of the 8th Radio Research Field Station at Phu Bai, spring 1968

Thomas Gilbertson

Born Vallejo, California, 1946
Served in Vietnam, Army Security
Agency, 8th Radio Research Field
Station, 509th Radio Research Group,
Phu Bai, Hue, and Camp Evans,
security guard, 1967–70

I stayed in Vietnam for three years because I felt guilty – guilty for being part of it all, guilty for not being more a part of it. Mostly I felt guilty for not being one of the oozing gray bags of human matter stacked in the chilled Conex boxes across Highway 1 near the Phu Bai airstrip. For over ten years after I returned I found myself constantly explaining my role in the war – apologizing for coming back relatively unscathed, I guess. For another ten years I tried to make sure that every kid I taught art to in the schools knew that war was wasteful and an admission of failure; that Secretary of Defense Robert McNamara and Nixon were scoundrels; that Sylvester Stallone and others of his ilk were opportunists;* and that if a few of the sons and daughters of our senators, congressmen, and business leaders had returned in rubber body bags the war might have ended sooner.

Today my gait is wobbly and painful, a memento of an April Fool's morning near Phu Bai in 1969, and I do odd-looking paintings of flawed landscapes, dead plants, and old toys framed in lead and clad in beeswax. Sometimes, as I drive through a barren mountain pass in Nevada, when it's drizzling rain and the

light is just so, I am surprised not to see a bunker, swathed in barbed wire, looming from the crest of the hill; not to hear the chattering staccato of automatic weapons and the thump of mortars wafting through the mountains; not to see an arc of tracers splattering through the advancing night.

And when I hear the marching band at a high-school football game, for an instant I am once again huddled in the corner of a backhoe trench on a cold, dark afternoon in 1968, next to the runway at Camp Evans. The air vibrates like a tuning fork after a series of 122mm rockets has skipped across the steel airstrip. An army band practices a few hundred yards away as the crew chief gives us the signal, through the roar of engines, that it is time to scramble out of the ditch and run for the yawning ramp of his C-130 transport, dive past the rudely stacked body bags, crawl under one of the red nylon straps on the floor of the already moving plane, and pray that the pilot will guide us safely through the torrent of rockets, mortars, and sniper fire. Most vividly of all, I recall a stuttering, bawling, milk-cheeked grunt with century-old eyes clinging to the wall of a trench, babbling about how he was the only survivor of an ambush on his outfit that morning, and now they were going to get him.

* The star and creator of the *Rambo* Vietnam War films, who was of draft age during the war, did not serve in Vietnam.

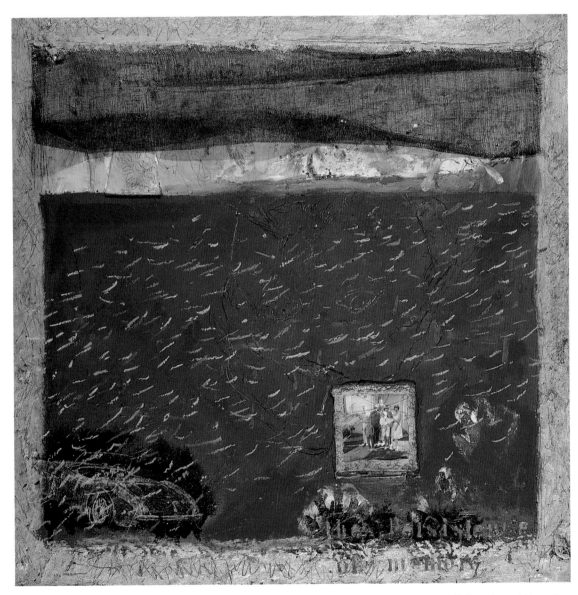

58 *Night Life (Persistence of Memory).* 1982. Oil, oilstick, and plaster on pegboard with fabric, photograph, and cracked glass, 24 x 24 in.

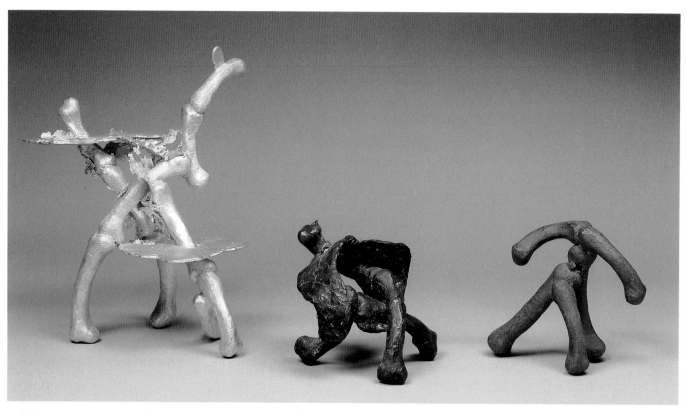

59 Left to right: *Paddy Bones.* 1979.
Cast aluminum, 15½ x 12¾ x 12¾ in.;
Bones Won. 1979. Cast bronze, 7 x 7 x
5 in.; *Bones Won 2.* 1979. Cast lead
alloy, 8 x 6¾ x 5 in.

A photographic poem from Vietnam:

Note to God and Country
Green on the outside
and black within
I stand smiling with a friend
but my spirit is betrayed
and cursing you is my only prayer.

Stan Gillett

Born Dearborn, Michigan, 1947
Served in Vietnam, Army, 4th Battalion,
199th Light Infantry Brigade, north-
west of Saigon, rifleman, 1969–70

From a series of letters, 1985–95:

For me, Vietnam illuminated, in exquisite relief, the dark side of being: all the hypocrisy and good intentions, failures and heroics, collaged in one horrific mindfuck. My infantry experience was divided between the rice paddies and jungles roughly sixty miles northwest of Saigon. As a simple enlisted grunt, I was not privy to information about how our unit coordinated with the big picture of the war. As a matter of fact, I didn't give a damn where I was. Subjectively, I felt "They" were in control and my goal through the whole ordeal was to stay alive somehow. During the days we searched the terrain; during the nights we set up ambush. My dominating emotion, which ebbed and flowed but never diminished, was fear. I shared point position for six months, caught shrapnel in the legs, had dysentery and malaria. In the hospital at Cam Ranh Bay we had a sapper attack that wounded hundreds of bedridden patients. The point is: I never felt safe anywhere.

This overriding sense of fear was probably the dominating influence in the art that followed ten years later. Depression, anger, outrage, etc., came and went, but I can still trace the lines of fear. The drawings all came from the jungle experience and its attendant sense of impending disintegration. The *Bones* series of sculptures comes from the rice-paddy period of the tour. I recall the smell when I came upon rotting bodies in the fields – the skin and bones. I remember how the bones would project through the flesh: the strength of dead bones, their integrity, their clean dominance over life. Bodies fresh-killed in the rice paddies seemed somehow to support the geography – actually to hold the scene together physically. They were so serene and strangely formal; and very dead. I made these connections after the work was completed; while it was in progress, I could not read the sources.

I have been working as a registered nurse at a hospital. I nurse collapsed people and search for a balance of meaning that doesn't exist . . . just an average guy. Maybe I'm doing some payback on the misery scale?

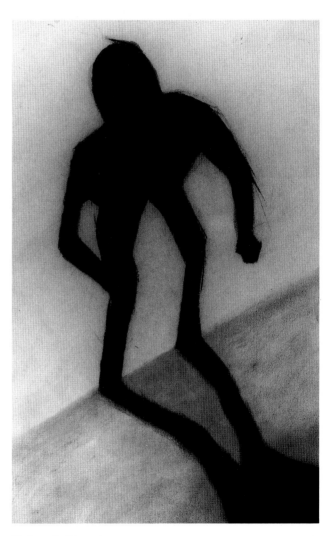

60 *Fear*. 1980. Charcoal on paper, 27 x 19¾ in.

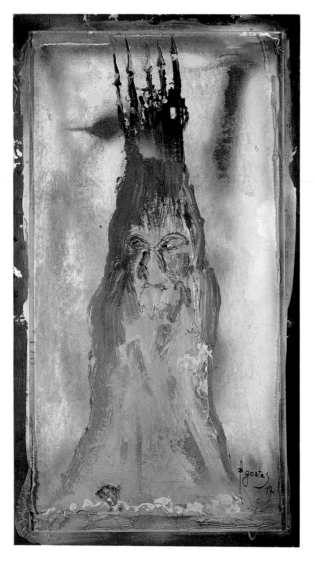

61 *Mental Anguish.* 1982. Acrylic on
burlap over hardboard, 45½ x 25½ in.

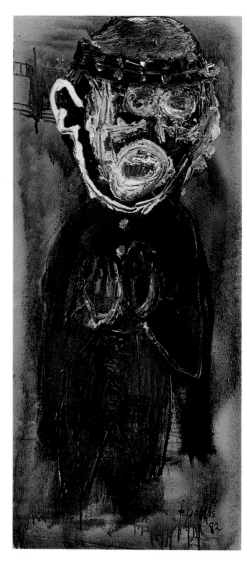

62 *Physical Pain.* 1982. Oil and acrylic
on two-ply cardboard, 38 x 17 in.

Ca. 1967

Theodore Gostas

Born Butte, Montana, 1938
Served in Vietnam, Army, intelligence
officer, 1967–73, prisoner of war, cap-
tured at Hue, held in southern China
and Hanoi, 1968–73

From a series of letters and statements, 1983, 1988, and 1995:

What is *Mental Anguish*? It is a painting by Theodore Gostas. It is a companion piece to *Physical Pain*. Gostas has carved himself in art history by hacking and hewing at the mountain of life; he has succeeded in ingesting it all and then handing it back. . . . He was a prisoner of war in Vietnam. He was tortured and squeezed like a diamond in the grip of fear, terror, and stress, then set free. So he paints.

At the top of the painting, do you see the castle where a head of hair should be? This is the haunted palace Edgar Allan Poe created in one of his poems. The face beneath the castle is not pretty or ugly; it is one of the greatest faces ever painted, for it says absolutely nothing. There are no real limbs beneath the face. Arms and legs are not needed in solitary confinement. The sky background is sick – not promising. . . .

Having established through interrogation that I fear werewolves the most, the Communists chose a full-moon night to put me in with one, as a roommate. No doubt he was a drama student or from a Vietnamese acting troupe, but to my tormented mind, driven through hell by four years in solitary confinement, he seemed authentic. . . .

There is no mystery to my art, though some might find it mysterious. I am a war artist, and if there is mystery in war it is only perceived as such by those who have not lived with war. In the pain of war some objects may change form, but they are never out of focus. . . . A prisoner of war may go mad and become a castle-haired mountain of shifting

flesh. Things are done this way because my pain has been too intense for any other form of expression, including screaming. . . . I tried poetry. A three-star general read my book of war poems and called me to his office and said I was the poet laureate of the United States Army. I was flattered and full of pride, but I came to realize that my poetry was born of the excitement of freedom and was, therefore, not the best vehicle for expressing my appreciation of life, living. I decided that poetry was not nearly as important as the expression of my pain, as manifested in painting and drawing. I did my bit with fear and survived; pain, however, was and sometimes still is the only adversary to which I buckle, and as a result, I pay pain tribute. I try to avoid bedlam, the place where souls cannot communicate their anguish because they lack control. Control is the secret to communication and artistic expression. I force the viewer to look at my art and thus at me. The viewer may rail at me, call me names, or turn away in disgust, but he is changed because I have controlled my scream enough to let him hear it and see it. . . .

Often I hurry when I paint because my feelings of pain shift from one image to another instantly and I feel compelled to rush after them all, to express as many as possible. Usually, I find myself settling into a rhythm of brushstrokes that slowly erodes away the anguish and loneliness precipitated by the pain. As a painting draws near completion, I have a fear that I may only have screamed, and not really communicated my feelings and experiences. . . .

I love color – deep, rich, intense, and vivid color. Color is almost godlike to me. It soothes and numbs, explains, speaks, and confuses. My heart aches with frustration when I can't for some reason deepen colors to suit my aims. . . . I have used symbolism and expressionistic imagery to describe my experiences and feelings while incarcerated. . . .

War still blooms like a human-consuming Venus flytrap. I would like to hold a mirror up to war and hope that once it looks at itself, like Medusa it will begin to die. But I could not hope to be the instrument of war's death; such vanity is folly. I just want to keep on pushing war around, making it feel uneasy and afraid to sit down.

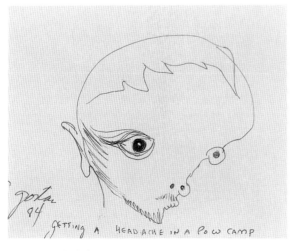

63 *Getting a Headache in a POW Camp.* 1984. Ink on paper, 4¾ x 6 in.

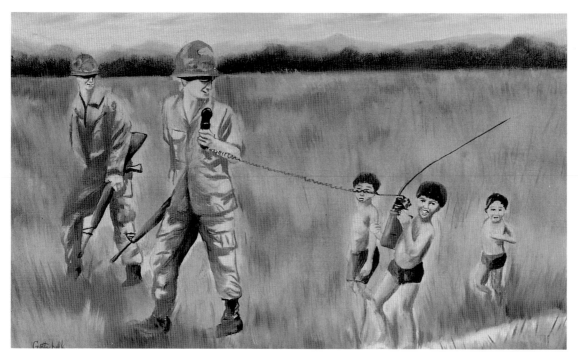

64 *With a Little Help from My Friends.*
1988–89. Oil on board, 9¾ x 15 in.

At San Juan Hill, 1969

Michael Gottschalk

Born Mount Clemens, Michigan, 1947
Served in Vietnam, Army, 6th Battalion,
11th Artillery, 23d Infantry (Americal)
Division, San Juan Hill, I Corps, 105mm
howitzer artilleryman and Fire Direction
Center radioman, 1969–70

I was drafted in June 1969 and away to the U.S. Army I went, along with many others who were depressed and bitter about the war. Some people considered the possibility of refusing induction or moving to Canada. I decided that it wasn't fair to do that; too many people were going. So I became a part of the big green machine.

After seeing the reports of Vietnam on television every night, I found it very strange and eerie actually to be there. I don't think I will ever forget my first sight of it, as the jet door opened and the steam and heat hit me in the face.

I ended up with the Americal Division, about fifteen miles inland from the South China Sea. We lived like animals in holes in the ground on San Juan Hill, Bravo Battery. Fortunately, our first sergeant discovered that I had some college background (it was art school, really) and I was transferred to the Fire Direction Center, fifty feet away. So at least I didn't have to hump ammo out of the ammo pit any more, something the gun crews had to do daily. In the Fire Direction Center we had a lot of idle time between fire missions, which gave me time to sketch. I hung my work on the Conex walls.

I went on a few scary gun-jumps. Once I nearly got blown away by a land mine and VC. Seeing bodies disappear into the air and smoke is not very appealing, so I have never wanted to depict that day.

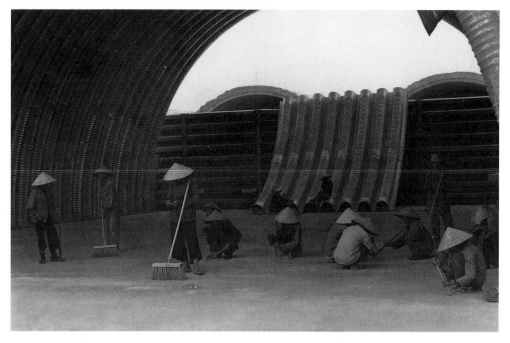

65 *Phu Cat.* 1968. Photograph, 6 x 9⅜ in.

At Phu Cat Air Base, October 1968

66 *Firefight, Binh Dinh.* 1969. Color
photograph, 7½ x 11¼ in.

Bill Hackwell

Born Newport, New Hampshire, 1948
Served in Vietnam, Air Force,
46th Tactical Reconnaissance
Wing, Phu Cat Air Base, Binh Dinh
Province, Central Highlands, aerial-
reconnaissance photography
processing and intelligence, 1968–69

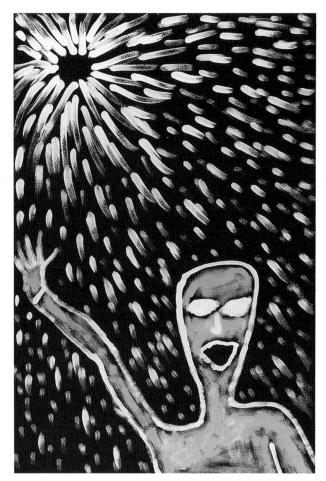

67 *Night Mission*. 1994. Acrylic and ink on paper, 19 x 13¼ in.

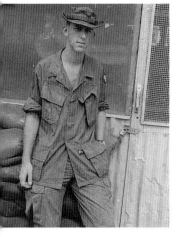

At Bien Hoa, February 1969

Stephen Ham

Born Salina, Kansas, 1948
Served in Vietnam, Army, 2d Battalion
(Combat Intelligence Battalion),
2d Infantry Regiment Mechanized,
1st Infantry Division, and 101st Airborne
Division, 17th Assault Helicopter
Company, Lai Khe, Iron Triangle, and
Camp Eagle, intelligence analyst,
1968–69

When I arrived in Vietnam, my orders were for the 1st Cavalry, but they canceled these and sent me to an experimental unit called the Combat Intelligence Battalion; it was the only such unit ever formed.

From Dead Vet greeting card #18:

The first time I saw men straight from combat was at night when they walked into my tent. We looked at one another without a word. It was all incomprehensible and mad but one thing I understood – this was the metamorphosis that awaited me and my friends. In a few days we would be like them.

My job was to collect and monitor intelligence at the battalion level in the field. I served with many different units, mostly infantry and mechanized infantry. In October, after days in the mud in the middle of a firefight, I decided to die clean. Several weeks later the Combat Intelligence Battalion was disbanded and I was sent to the 101st Airborne, where I flew recon with the Kingsmen: *Death and Destruction 24 Hours a Day – If You Care Enough to Send the Very Best, Send the Kingsmen.*

From Dead Vet greeting card #33:

At three thousand feet I watch my piss roll across the metal floor of the helicopter and out the door into the night. It's my last mission and I'm scared shitless. After six hours I get out and throw up next to the gun mount. I wondered if I was going to get in trouble for pissing in the colonel's copter. Who would clean it up? I wipe my mouth on my shirt sleeve and get into the truck. The man next to me says, "Man, you stink." Three days later I'm home.

My Dead Vet cards are different from my paintings; they are greeting cards or letters from the dead: I'm a medium for the dead and I'm processing their pain. In Dante, the gate to heaven is found by plunging into the depths of hell. This kind of art puts us in touch with something deep within, something genuinely human; there the community is created, isolation is broken.

The SCREAMS I HEAR Belong to
the MEN who ARE still Burning
in my HEAD.
HE BURNS Like oil on WATER
HE BURNS Like mo GAS.
HE SCREAMS FOR me to kill Him
HE moves FOR His M-16
I Pull Him AWAY. His SkiN
comes oFF in my Hand...

MEMORIAL DAY

68 Four Dead Vet greeting cards,
exteriors and interiors. 1994. Ink on paper,
5 x 7 in. each

*The wounds in MY
HEART ARE REAL I
HAVE WATCHED them
DIE........MeMORiaL DAy

MEMORIAL DAY

MY LiFe WAS
SAVED BY
SO MANY.

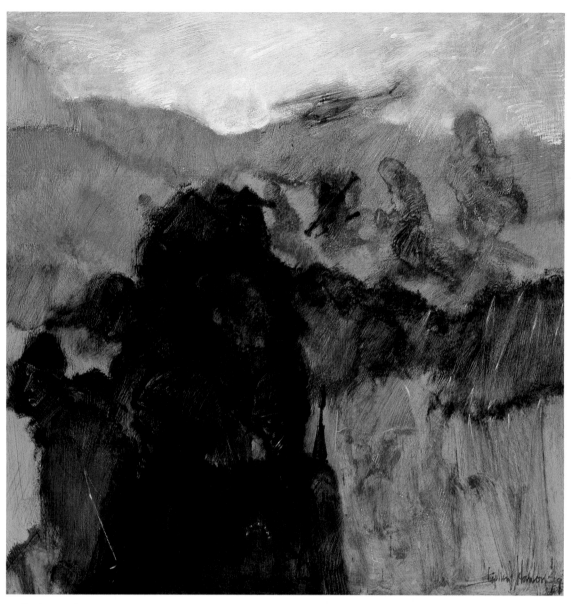

69 *Chu Lai.* 1979. Acrylic on canvas,
48 x 48 in.

Steven Hanlon

Born Boston, Massachusetts, 1947
Served in Vietnam, Marine Corps,
2d Battalion, 4th Marine Regiment,
3d Marine Division, Chu Lai, gunner,
1965

From a letter, 1983:

I joined the Marines on my seventeenth birth-
day to escape high school. After boot camp
I joined the 4th Marines at Kani Oi Bay, Oahu,
and received training as a gunner on a 3.5
rocket launcher, the shoulder-held type. It
was at this time (1965) that the 4th Marines
were committed to combat at Chu Lai. Their
job was to secure the beachhead there and
set up a perimeter of defense around an
airstrip that was to be built by the Seabees,
sea-going engineers. The strip was used by
the air wing attached to the 4th Marines,

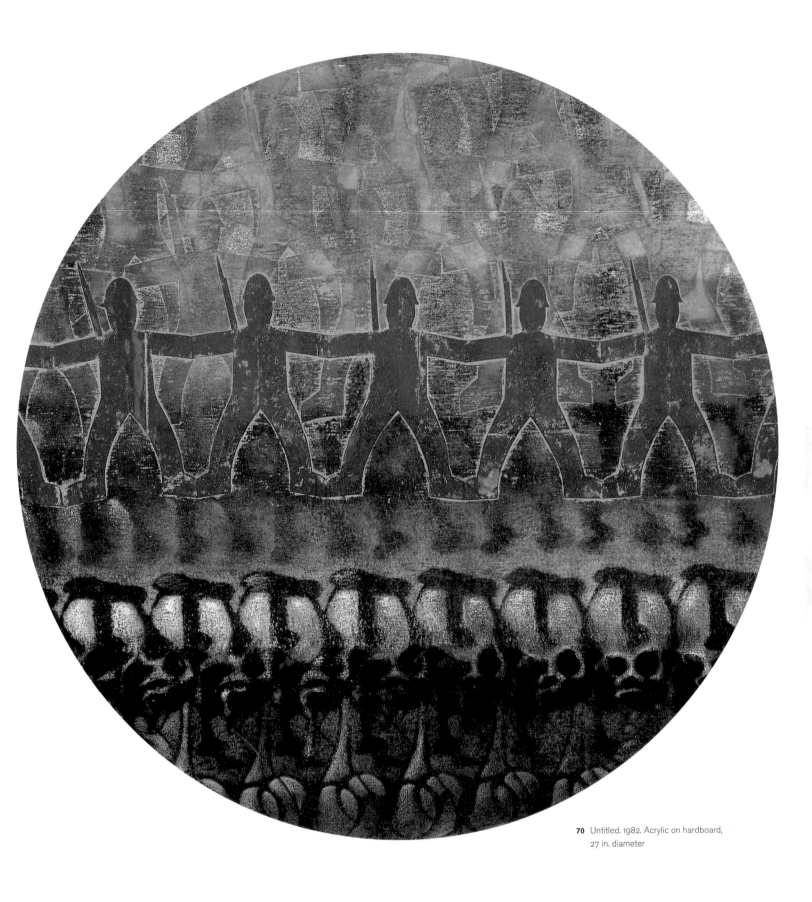

70 Untitled. 1982. Acrylic on hardboard,
27 in. diameter

known then as the Black Sheep. They ran sorties over North Vietnam and supplied close air support while contingents of the 4th Marines were engaged in battle around Chu Lai.

I participated in four major engagements with the North Vietnamese. After the loss of many close friends and four and a half months of living hell, I was evacuated with what was then termed battle fatigue. The next five months were spent at Trippler Army Hospital in Hawaii.

I went back to what was then termed the "real world" in Marine vernacular – civilian life – and did my best to fit in to what was then the American Dream. I never seemed to regain this sense of home that I had known before. Not wanting to alarm my friends and family by staring at the walls and drinking, I decided to enroll in school.

I was having a great deal of difficulty adjusting to my new life at school – strong emotional surges of unknown origin kept me from being able to settle into the required routines of campus life. Chaos ensued. I decided to move to a more pastoral setting and came to Humboldt County to study art at the university.

All of my Vietnam art was done in the last four years. There are about fifteen pieces, but only four are literal enough to be readily identifiable as such. The rest are . . . well, I'm still working on a definition.

As I look at this piece [no. 70] now, it seems almost metaphorically trite. It was a beginning, trying to express the evolution of the dying process in war. The cookie-cutter or paper-doll image pasted across the surface developed to express the childishness and foolishness, wastefulness, mindlessness of adolescent lemmings marching gloriously into oblivion. There's almost a comic-strip heroic feeling in this piece.

71 Untitled. 1983. Driftwood and leather shoes with acrylic and polyurethane foam, 48 x 48 in.

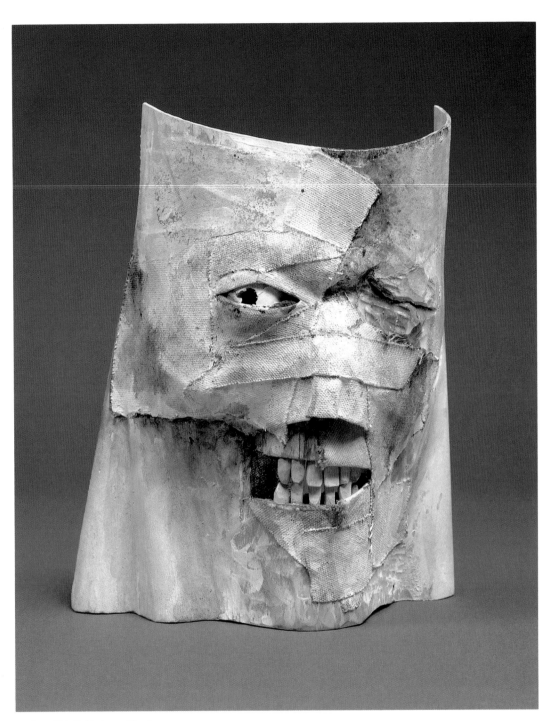

72 *Ritual Suicide Mask.* 1979. Wood, gauze, and paint, 10 x 8 x 3½ in.

With Task Force Boston, between Pleiku and Cambodia, 1968

Randolph Harmes

Born Omaha, Nebraska, 1944
Served in Vietnam, Army, Pleiku
Subarea Command (PSAC), Pleiku,
cook, 1967–68

From two letters, 1981 and 1996:

I couldn't even read novels or other books about Vietnam until well into the 1980s. I feel no connection, empathy, or (until recently) sympathy for my fellow veterans. I don't like hanging out with them or thinking of myself as one. My story is not at all exciting; the only weapon the army issued me was a mess-kit knife; I didn't kill any babies or lose any body parts. Nevertheless, I still was (and to some degree am) overwhelmed by guilt at my participation, however detached, and by my lack of courage to stand by my convictions.

My interest in masks stems from an ongoing admiration for the woodcarving of the North Pacific Coast Indians. I have occasionally used Northwest Indian motifs for their exotic or anecdotal value. My masks mark a change in my interest from the appearance of Indian art to the purposes for which it was used. They show little physical resemblance to Indian masks, but they represent, to a degree, the assimilation of Indian liturgical mask-making traditions. They deal more with feelings than with specific experiences. *Dulce Bellum Inexpertis* translates as "war is sweet to those who have not experienced it." This was a popular theme during the reign of Elizabeth I; the title is taken directly from a sixteenth-century poem by George Gascoigne, a veteran of the wars of Holland. It compares the realities of war with the myths of war. (I also think of Wilfred Owen's poem "Dulce et Decorum Est" – Owen died in World War I.) It is concerned with anger and rage: anger at being used, lied to, and manipulated for the benefit of Litton Industries, Honeywell, and Bankamerica. The *Ritual Suicide Mask* deals more with guilt: guilt over surviving, guilt over having participated, in any manner, in the war. Making the masks was a way for me to put some of this behind me – kind of primal screams whose purpose is to expose, examine, and then expunge or exorcize these old ghosts. A focus these works share with traditional masks is transformation: transformation of the maker/wearer, transformation of the mundane to the mystical and vice versa – magic.

. . . Yes, I am giving up some of the guilt. For years I considered myself personally responsible for every aspect of that war – from racism within the service to My Lai to defoliation (in spite of the fact that the army neglected even to issue me a gun, and I never felt compelled to point out this oversight). *Ritual Suicide Mask* was made as a means of figuratively beating myself up for all these things I took no initiative to stop, and because I felt guilty about not ending up like the mask (that is, surviving).

Since Vietnam, I've been preoccupied with the Holocaust: how do we normal, walking-down-the-street kind of people end up doing these incredibly horrible things to each other? And what about those to whom they're done? That's where another mask, *A 40762, Exuviae,* comes from: it has its genesis in Vietnam, but generalizes individual feelings and concentrates on the victim of violence. The untitled mask is just mean little flags (U.S. and Vietnamese) eating one another.

73 *Dulce Bellum Inexpertis.* 1979. Stained wood with thread, 11¾ x 9⅞ x 3½ in.

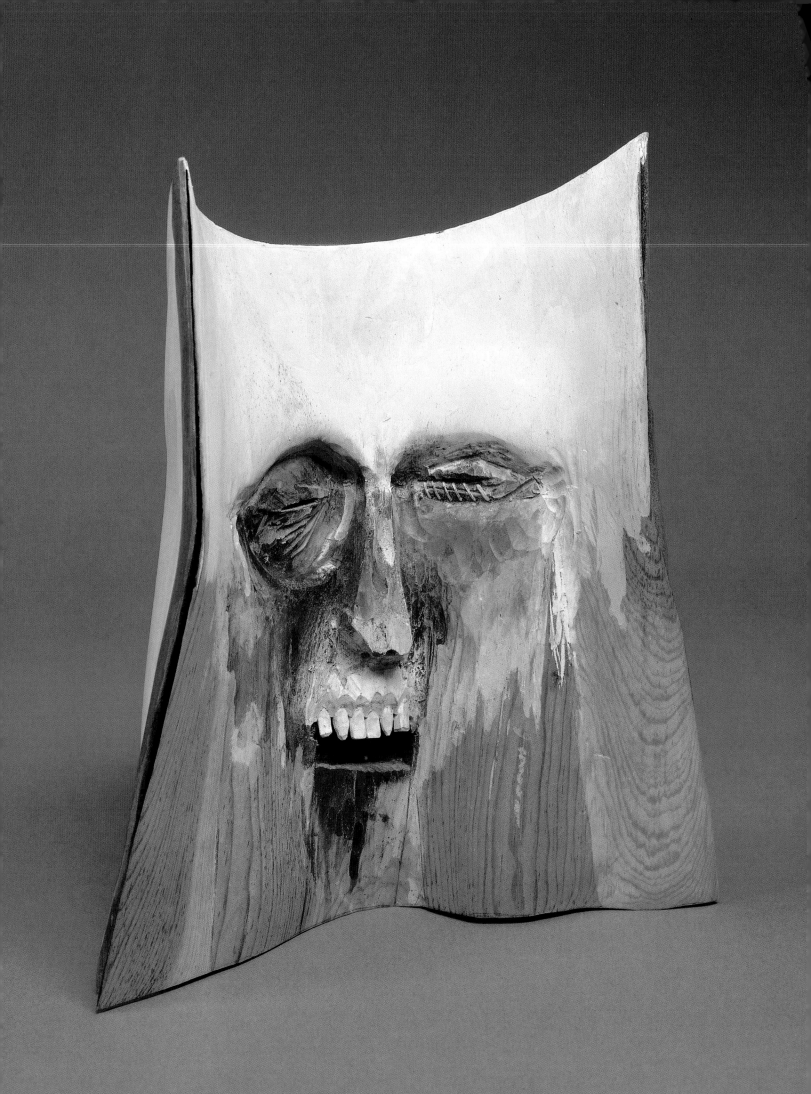

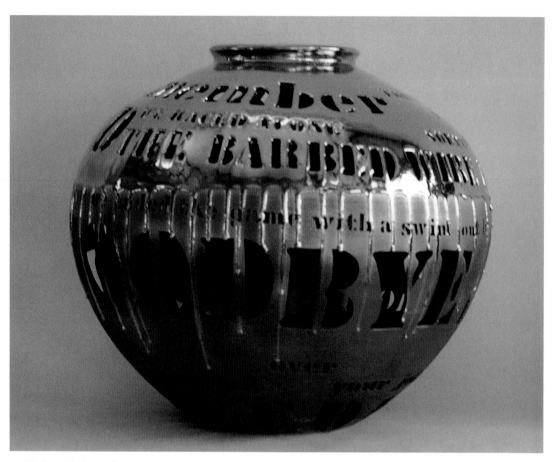

74 *War Songs: Safewater Buoy 2.* 1995. Incised porcelain with black matte glaze and platinum lustre, 19 x 19 x 24 in. Master ceramicist Stephen Freedman

In Da Nang, 1968

Incised into *War Songs: Safewater Buoy 2,* a poem written in Vietnam, 1968:

Do you remember the day I surprised you at the beer party in Da Nang and we raced along the barbed wire beach until our fatigues were so green with happy sweat that we ended the game with a swim out by the fishing buoy and that night after waving goodbye from the helicopter I sat and chuckled over your jokes while they killed you.

Grady Estle Harp

Born Enid, Oklahoma, 1941
Served in Vietnam, Navy, assigned to
the Marine Corps, 7th Fleet Special
Landing Forces, 228th Battalion,
Quang Tri Province, Da Nang, and the
DMZ, battalion surgeon, 1968–69

A poem written in Vietnam, 1968:

War makes you do such things
as keeping an IV running on a dead body
 all night
so his neighboring wounded buddy
won't give up until he can be Medevaced
to a field hospital
the next lonely morning.

I heard a lot of one-way conversations
at night
in Vietnam.

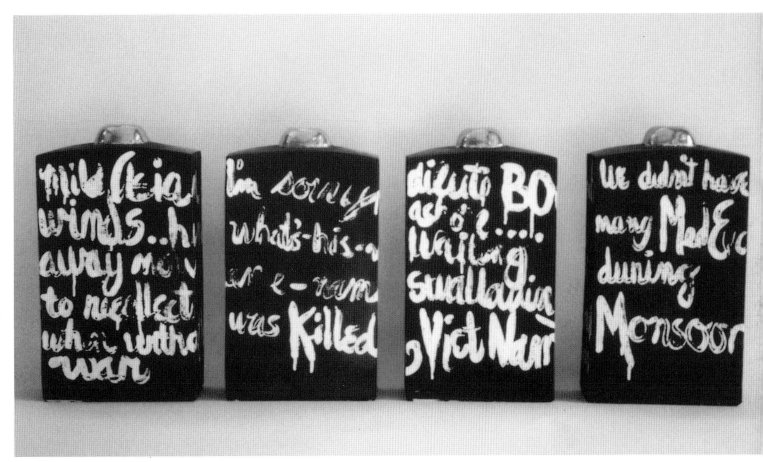

75 *War Songs: Sentinels.* 1995. Porcelain with black matte glaze, wax resist, and gold lustre, four units, 21 x 12 x 5 in. each. Master ceramicist Stephen Freedman

Inscribed on the four vessels, left to right, fragments from some of Harp's *War Songs*, poems written in Vietnam, 1968–69: Mild Asian winds have . . . away now . . . to recollect when without the war / I'm sorry what's-his-name was killed / dilute bombs ashore . . . silently swallowing Vietnam / We didn't have many Medevacs during monsoon

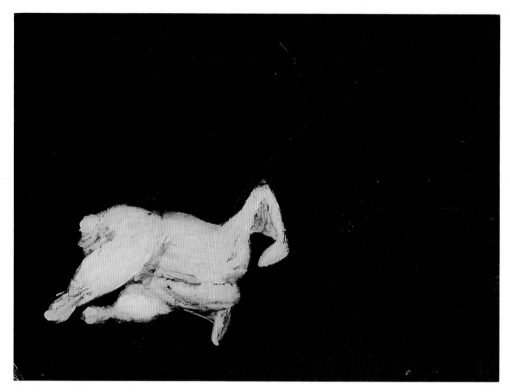

76 *Naked.* 1970. Oil on canvasboard,
19¾ x 25¾ in.

At Lai Khe, 1969

Michael Helbing

Born Elmhurst, Illinois, 1946
Served in Vietnam, Army, 1st and 26th
Dobel Battalion, 1st Infantry Division,
Bien Hoa and Lai Khe, radio
mechanic, 1969–70

The chicken painting (*Naked*) was the first work I did when I got back from Vietnam. It was done the first week of April 1970. It expresses the way I felt at the time – about myself and about the people who didn't make it back. The chicken is naked, raw – no head, no legs, no feathers – just meat. It is something of an expression of defense, I think: No matter how you cook me, you can't eat me.

Club of War was done in 1981. It is a rather intellectual expression of my feelings about power – it is made of white and black marble (good and evil?) and is covered with mirror fragments, reflections of the surrounding environment, and multicolored broken glass, which makes it pretty. The word "club" has two meanings: you can swing it or join it. As a functional war club its only departure from traditional form is that the user's hand will also be destroyed in wielding it.

The title *One, Two, Three, Four* comes from the Vietnam-era song by Country Joe and the Fish, whose chorus goes, "One, two, three, what are we fighting for. . . ." I originally titled it *One, Two, Three, Four, Let's Go to*

77 *One, Two, Three, Four, Let's All Go to War.* 1980. Scrap-metal elements and enamel, 68 x 49½ x 52 in.

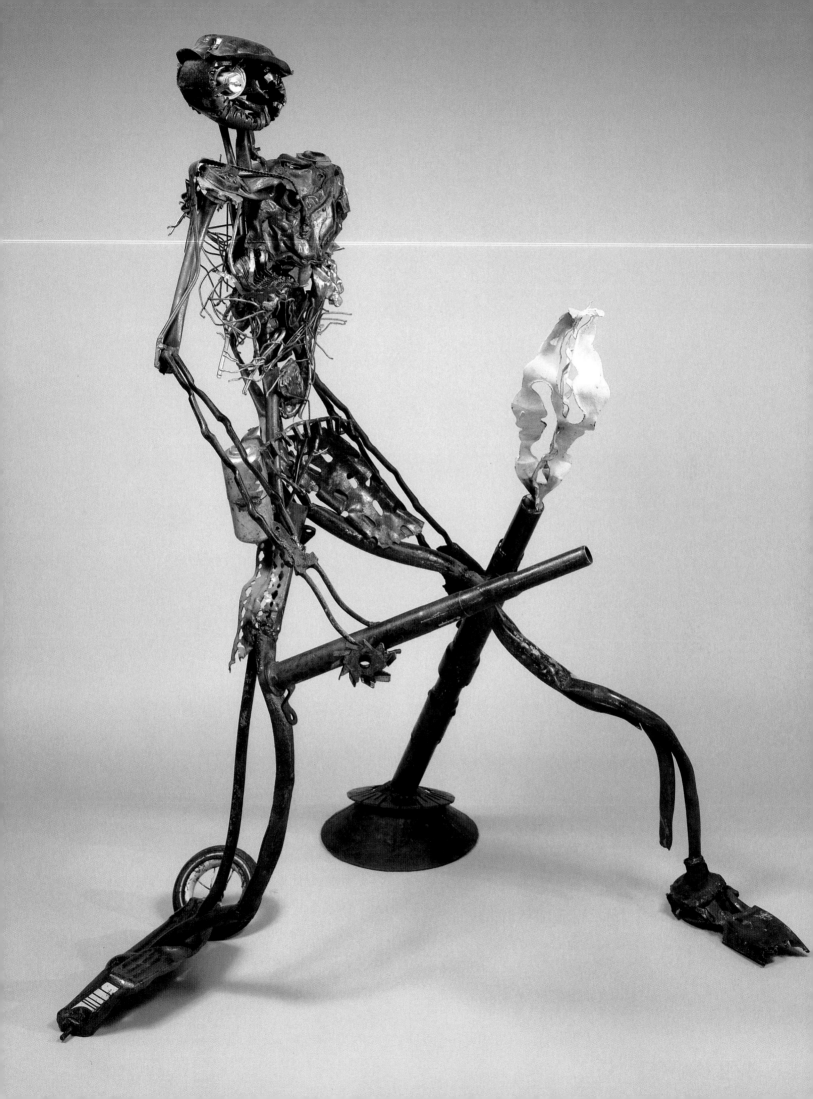

El Salvador – I made it at about the time of
that war, after Vietnam, but it seems too topi-
cal to me now. It could just as easily be called
Off to War. It is really about young people
who embrace the "romance" of war and with
a jaunty step go off to dance with death. It is
made of junk that was run through a shredder.
One foot is a crushed and cut tricycle. The
figure is intentionally skeletal, with a stance
caught in mid-stride, at the moment of impact
when death has happened but he has not
yet realized it.

I arrived in Bien Hoa in January 1969, expect-
ing to get shot when I got off the plane. I saw
the departing vets getting on board after a
year in country, and I thought, "Oh, shit, will I
look like that in a year?"

I went to Xei An with the Big Red One –
infantry. This place is crazy, and I'm in it: the real
and the imagined begin to blend together . . .
in a guard tower, a rocket misses me by a foot
and kills somebody else. Luck? Fate? Who
cares? Sorry, fella.

A friend got burned alive – did I see it?
I felt it. I was in the MASH unit drinking beer
with my commo trading buddy when he was
brought in. Looked like a charcoaled potato
with pink cracks in his face and a black hole
that talked. We all agreed that he was dead –
me, my buddy, and the burned guy. He died
on a plane to a hospital in Japan. A priest says,
"Godsway"; fuck him. Pull in a little deeper.
See some rotting natives. Were they VC?
Must be – we pick up our own parts quicker.

Keep observing; nobody would believe
this; it is a nuthouse run by the inmates. There
are pretty lights in the sky at night – on the
other end of them, somebody is dying.

I extended my tour in country to get home
sooner; I didn't think I could take the Stateside
Army, so I played Russian roulette a little
longer, thinking, When I get HOME I'll be free
of this madhouse.

Home – it's over – a plaster ceiling, lying
on a couch . . . they are still over there, the
others. I didn't get killed, so am I a quitter?

I watch the movie *M*A*S*H* and laugh in
all the wrong places.

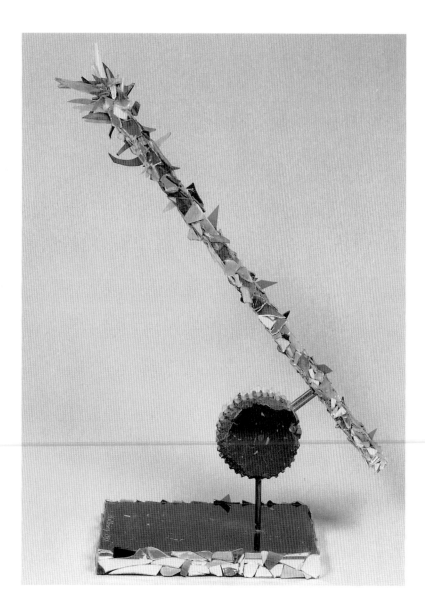

78 *Club of War: Ain't It Pretty, Don't You
Want to Swing It?* 1981. Steel, marble,
mirror, and glass, 27 x 12 x 6¼ in.

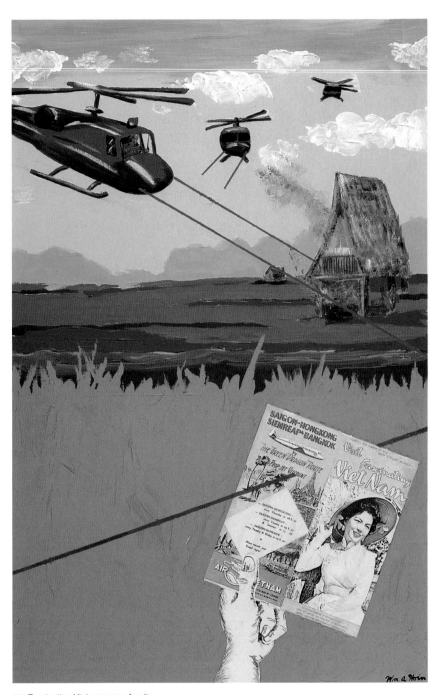

79 *Fascinating Vietnam*. 1977. Acrylic
on canvas with printed-paper collage,
33¼ x 22½ in.

Before I went to Nam I was trained as an
industrial-arts teacher at Millersville University
in Pennsylvania. Drawing was always some-
thing that I did as an avocation, or for fun.
While in Saigon I started carrying a sketch
pad with me and would draw street scenes,
just to maintain a sense of reality about my
situation. Amusingly, street children often
gathered round to see what I was doing. They
would greet me in French, though many could
speak English. I guess they didn't see Ameri-
cans as being very creative. I gave many of
my little drawings to them.

 I suppose this encouraged me to become
more involved in fine arts, as an artist and
teacher. I even developed a keen interest in
oriental art. The painting *Fascinating Vietnam*
I believe has some of the philosophies of yin
and yang that I observed in Vietnam. While
there was a great amount of beauty to be
seen, it was tempered by the events of that
time and place. The mixture of materials and
ideas in most of what I try to create has this
dichotomy.

On guard duty at Davis Station, Tan
Son Nhut Air Base, Saigon, 1963

William Hoin

Born Lancaster, Pennsylvania, 1939
Served in Vietnam, Army Security
Agency, 7th Radio Research Unit,
Saigon, radio monitor in communica-
tions security, 1963–64

80 Letters home. 1966–67. Ink and colored pencil on paper, dimensions variable

In Vietnam, March 1966

I started drawing on the envelopes of letters home on the way over to Vietnam, or just before I left Stateside. I drew the pictures to amuse myself and pass the time, to illustrate the topics of my letters, and to convince my family not to worry about me by injecting some humor into the overall situation. I wanted also to make up a scrapbook of my experiences in country.

Frankie J. Howery

Born Chicago, Illinois, 1943
Served in Vietnam, Air Force, 366th
Field Maintenance Squadron, Da
Nang, aircrew egress systems
technician, 1966–67

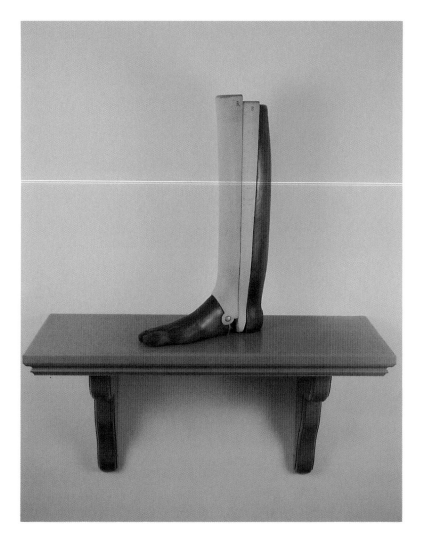

81 *War Trophy.* 1993. Carved poplar boot last with wooden shelf, 33 x 22 x 11 in.

In civilized cultures there has always been an ambivalent relationship between soldiers and the society they serve. A British verse sums it up:

God and the soldier, we adore
In time of danger, not before.
The danger's past and all things righted,
God's forgotten and the soldier slighted.

I suppose that "slighted" understates the case for the Vietnam veteran. Our reception by American society upon our return from Southeast Asia was less than hospitable and often openly hostile. Suppression became our natural coping mechanism; we never spoke *of* the war, we only spoke *around* it, if indeed we spoke at all. But the experience of going to war begs for release in some form and the suppressed emotions will surface in one way or another. In my case sculptural images are sparked by the war experience;

they arc across the minefield of memory like tracers. They hold me hostage, controlling my waking and sleeping hours, until I am compelled to deal with them. Sometimes the art flows effortlessly, like whistling. Usually not.

Some images never do coalesce. I work and rework them and still they remain ephemeral visions, like those from my other life as a soldier . . . those moments when we assembled before the beginning of morning nautical twilight, trying to find our way into the known. Now, years later, images form and reform out of the mist of what was reality, steeped in a quarter-century of impure memory. They tease and nag. They ebb and flow. What triggers them and what solid states they will ultimately take, if any, remain a mystery even to me. When a sculpture emerges, I am as astonished as anyone. If nothing lasting develops, the journey through the minefield transforms me nonetheless. At times we need to tell the story simply for the sake of the telling.

At Ban Me Thuot, 1964

Ken Hruby

Born Fort Mead, South Dakota, 1938
Served in Vietnam, 3d Battalion,
44th Infantry Regiment, 23d Infantry
Division, and 23d Ranger Battalion,
Army, Advisory Team 44, Ban Me
Thuot, Tuy Hoa, Quang Ngai, Central
Highlands, and coast, II and III Corps,
senior battalion advisor, 1963–64

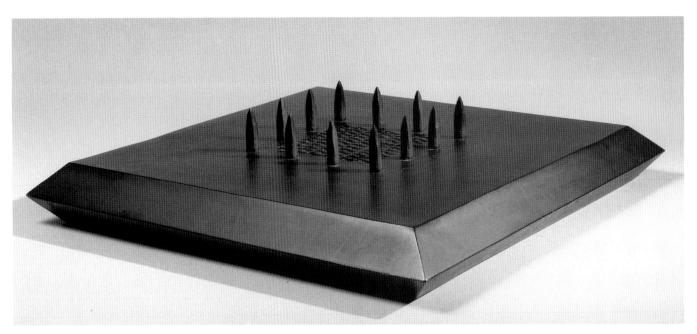

82 *Prairie Piece #14: For a Foreign Prairie.* 1983. Forged and welded steel, 5½ x 23¼ x 23¾ in.

Stateside, basic training, spring 1969

Meredith Jack

Born Kansas City, Kansas, 1943
Served in Vietnam, Army, 369th Signal
Battalion, Tan Son Nhut Air Base,
Saigon, fixed-station facilities controller,
high-grade communications, 1969–70

I regarded the whole Vietnam situation as a geopolitical mistake and I question my own participation in it. I don't have any horror stories or humorous anecdotes of the war: I was one of the seven people who supported every fighting man in the field and my memories are of dullness and lethargy, doing a job that would probably have been quite interesting in better circumstances. I worked in high-grade communications, the military equivalent of AT&T.

During 1969 and 1970 I was not an artist, though I had been one before and would be one again. I was a 32D20 assigned to the TSN detachment of Company A, 369th Signal Battalion, RVN. It was good duty and drew good pay; it kept me safe and busy. I had some access to art supplies from Saigon bookstores and I could draw. I had allowed myself to be drafted, trained, and assigned without much active intent; I had felt dimly that I would be missing something if I didn't go, and when I got my draft notice in my last semester of graduate school, though I was closer to Canada than Kansas, I packed up, went home, and accepted what seemed inevitable. I still wonder if I made the correct turn when I got on

the highway and to this day my feeling is one of sadness; I grieve for those who died, or worse. I question the sanity and integrity of those who sent us there.

I had known before I was drafted that I wanted to make art; others found their way into art after Vietnam. *For a Foreign Prairie* is about the quiet after. In format and proportion it refers to the similarity between the prairies of the Midwest and the rice-producing area of Vietnam where I was stationed. The forged spikes are similar to missiles, bombs, bullets, pungee sticks, and other implements of destruction. They surround and hopefully protect the rows of grave mounds – I'm not sure whose. War and art share some attributes. Some vets have never really returned from Vietnam; some are still traumatized by the horrors they witnessed or the wounds they received; some miss the exhilaration of living on the edge. If artists are truly doing their job they take some similar risks, exposing to public view their innermost concerns and feelings. They too must put themselves in harm's way and live on the edge.

Mama San

As convoys came over the Hai Van Mountains from Quang Tri and Hue south to Da Nang, they would become strung out and stop for stragglers. One routine stopping-point at the south end of the Hai Van Pass was the roost for several enterprising ladies who sold their wares to the drivers.

I was taking photos of the drivers when this fortyish woman came into view. As I snapped a shot of her she broke into a knowing grin and pointed at me. She said something to the other ladies that I could not understand, but that was plainly a joke, sending them into gales of laughter. I've always had the feeling that the joke went something like this: If you're so rich, how come you're not smart?

Although we had our cameras, our guns, our airplanes, our filter cigarettes, wealth beyond comprehension, we lacked the simple wisdom to observe the obvious fact that, beyond any shred of doubt, we were going to lose the war.

The camera does not blink, does not care, does not forget, does not interpret, does not impose philosophy or sophistry on the subject. These images are neither better nor worse than How It Really Was. In time, because we're all getting "short," all personal memory of this war will be gone, but these unvarnished images will remain.

83 *Mama San.* January 1971.
Photograph, 10 x 8 in.

"With an Easter present from Charlie: a booster from a 122mm Russian rocket, detonated at Tam Ky, killed one, April 1971"

Richard Hyde Jack

Born Newport, Rhode Island, 1947
Served in Vietnam, Army,
Headquarters, USARV, Da Nang,
combat photographer, 1970–71

84 *The Young Rascals.* July 1968.
Photograph, 4 x 6 in.

Art Jacobs

Born Lawrence, Massachusetts, 1946
Served in Vietnam, Army, 15th Medical
Battalion, 1st Air Cavalry Division,
Quang Tri, Dong Ha, and Khe Sanh,
Medevac helicopter pilot, 1967–68

From a letter, July 1968:

LZ Sharon, 158 days to go.
This picture will probably haunt me for a long
while. It was taken at just after 7 P.M. We had
been flying almost nonstop since 4 A.M. We
picked up almost 100 wounded today (and 20
killed, including a gunship crew shot down
the day before). Dad, we are nothing but a
bunch of scared kids being 40-year-old men.
I'm the oldest one in this picture at 21 [far
right]. That's Walt, my copilot, on the far left
(we call him Lt. Fuzz). We are pretty cocky
because we think we're good at what we do.
I suppose the bravado gets us through the
day, but every night I feel like a zombie.

Dad, I shake when I'm alone because
before each mission they all look at me like I
have all the answers. If they only knew how
many times their "hotshot" aircraft command-
er was guessing about whether to zig or zag!

In my performances I transform myself into a sculpture that is both aggressive and adaptive. I wear an irregular lattice composed of locally found sticks, cord, tape, and occasionally foam rubber; my body is generally covered with mud. I have appeared with this structure in galleries and museums, on the street and in subways.

I also make *War Drawings,* a series of two-dimensional games played with pencil and erasures, most often on paper, though I've done variations on painted wood, fabric, and plastic surfaces. I draw x's and dots, black tanks and white ones. The x-men and dot-men fight each other for domination of the maze in which they live. The troops are moved – or killed – when they are erased or redrawn. The remaining ghost image becomes a history of their movements.

Excerpts from *Rat Piece,* 1976:

vietnam dong ha marines it's summer time 125 degrees heat sweat like pigs work like dogs live like rats red dust covered everything

celts druids or priests great festival once every five years colossal images of wicker work or of wood and grass were constructed these were filled with live men cattle and animals of other kinds fire was then applied to the images and they were burned with their living contents . . .

north viets would hit us with rockets artillery and mortars we would jump in our rat holes we lived in a constant state of tension anger there were no hamburgers or ice cream only occasional warm beer or coke . . .

vietnam dong ha marine corps our camp covered with rats they crawled over us at night they got in our food we catch them in cages and burn them to death I remember the smell some enjoyed watching the terrified ball of flame run . . .

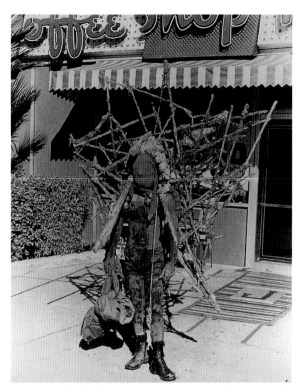

85 The artist performing as Mudman: *Wilshire Boulevard Walk,* Los Angeles to Santa Monica, 18 miles, 12 hours, sunrise to sunset, January 28, 1976

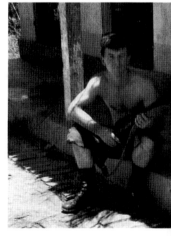

At Dong Ha, summer 1967

Kim Jones

Born San Bernardino, California, 1944
Served in Vietnam, Marine Corps,
3d Battalion, 4th Regiment, 3d Marine
Division, Dong Ha, Camp Carroll,
and Khe Sanh, mailman and general
Marine activity, 1967–68

86 *War Drawing.* 1995–96. Pencil on
paper, 11 x 14⅛ in.

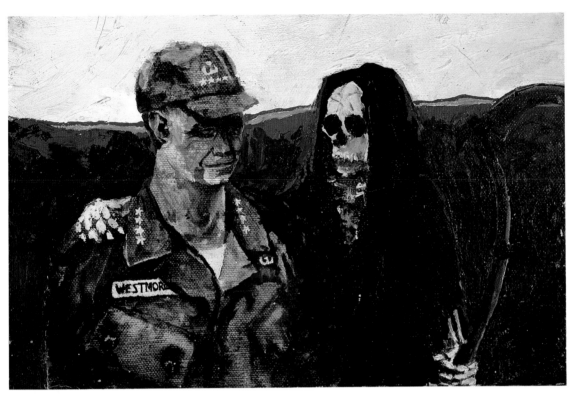

87 *Westy and Friend.* 1978. Oil on canvas, 7¾ x 11¾ in.

From letters, 1986 and 1995:

I remember the randomness in the scattered piles of spent shell casings that grew next to the M-60 machine gun that I was operating. There was an odd beauty in the golden, reflective heap of spent links and brass that would litter the edge of my position in the deafening silence following the firing of the M-60. I sometimes found myself transfixed during that lull, the air heavy with the pungent smell of gunpowder and cordite, surrounded by our deadly debris, mesmerized by the haunting, abstract beauty of the battlefield, yet unable to reconcile that vision with what I had really done.

What had I done? How much was a dream, how much reality?

Nui Ke was a real and very big hill mass that sat squarely between the west and south forks of the Perfume River, some fifteen kilometers south of Hue. The word "nui" means mountain in Vietnamese and "Ke" is just a name without another meaning, or so I have

Near Firebase Blitz, 25 kilometers southwest of Hue, around September 1, 1970

Michael Kelley

Born Van Nuys, California, 1946
Served in Vietnam, Army, 1st Battalion, 502d Infantry Regiment, 101st Airborne Division, west of Hue, Annamitic Cordillera, rifleman and machine gunner, 1969–70

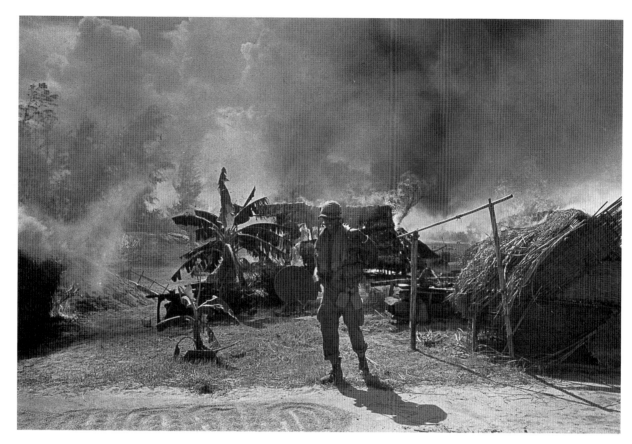

91 *Operation Land Clearing, 11th Brigade, Americal Division, Quang Tin Province.* 1970, printed 1995. Gelatin silver print, 13 x 19 in.

With the Americal Division, LZ Hawk Hill, 1969

László Kondor

Born Fugyiyasarhely, Hungary, 1940
Served in Vietnam, Army, 70-71 /
DASPO (Department of the Army
Special Photographic Office),
Americal Division, Chu Lai, combat
photographer, 1969–70

I was with a line company in an area called the Barrier Islands, a coastal plain with sand dunes wedged between the sea and the rice paddies. I was attached to an infantry squad with a machine gunner named Pineapple. Pineapple had earned his nickname because of the scars of childhood acne. He was short, squat, and bowlegged, and he was the pig-man. The grunts called the M-60 machine gun the pig and the man who carried it was the pigman. Pineapple was a good pigman. He carried the pig slung on his shoulder, from which position he could fire standing up.

The squad was walking along the sand dunes, checking abandoned enemy bunkers, when we began to receive fire from one. It was a lone North Vietnamese. For a while the grunts had fun with him: from behind the dunes they held targets up on sticks for him to shoot at. After a bit, in the heat, we had

had enough of that and began to flank his position. Pineapple covered us from twenty-five yards away. The company commander sent up the Kit Carson Scout to get the NVA to surrender. After a short exchange, first some ammunition, then an AK-47 rifle flew out of the bunker. Then the soldier emerged, wearing only a belt and a loincloth.

Everyone started hollering, "Hey, we got ourselves a real live dink!" I was excited. This was my first enemy face to face. So close! I had raised my camera when from behind me Pineapple opened up with the M-60. Rounds flew by us, hitting the prisoner in the face and chest, picking him up, so that he shook and wiggled obscenely, and dropping him. Just as suddenly the gun stopped.

After a stunned moment we started screaming, "What the fuck, Pineapple! Are you crazy? He was surrendering. He was unarmed. Why the hell did you kill him?" Pineapple walked toward us with a weird grin, saying, "This dink was not right. There was something not right about him." He kicked the almost naked body over. Two hand grenades were jammed in the soldier's belt, with wires running from the pins to his wrists. By raising his arms to surrender he would have killed us all, and died himself. What kind of enemy was this? I was scared. That day I stopped calling them dinks. They were The Enemy or Mr. Charles.

Pineapple was nineteen and had been in Nam for a year. He could sense from twenty-five yards what I could not see from ten feet.

92 *LRRP Team Arkansas, 196th Brigade, Americal Division, Waiting for the Extraction Chopper.* 1969, printed 1995. Cibachrome print, 13 x 19 in.

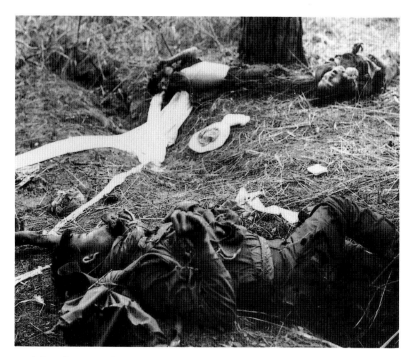

93 *A Curse Prayer.* 1968. Photograph, 4½ x 6½ in.

Poem accompanying the photograph:

I want the taste of all the tears
 shed in Vietnam
 on every politician's tongue
 I want the sight of all the blood
 to drown their eyes
I want all the pain
 to flow through their veins
 I want all the screams of agony
 sounded and stifled
 to echo in their ears
I want all the sorrow
 to visit them in their sleep
 and give them heart attacks
 if that doesn't put an end to it
 then maybe they're right

In Cheo Reo Province, 1968

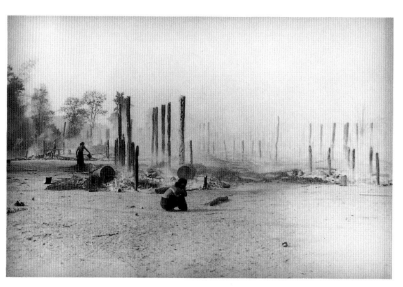

94 *Ceremony of Flame.* 1968.
Photograph, 4½ x 6½ in.

Poem accompanying the photograph:

The ceremony of flame
purifies a lifetime of possessions
into wisps of hazy smoke

Yet what's one village less
to the world
or a few tears more
to the sky

Jerry Kykisz

Born near Hanover, Germany, 1947
Served in Vietnam, Army, 1st Battalion,
35th Infantry Regiment, 4th Infantry
Division, and MACV Mobile Advisory
Team 55, Cheo Reo Province, Central
Highlands, platoon leader, 1968–69

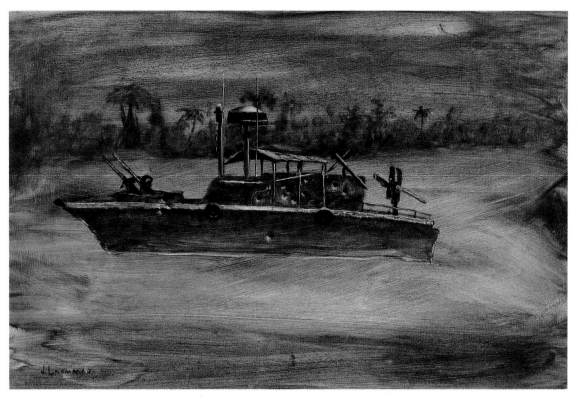

95 *Last Patrol.* 1997. Oil on hardboard, 16 x 24 in.

I know Vietnam happened, but I still have a hard time believing what I experienced. It was a time of extremes: good luck, bad luck, fear, anger, hatred, love, trust, betrayal, sadness, loss. Never wounded, but some of the pieces are missing.

Even today I find myself, in the middle of a conversation with someone, flashing back to Vietnam and then struggling to pull myself back to the present so I can appear somewhat coherent. In my mind I still spend time in Vietnam. I had a friend named "Boats," don't remember his real name — wish I did. He would help me study for the test to achieve a rank of petty officer. When he was killed in a firefight part of me went with him. I worked hard to stuff the feelings. They never taught us how to do that. I guess they figured we would learn that part on the job.

On the My Tho River in the Mekong Delta, November 1968

John Laemmar

Born Evanston, Illinois, 1948
Served in Vietnam, Navy, River Assault Squadron 13, My Tho, Dong Tam, Nha Be, Mekong Delta, 20mm machine gunner, later boat captain, mechanized landing craft, 1968–71

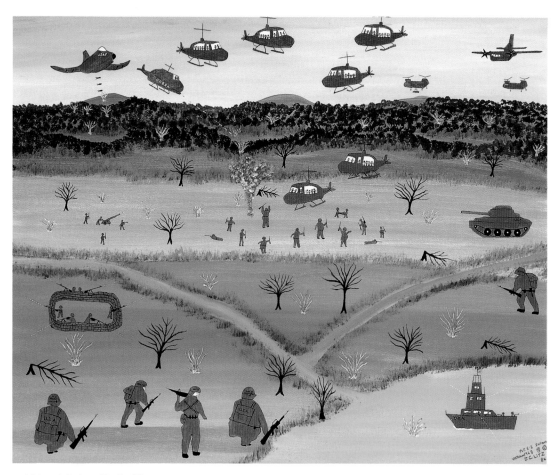

96 *Vietnam Infantry, 1968.* 1984. Oil on canvas, 23¾ x 29¼ in.

With Company D at LZ Santa Barbara, Tay Ninh Province, November 1968

James Litz

Born Buffalo, New York, 1948
Served in Vietnam, Army, 1st Battalion,
7th Cavalry, 1st Cavalry Division, Tay
Ninh Province, Central Highlands,
and Ho Chi Minh Trail, M-60 machine
gunner, 1968

I did not start to paint until I was thirty-three years old. I have no schooling in art. I am a self-taught or primitive or naive painter. I paint humorous, colorful, childlike paintings because I have no art education, and I began to paint because I never held employment after my return home from Vietnam, because I had trouble taking orders from people in an authority role.

My father told me to join the Air Force Reserves when I graduated from high school in 1967, but I did not want to be obligated to a six-year commitment to the Reserves. I took my chances and was drafted in 1968, into the company and regiment George Armstrong Custer commanded when he lost the Battle of Little Big Horn. I left Oakland [California] army terminal on my nineteenth birthday and arrived in Vietnam in the 1 A.M. dark. I remember they turned the runway lights on just long enough for the jet to land. I was processed and flown to the jungle to serve with an M-60 machine-gun squad, mainly along the South China Sea coast. I only served in Vietnam about three or four months. My entire time there was spent in the jungles.

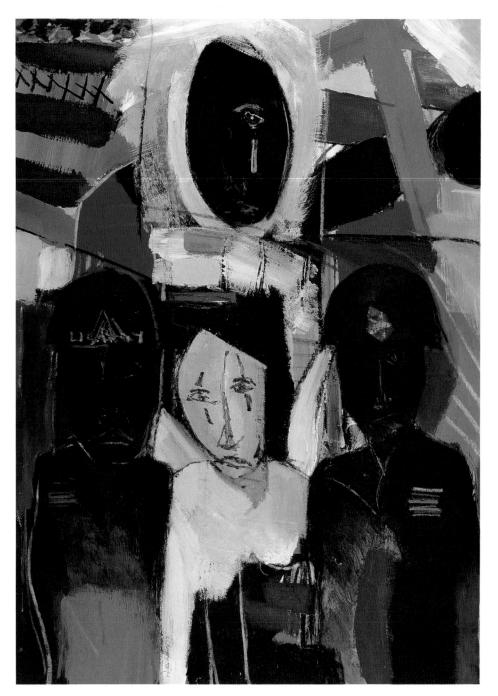

97 *Motherless Child.* 1983. Acrylic
and crayon on paper, 30 x 22 in.

In Vietnam, 1965

Ulysses Marshall

Born Crisp County, Georgia, 1946
Served in Vietnam, Army, 1st Battalion,
503d Infantry Regiment, 173d Airborne
Brigade, Bien Hoa, infantry light-
weapons specialist, 1965–66

Blue Angels is about a particular incident, a day in February 1965. We were on a search-and-destroy mission and got caught in an ambush; half the platoon was killed, some from friendly fire. I was wounded, and as my friend pulled me to safety, I had a vision. I saw angels with huge wings and long trumpets standing in the sky. I was thirty days to DEROS.

After I got home and began to paint, I wrote about the war as I had experienced it through the eyes of a nineteen-year-old black man:

Vietnam is a painter's illusion, a nightmare; a dream without an ending, forcing upon young men and women death and destruction.

Vietnam is a black man screaming in a strange world, fighting for a freedom he is yet to have.

Vietnam is a loss of dignity, identity, and pride. It becomes a struggle from within – from the hunting of human lives.

Vietnam is America, for in America black men continue to lose their lives. Bang!

Now I work with children who struggle each day to find comfort, friendship, and love. The Vietnam of yesterday is my tomorrow: to give hope to helplessness and meaning to determination. From a place where I was trained to take a life, today I try to save one. Vietnam is a dream deferred, a place where I found and lost myself and my friends. It is a place I have learned to forgive and to forget.

98 *Blue Angels.* 1983. Acrylic and crayon on paper, 30 x 22 in.

99 *Heroes.* 1983. Acrylic and crayon on paper with collage, 30 x 22 in.

100 *Artifact II.* 1979. Molded ABS plastic with paint and fabric, 48 x 25 in.

With a South Vietnamese civilian at Phuoc Mai Thu, January 1971

Brian Maxfield

Born Geneseo, Illinois, 1949
Served in Vietnam, Army, 1st Battalion,
27th Infantry Regiment, 25th Infantry
Division, and Headquarters Company,
2d Brigade, 101st Airborne Division
(Airmobile), Cu Chi, III Corps, and Phu
Bai, infantry grenadier and special-
services artist, 1970–71

For King
Gasping, legless
red smoke billows
where a man once stood.
Cover him with a poncho:
a finely wrapped package
for a young wife and child.

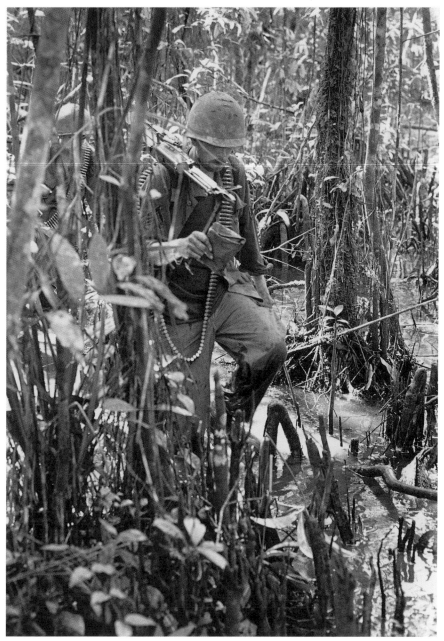

101 *Delta Grunt* (IV Corps). 1970. Silver
gelatin print, 20 x 16 in.

In an abandoned Viet Cong camp with
monkey skulls, remnants of a VC meal,
Long Kanh Province, III Corps, 1970

James N. McJunkin, Jr.

Born Sylacauga, Alabama, 1949
Served in Vietnam, Army, 221st Signal
Corps, with 1st Cavalry Division and
11th Armored Cavalry Regiment, Long
Binh Army Post, still photographer,
1970–71

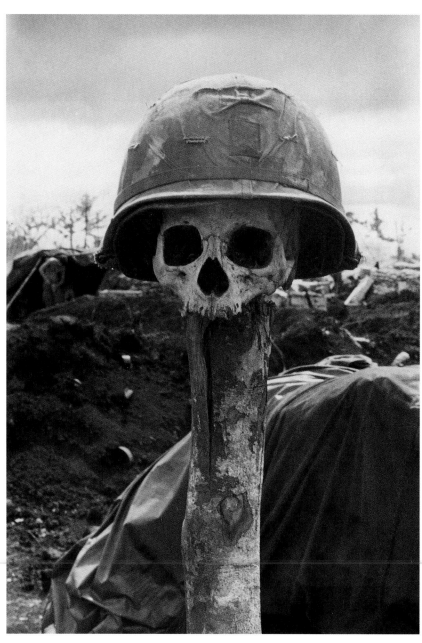

102 *The Sentry* (Firebase Bandit II,
III Corps). 1970. Silver gelatin print,
20 x 16 in.

From a letter, 1995:

I was there to photograph the U.S. Army
presence in Vietnam for the military media,
historical archives, and posterity. I was sta-
tioned at Long Binh, but I usually stayed on
firebases or with troops in the field, from II to
IV Corps. I returned to Long Binh for several
days each month to turn in film and pick up
new assignments.

On the firebases I photographed the
daily life of the troops and went on patrol with
units. Some of my assignments were vague,
like documenting the 11th Armored Cavalry
in III Corps, or had a narrow scope, such as
recording MEDCAP operations, in which we
offered medical attention to civilians, or doc-
umenting the barges that transported heli-
copter fuel up the Mekong River.

I was never anywhere long enough to
establish a real friendship. In the bush I was
with soldiers who lived and worked together;
I was always the new guy, the one who might
or might not be reliable. I remember liking it
when ARVN soldiers came along because
they were generally held in contempt; on those
occasions my status rose.

The Sentry shows one of a number of
skulls on stakes set around the camp at Fire-
base Bandit II – some had helmets and some
not. I'm not sure of their exact significance; they
seemed to be a mixture of warning, bravado,
and wartime decoration. The photograph of
boys hamming it up for the camera was taken
at Bear Cat. Children were my favorite sub-
jects, especially kids from the country, or small
villages. I don't remember too much about

103 *The Boys* (near Firebase Bear Cat, III Corps). 1971. Silver gelatin print, 16 x 20 in.

The Shrine, since I contracted malaria soon after taking it. I recall that we were on a convoy of landing craft on the Mekong River that had picked up a load of helicopter fuel in the South China Sea. Going downriver, when the fuel bladders were empty, there was seldom any trouble, but on the return trip the barges were full and slow and they were almost always ambushed. On this particular trip some of the boats were damaged in an ambush and stopped at a village for repairs. Two of the men knew of an opium den nearby and asked if I wanted to take some photos of it. This photo was taken shortly after we visited the opium man, and it's a wonder it's in focus. This was the last photograph I made in the field. The significance of the shrine itself is a mystery to me.

When I think about Vietnam, I seem to be remembering part of someone else's life. Most of what I saw and did does not seem real. If it were not for my pictures, I could easily convince myself that I was never there.

104 *The Shrine* (near Vung Tau, III
Corps). 1971. Silver gelatin print,
20 x 16 in.

105 *Abandoned.* 1979. Alabaster and
bronze, 36 x 16 x 13½ in.

John McManus

Born Everett, Massachusetts, 1944
Served in Vietnam, 40th Signal Battal-
ion, 1st Signal Brigade, 267th Signal
Company, Bien Hoa, Song Be, and
Firebase Bear Cat, telephone lineman,
1966, 1968

The *POW* pieces started with my belief that there are still American POWs in Vietnam, China, Russia. I became obsessed with the blindfold: the idea of being bound and blindfolded.

During the 1968 Tet offensive, one night in Song Be the Viet Cong dragged a guy off – he was on a listening post on one of those foggy nights when you couldn't see the guy next to you. We heard his moaning over the radio and the rustling of the bushes. We were only a few hundred yards away and no one could help him.

We are blindfolded on this planet; we are unable to see what we do to each other. We are taught to see what we are told to see. When I found stone I found life itself; when I sculpt, I learn to see.

106 *POW* series. 1989. Left to right: *Pride*. Bronze with paint, 19 x 12½ x 7 in.; *Broken*. Bronze with paint, 14 x 13 x 5½ in.; *Death*. Bronze with paint, 10 x 12 x 7½ in.

107 *POW*. 1988. Alabaster and bronze, 37 x 19½ x 10¼ in.

108 *Cache.* 1982. Bronze, 17 in. high

Near Nui Loc Son, July 1970

James McNeely

Born Saint Paul, Minnesota, 1949
Served in Vietnam, Army, 169th Light
Infantry Brigade, Americal Division,
Chu Lai, squad leader, 1969–70

So much of the art of Vietnam veterans, created just after they came home, is full of pain and ghosts. I made my first sculpture twelve years after leaving Vietnam. The gesture of the soldier, who has just found an enemy cache, is one of victory or celebration; for me, it is the gesture of being one step closer to home.

109 *Falling Airman*. 1975. Oil on canvas, 60 x 48 in.

In the cockpit of a P-2 long-range reconnaissance patrol plane, on patrol over the South China Sea, 1967

My squadron made it through the war unscathed, but one of our sister squadrons lost two crews of twelve men each within one month at night over the water from missile fire. Only small bits of debris were ever found. I've often wondered if they were conscious during their fall into the sea. Were they reaching for the water to soothe their burning bodies? No one knows if they had parachutes on, but I always saw them with chutes streaming behind them, changing into futile wings that could not support or save them. We the survivors have as our highest obligation the remembrance of our colleagues.

Leo McStravick, Jr.

Born Monroe, Louisiana, 1943
Served in Vietnam, Navy, Patrol
Squadron 17, Cam Ranh Bay Naval
Base, low-level reconnaissance
pilot, 1967–68

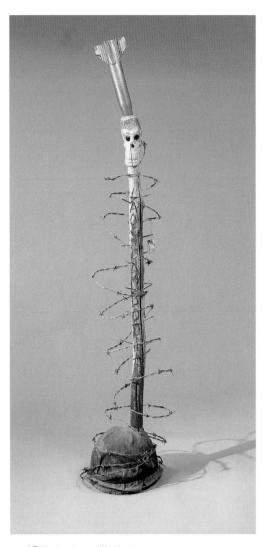

110 *LZ Hurricane.* 1991. Wood, wire,
helmet, and paint, 48 x 2 x 2 in.

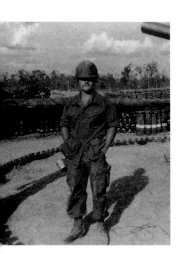

At Fire Support Base Ge La, 1969

Josef Metz, Jr.

Born Obersdorf, Austria, 1947
Served in Vietnam, Army, 8th Battalion,
6th Artillery, 1st Infantry Division, Lai
Khe, artillery crew member on 155mm
towed howitzer, 1969–70

From a letter, 1982:

My family immigrated to the United States
from Austria in 1957. I was in school until I
was drafted into the U.S. Army in 1968. All
through my school years, art was my favorite
subject and I always had an ambition to
become an artist.

In the army my duty station was Vietnam.
While there, I became a U.S. citizen. My expe-
rience in Vietnam was with the 1st Infantry
Division, forty miles west of Saigon. There I
spent a great deal of time at fire support
bases; my longest stay was at Firebase Ge
La. Other than being ill at times, I suffered
no permanent physical injuries. As for my
returning home, it was a joy. As for my fellow
countrymen, I wish they could have supported
us more respectfully.

My art works about Vietnam have been in
the making for some time. Their meaning is
difficult for me to state exactly: I can say only
that I have needed to express these emotions
concerning that period of my life. I would like
to feel that I have made a contribution in my
art for future generations of Americans, so
that they can have a better knowledge of what
one artist soldier experienced while serving
his country in Vietnam.

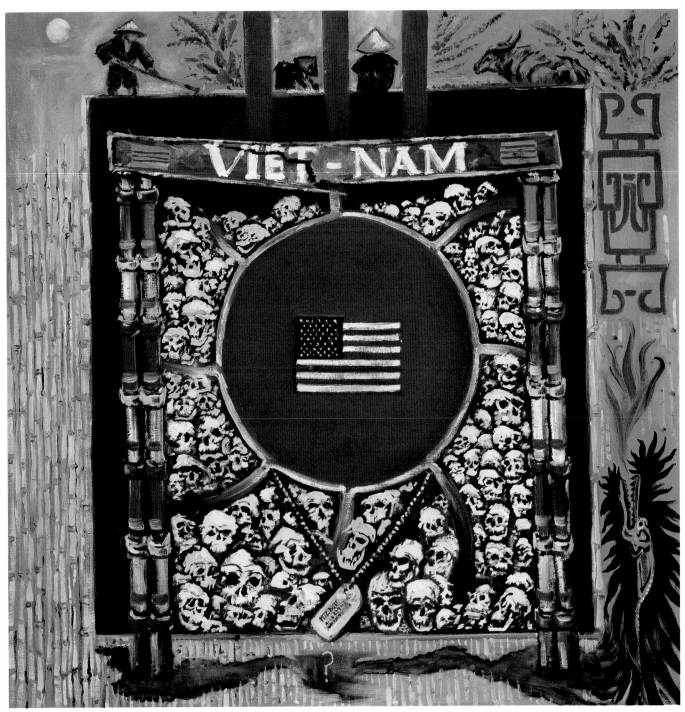

111 *Cycle of Nam.* 1982. Oil on canvas,
24½ x 24½ in.

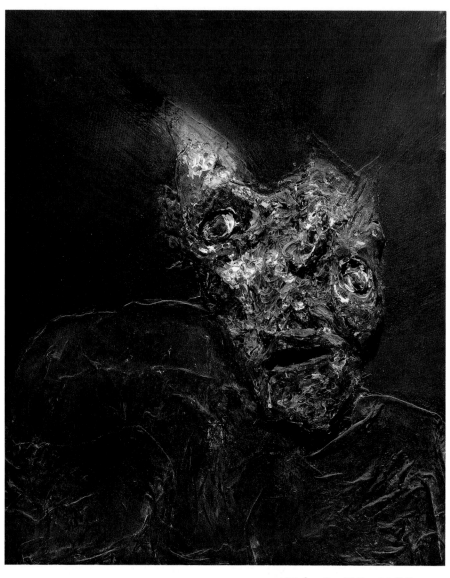

112 *Soundless Wailing.* 1975. Cotton rag and acrylic on canvas, 28½ x 23 in.

At Cu Chi, 1968

Karl Michel

Born Atlanta, Georgia, 1947
Served in Vietnam, Army, 25th Infantry
Division, 25th Military Intelligence
Detachment, Cu Chi, combat intelli-
gence officer, 1968–69

From a series of letters, 1982–86:

My interest in images of dead people no doubt has its roots in my Vietnam experience, al-though I had seen dead people before, when I worked as a nurse's aide in a hospital. When I got to Vietnam and saw my first freshly killed people – two North Vietnamese and one American – it hit me very hard, because then I confronted the seriousness of what I was involved in: I had developed the informa-tion that led to an assault on a North Viet-namese Army position. These people were dead because I had started a chain of events that led us to a point of confrontation. This occurred on my first operation there.

My job was to provide intelligence infor-mation to units of the 2d Brigade of the 25th Infantry Division. I worked out of Cu Chi base camp and covered an area northwest toward

113 *The Agony of Others*. 1994–
present. Acrylic on board,
20 panels, 40 x 30 in. each.
Collection of the artist

114 *Loomings.* 1983. Pastel on paper,
34¾ x 25¾ in.

ularly the smell of blood and cordite in the air. I am always interested that people see so much of the macabre in my images. I am cut off from this. It is almost as though I were immune – or perhaps I am just the messenger who doesn't know the content of his message.

Four years after returning from Vietnam, I experienced a series of hallucinations accompanied by a flood of images and sensations from that time and place. The visions of people's faces obscured by a whipped-creamlike mask were so powerful that I had to do something with them. I started drawing them as a way of giving them a more objective reality. I've been making art ever since.

Art mirrors my desire to create and destroy. For many years the technique I employed reflected this dichotomy. I would put the paint on and sand it off over and over again, until an image gradually emerged and was refined. As I worked and reworked an image, I felt that many paintings eventually became one painting, with one narrative. The idea of telling that story seems important to me, but I'm never sure just what it is....

I made *Loomings* in 1983. I see the brown and red form as the trunk of a body, or even the trunk of a tree that has been mutilated. The title, from the first chapter of *Moby Dick,* reminds me of the fear of injury that was such a big part of my life in Vietnam. I feared having my arms and legs blown off more than being killed. *Looming* means imminent possibility. It's like a pressure – the pressure of anxiety. Also, I was constantly exposed to the mutilation of other people's bodies. It was omnipresent; one had to become hardened to it. I can recall looking into the empty skull of an NVA sapper whose brains had been blown out. I found myself thinking of the aesthetic qualities of this image: the beautiful colors of red, purple, and violet. I guess *Loomings* is a reminder of those wounds to all those bodies: this one flayed trunk symbolizes that accumulated experience. I find that I have a very apocalyptic imagination; the whirling black face hovering in the upper right corner of the painting must have some connection to my sense of this darker side of life. It's a stylized skull and crossbones, signifying death or danger.

There is often a prejudice against art that is done out of necessity.

the Cambodian border. I went to Vietnam with a very romantic notion of what war was like. It didn't take long for all that fantasy to dissolve. I was shocked by the level of brutality, and it was even harder to accept when I found myself participating in it. I was involved in a lot of hostile interrogations where people were beaten and tortured. I saw myself and others behaving in a manner that was very incompatible with my idea of how American soldiers were supposed to act. This vision of our darker side has become the basis for my art – or at least a starting point. My work is intuitive, and I do not attempt to present literal Vietnam imagery. Instead, I am concerned with representing the emotional reality of that experience, with directness and intensity. There is an impulse to anesthetize this raw material in order to make it more acceptable, but I feel there is a certain dishonesty in that.

Are these people following me around now? I do know that I can never erase the memory of their mutilated bodies, and partic-

115 *Memory of War.* 1977. Bronze on
wood base, 19½ x 7 x 8¾ in.

On patrol in the jungle, 1969

John E. Miller

Born Charleston, West Virginia, 1948
Served in Vietnam, Army, 3d Battalion,
503d Infantry Regiment, 173d Airborne
Brigade, II Corps, Bong Son, Bao Loc,
and the jungles of northern South
Vietnam, grunt, 1968–69

From two letters, mid-1980s:

Soon after arriving in Vietnam, I was in the Tiger Mountains in the Highlands and participated in my first significant fight. We chased the NVA for several days, killing all those who were slower than we were. It felt good to chase and kill those guys, and many more — that is, until I returned home and spent the next ten years or so being haunted by what I had done.

During that chase I saw the person who eventually inspired me to create *Memory of War*. When I saw what was left of him, I puked. I saw him in my dreams for many years afterward. He was the first dead guy I had ever seen. I was part of the conspiracy that helped to make him dead. Before the army, I had been a hunter and was convinced that seeing a dead person would not bother me. I was very wrong.

The alphabet letters on the side of the head represent the dreams that he had once held for his future: a small farm . . . a wife . . . some kids . . . a water buffalo . . . living happily ever after. All gone. Just another dead gook with his brains blown out. Years later, after many, many sleepless nights, I wished I hadn't been there to help make him, or the others, dead.

Once, at an art show, I overheard someone say about my sculpture, "This is sickening." I was gratified because that's exactly what I want it to say: War *is* sickening and all it does is hurt people.

Woman in Grief is my ex-wife. Many of us came home, got married, and ended up with ex-wives. I wanted this sculpture to express the anguish suffered by wives and girlfriends of soldiers — the pain of never seeing or holding their sixty-thousand-or-so boyfriends or husbands again; the anguish when they did get their loved ones back, but couldn't understand or share their mates' on-and-off madness. The men they remembered were not the same and, sadly, would never be the same — not as they were before Vietnam scrambled their brains.

Many people suffered from Vietnam, but very few remember the pain of the women. Don't forget them.

I don't do art anymore and I don't think of Vietnam much anymore. I don't remember the names or faces of my comrades-in-arms — I wish I could remember them. But I do, finally, sleep well.

116 *Woman in Grief*. 1977. Bronze on wood base, 5 x 4 x 5 in.

117 *Mascot.* 1982. Ink on paper,
21¼ x 29¼ in.

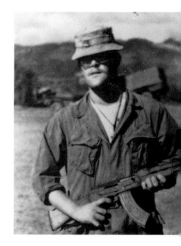

In Vietnam, February 7, 1969

Grady Myers

Born Roswell, New Mexico, 1949
Served in Vietnam, Army, 1st Battalion,
8th Regiment, 4th Infantry Division,
Dak To, Kontum, and Pleiku, light-
weapons infantryman, 1968–69

118 *The Toymaker.* 1982. Ink on paper,
29¼ x 21¼ in.

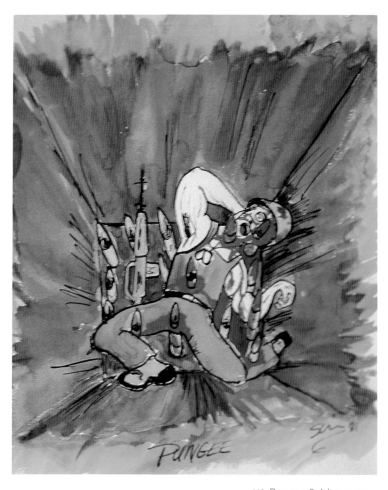

119 *Pungee.* 1981. Ink on paper,
12¼ x 11⅜ in.

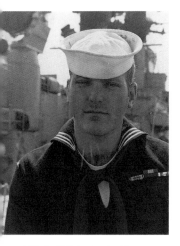

With the USS *England,* 1968

Scott Neistadt

Born Brooklyn, New York, 1947
Served in Vietnam, Navy, USS *England*
and USS *Halsey,* Tonkin Gulf, South
China Sea, sonar technician, 1967–69

A nursery rhyme:

War Games
These little pins are the markets
These little pins are the guns
These little pins have the power
And these little pins have none.
And these little pins are the people
　　who cry we we wee wee weee
All the way home.

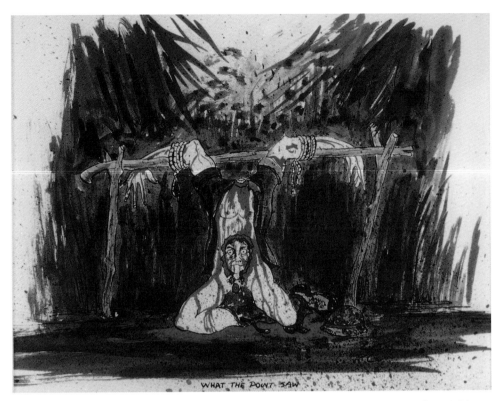

121 *What the Point Saw.* 1981. Ink on paper, 14½ x 16¾ in. Present location unknown

120 *Honorable Discharge.* 1981. Ink on paper, 14¼ x 16¼ in.

122 *War Games.* 1983. Ink, gouache, and
collage on paperboard with glitter,
wood, and brass, 27½ x 30½ x 18 in.

123 *Suoi Tre, Fire Support Base Gold.*
1995. Oil on canvas, 60 x 84 in.
Collection of the artist

I arrived in Vietnam in August 1967, about
five months after the battle of Fire Support
Base Gold, at Suoi Tre in Tay Ninh Province. A
sense of urgency and tension was still in the
air as Captain Bill Allison took over command.

Supply seemed limited. I was issued a
dented helmet, a rifle that did not function
because it had been damaged in a previous
ambush, no cleaning rod, and a flak jacket
obtained from a pile of used and discarded
equipment. As we used to joke, an all-
expenses-paid vacation to Southeast Asia.

Jim Frost, an eighteen-year-old buck
sergeant, was my squad leader. He had already
aged and looked older than me at twenty-
three. Sergeant Kay, a Korean War veteran,
was platoon sergeant. A thing that I noted
about Kay, Frost, and a number of others in
the company was their faces: they looked as
though they had not slept much and had a
haunted and glassy stare; I had seen that

At Nui Ba Den (Black Virgin
Mountain), December 1967

James D. Nelson

Born Beloit, Kansas, 1943
Served in Vietnam, Army, 2d Battalion,
22d Infantry Regiment Mechanized,
25th Infantry Division, Camp Ranier,
Dau Tieng; 18th Military Historical
Detachment, 25th Infantry Division,
Cu Chi, rifleman, 1967–68

look in a painting by Howard Pyle of a World War I soldier at the end of a trench, staring into the night.

Company C was equipped with tracks, armored personnel carriers with 50-caliber machine guns in their turrets. In the battle it had been the leading rescue unit that saved its sister battalion.

In the jungle I saw endless ambushes, firefights, land-mine explosions, and night patrols; we dug twilight foxholes that filled with water immediately in the constant rain. As I worked with them, I realized that the men I was serving with had witnessed hell itself: Suoi Tre, March 21, 1967.

This painting is a memorial to those I served with and to the American soldiers of the 3d Brigade, 25th Infantry Division, who, some dying, some surviving, took part in that engagement. After the war, veterans sent me their photographs and descriptions. I remembered what had been described to me by members of my company. My purpose was to create a chronicle of battle.

The battle took place in an oval clearing. Transported to Fire Support Base Gold by helicopter the day before were three batteries of 105mm howitzers and the 450 infantrymen of the 3d Brigade, almost all young draftees. The assault lasted four hours.

In the painting waves of North Vietnamese soldiers are overrunning the perimeter of the American firebase. There was a lot of hand-to-hand fighting. M-16 rifles jammed; at right a soldier is swinging one of these. Company B is in the foreground. A quad-fifty machine gun is being turned around by the enemy to be fired on the U.S. batteries. Lieutenant

Colonel John Vessey's howitzers are being leveled to fire at the oncoming enemy.

At least 2,500 seasoned North Vietnamese troops of the 271st NVA Regiment carried out the attack. Some of these are shown in the lower foreground, unleashing an unrelenting bayonet, grenade, and hand-to-hand assault, flooding even into the howitzer emplacement. Toward the end of the battle, American units were down to their very last rounds of ammunition.

I tried to capture the fantastically fierce defense by the inexperienced American troops, and have included at least fourteen portraits of actual members of Company B. The last-minute appearance of a come-to-the-rescue column of tracks and tanks is shown at left.

If the battle had been lost, the North Vietnamese and Viet Cong could have claimed a latter-day battle of Little Big Horn. A Communist victory, so desperately needed, would certainly have further dispirited an already divided and embattled American populace. It might have demanded that its army be withdrawn from South Vietnam, leaving North Vietnam and its Communist allies in control of the South without shedding any more blood. But the opposite took place. I have painted it in an *alla prima* style.

The numerically weak, inexperienced 3d Brigade defeated a much larger, more seasoned force. I try to honor and show what they had not taken into account: the still-surviving spirit, inventiveness, and valor of an American youth that — sometimes foolishly, but always bravely — took up the call to arms. Four hundred and fifty U.S. soldiers beat back twenty-five hundred Viet Cong and North Vietnamese, with thirty-one Americans killed in action and eight hundred enemy killed.

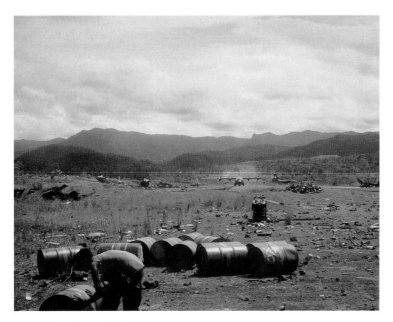

124 *MIA, KIA, POW, DOW.* 1970.
Color photograph, 12½ x 14½ in.

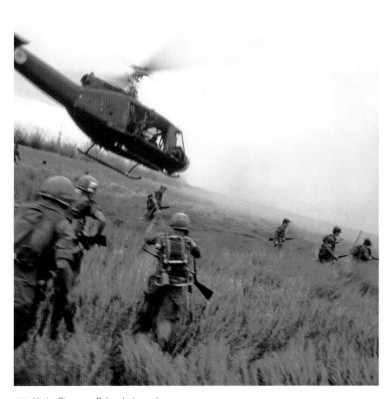

125 *Under Fire.* 1970. Color photograph,
14½ x 14½ in.

*M*emories of a Pilot
I remember:
Friends and enemies blown to bits before my face
Burning helicopters next to mine crashing to the ground
Bullets hitting my aircraft, the noise, the debris, checking
 for injuries, trying to stay aloft
Blood and guts spilling out while my crew struggles to
 save the lives of soldiers
The tension and chaos of jungle landing zones while
 bullets approach from all directions
The stench of bodies lined up on the ground, rotting in
 the sun for days
The hysteria of begging civilians I could not help
Deformed, scarred, and mutilated children
Rockets sent into villages declared as belonging to the
 enemy
Returning to base after spraying missions, my crew
 drenched with Agent Orange

I remember that it all seems like yesterday when we
 were young

At Cu Chi, May 1970

Gary Newman

Born Hinsdale, Illinois, 1946
Served in Vietnam, Army, 269th
Aviation Battalion, 1st Aviation Brigade,
Cu Chi and Chu Lai, warrant officer
and helicopter pilot, 1970–71

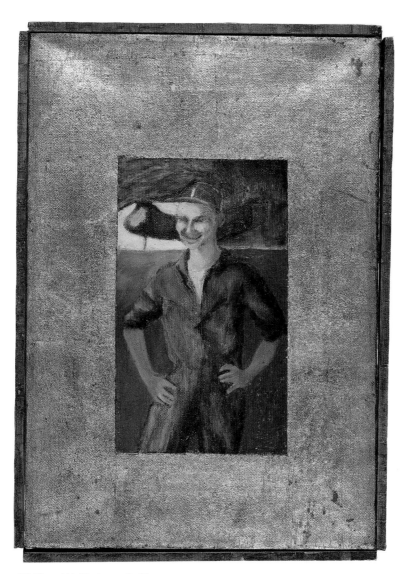

126 *Memorial to Tim Lang.* 1964. Oil and gold leaf on canvas, 10 x 7¼ in.

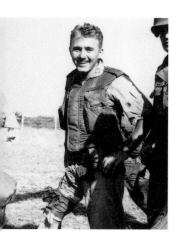

At Cu Chi, about twenty minutes after being wounded in the cockpit of his helicopter, January 16, 1963

Richard J. Olsen

Born Milwaukee, Wisconsin, 1935
Served in Vietnam, Army, 33d Transportation Company (Light Helicopter), Bien Hoa, helicopter pilot and flight leader, 1962–63

In the early years after the war I had to paint Vietnam in order to tell it. Nam became the only truth; the experience of the war became the authority to paint. After that all else paled; everything else became absurd, trite. After all, why paint unless you must? You must when you can put your whole self into it. My self-appointment as an artist was catalyzed or crystallized in Vietnam. Here was a world larger than one could imagine: a world far beyond my control. In such a world men are identified by what they do: by deeds and especially by courage. That medium – Teilhard de Chardin calls it the noösphere – became the air we breathed. D Zone ("D" for death) was the area of operations we flew into every day. We were enthusiastic about nation building, suppression of totalitarianism – I am speaking here of the early phase of U.S. involvement and the collective idealism of the Kennedy years.

As a pilot flying a helicopter, I read Ho Chi Minh's writings, and I understood that we were involved in a world process, not a local insurrection. That year in Vietnam, if it didn't kill me, would form the rest of my life, especially my life as an artist.

The helicopter we used then, the CH-21, was obsolete and hard to fly. It had been designed for the arctic, not the tropics. Flying it was a performance; it took a certain skill, daring, and a sense of the urgency of the mission; it had to do with functioning under tension. It had to do with expecting a surprise at all times. You were always thinking about emergency procedures, getting hit in the flight controls, the blades, the transmission, the torque tubes, about fuel running low, being over enemy territory, about where to go in a forced landing, returning to a friendly place. Everything at once. Like art.

Toward the last day of my tour I began to know that I had to stay alive in order to paint. Then and only then I began to feel the need not to get wasted – I began to feel awe and wonder at the miraculous experience of staying alive. I saw that the same sense of urgency I felt in Vietnam was needed for painting. Being a painter, one continues to live at that level of urgency. My paintings, drawings, and prints after I returned from Vietnam oiled the gears of my deep engagement in art, heightened and liberated my convictions about the war, and what art could be and needs to be. I felt, and still do, that in order to paint one must be inside life, death, so hard that everything is understood, dealt with, nothing left out. The idea, the urge to paint is clear, but the painting must make it on its own terms, visually, not verbally. All LZs are hot; art is hot, or it doesn't exist.

I came back to the United States and found the art of the 1960s, which was asking the question: How can you create unusual art? How do you set up the audience to expect one thing, and then ambush them with a surprise? Alan Kaprow was making the first Happenings and I know that flying a helicopter

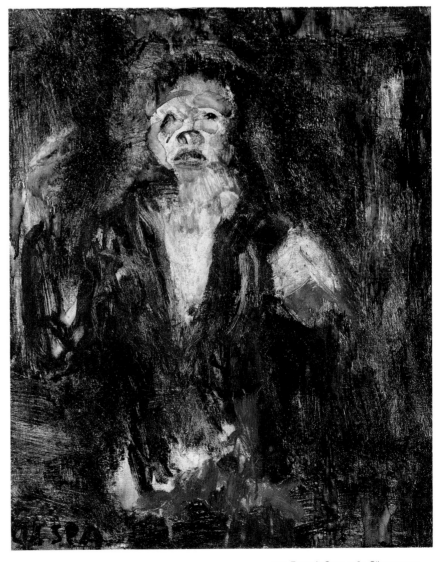

127 *Enemy's Grave.* 1964. Oil on canvas, 28¼ x 24 in.

in combat was way beyond, but similar to, the thing he was after: Vietnam was a Happening. The art that comes out of Vietnam is authentic; it has historical momentum; there is a history being made in the painting while it is being painted. It is a mark on the earth.

This art is THE. I want to make an art that is THE.

Enemy's Grave is a portrait of a Viet Cong soldier, missing an arm and the lower half of his body, staring up through the veil of the rice-paddy water with the universal stare of the warrior: death – why me? – could be you. The stare of the dead is not so different from the stare of soldiers when they come in from patrol: the red eye that has seen something. The red eye is truthful and knowing.

The little portrait of Tim Lang: Tim Lang was a raw-boned lumberjack from Spokane, just taking control of his life and becoming a man when 103 bullets sent his helicopter crashing into the trees somewhere en route to Tay Ninh. It was the last week of his tour. I made it small and gave it a border of gold leaf because it is a little shrine, like an icon; I was using twelfth-century thinking to make a traditional kind of memorial art to my friend.

Early Morning Visitation is about Viet Cong–organized terror activity in rural South Vietnam. It depicts a village chief's head on a stake; he had not complied with the 2 A.M. demands of a gang of Viet Cong: "Give us your fish, rice, taxes, hiding places, your toughest youth. . . ." The trophy head was always set on a stake in the middle of the village to greet the villagers first thing in the morning. With this painting I was thinking of Goya, of Francis Bacon: I aligned myself with tough painting, which is what I was thinking my art had to be. I had the urgency to say something. Vietnam became my painting statement. Later these earliest paintings were an embarrassment to me, a nuisance to be hidden, part of learning to paint. Only much later still did they seem part of the fabric of my life, worthwhile.

I can't get Vietnam out of my system. I couldn't get rid of it even if I painted flowers.

128 *Early Morning Visitation, Compliments of the Viet Cong.* 1964. Oil on canvas, 37 x 29¼ in.

129 *Cong: Kill 'Em.* 1964. Asphaltum and gouache on shellacked paper, 17¼ x 11⅜ in.

130 *Blood Spots on a Rice Paddy.*
1976. Acrylic on paper, 11½ x 11¾ in.

131 *Wall LXXVIII.* 1992. Oil on linen,
98½ x 126 in. Collection of the
artist

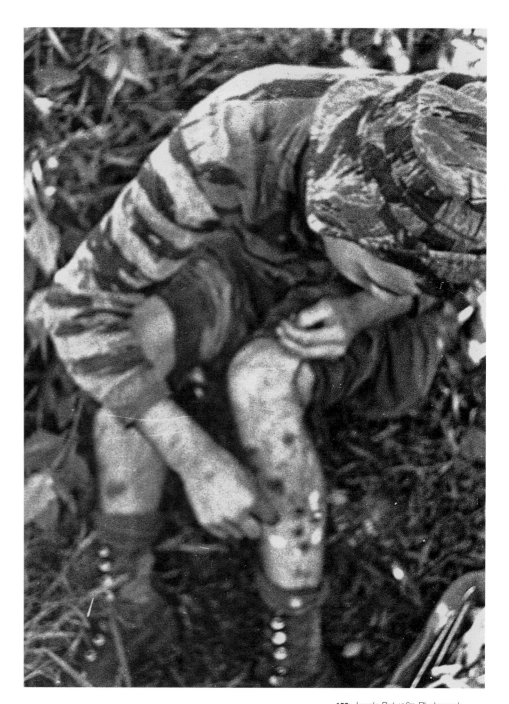

132 *Jungle Rot.* 1967. Photograph, 38 x 28 in.

Chip [Paul Owen] on a burning hillside, Vietnam, 1967. "We were resting on this burning hillside (mountaintop). There must have been napalm bombing not long before we arrived. It was surreal, like being on another planet."

Paul Owen

Born Saint Paul, Minnesota, 1946
Served in Vietnam, Army, 2d Battalion, 327th Regiment, 101st Airborne Division, Da Nang, M-60 machine gunner; Central Highlands and Cambodia, LRRP point man; Phu Bai, Chu Lai, and around Hue, map and overlay draftsman, 1967–68

I had been sent to Da Nang for psychological warfare training. I was not interested in the training and remember little of it, though I did make some art work – I drew the face of a tiger for a propaganda leaflet to be air-dropped on the Vietnamese. Supposedly the Vietnamese feared the tiger, a symbol of a stalker that is silent and always present.

I was housed in a hotel. It seemed very quaint; the architecture was French, small and old. It was near the time of the Tet holiday, when there was usually an offensive by the North Vietnamese. There were sandbags, concertina wire, and a machine gun on the roof, just above the entrance. I was amazed at how comfortable we were there. For months I had been sleeping on the ground or in a hole I dug, and now I had a real bed in a building. The soldiers there even had music.

I first saw Lan at a ferry crossing on the Mekong River, playing with some other children. She was a beautiful child, with large, alert eyes that looked directly at me. I had been in Vietnam for six months but had had no opportunity to talk with people. Here was a young girl who spoke English, so I tried to speak with her. An MP appeared and chased the children away. He said that sometimes children were used to carry hand grenades because they could get close to the GIs.

One evening, a couple of days later, I was sitting in my room when a soldier stuck his head in the door and said, "Someone is at the front door, asking for you." I was confused and thought it was a mistake. How could someone possibly know me here?

When I got downstairs, I saw Lan. Later, I discovered that her family lived not far away and she knew all of the GIs stationed at the hotel. I remember how she stood on the curb while I stood in the gutter. She straightened my uniform and asked me to come meet her father. She took my hand and pulled me into

a run, saying, "We hurry, don't let MPs see us." She led me through the streets and down a narrow walkway among closely crowded houses to her home, where she introduced me to her father and baby brother. We sat at an old wooden table and talked. She asked me for a photograph of myself. I gave her the only one I had: an old high-school graduation picture in my billfold. She pulled out a worn cigar box and gently placed it inside. The box was filled to the top with pictures of other GIs. The memory of that box of pictures has remained with me to this day, a photograph in my mind. I never saw her again. Days later I was back in the bush.

Jungle Rot: In the jungle our cuts and scratches became infected and turned into painful sores. We called these jungle rot. At one time, when I was point man with the LRRPs, I had bandages on both arms from wrist to elbow and both legs from ankle to knee.

Ambush with Cord: The radio we carried was our only contact with the outside world. The radio cord, which crosses the frame, was our umbilical cord.

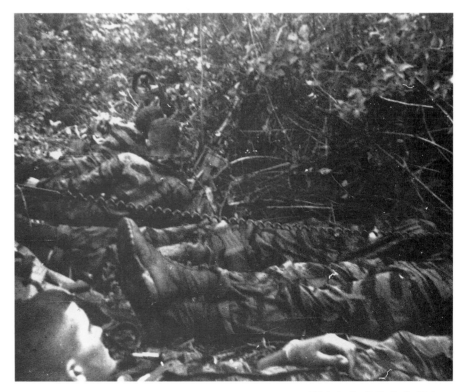

133 *Ambush with Cord.* 1967. Photograph, 28 x 38 in.

I've always found history and tradition inter-esting and important, but writing something meaningful about Vietnam is difficult. Like a lot of guys, I tried for years to get it under control and understandable, and then I resur-rected it.

Art saved my life, in a way. I was stand-ing in front of a mirror, trying to figure out how neck muscles worked, for a sculpture, and I felt a lump. It was cancer . . . when the sur-geon did a biopsy, he couldn't find it; I had to guide his hand to it. At any rate, that made me believe in some kind of magic – if I didn't believe in it before – and talking about art is something you have to be careful about, because you're fucking with magic. . . .

It's easy to write an artist's statement normally, if you're good at bullshitting, but the trouble with writing about art and Vietnam is that that's where a lot of us learned that bullshit can kill people. It took me years to relax and accept mediocre work from others because I kept seeing it in terms of life and death. . . . I went to Vietnam in August 1967. I was a platoon leader in a combat engineer battalion. This service included the Tet offen-sive of 1968 and combat operations as well as support. . . .

When I came back from Vietnam, my mother didn't say anything to me, but my brother told me later that she had had a big map of Vietnam and every time she got a letter from me she found the area I was in and marked it – probably the same thing she did for my father in World War II. I think it's a kind of magic some people do. . . .

The Pietà was based on a photo I saw of a young Marine at Khe Sanh. The face and pose reminded me of a Madonna, except that it was a young man. I was trying to show the pain and grief felt by young men in that situation, without missing the strength and compassion that were also present. . . . I always said that after those first few art works I wouldn't do any more work about Vietnam, but of course that wasn't true. I find it's still lurking there in the background, but now it's mixed with a lot of other things. . . .

This morning in the garden I cut some of my roses and took them to give people at work. It makes the fluorescent lights and soul-deadening corporate crap easier to deal with when you can look at something as beautifully formed and as real as roses. I swore in Vietnam that I would grow roses like my grandfather did, and everywhere that I've lived that I could do it, I have. Now they are more a link to him than they are to Vietnam.

Near the banks of the Dong Ngai River, 1968 (Page is at left)

Michael Page

Born Albuquerque, New Mexico, 1944
Served in Vietnam, Army, 168th Com-bat Engineer Battalion, operating with the 11th Armored Cavalry Regiment and 1st Infantry Division, III Corps, combat engineer, 1967–68

134 *The Pietà*. 1980. Walnut, 24 x 17 x 13½ in.

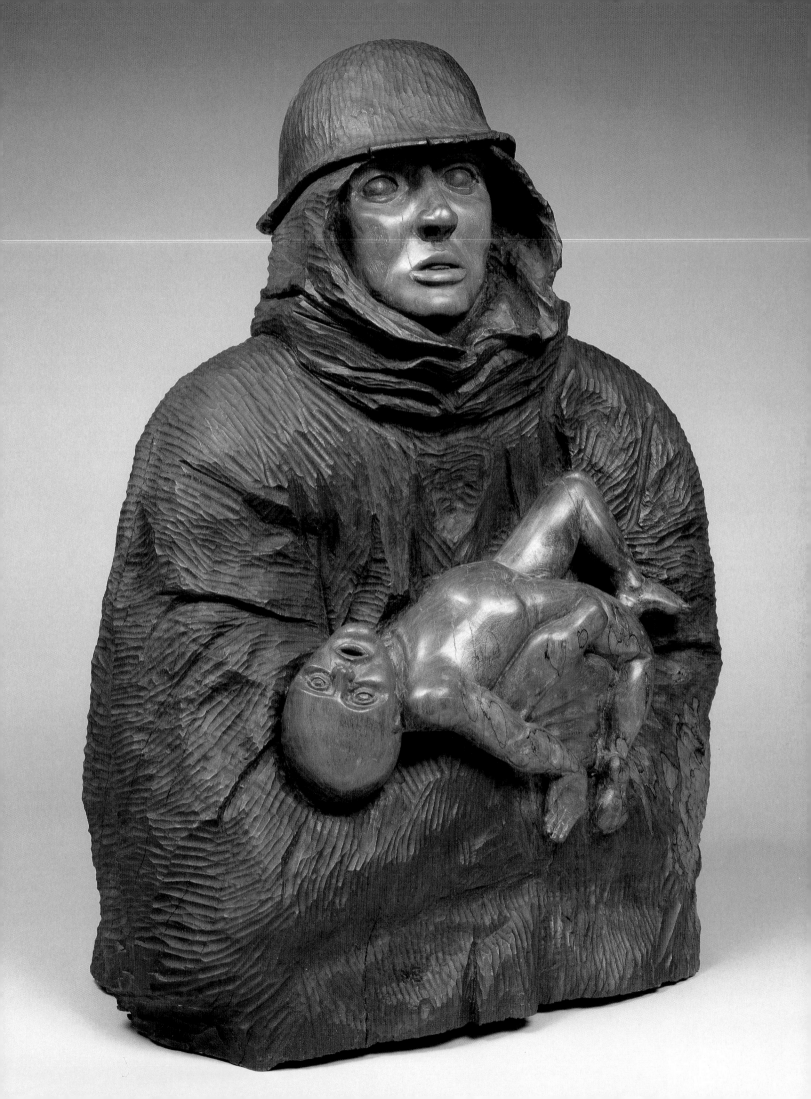

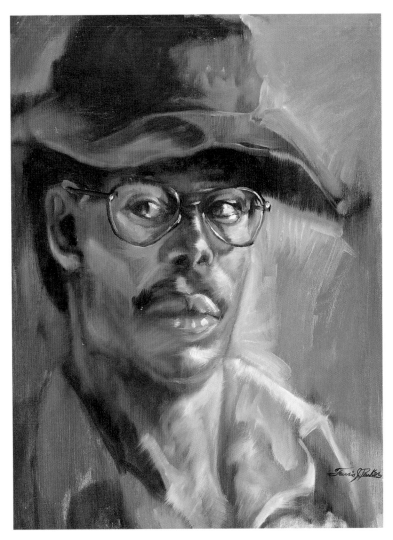

135 *Self-Portrait.* 1978. Oil on canvas,
24 x 18 in.

With the dog Sergeant at McChord Air
Base, Tacoma, Washington, Christmas
1969

Farris J. Parker

Born Wrightsville, Georgia, 1948
Served in Vietnam, Air Force, 31st
Security Police Squadron, K-9 Section,
Tuy Hoa Air Base, sentry-dog handler
and trainer, 1970–71

From two letters, 1987 and 1996:

I began working on paintings relating to my time in Vietnam out of a desire to project flashbacks into images. I wanted also to share my experiences with others. The influences on my work are both political and personal: as an artist, a black American, and a Vietnam veteran I naturally have been concerned with these issues. When the question is asked, What did you do in Vietnam? my response is: There it is; look at it; check it out; the art speaks for itself, and for us. The subjects of my paintings are all small events; they deal with the day-to-day process of trying to survive under adverse conditions. The motivating sources of my work are more difficult to pinpoint: it is hard to recall memories and mixed feelings that I've worked so hard to suppress – moments that were intense, spontaneous, fleeting, jarring.

I started the Vietnam paintings some four or five years after I left active duty. I can only assume it took that long for my mind to decipher information and put it into concrete images. Vietnam memories last forever; the slightest stimulus projects me back, in country. I can still tell by sound the difference between a Huey and any other kind of helicopter, especially at night.

Children Reaching and Playing is one of those small events. There were always local kids from Tuy Hoa around the base. GIs would throw c-rations over the perimeter fence to them. The perimeter was guarded and mined. Sometimes cans got caught in the fence and kids would come close to pick them out. Once a girl came too close and stepped on a mine and was killed. That event took place inside the barbed-wire barrier, where the mines were buried underneath the fence line.

Bombing Cambodia secretly, racial strife within the base – a lot went on on our side of the fence line. As a sentry, I patrolled the perimeter, mostly on night duty. I remember the fireflies and tracers.

. . . How do you measure bravery? The Viet Cong were willing to do anything. I remember seeing a U.S. helicopter laying down fire one night, and a lone line of tracer fire rising from the tree line: one guy was trying to shoot down the helicopter, even though the tracers gave away his position.

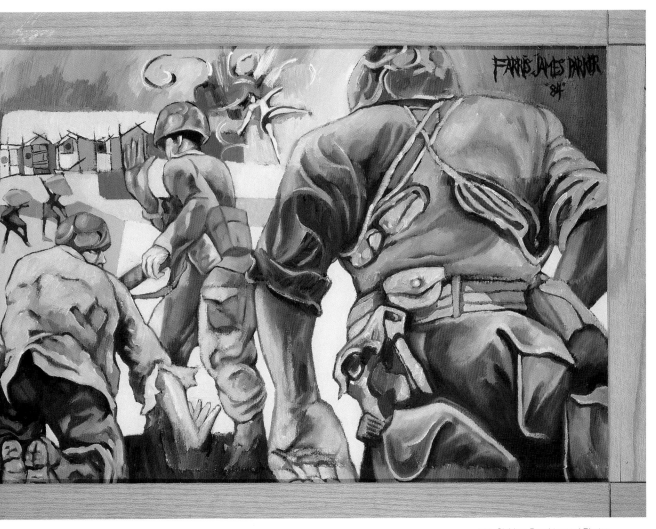

136 *Children Reaching and Playing:*
Canned Food in the Fence. 1983.
Oil on hardboard with burlap, canvas,
and wood, 25⅝ x 44⅞ in.

From letters, 1985 and 1995:

My feelings about the war, then as now, were intense and complex, sometimes contradictory. I grew old there, but that's not all; maybe that's the least of it. The war compelled me. I still think about it daily (though it's become something different than before); it shaped me in ways that I'm still discovering. I'm privileged to have it so.

There is a vast difference between the experience of a grunt and a door gunner, an engineer and a brown-water sailor. The Delta wasn't like the DMZ and 1965 wasn't like 1968. These drawings are of my war, in I Corps in the late 1960s and early 1970s. Some were mailed home in letters; others I carried with me; and I did still others back in the World. Although I didn't plan it, they now seem to me a record of that time: routine activities, sharp adrenaline rushes, small joys, death and fear and isolation. Drawing for me was a means of recording and relating what I was experiencing.

Gook Kid: "Hearts and Minds" is what we were supposed to think, but "gook kid" is what we saw. The younger ones liked to play; the older one cadged c-rats and set booby traps. Friendly villagers smiled a lot and bowed; hostiles were sullen. Those caught in the middle tried to be invisible.

In I Corps

R. D. Parks

Born Amarillo, Texas, 1950
Served in Vietnam, Marine Corps, 3d Battalion, 11th Marine Regiment, 1st Marine Division, I Corps, radio operator and forward observer, 1969–71

137 *Gook Kid.* 1970. Pencil on paper, 13 x 10 in.

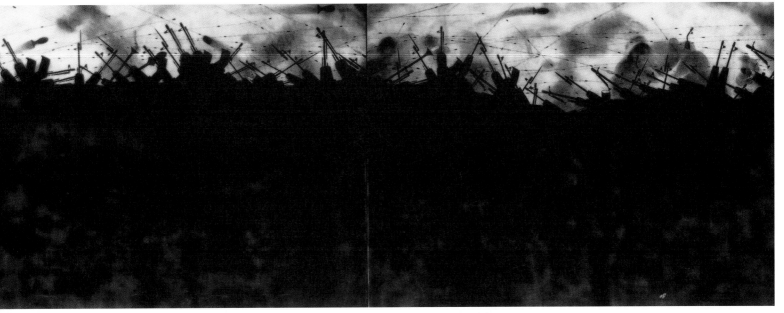

138 *Gimme Some of That Good-Time Lock and Load.* 1981. Graphite on canvas, two panels, 40 x 108 in. overall

From a letter, ca. 1983:

Our home base sat at the foot of the only mountain range for about a hundred miles. It consisted of two mountains: Nui Ba Den and Nui Ba Ra.

These paintings are from a diary that was written in my brain and in the brains of thousands of others, on a daily basis, in Vietnam. Some of the situations did happen to me; others were bad dreams, fears of what might happen, hallucinations; images that seemed to appear out of nowhere, for no reason.

It is through painting that Vietnam is now giving me and many others a new life. It is through art that we fight back, and it is through the eyes and hands of veterans that the truth is told.

John Plunkett

Born Oceanside, New York, 1948
Served in Vietnam, Army, 4th Battalion,
9th Infantry Regiment, 25th Infantry
Division, Cu Chi, Tay Ninh Province,
mud, rifleman, 1969–70

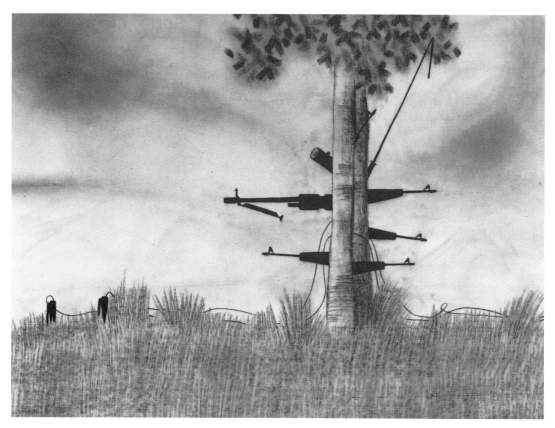

139 *Ambush Behind a Thin Wood
Line.* 1981. Graphite on canvas,
40 x 54 in.

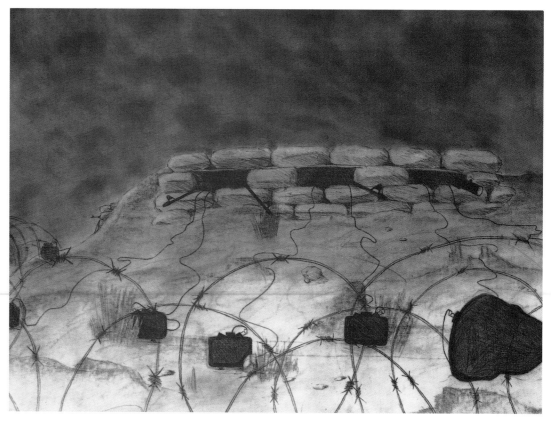

140 *Bunkers at Night.* 1981. Graphite
on canvas, 40 x 54 in.

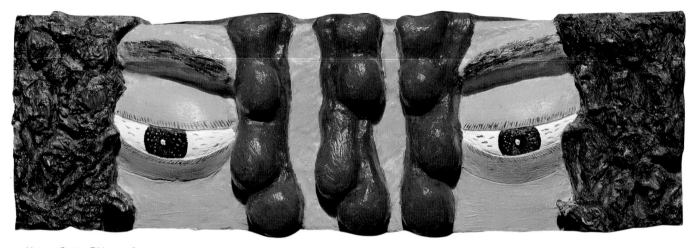

141 *Vietnam Service Ribbon.* 1976.
Alkyd and gesso on carved
cherrywood, 4¾ x 14½ x 2¼ in.

BELIEVING THE WORK SHOULD STAND
ON ITS OWN MERITS, THE ARTIST HAS
NO OTHER COMMENT.

At Tan Son Nhut Tent City B, 1967

Neal Pollack

Born Brooklyn, New York, 1945
Served in Vietnam, Army, 10th and 7th
Finance Sections (Disbursing), Tan
Son Nhut Air Base and Cholon,
finance clerk and M-60 machine
gunner, 1967–69

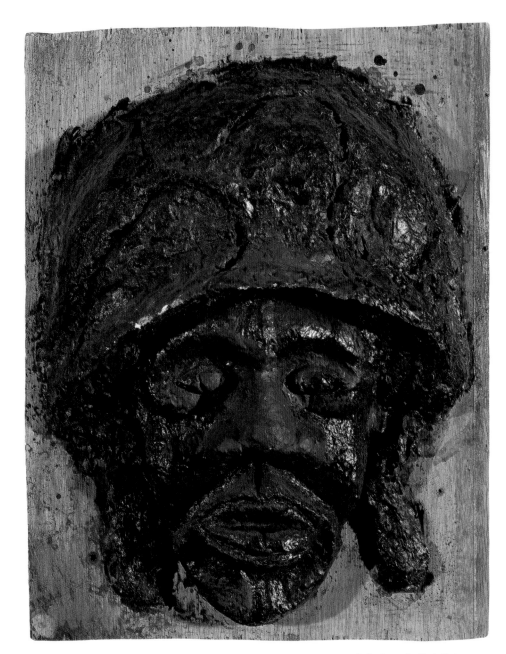

At Chu Lai, 1968 (Porter is at left)

142 *Reflections of a Black Vietnam Vet.* 1980. Papier-mâché and paint, 14 x 10¼ x 3½ in.

Leonard Porter

Born Marvell, Arkansas, 1945
Served in Vietnam, Army, 198th Light
Infantry Brigade, Americal Division,
Chu Lai and My Lai, grenadier, radio
operator, medic, 1968–69

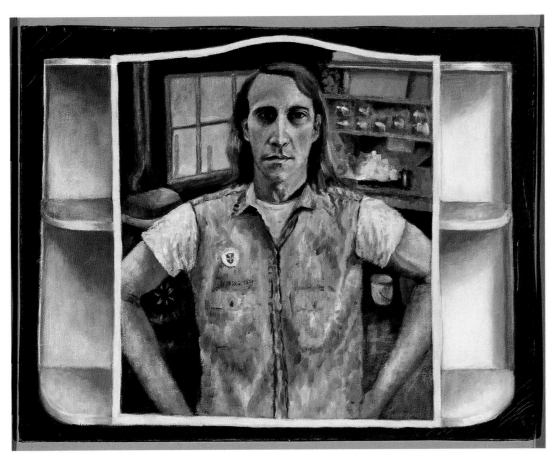

143 *Self-Portrait in Medicine-Chest Mirror.* 1973. Oil on canvas, 15¾ x 19½ in.

In Saigon, 1970

Robert Louis Posner

Born Trenton, New Jersey, 1943
Served in Vietnam, Navy, Naval Support
Activity, Da Nang, Phu Bai, Hue, Tan
My, Dong Ha, Quang Tri, Cua Viet,
Saigon, military journalist; later on the
staff of the Commander, U.S. Naval
Forces, Vietnam, 1969–70

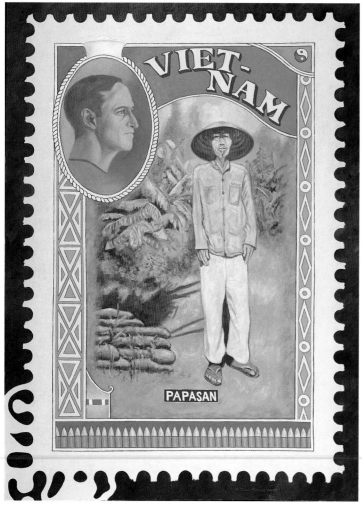

144 *Papa San*. 1985. Oil on canvas,
54 x 39½ in.

A poem written in Vietnam, 1969:

Perhaps They Will Say . . .
Perhaps they will say
(as they do of the painting at McConkey's Ferry)
that he was a Kulak in Nepal
(or a Jew in – but where haven't the Jews been?),
that he really didn't understand,
that he wasn't in the foxholes
(where weeks-old human feces are set afire
to serve as incense for the God
who frequents these holy depressions),
that he didn't have a USMC tattoo
torn to shreds by a drop of molten metal
(later identified as shrapnel),
that he never used his field cap
to cover the tip of his M-16 while
bouncing along in the back of a gray pick-up truck
day after day
from PX to PX
in search of the perfect camera,
that he never could relate how
(at the end of his rope)
he had gotten stone drunk at the club
and had to be carried back to the barracks,
that he was never invited to sup with a Viet family
(and gagged on *nuoc mam*),
that he never lay with a dark-toothed, rank Viet girl
on the dirt floor of a bunkered peasant hooch
paying in piasters and the black syph
(but it was good)
(but you couldn't communicate with her)
(my dick communicated with her pussy,
what more do you want?),
that he never shot into the dark on patrol
and wondered later whether there had been anything out there,
that he never wore jungle boots
or camouflage greens
or a black beret
or the group of pockets sewn together called jungle greens,
that he never wrote his church publication that
yes, we are doing some good over here,
that he never stood behind a banana tree
laughing at the VC and the village popular forces
killing each other in between tracers,
that he never bought anything on the black market,
that he didn't number his letters home,
that he never heard bullets piercing his helo,
that he never rode the Perfume River,
that he never saw a buddy killed,
that he wasn't really where the action was,
that he didn't really die.

146 *Four Self-Portraits with Vietnam Medal.* Left to right: *The Dream; The Reality; The Nightmare; Agent Orange.* 1984. Oil on paper, 17 x 17 in. each

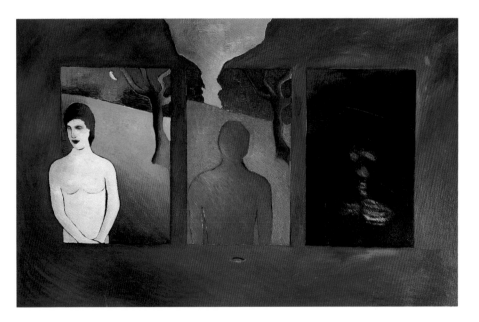

145 *1, 2, 3, Destruction.* ca. 1983. Oil on primed paper, 42 x 72 in.

On the boat deck of the USS *Annapolis,* off the coast of Vietnam, 1967

Bill Reis

Born Pawtucket, Rhode Island, 1950
Served in Vietnam, Navy, 2d Division,
USS *Annapolis,* Tonkin Gulf, petty
officer, 1967–68

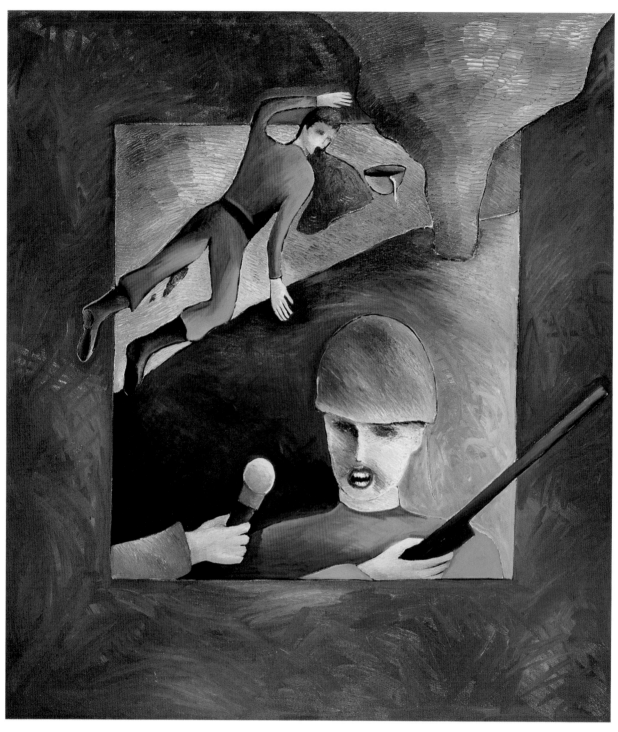

147 *The Valediction.* 1983. Oil on primed paper, 49 x 45 in.

Some famous artist – Motherwell, I think –
said, "Art is a luxury for which the artist pays."
My work is based on the media and its
positive/negative reflections on the Vietnam
War and how it affected all of us.

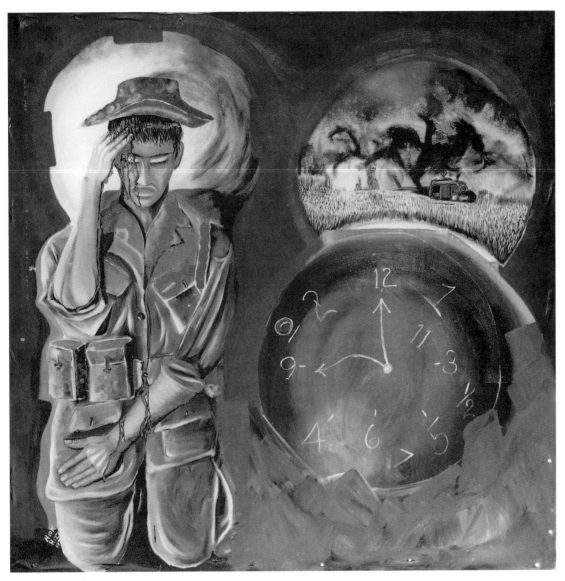

148 *Death.* 1975. Oil on canvas, 48 x 48 in.

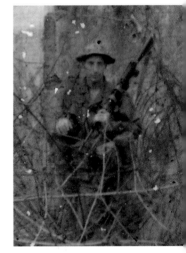

On a rubber plantation near Pleiku, 1969

Nick Rizzo

Born Fort Wayne, Indiana, 1948
Served in Vietnam, Army, 6th Battalion,
14th Artillery, attached to 5th Special
Forces Group, II Corps, Dak To, Da Lat,
Tay Ninh, Ban Me Thuot, Nha Trang,
Pleiku, Kontum, radio operator, 1968–69

I served as a radioman for many Special Forces missions during the first part of my tour and spent the second part in an artillery unit. It was a never-ending battle to survive. When it came time to run I had no shame in putting on my track shoes, and when it came time to hold our ground we gritted our teeth and did so. After being raked through the coals from front to back, and then some, we still did our job. After killing innocent people in the name of war, and meeting the enemy head-on, and seeing our friends killed, we kept on going, and after we went home, back to the World, we had to survive that. And some did not.

Remembering back, as I often do:

After basic training, on a chill of a November day, I got on this big airplane and lifted into the sky of 1968, thinking: I will go over there and get this war over with in a month or two. The big cool plane made a steep dive and we landed; the door opened and as I walked out a strange smell sucked up my nose, and it was surely hot. Welcome to Vietnam.

Out to the west of Pleiku, we were following a battalion of NVA and we came across a bunch of enemy bunkers. We had to search them. Since I was small I was elected to go in. I crawled down the entrance carefully, looking where I put my hands and knees, shining my flashlight all around. Lying on the floor were a couple of baskets and some eating utensils. One basket was turned upside down in the middle of the floor. Sometimes the NVA would leave booby traps like that. I slipped one hand under its edge, held my breath, and lifted it. I saw some papers and a map; what a relief. I got the hell out of there. We must have been very close on their trail for them to leave those items behind. Ya know if ya hold your breath when something blows up, it don't hurt as much.

Another time, as we ran for a chopper under enemy fire, the lieutenant yells at me, "Rizz, the gunner got hit on the way in. Give me your pack and take his place." There was no time to argue. I put on my helmet as we were lifting off. The pilot said, "Incoming at two o'clock," so I opened up on them and did not stop shooting until we were way out of range. I recall pushing the trigger on the 60 cal with very intense emotion. In this case, ya don't hold your breath, you let it out so you make a smaller target.

Once we stopped at midday to eat in very thick underbrush. The lieutenant sat about ten feet to the right of me, and ten feet to his left and right were two South Vietnamese ARVNs, and directly facing me was another American. The underbrush was so thick we could hardly see one another, but as we sat eating, we were talking to each other. I had just taken a bite when pop, pop, pop, enemy small-arms fire filled the air, bullets hitting everywhere, like rain coming down out of the sky, only horizontally. I dropped my food and grabbed my rifle and crawled over to the lieutenant and fired a couple of clips on full auto and bam it was over. The lieutenant called in artillery on them and that was it. That was a firefight, quick and devastating; as I recall, one man dead and two wounded, and lunch given up to the ants.

Ants, those damn ants. As we settled down for the nights and I dug my foxhole, it seemed the ants would always be there. They would crawl up my legs and bite the hell out of me, and if we did get the chance to sleep I would sleep with my eyes open and in the morning my eyes would focus on the gray light of the misty morning jungle, in a place dead still with life, and life that was dead still.

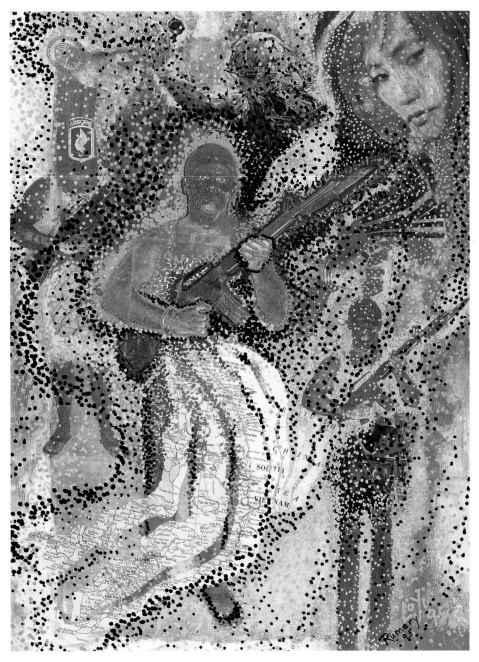

149 *NAM MAN 94*. 1994. Paper collage,
ink, and colored pencil on paper,
31 x 23¼ in.

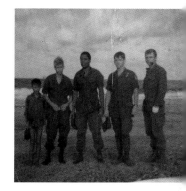

Outside the village of Phu Hip, near
Tuy Hoa, South China Sea coast,
December 1967, after a band-aid stop
at the 91st Evac; Rumery is second
from right, with Short-Time, Little Red,
Smokey, and Plato

Michael Rumery

Born Earth, 1947
Served in Vietnam, Army, 4th Battalion,
503d Infantry Regiment, 173d Airborne
Brigade (Separate), Dak To, Ban Me
Thuot, Tuy Hoa, Anh Khe, Bong Son,
Kontum, Cambodia, and Laos, M-60
machine gunner and Kit Carson Scout
team leader, 1967–69

Two passages from an unpublished novel, *NAM MAN:*

Candy came back from his visit to the World in haste. He had suffered through three weeks of home leave before returning to Nam for a second tour. His short stay in his hometown made history of a sort. His first stop there was Mom's No Nothing Tap, where he had worked before the war. He'd liked working there because you could smoke dope while tending bar. This was the type of establishment where people carve their initials in the bartop with a machete.

Candy drank constantly while he was on home leave and smoked prodigious amounts of skunk weed, personally imported from Southeast Asia, his previous habitat. Above the front door of his house he painted a large capital U with a screw through it: his coat of arms. As another attention-getter, with spray paint he drew a huge portrait of his favorite character, Luke the Gook, on his driveway. In three weeks home he broke with his girlfriend, his family, his town, and his country. He didn't belong there anymore. He was a NAM MAN. MAN was NAM in reverse, and Candy had experienced that reversal, physically and spiritually. As an encore he shot up his house with a .357 magnum and burned it to the ground. Nothing was left but Luke the Gook's smiling face, a concrete cenotaph. Then he went back to Nam, where things made more sense and he didn't feel like a foreigner. It was his summer job. He was, at this time, about twenty years old.

In Vietnam he was Doc Candy, a medic, and a good one, brave and fearless. "How do you find a wound in the dark?" he would ask. "You feel for it."

. . . Texas spent his spare time drawing. It was a temporary absolution for his sins. Killing tormented him, the dead haunted him. He wanted to smother his mind with drugs and alcohol, but in the boonies he couldn't get any. He told Shakespeare about it. As usual, Shakespeare understood perfectly and replied with ready sympathy, "Oh God, I could be bounded in a nutshell and count myself a king of infinite space were it not that I have bad dreams." Realizing that other people had similar problems, Tex didn't feel so alone.

Sandbag architecture was the subject of his current drawing. He titled it *Still Life with Sandbags.* Still life – that was the key idea. Drawing, he journeyed from the three-dimensional world of brutal reality to the two-dimensional realm of the page, where he was God and there was no strife, only life, only problems to solve.

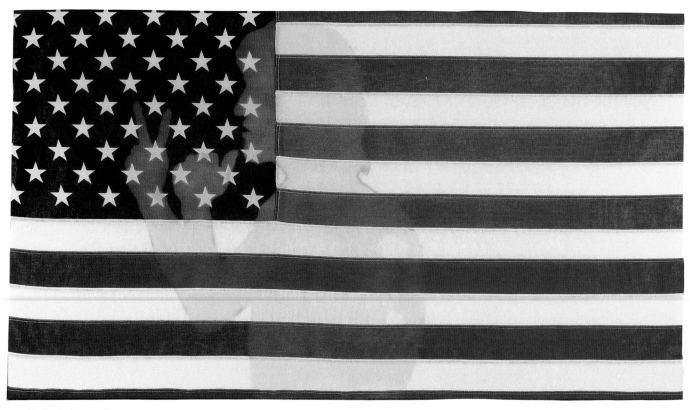

150 *Profile of a Vietnam Vet.* 1977–82.
Faded and stained cotton,
30½ x 54¼ in.

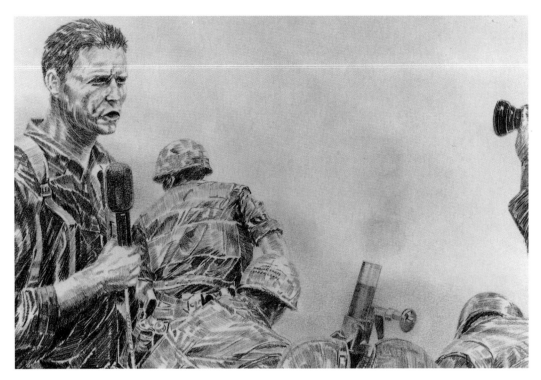

151 *Informants Misinforming*. 1980. Pencil
on paper, 13½ x 17½ in.

Inscription on the drawing's mat:

Rarely had contemporary crisis-journalism
turned out, in retrospect, to have veered so
widely from reality.

— Peter Braestrup,
Washington Post war correspondent, 1977

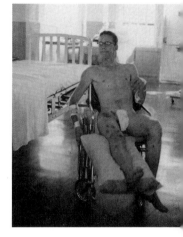

At Yokosuka Naval Hospital, Japan, 1970

Dale E. Samuelson

Born Chicago, Illinois, 1949
Served in Vietnam, Marine Corps, 2d
Battalion, 5th Marine Regiment, 1st
Marine Division, An Hoa and Da Nang,
rifleman, 1969–70

From a letter, 1984:

Came into Da Nang and flight was delayed
in landing because of rocket attacks, finally
landed, stayed the night. Following day took
off for An Hoa, nineteen miles southwest,
spent two days in the rear filling sandbags,
standing watch at night, put up barbed wire,
filled more sandbags, stood watch at night,
fell in the red mud, got in a firefight with a rat
who stole my apple and baloney sandwich,
next day moved out to Liberty Bridge with
small patrol. It took about a day and a half to
get there (four or five miles) because the
point men kept tripping wires and setting off
booby traps (had to spend most of the time
waiting for Medevacs); finally got to the
bridge and joined my wonderful squad.

From then on:

Ran patrols during the day, chased gooks

Stood watch at night

Ran patrols during the day, looked for gooks

Set up night listening post

Ran patrols during the day, looked for gooks, called in air strikes

Set up night ambushes

Ran patrols during the day, waited for Medevacs

Stood watch at night, called in artillery, killed a water buffalo

Ran patrols during the day, chased gooks

Set up night listening post, threw grenades, fell asleep

Ran patrols during the day, shot at gooks, blew up bunkers

Moved out at night (dumb) stood watch

Ran patrols during the day, wait for Medevacs, got lost

Set up night listening post, fall asleep

Sandbagged patrol during the day, get sniped at

Set up night listening post

Air-lifted out (helicopter ride), new position, waved to my buddy Rick changing positions

Stood watch at night

Run patrols during the day	Get in a firefight
Set up night listening post	Popped flares, call in arty
Run patrols during the day	Blew up bunkers
Stood watch at night	Call in artillery
Run patrols during the day	Wait for Medevacs
Set up night ambush	Shoot at noises in the night
Run patrols during the day	Shoot gooks
Move out at night (dumb)	Get in a firefight
Run patrols during the day	Chase gooks, get lost
Stand watch at night	Shoot at noises in the night
Daytime listening post	Shoot at your own guys coming in, sorry
Stand watch at night	Fall asleep
Run patrols during the day	Call in air strikes
Set up night listening post	Get in firefight, set off claymores, kill more wildlife
Run patrols during the day	Run into gooks
Airlifted out to new location	Wave to my buddy Rick again
Stand watch at night	Set off claymores for the fun of it
Run patrols during the day	Call in air strikes
Stand watch at night	Kill mice in fighting hole with E tool
Sandbag patrol during the day	Get a tan
Stand watch at night	Get hit by your own artillery, fall asleep

Go on water runs	Jump in the river to get the grime off and see three bodies
	floating toward you, empty canteens and start all over again
Stand watch at night	
Run patrols during the day	Wait for Medevacs
Move position, airlifted out	Wave to my buddy Rick
Set up night listening post	
Run patrols during the day	Shoot gooks
Stand watch at night	
Set up night ambush	Fall asleep
Run patrols during the day	Look for some guy who was captured by the VC
Stand watch at night	
Run patrols during the day	Still looking for the same guy
Stand watch at night	
Run patrols during the day	Kill *chieu hoi*
Set up night ambush	Killed a water buffalo
Run patrols during the day	Get sniped at
Set up night listening post	
Run patrols during the day	Shoot another *chieu hoi*
Stand watch at night	Get shot at, call in artillery
Run patrols during the day	Call in air strikes to blow up bunker
Set up night listening post	
Move position again (another helicopter ride)	Wave to my buddy Rick he's still alive
Run patrols during the day	Wait for Medevacs
Get blown up and Medevac'd out	But the routine for the Marines continues
Airlifted out (helicopter ride), waved goodbye to my buddies	

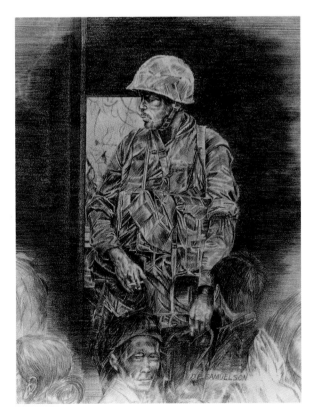

152 *The Modern Centurion.* 1980.
Pencil on paper, 17½ x 13 in.

Inscription on the drawing's mat:

If the trumpet give an uncertain sound, who
shall prepare himself to the battle?
— 1 Corinthians 14:8

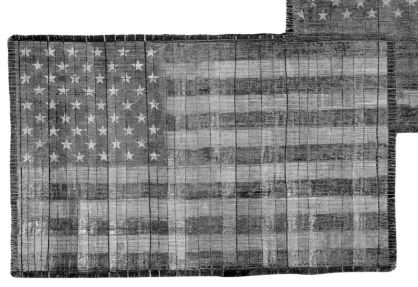

153 *State of the Union No. 2: The Mourning After.* 1989. Loom-woven collage, Mylar, tissue paper, newspaper, rayon, cotton, and metallic warp yarns, polymer medium, metallic fringe, Pelon, and eyelets, 22 x 32½ in.

Aboard the USS *Kitty Hawk* during R & R, 1967

Arturo Alonzo Sandoval

Born Española, New Mexico, 1942
Served in Vietnam, Navy, USS *Kitty Hawk*, Yankee and Dixie Stations, South China Sea, assistant boiler division officer and administrative assistant to chief engineer, 1967

From a memoir, 1992:

1967 – Slowly, very slowly I began to realize that being on board the *Kitty Hawk* wasn't just a hiatus from college and my art. I brought an art work in progress with me, thinking I could get to it sometime. *No time for art making!* The reality began to set in when I first saw the Vietnam Highlands from the captain's deck. What a jolt I felt, being so close to Vietnam. A sense of insecurity ran through me and for a moment I panicked. There was always something surreal about me being a naval officer. Having no engineering degree, but a B.A. in art, it made no sense to me to be placed in the ship company's engineering department.

General Quarters was always something I hated, but when it wasn't just a practice drill I never really knew what the outcome and consequences would be – the injuries and death. General Quarters gave me my first on-board experience of death: a boiler blew and the steam and blast killed a young seaman instantly. Others followed: a helicopter landing on deck badly and tilting overboard, four crewmen dead; another Elmer Fudd landing with port wheels off deck, helicopter tilting overboard, six dead. And the many pilots who died. Too many intelligent, energetic, committed young pilots; I'd have breakfast or lunch with them and they never returned for dinner.

In 1984 I began to search for a design or symbol to use for a series of art works on political issues; I chose the American flag. I wanted to move away from abstraction; in the process I found myself rediscovering the pain from these past events.

David Given, from a gallery announcement, 1988:

Fallen Timbers: Ohio to Vietnam
In Ohio's history the Battle of Fallen Timbers was one of nature's making and man's making. In 1794, several days before "Mad" Anthony Wayne's battle with the Indians near Toledo, where 1,300 Indians and British were felled, a tornado ripped through the area, felling hundreds of trees. Life, whether it be man or tree, when cut down is a loss. . . .

For me, the Vietnam Memorial wall in Washington, D.C., has two sides: an American side, which we can see, and a Vietnamese side, which we don't see. I was a medical corpsman in Vietnam, first with the 1st Division, 3d Battalion, later with the 3d Division, 3d Battalion, 26th Marines. I saw a lot of fallen timber on both sides of the wall. In that my primary job was to preserve life and not take it, I was able, by the grace of God and the blood of Jesus Christ, to preserve my sense of compassion and aesthetics, which war can easily change to cynicism and pragmatism, as it can change scenery to terrain, and human beings to body counts or the enemy. *Fallen Timbers* is an attempt to express the beauty and the loss on both sides of the wall. . . . A tree that falls is still a tree, no matter on which side of the wall it falls. To the best of my knowledge, I am the only tree from my combat company left standing in Columbus, Ohio. Six others fell. The Accounting of the Columbus Six: Larry V. Flora, Richard L. Holycross, Albert M. Butsko, Lueco Allen Jr., Hugh C. Goins, Samuel L. Parker.

At Khe Sanh, ten months in the field, July 1967

154 *Fallen Timbers/Fallen Time.* 1989. Color photograph by David Given, machine-stitched with fabric netting, colored threads, acetate transparencies, and metallic fringe by Arturo Alonzo Sandoval, 32½ x 22 in.

Arturo Alonzo Sandoval and

David A. Given

Born Columbus, Ohio, 1947
Served in Vietnam, 3d Battalion, 1st
Marine Division, and 3d Battalion, 26th
Marine Regiment, 3d Marine Division,
Phu Bai, Chu Lai, Dong Ha, Con Thien,
and Khe Sanh, medic, 1966–67

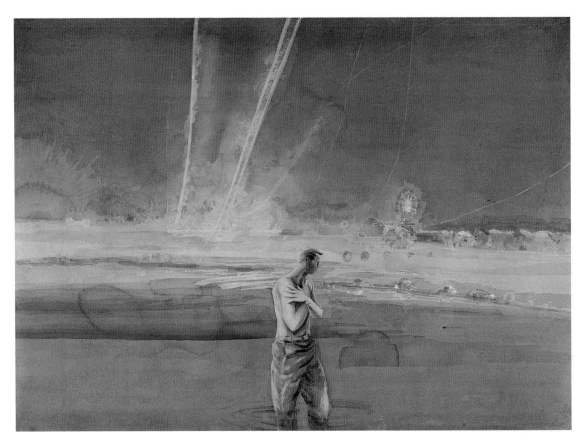

155 *Goodbye Vietnam.* 1983. Watercolor
on paper, 27 x 35 in.

"Portrait of the artist as a meditative
Vietnick, shocked to find himself 'in
situ,' Vietnam, 1966"

David Alan Sessions

Born Mason City, Iowa, 1941;
died Seattle, Washington, 1994
Served in Vietnam, Army, Military
Assistance Command (MACV),
Tan Son Nhut Air Base, Saigon,
classified-documents cage clerk,
1965–66

From several letters, 1987, 1989, and 1993:

... Last week I saw the movie *Platoon* and couldn't breathe for a couple of days; it opened up that damned sadness that I think may never go away. I know now that my main reaction to Vietnam is to see its absolute absurdity. I shake my head in amazement at having emerged unscathed, and that we all are walking around, talking, laughing. When I get really morbid, I think: What if the artists had all died, and we didn't have any of their art or wisdom? But neither I nor they did.

Or maybe we did, and this is some weird purgatory.

... Still working on the theme of Natural Disorder, which still seems to be how I see things. But I've always been cross-eyed....

I am an absolute believer in history. Art is a record: think of the art germinated from other wars (Mesopotamia to Korea), produced unsolicited, in reaction to the particular skirmish. The art that comes out of Vietnam is unique to that war; it was not produced by war illustrators, but by soldiers (and a nurse or two). We have acted upon that primal aesthetic urge to make visual commentary on an event (Vietnam and aftermath) that profoundly touched our bodies, hearts, spirits, souls — whatever it is that constitutes the Human Thing and causes it to make art.

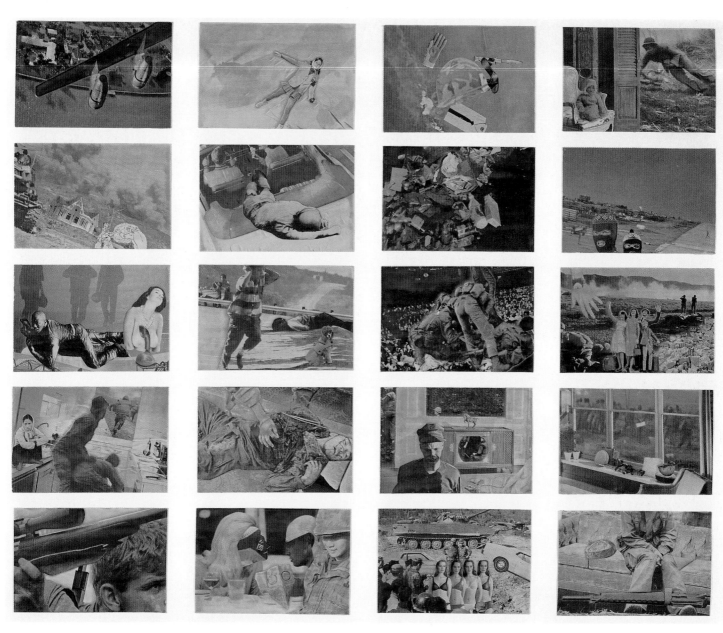

156 *Contained War.* 1976. Watercolor, photographs, and collage on board with polyurethane, 24¼ x 30¼ in.

157 Untitled (grunt on a split-bamboo walkway, City Cache, Cambodia). 1970. Silver gelatin print, 14 x 11 in.

In Phouc Vinh, Easter Sunday, 1970

R. Dean Sharp

Born Racine, Wisconsin, 1947
Served in Vietnam, Army, 1st Battalion,
5th Infantry Regiment, 1st Air Cavalry
Division, Quan Loi, 1st Air Cavalry
Public Information Office, Phouc Vinh,
and Cambodia, rifleman and combat
photographer, 1969–70

At first the army took advantage of my art and photography education by putting me in the infantry. One day, not long after going into the jungle as a grunt, I was moving with my company along a trail system when we came across some NVA dead. The other new guys and I were led forward along the path, like initiates to some terrible fraternity: sprawled on the ground were three dead men, their broken bodies in stark contrast to the riot of living vegetation around us. It was not so much their wounds — although they were horrible the first time and every time — it was their eyes. They had flies in their eyes, and ants. I waited for them to blink, to brush away the insects, but they did not and could not.

A captain in clean, pressed fatigues and aviator sunglasses flew into the bush to pin medals on a few of the men in my company, Bronze Stars and Purple Hearts that looked as out of place on the filthy, sweaty jungle fatigues as did the captain himself in that spot. After the brief pomp, as he was waiting for another bird to lift him back to a hot meal, a bunk, and a shower, I asked where he had gotten his sunglasses. I said that I was a photographer and had spent so much time in darkrooms that the tropical sun was killing my eyes. Even through his dark glasses I could see that a random cosmic thought had hit him. A few weeks later I was reassigned as a combat photographer.

Later, the captain was given command of an infantry company. I was with them the day he walked them down an NVA road named the Jolly Jungle Highway and into an ambush. I still have the Leica camera that collected its own Purple Heart that day.

Mostly I went out and worked with line companies in the bush, but I also had to cover such distasteful things as awards ceremonies (row after row of people getting generally useless medals pinned on them), accidents, suicides, and the Sunday hospital tours. On these the three generals from Division would visit wounded and sick men in the major field and evac hospitals. We would have to shoot a Polaroid of the general as he talked to each injured grunt, zip it off, and then slip it to the general so he could present it.

One day, working our way down a ward, we came to a guy so badly wounded that I knew if he lived neither he nor his family would want to have a picture of him in that condition. I tried to hide the camera, but he had seen the flashes. He started to cry because he knew he was so badly fucked up that I would not take his picture. I hated myself that day. I hated the war, the general, and my craft. I still wonder if that poor grunt made it.

I took a series of photographs at the site of a huge NVA cache in Cambodia — possibly the biggest found in the war. It was called the City Cache because it had dozens of buildings: storage bunkers filled with cases of weapons, classrooms, training and hospital and staging areas. The NVA built split-bamboo walkways throughout the City Cache so they could move munitions in the rainy season. It was first spotted by helicopters and my old line company, Charlie, 1/5, was sent in to explore it. Photographers weren't allowed there, but because I knew the battalion commander, he let me go in. For about three days I was the only photographer there.

Looking back, I see that I was very lucky. So many people I knew were not. I spent enough time in combat to learn that it is hours of incredible boredom and living in the dirt like a miserable animal, punctuated by moments of great terror.

I almost did not go. I did not believe in the war, but I also felt I had a duty to go. My first son was five days old when I left for Vietnam. At the Seattle-Tacoma Airport on my way to Fort Lewis, I saw a big sign that said *Air Canada*. I thought about it for about half an hour and then called my wife. She was willing to sell everything we had, take the baby, and meet me in Canada. But for whatever reason, I could not do it.

I have started making photographs again, after almost twenty years.

158 Untitled (refugees near a rubber plantation outside Mimot, Cambodia). 1970. Silver gelatin print, 11 x 14 in.

159 Untitled (Da Nang, waterfront). 1967. Photograph, 6½ x 4½ in.

In the courtyard of the Modern Hotel, Da Nang, late spring 1968

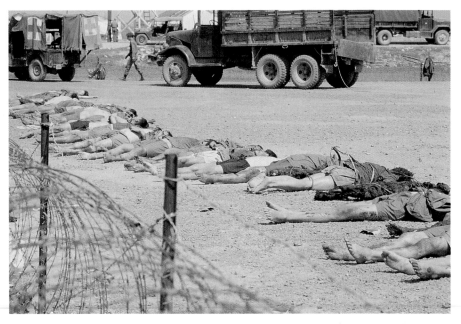

160 Untitled (helicopter LZ, I Corps Advisors' Compound, Da Nang, Tet offensive). 1968. Color photograph, 4½ x 7 in.

John Shimashita

Born Poston, Arizona, Internment Camp #2, 1945
Served in Vietnam, Army, Detachment B, 1st Military Intelligence Battalion, Air Reconnaissance Support (MIBARS), Da Nang, photo-lab technician, 1967–69

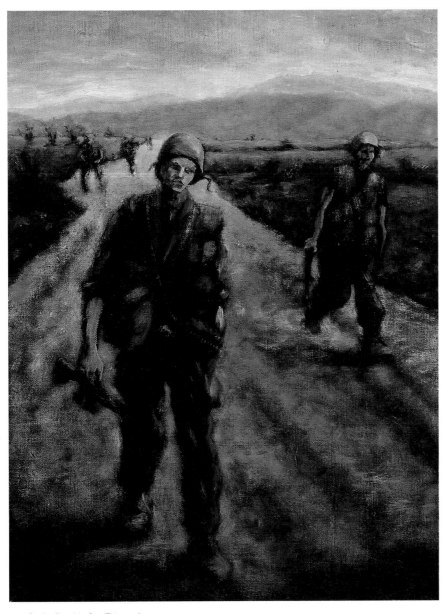

161 *On the Road to Con Thien.* 1980.
Oil on canvas, 24 x 18 in.

Near Khe Sanh, June 1968

Charlie Shobe

Born Petersburg, West Virginia, 1940
Served in Vietnam, Marine Corps, 1st
Battalion, 4th Marine Regiment, 3d
Marine Division, DMZ, Dong Ha, C-2
firebase, Con Thien, Camp Evans,
and the Khe Sanh area, reaction-force
platoon commander, logistics, motor
transport, and company commander,
1967–68

December 1967

Flying over the DMZ with the company payroll in a metal ammo box, I sit on the floor of a windy, rattling old helicopter, watching the hundreds of bomb craters pass below; filled with water, surreal, like the surface of some imaginary green planet. Cold fog blows through the craft and it's just me, the door gunner, and the guy on the floor under the poncho. The poncho is tucked around the body, but the wind keeps blowing it off the head and shoulders and it snaps and flaps and beats violently on the face. The body has sandy hair and dark dried blood on the neck and behind the ear. I try not to look. The door gunner and I both stare. The gunner shifts in his seat, adjusts the machine gun, and pulls the poncho up over the face. He props his muddy boot on the poncho, holds it there with his heel against the head, and again looks out over the M-60 barrel, down at the foggy green below. A Christmas present for Mr. and Mrs. John Doe from the U.S. Government.

My paintings are of the horror show that was Vietnam: butchery carried out for politicians, bureaucrats, and ambitious generals whose egos would not let them say "enough"; art for an indifferent public; art to honor those who lived and died there, and earned only a few hundred dollars a month. It would take a lifetime to paint it all.

Con Thien

Con Thien was the end of the road. Beyond was the DMZ, the river, North Vietnam. The military maps showed villages, houses, agricultural centers, churches. By the time I got there the buildings had all been demolished, the people "relocated" to tin-roofed shacks in a kind of third-world slum city outside Dong Ha. Some of them got food from the trash dump at Dong Ha; I don't know how the others lived. There were thousands — proud farmers reduced to living in shacks and eating garbage. In Washington, our leaders spoke of winning the hearts and minds of the people.

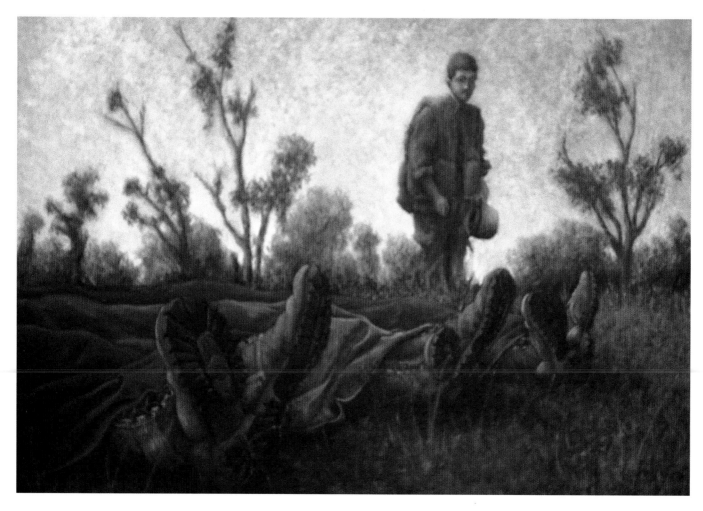

162 *Class of '67.* 1984. Oil on canvas, ca. 22 x 28 in. Present location unknown

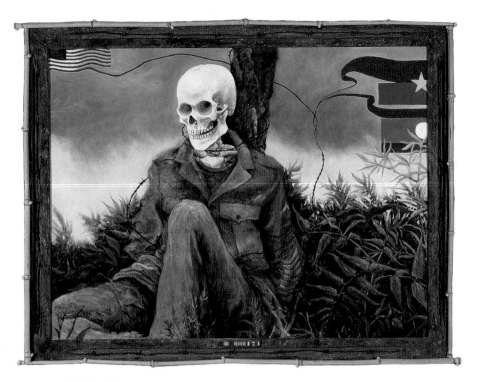

163 *Waiting for Henry Kissinger.* 1990.
Oil on canvas, 30 x 40 in.

One afternoon I watched a patrol returning to Con Thien through the hot yellow dust. As the Marines filed past I saw a guy drenched with sweat and wearing a belt of M-60 ammo hung Pancho Villa–style around his neck and body. I took his picture with a cheap Instamatic camera that I kept in a plastic bag during the wet times – sweat or rain – and years later I painted *On the Road to Con Thien* from that photograph.

The Class of '67
In June 1968 we were on an operation in the hills between Khe Sanh and Laos. One night NVA sappers crawled up through the wet elephant grass and overran our position. In the ensuing firefight we took heavy casualties. The sky was lit up with parachute flares and on the ground the night swayed out through the trees and became a kind of surreal blue day. The armorer working with me had his leg blown off at the knee by a grenade; the corpsman who came to help him was shot through the shoulder. When daylight came the NVA had pulled back and mortared us for the next few hours. Being a short timer, with a flight date at the end of the month, I had dug a deep foxhole and during that morning I shared it with eight or ten different people: my wounded company commander, a wounded air liaison officer, a wounded jeep driver, a wounded artillery forward observer, a wounded mortar man, the communications officer, and some others.

When the bodies of the dead were laid out in the clearing and covered with ponchos, they all looked alike. They lay in short rows on their backs with their toes pointing up and outward. In death they were all the same, except for the one who had only one foot – one boot. This scene occupied a little part of my mind for many years and I finally painted *Class of '67*. June was graduation month; some of them had probably been finishing high school the year before.

Hard Edge, Hard Corps
In the summer of 1970 I went back to college in West Virginia. The campus was alive with rock bands, speeches, and demonstrations for and against almost everything. I ignored most of my classes and painted all day long: huge canvases on heavy frames. I used a 1½-inch housepaint brush and acrylics, which were fairly new at the time, fast and loose to work with, and did big paintings of Marines with their weapons coming through elephant grass or standing around in groups, waiting to get on helicopters. The other painting students would come around, as art students do. They were all doing hard-edge painting. They would tape off squares and circles and overlapping geometrical shapes, paint one area, then lift the tape and paint another. It didn't excite me much. All that tape, all those hard edges. One day the head of the art department called me into his office and told me I would not get an A in my painting class if I did not do hard-edge painting. Hard-edge, he told me, was what they were doing in New York. I stood in the hall outside his office and I thought, "I'm twenty-nine years old and I've been in Vietnam for thirteen months, and I've seen some of the worst and best that humanity has to offer, and here's some guy telling me that I've got to screw around with masking tape all day." I went back to the studio and painted more Marines and listened to the rock bands outside my window.

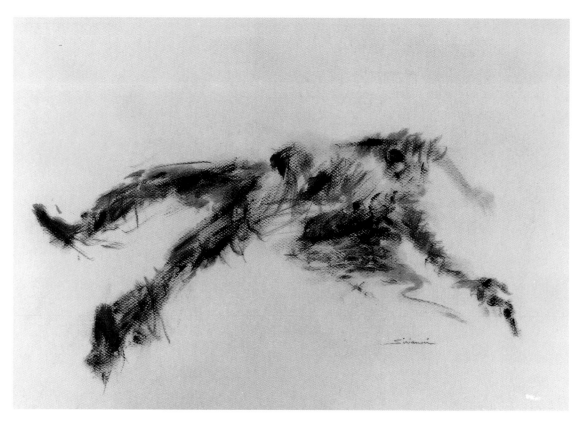

164 *Suicide.* 1981. Lithographic crayon
on paper, 18 x 27 in.

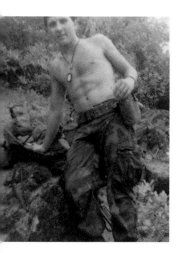

On patrol in Que Son Valley, 1969

Ralph "Tripper" Sirianni

Born Buffalo, New York, 1949
Served in Vietnam, Marine Corps, 2d
Battalion, 7th Marine Regiment, 1st
Marine Division, Quang Nam Province,
I Corps, rifleman, 1969–70

My Military Occupational Skill (MOS) was rifleman (grunt). For most of my twelve-month tour I was a squad leader. I couldn't speak Vietnamese so occasionally, to communicate, I'd draw for the people I met in villages. I wish I had some of those drawings now, but I always gave them away. It took me some time to redevelop my skills as an artist when I returned home. I was very tense.

Suicide was done in about the time it takes to squeeze the trigger. It's one of the fastest pieces I've ever put together. Two fellow employees of the Buffalo Veterans Administration hospital, both Vietnam vets, killed themselves within a short time of each other. Their deaths inspired this piece.

Deceit is one of many works I've made about the POW/MIA issue. While most were done to arouse public awareness, some were created out of sheer frustration. Around 1980 we began to hear increasing evidence of government cover-ups about POWs. So much anger gushed out of me and onto the surface of this paper. From fifteen feet away I threw various media at it. Up close I gouged my nails into the rag and clawed across the finished drawing. The face of an American prisoner looks out from the upper left corner of the flag. The U.S. flag and its captive are

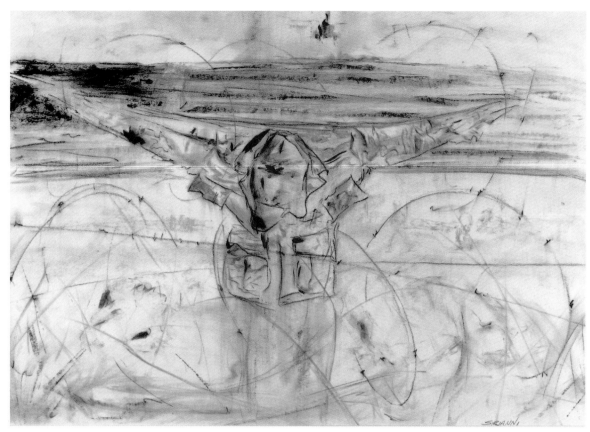

166 *Crucifixion/Nam.* 1981. Charcoal and lithographic crayon on paper, 23 x 34 in.

behind a bamboo cage with dark silhouettes of enemy soldiers, prisoners, and the Capitol building.

Crucifixion/Nam portrays an actual experience of mine. Once, in Vietnam during the early morning hours, while our unit was not far from our rear base, LZ Ross, we could see the compound coming under attack. The area was lit up with tracer rounds, pop-up flares, and incoming fire. We were told to move in on foot to intercept the enemy. It was dawn when we reached Ross. The enemy was gone, except for the dead stacked along the road. In the compound our dead were in bags waiting to be lifted out on choppers. Years later, as I recalled this incident, I chose to portray it as a spiritual reckoning. Bodies are lifted into the sky in the hazy background, but the focus of attention is on a tattered camouflage shirt, perhaps that of a dead GI, that's stretched across and nailed into a piece of wood. The face of Christ is inside the shirt, so that it has become a shroud. Concertina and barbed wires crisscross the site.

When I think of Nam, I remember being scared. There was so much to fear. I have nothing against the people there, but I have no desire ever to return.

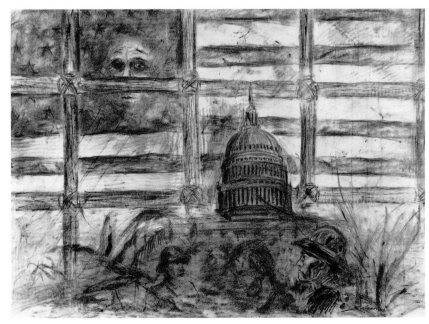

165 *Deceit.* 1981. Charcoal, lithographic crayon, pencil, chalk, and acrylic on paper, 23 x 34 in.

Writing means thinking and I just can't think for long about the war. It brings up such conflicts. It's all right and it's all wrong. On the one hand the war was despicable; on the other, being a young infantryman in Vietnam was probably one of the best jobs ever. It was certainly more interesting than anything I've done since.

It's taken me a long time to combine war with art. What happened to me in Vietnam has become a set of stories in my mind. These stories have been developing over the years since I've been back from the war, and I don't know whether these stories, my memories of Vietnam, truly match what happened.

Much of what happened in Vietnam happened by chance. Why wasn't *I* killed? Since then, I've been studying the mathematics of chance and watching the patterns that occur in random processes to try to understand the events of which I was a part. The paintings are abstract fields of points – distribution patterns of points from statistics and probability theory – while the points themselves are recognizable images – helicopters, jet fighters, numbers, letters, words, the shapes of jungle camouflage, the essence of Vietnam. The paintings contain violence, but it is the violence of helplessness in the face of chance, and the viewer participates in that violence through the image of random events. The paintings are altarpieces and icons because altarpieces and icons can contain violence, the violence of crucifixion or of martyrdom, while still holding the mind and eye in contemplation. The technique of mathematical modeling, together with the images and symbols of the war, gives me a way, while painting, to watch again and again the events, people, and places of Vietnam. I can't paint what napalm or white phosphorus or claymore mines do, nor can I paint what a firefight is like. Any attempt to do so would end up like a poster for a bad horror movie, and would repel the act of memory. The paintings are memorials and making them is a ritual act that helps me to remember the war, and to give meaning to the fact that I am still alive.

Recently, I made an entire roomful of sand paintings of military images and images from nature, titled *Battle Maze*. Hidden under the sand were hundreds of small explosive charges wired together and controlled by a random computer program. As people watched, bits of the paintings exploded. It was a beautiful place slowly destroyed by random violence. A real boy's show: you make something beautiful and then you blow it up.

In another installation, *1 Out of 5*, I covered an entire wall with computer-generated random sequences of two images – a burning helicopter and a camouflage pattern. As I pasted each image to the wall, new shapes and patterns emerged, taking on a syntax and meaning. But since the entire process was random, "it don't mean nothing," as we used to say in Vietnam.

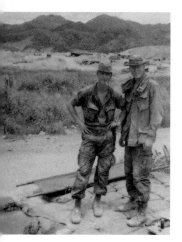

Smith (right) on his nineteenth birthday, just off patrol between LZ Stud and Khe Sanh, 1969

David Smith

Born Portland, Oregon, 1950
Served in Vietnam, Marine Corps, 2d
Battalion, 9th Marine Regiment, 3d
Marine Division, I Corps, A Shau Valley
to Khe Sanh, rifleman, 1969

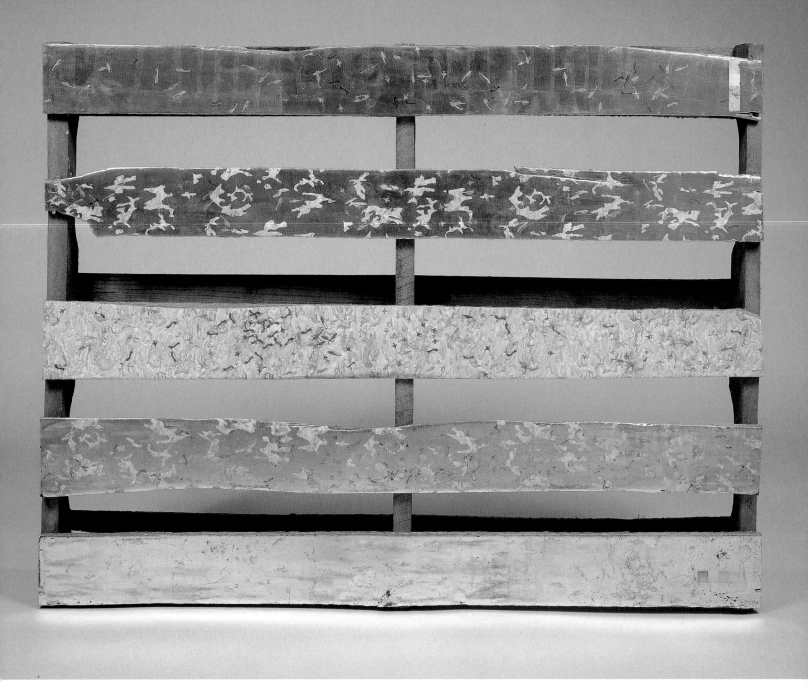

167 Untitled. 1986. Egg tempera, encaustic, bole, and gold, aluminum, and pigmented leaf on gessoed wood, 39 x 51 in.

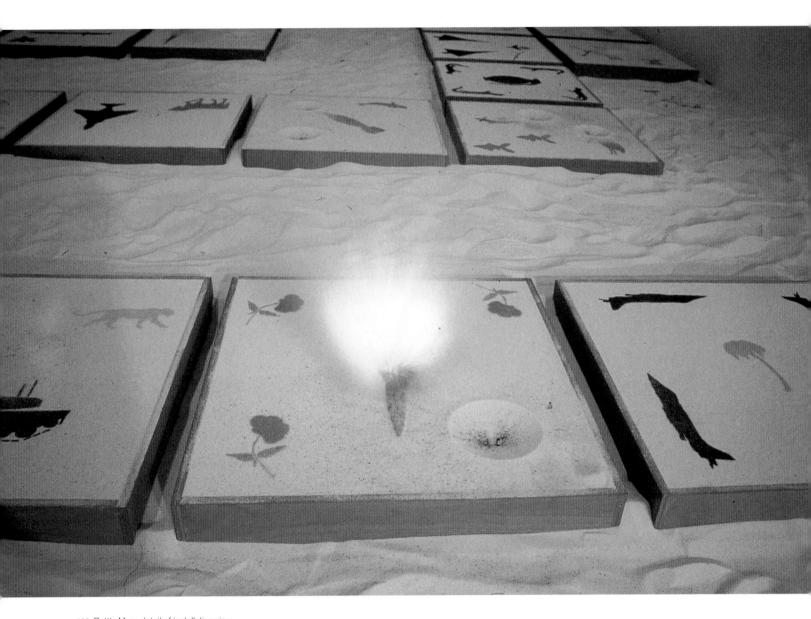

168 *Battle Maze*, detail of installation view.
1991. Colored sand and computer-
controlled explosive charges, 43 x
18 ft. No longer extant

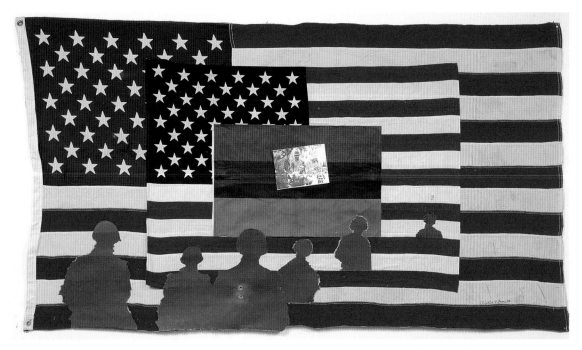

169 *Silhouettes of Soul.* 1996. Collage, cotton fabric, and photographs, 31 x 57 in.

I still recollect Vietnam anniversary dates, sometimes once a month, sometimes once a year. I will always remember January 14, 1969, when the soldiers of the 25th Infantry Division, Charlie Company, were ambushed in Tay Ninh Province by a North Vietnamese column a mile long. The firefight lasted six hours and we lost Lieutenant John L. Warren and Captain Farrell of Bravo Company, who was killed by a sniper round while going for a radio. These memories of fellow veterans, brothers – black, white, blood or soul – I served with in Vietnam, will live with me forever.

Some say it haunts you, some say it bothers you that people are in the state they are in about the Vietnam War, because they don't know. They don't have the right to have the feelings that a Vietnam veteran shares in combat. This is a feeling special to vets.

Extinguishing anger was a big part of being back in the World. Their wives may forget them, their sisters and brothers, but their memory lives on with a fellow brother who you were with in combat.

Afro-Americans played a very significant part in Vietnam. They participated in a very difficult war when their heroes, such as Muhammad Ali, refused to go to Vietnam. I remember other brothers who were even injured and killed because they believed in not fighting the "white man's war." Because the Little Man [the Viet Cong] always had his stuff together. We had a saying: Sir Charles would hang your best shit up. So you always kept your stuff wired tight. The Vietnam War experience is one that I treasure and will take to the next life, because I love my fellow Vietnam veterans, Afro-Americans, blood, soul.

The art work is three American flags: one large, representing the whole United States, all of America, white, black, what have you; the second is the flag of the Vietnam veteran – a flag for all who served there; the third is the Afro-American flag, and represents the brothers who served there. The photograph in the center is of my comrades. I think we were on ambush at the time. These are the guys I would give my life to.

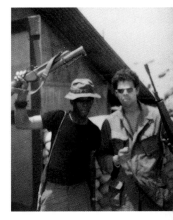

In Vietnam (Smith is at left)

Will Smith

Born New Orleans, Louisiana, 1949
Served in Vietnam, Army, 2d Battalion, 22d Infantry Regiment, 25th Infantry Division, Tay Ninh Province, radio operator, 1968–69

170 *Foxhole Prayer*. 1991. Watercolor on paper, 12 x 10 in. Based on a photograph by David Douglas Duncan

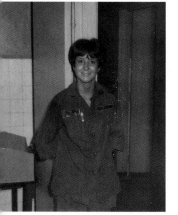

On Wards 2 and 4, 67th Evac Hospital, Qui Nhon, February 8, 1969

From a letter, 1996:

When I returned to the World, I thought I'd leave Vietnam behind and go on with my life, untouched by the events of the past. By the time I realized that Vietnam could never be left behind, that it was as much a part of me as my brain and heart, that it directed my soul as much as my organs directed my body, it was too late to talk about it. Words caught in my throat and welled in my eyes. Of necessity writing and painting became my voice.

Most of us were very young and inexperienced when we joined the different services and were sent to Vietnam. We wanted so much to hold onto that youthful innocence, despite the war. It was, of course, a losing battle, but one we thought worth fighting.

From a manuscript:

There were hundreds of those boy faces with old, old eyes. I could see the faces of all those kids who had been on [Ward] B-8: Willie from Detroit; the triple amp – I can't remember his name – last week in bed 7; the little tunnel rat from Puerto Rico with no legs. I could see the faces of friends from high school, sent to this place to fight a faceless enemy. I could see faces staring out of Glad bags; and the face of an old woman, her features so distorted in my mind that she was nothing but a gook to me. How I used to wince when I heard others use the word *gook*. When did that change happen? And how? Why couldn't I see anything but a gaping hole with a tube hanging from it? Where was her face?

Mary Louise (McCurdy) Sorrin

Born Woodward, Oklahoma, 1946
Served in Vietnam, Army Nurse Corps,
12th Evacuation Hospital, Cu Chi, and
67th Evacuation Hospital, Qui Nhon,
intensive-care nurse, 1968–69

From letters:

In the summer of 1970 I was listening to Jimi Hendrix play "The Star Spangled Banner" in Georgia; in the summer of 1971 I was on a Huey chopper, en route to Beautiful Chu Lai by the Sea. For Americans the war was winding down; the Americal Division was withdrawing from Chu Lai, except for me and about sixty other lucky soldiers, assigned to look for signs of American POWs in military intelligence field detachments. Always there was the fear that someone or something terrible would materialize.

When I was eventually withdrawn, I went in one day from Chu Lai to Da Nang to Saigon on a Huey, then on the Freedom Bird back to the World: to a bubble chair, Day-Glo, black light, homegrown grass, Miller draft, and the banks of the river Charles. Within one week of notification I was in Boston. For years I dreamed of that strange man at the window; was he attempting to give me some sort of signal? Who is looking out and who is looking in?

This painting has been worked and reworked for more than twenty years and at times destroyed, though the original portrait was always resurrected. That's the whole Vietnam connection: sometimes the memories are very sharp, sometimes buried or covered over in paint. Sometimes the memories and the painting sat in a closet of sorts, only to resurface again. It is an attempt to accept and face the reality of Vietnam, to document on canvas one image that might bring closure.

171 *Self-Portrait: The Vietnam Vet.*
1973–85. Acrylic on canvas, 30 x 24 in.

At Chu Lai, 1972

Benjamin I. Suarez

Born Camagüey, Cuba, 1950
Served in Vietnam, Army, 525th
Military Intelligence Group,
504th Signal Battalion, Chu Lai,
radio teletype operator, 1971–72

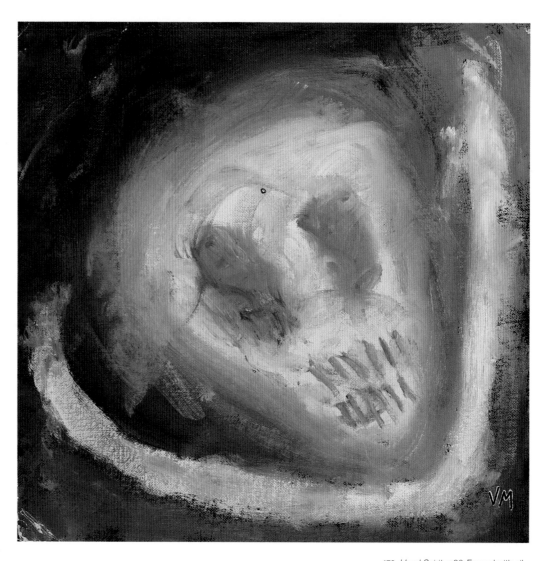

172 *Head Spirit*. 1986. Enamel with oil on canvasboard, 12 x 12 in.

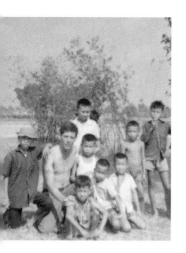

"No smiles: me and some Vietnamese kids, February 1969"

Gregory Van Maanen

Born Paterson, New Jersey, 1947
Served in Vietnam, Army, 1st Battalion,
505th Infantry Regiment, 82d Airborne
Division, southwest of Saigon,
III Corps, rifleman, 1968–69

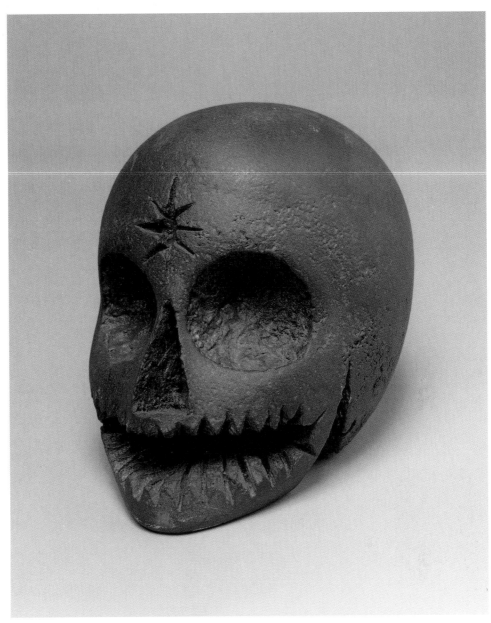

173 *Head.* 1992. Cast iron, 6 x 5 x 7½ in.

Vietnam: It's no easy
task to turn yourself
invisible, under force,
when you don't know
how.

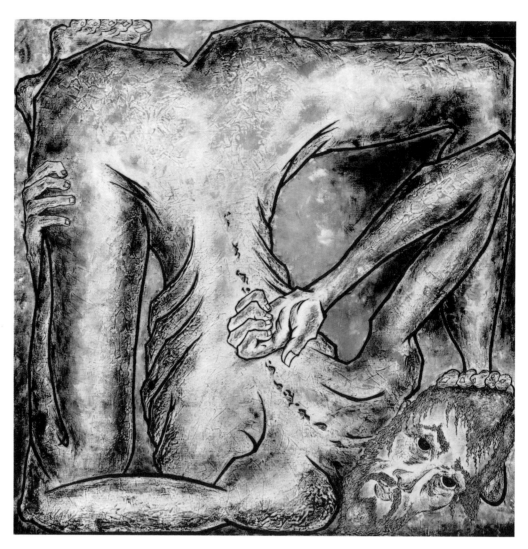

174 *The Man in the Box.* 1978. Acrylic
with modeling paste on canvas,
36 x 36 in.

During Operation Lincoln, in the jungle
of the Central Highlands, somewhere
between Pleiku and Ban Me Thuot,
May 1966

From a letter, 1996:

I wasn't a captive, or a prisoner of war (at
least not in the physical sense, though a lot
of us have been prisoners in other ways).
Every spare moment not given over to daily
life is spent in the hell of remarkable memo-
ries, whose accuracy is terrifying. . . .

Everyone should know this with certainty:
there was no peace with honor.

John Weaver

Born Florence, South Carolina, 1938
Served in Vietnam, Air Force, Forward
Air Control Team, attached to Army, 3d
Brigade, 25th Infantry Division, Pleiku
and Central Highlands, air-to-air and
air-to-ground radio communications
and air-strike coordination, 1965–66;
1967

From a letter written in Vietnam, 1970:

Last night we set some booby traps and a poor *deer* walked into one and was killed. He was so torn up that we couldn't even get the meat off for some steaks. The guys just buried him. . . . Don't worry about me – I'm keeping my shit in order. I just pray that I haven't changed when I come back. This war is cruel, but in a funny way. It's hard to explain: we're not fighting every minute; we're just conscious of the enemy every minute. . . .

From a series of letters written in Australia, 1984, 1988, 1992, and 1996:

After one day, I hated being in the rear. The field was my home. I felt I had some control over my life when I was walking point; in the rear we were sitting targets.

You know, I never wanted that "war"; if I had to do it all over again, I probably wouldn't have gone – all those dead and walking wounded. But I'm not ashamed of what I did: I'm proud. I did my best. I did what was asked of me by my country. I saw death and pain, but I also saw great strength. . . .

If my country feels shame or guilt because of its involvement, tough shit. I refuse to share that feeling any longer. I've been there and now I'm back.

I paint every day – cheap junk for the locals – cake-and-ice-cream art, but I also lay out and plan some big, good, meaningful stuff. Living in Australia, lately I've been painting the reality of the Anzac vets – why they went, their courage, male images, history – it's all

so, so different from ours. Mention Vietnam here and, man, does one get some funny looks. So much for a cupcake-and-ice-cream war. . . . All I want is a chance to show the world that the lowly grunt has insight, feelings, an understanding of life and death that few others have. Do I want to be remembered as a Vietnam vet artist or as an artist? Do I paint my anger to attack the public or to educate it? Do we think of Goya as a painter of the disasters of the Napoleonic wars, or as the painter of the royal family of Spain?

I'm told my first wife says the guy she married died in Vietnam (ha); I'm a cute ghost, for sure. . . .

At times I wish I could turn off my mind. I believe I'm toooo emotional about my world. All wars are hell, but the losses aren't just in the number of body bags that come home. You have to count everything that happened – all this muddy shit, these foggy years. I'm tired, at times so tired. All the pain, all the loss – I wish at times I could turn it off. I'll try to paint it and touch a few hearts and maybe heal mine.

War was always shown to me as the proper, moral, and American way to deal with international problems – heroes, glory, black-and-white answers. After serving in Vietnam, I knew war wasn't like that. In *The Vietnam War* I hope the contrast of colors, the pain of the wounded, the compassion of the medic, the contrast of lettering, and the indifference and ignorance of those who weren't there can all be seen together.

Well, I'm still here, still on R & R.

"Christmas 1970, Camp Eagle, me and my possessions: an ammo can containing letters, pictures, and foot powder (ha)"

Kenneth Willhite

Born Pontiac, Michigan, 1949
Served in Vietnam, Army, 2d Battalion,
502d Infantry Regiment, 101st Airborne
Division, Camp Eagle, Phu Bai, A Shau
Valley, Quang Tri, grunt, point man, and
ground-pounder, 1970–71

175 *The Castrator.* 1983. Acrylic on
 canvas, seven panels, 36 x 55 in.
 overall

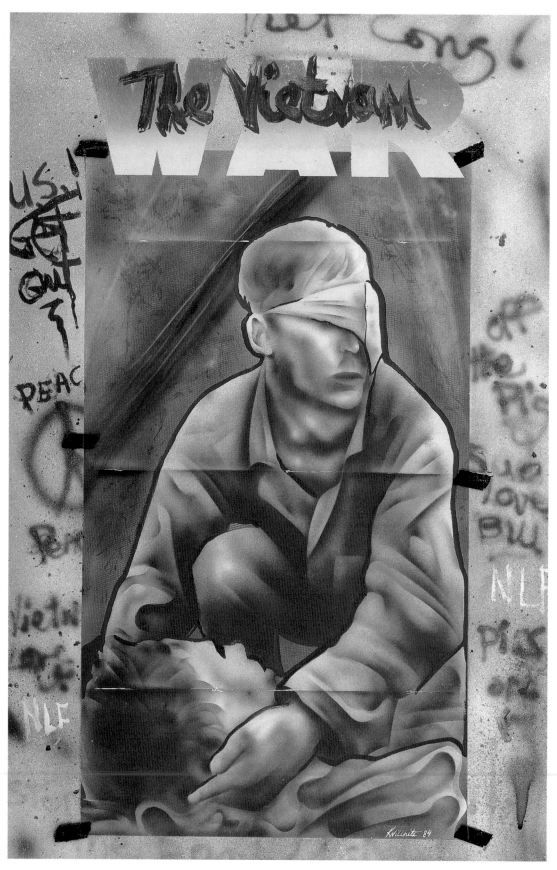

176 *The Vietnam War.* 1984. Watercolor and gouache on board, 30 x 20 in. Central image based on a 1966 photograph by Henri Huet

In 1970 I was sent to Vietnam and assigned to a combat-engineer company, building roads and clearing land in the jungle, until an army entertainment director heard me playing guitar at a service club. He suggested I form a band to perform for the troops in the field. For the next two months my band, the Soul Coordinators, and I traveled to remote fighting areas throughout Vietnam, often setting up drums and amps in the deep jungle mud. Sometimes our music competed with artillery fire.

In Vietnam we seldom talked about our feelings or about the war; conversations were limited. Music and photography were my forms of expression, then as now. Recently I wrote a quartet, *Quiet Shadows,* a portrayal of four soldiers on guard duty in Vietnam. Guard duty began while it was still daylight, late in the afternoon. One day I was on guard duty near a very strangely shaped tree, which I was sure would fool me later into mistaking it for an enemy soldier. I tried to memorize its shape but sure enough, when night fell I knew

that tree was the enemy. All night I continued to perceive other shapes as dangers that in the morning light proved only to be natural growths in the jungle surroundings.

The four musicians sit facing outward in the four cardinal directions. Like the soldiers they represent, they should not communicate with each other during their watch, verbally or visually. While they experience similar emotions and thoughts, their interpretations of that experience will be unique to themselves. Their world is a shared experience characterized by limited communication, at times producing chaotic effects, but also capable of generating spontaneous patterns of beauty.

I use both music and photography to try to capture events and relate them to emotions and feelings. With photography in Vietnam, I wanted the viewer to question the relationship between the actual subject of the photograph and the environment the subject was photographed in. My Vietnam photographs reflect the many different emotional highs and lows that I experienced while in country.

Many artists who are not Vietnam veterans have expressed their views about Vietnam and the war by looking through a window they have never opened. That expression is legitimate and valuable. However, the conversation I hope to engage in, through photography and music, is from the heart of my experience, bringing the receptor through the glass and into the sea that is truth.

At Lai Khe, May 1970

Kimo Williams

Born Amityville, New York, 1950
Served in Vietnam, Army, 168th
Combat Engineers Battalion, 20th
Engineer Brigade, Lai Khe, combat
engineer and band leader of the
Soul Coordinators, 1970–71

177 *The Real Gig* (the Soul Coordinators in Vietnam). 1970. Color photograph, 11 x 8 in.

\mathcal{I} was in the U.S. Air Force for twenty years. I served in Vietnam in 1968–69. A very close friend of mine was killed the day before he was to leave Vietnam. He was assigned to a rescue squad and volunteered for a rescue mission. It is painful to live with death constantly surrounding you, knowing that it could grab you just as easily as the other guy. I thank God every day for allowing me to return alive and as a whole person, but the memories are difficult to extinguish.

I started painting in 1978, after a heart attack. At that time I was advised by a doctor to get involved with something that required patience.

This work was not done by the congressman riding to work in his chauffeur-driven limousine, reading the *Washington Post*, nor was it done by the anchorman on the six o'clock news, but by the man who pulled the trigger on the M-16, dropped the bombs, and threw the hand grenades. This is the war by those who fought it.

At Phu Cat Air Base, probably 1968

178 *We Regret To Inform You.* 1979. Oil on canvas, 35½ x 26½ in.

Cleveland Wright

Born Waynesboro, Georgia, 1931;
died Greensboro, North Carolina, 1992
Served in Vietnam, Air Force, 37th
Supply Squadron, Phu Cat Air Base,
Binh Dinh Province, Central Highlands,
NCO in charge of inventory section,
1968–69

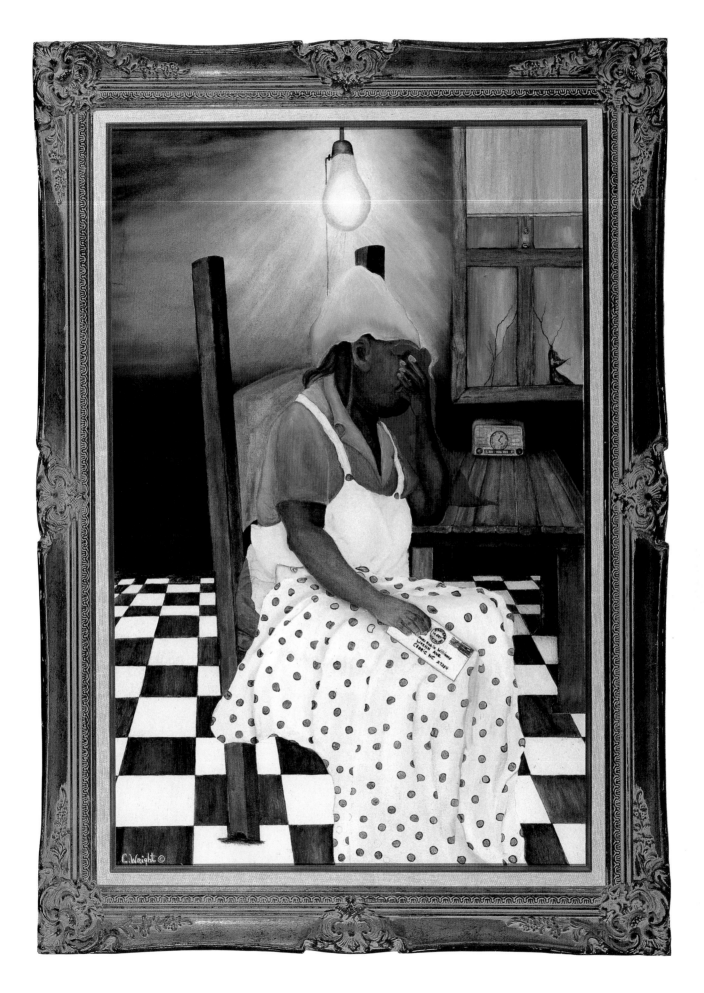

From notes and letters:

The figure I draw is the depersonalized soldier, the soldier within, who has suppressed the emotion of the community of war. To me it is impossible to see war as anything but an old habit of thinking, an old frame of mind, and an old male political maneuver. The physical act of war contains many ingredients: the personality of heroism, horror, a strange glamour, destruction, and desolation. I have internalized the experience of the physical act of war and transformed it into the metaphorical gestures of the human form. The living form becomes a brutalized icon.

These figures are the vehicle of my interpretation of the moments in Vietnam that deal with the remoteness, transcendence, and finality of life. They are silent screams, ritual destruction, intoxication, insanity, sorrow, and death. They are images of power, but also represent savage men. They are caught between the image of a soldier dehumanized by war and that of a man trapped in a state of raw self-conflict.

My drawings show lacerated, visceral images of exposed veins and muscles; through this kind of imagery I intend to show my figures as actual men, not heroes – men whose own bodies explode from within. The seared skins express an unsuspected ferocity and frailty that is as self-wounding as it is defiant.

The figures require a space of their own. For most of my art career I've been interested in spontaneous human gestures. I have enhanced the definition of the figures with a violence of line and with acid color.

Life is never solved. It is good that the art in this collection is controversial. I see that it unfolds a mystery, a mystery of strange tongues, strange smells, names of villages that we can hardly pronounce, an ignorance of ethics. The art suffers the anguish, the stripped skins and minds of soldiers who no longer exist.

There is the real and there is the dream. You make art somewhere between the reality of being and the reality of becoming.

In I Corps, 1970

Richard Russell Yohnka

Born Chebanese, Illinois, 1951;
died Chebanese, Illinois, 1997
Served in Vietnam, Army, 571st Ordnance
and Detachment Team 2, attached to
101st Airborne Division, Camp Evans,
north of Hue, Phu Bai, and Da Nang,
small-arms, security, and demolition
specialist, trained in chemical, biological,
and radiological warfare, 1971–72

179 *I'm Hit.* 1979. Pastel on paper,
60¼ x 42½ in.

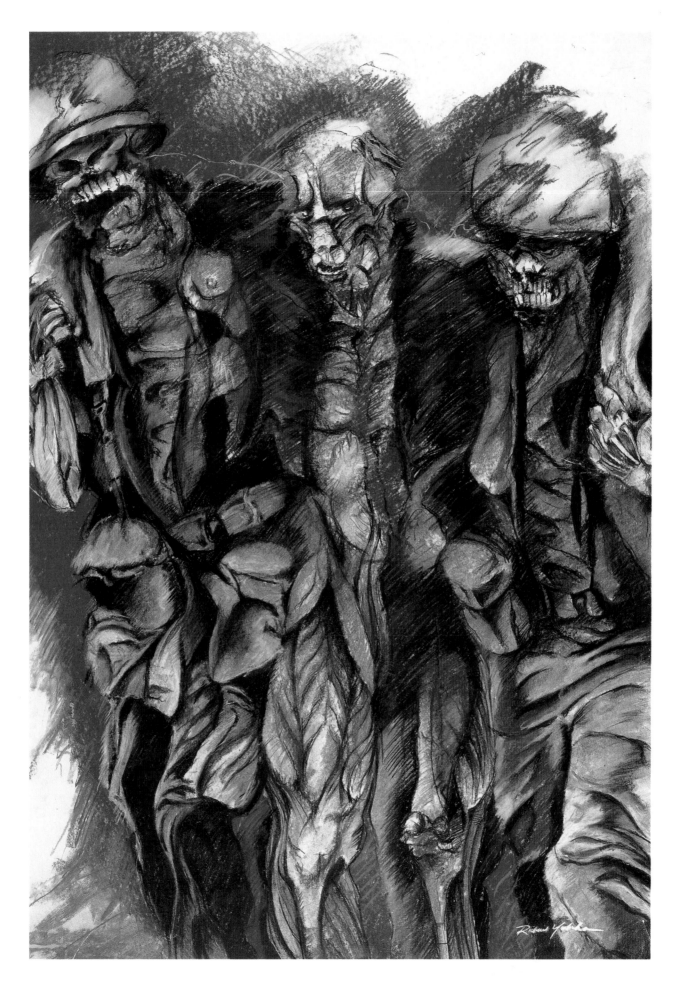

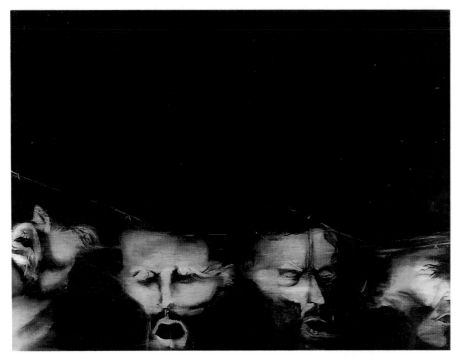

180 *Echoes.* Undated. Oil on canvas,
36 x 48 in.

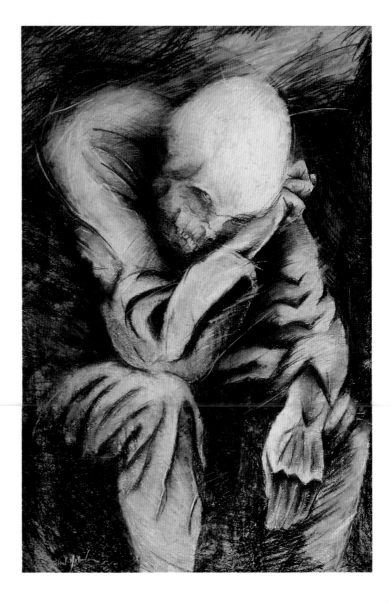

181 *The Survivor.* 1981. Pastel on
paper, 60½ x 40½ in.

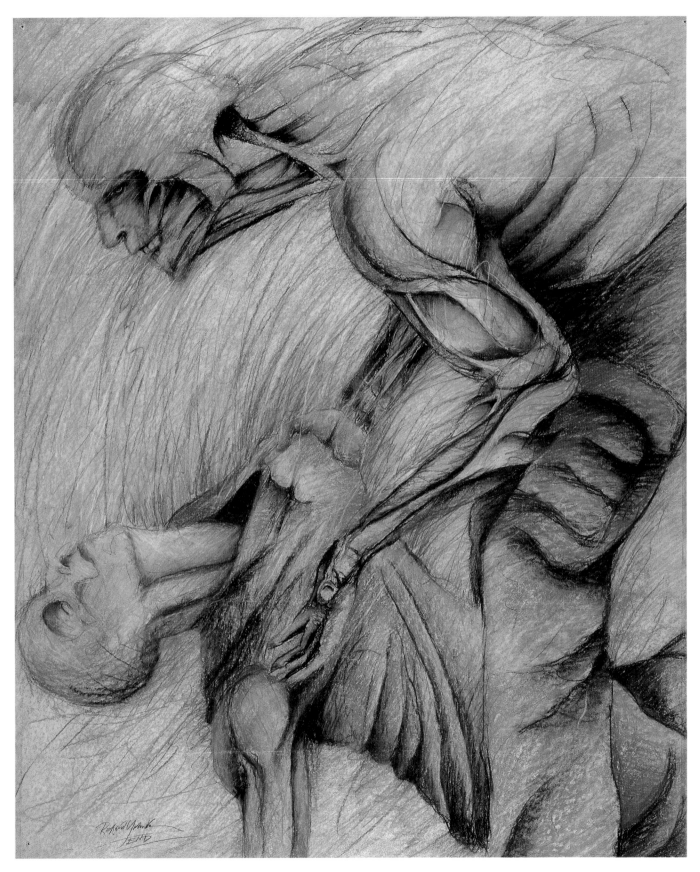

182 *This Is How You Died (The End).*
Undated. Pastel on paper, 60½ x 51 in.

I have the peculiar distinction of being, so far as I know, one of only two art historians who served with the army in the Vietnam War. By default, I suppose, this makes me a qualified expert on the art of Vietnam veterans. Let me therefore state right away that I had a limited combat role, although several times I managed to come close to being killed by incoming artillery, a truly terrifying experience. I am both intrigued by and uncomfortable about the art in this book: intrigued because I had no idea that Vietnam vets had done much art, let alone enough to form such a repository; uncomfortable because of my own desire to bury this part of the past as thoroughly as possible.

This is not easy art to discuss. In the first place, hardly anything has been written about the art of Vietnam veterans, so there is no significant body of critical work to build on. What little has appeared is generally written from a very liberal bias. Regardless of their political persuasions (which run the full spectrum), all the Vietnam veterans I have spoken to are deeply offended by the use of their art as a vehicle for someone else's political opinions. Yet to treat it neutrally is hardly possible. I cannot simply objectify such a troubling period of my life. Moreover, to treat it as a relic of the past by writing in the well-honed jargon of the intellectual would fail to do justice to the art, which is highly personal. However, it is difficult to discuss Vietnam from personal experience without imposing my point of view on the art. I have nevertheless tried to do so here.

Art as Experience:
Works by Vietnam Veterans

Anthony F. Janson

Served in Vietnam, Army, 709th
Maintenance Battalion, 9th Infantry
Division, Dong Tam, clerk and
electronics repairman, 1969

What is my own perspective? I went into the army very reluctantly, holding strong pacifist feelings. It is testimony to the power of art that my antiwar feelings were first stirred, as a child, by Francisco de Goya's *The Third of May, 1808* (fig. 1). To a young boy it was an unforgettable image of destruction, as incomprehensible in its terror as it was stark in its portrayal of unspeakable tragedy. I entered the army for mundane personal reasons: it was the only way to marry the woman I loved; otherwise, I would undoubtedly have left the country to avoid conscription. I still feel that in going, I let my conscience down. It remains one of the great regrets of my life, and continues to trouble me greatly.

I hated the army from my first day of basic training, which was a loathsome experience. I went to Vietnam in early 1969, serving with the 9th Infantry Division, southwest of Saigon, opposed even more vehemently to the war. The vast majority of men who entered the army during the Vietnam era were young and poor. In the appalling circumstances of the war the goal of soldiers became sheer survival, their sole emotion rage.

The point is critical to understanding the peculiar impact that Vietnam had on many veterans, myself included. It is hard to describe the bitterness so many of us felt. The anger was magnified by the reception veterans received upon returning home to an ungrateful country. During the course of 1969 the United States underwent a remarkable shift in attitude toward the war. The contributory role of the media was oddly ambiguous. On the one hand, television brought the horror and futility of Vietnam home to every living room in America. The sheer accumulation of carnage seen on the evening news did much to turn public opinion against the war. On the other hand, the reporting itself was often blatantly dishonest, for it became bound up in the machinations of policymakers who overtly manipulated it. As a result, Vietnam veterans returned to an America that was ashamed at losing the war, and for having prosecuted it in the first place. Vietnam was a dirty secret that everyone hoped would go away. If I had not been a pacifist before I went to Vietnam, I surely would have become one while I was there.

I can't claim to speak for Vietnam veterans or the artists among them. Such a thing is inherently impossible anyway. But regardless of the sometimes vast differences of opinion that separate us on many issues, we share the bond of common, and extremely difficult, experience. For that reason, every Vietnam veteran is to me a brother. I have therefore tried to interpret the art of my fellow veterans for readers who are unfamiliar with art in general and this genre in particular. The writing has been arduous and humbling. Others will have the privilege of writing about this subject in greater depth. My contribution, I hope, is to discuss the work with a sympathy and understanding that I believe very few others have to offer.

It is impossible to know how long veterans have been making art. In this country the tradition, if it can be called that, dates back to around the Revolutionary War — that is, to the first American veterans. In modern times, we know that artists made paintings and drawings during and after the two world wars, but surprisingly little of that work has been preserved; the same is true of the Korean War. The main reason is not simply the vicissitudes of combat and time, but also the lack of any sense that it might be important. In fact, it is sheer good fortune that a repository of Vietnam War art exists at all. A large percentage of the art made by Vietnam veterans in the years after the war was destroyed by the artists themselves. Sometimes works turn up at garage sales. While most of these are hardly masterpieces, it is

Figure 1. Francisco de Goya. *Execution of the Madrileños on the Third of May, 1808*. 1814–15. Oil on canvas, 8 ft. 9 in. x 13 ft. 4 in. Museo del Prado, Madrid

striking that so little significance has been attached to them. It was, it seems, the act of making them that was important. This suggests — wrongly, as it turns out — that they served as little more than vehicles for exorcizing demons and could be discarded once they had served their magical purpose. Too often the work of veterans has been seen simply as "art therapy" for men and women seeking to rebuild shattered lives. Only a very small number of works by veterans, in this collection or elsewhere, originated in a therapeutic context, as a means of dealing with trauma.

Furthermore, to treat veterans' art merely as therapy is to miss the larger point. In the first place, these works are documents of their time and for that reason of great historical interest, just as diaries and oral histories are. Additionally, many are legitimate works of art, especially the ones assembled in this book from the collection of the National Vietnam Veterans Art Museum. As such, they deserve to be treated with respect. Though the art of Vietnam veterans cannot be classified as a movement, it should be studied like any other body of art. It participates in the widespread tendency during the late twentieth century to develop kinds of art based on shared personal or social experience. Like outsider and barrio art, it is a distinctive current and is found everywhere around the country, motivated by its own impulses and waiting only to be recognized, however belatedly. Yet the art of veterans has never become an organized entity, like feminist art, with an agenda that it actively promotes. Until very recently, it even lacked any permanent home.

The problem with what might be called special-interest art is that it demands we view it not as pure art but first and foremost as expression. It is not easy to accept the primacy of content in a culture imbued with the attitude of art for art's sake and burdened by an emphasis on formalist art criticism. Nevertheless, under the banner of revisionism we have learned to tolerate art forms that would never have been accepted by traditional — or even traditionally modernist — standards. The art of Vietnam veterans may be included in this expanding canon, which readily admits it. The fact is that at the end of the millennium contemporary American art is issue-oriented as never before — almost, it

would seem, to the point of iconoclasm. As a consequence, aesthetic values have become a decidedly secondary consideration. Does this mean that we must suspend all aesthetic judgment? Such a thing is neither possible nor desirable. But it does require that we evaluate whether the artistic expression is suitable to the statement each work seeks to make. For that reason, I have chosen to discuss this art primarily in terms of the experience of the Vietnam War itself and the kind of personal meaning that it has to those who participated, as I did, in the conflict. At the same time, I will treat it in the context of modern art as a whole, because it participates in much wider tendencies that have prevailed since 1945. One cannot imagine it having been done at any other time. Thus, content and mode of expression condition one another. These factors may serve to make Vietnam veterans' art comprehensible to those who were fortunate enough to remain untouched by the war.

Paintings and Drawings

Like the other major wars of this century, the Vietnam War was heavily documented by photography and film. The National Vietnam Veterans Art Museum itself has a substantial collection of slides and photographs, taken by combatants, that are often very explicit indeed. Why, then, did so many veterans feel the urge to make art when there is such a rich visual record? Surprisingly (since we all tend to judge art according to photographic standards), a large portion of Vietnam veterans' art is not particularly realist, or realistic. On the contrary, much of the best work not only takes considerable liberties with visual truth, but interprets it in a decidedly unnaturalistic, often abstract manner. The reason is that even the most accurate photograph represents only one sort of truth, and not necessarily the most meaningful kind at that. In the first place, a photograph captures only a certain slice of reality and, by its very selectiveness, distorts the larger experience that it purports to represent. We see this even in images that are patently based on photographs, such as those by Michael Kelley (no. 88), Dale Samuelson (no. 152), or Mary Louise Sorrin (no. 170). Since they are one step further removed from actual experience, these rudimentary drawings and paintings are less faithful to visual reality, yet they strive to be truthful in a larger sense.

The issue lies in the choice of image and how it is manipulated in the replica, which in turn further alters the nature of what is depicted. What is changed? What is emphasized? What is omitted? In such works one sees the artist working to transform an image acquired secondhand.

When we were over there, in Vietnam, almost everyone took photographs of his or her buddies. *The Young Rascals* by Art Jacobs (no. 84) and an untitled photograph by Ray Burns (no. 23) are good examples of the kind of picture familiar in every war of this century: of men, so very young at the time, posing heroically even in their nonchalance. What has become of all those thousands of photographs? Most no longer survive. Many just faded away, like the public memories of the war itself. Others were intentionally discarded. (I threw mine away years ago.) "Friends forever" lost contact with each other soon after the war, as they struggled to find new lives, since the old ones they had left behind in many cases were gone forever. Curiously, it is the verism of those pictures that conspires against them. One blinks at them in disbelief: God, were we ever that young? Over time, the people immortalized in snapshots lose their individuality. This strange truth is well conveyed by Elgin Carver's painting after a photograph, *Exiles on Main Street* (no. 27). It employs a kind of abstraction, vivid colors, and bold stylization to make an average scene memorable. Each face looks different, but the seven men become prototypes and as such represent something much larger than themselves. They stand, in a sense, for everyone who went to Vietnam: posing in their fatigues in the cluster of a group portrait taken, perhaps, during a quiet moment at a firebase. They are smiling, but one bears a gaping, cartoonlike stomach wound. In the background is an American city street with a bright red fireplug; a woman and child standing by a front stoop may signify the normal life soldiers left behind when they went to Southeast Asia — from the World, as we called it — although they are, incongruously, Vietnamese.

The selective and transformative nature of art in dealing with photography is further shown in *Contained War* by David Sessions (no. 156). Its twenty postcard-size images are composed of photograph elements

collaged with watercolors laboriously copied from photographs; the technique, incorporating over- and underpainting, deliberately obscures some details and heightens others. But rather than serving to measure the realism of the rest, these surreal details call the reality of the whole experience into question by super-imposing vignettes from the war against others of the World: an average family cheerfully waving good-bye to soldiers trudging along a beach littered with sandbags and the debris of war; a soldier sprawled across the back of a convertible; a soaking-wet infantryman crawling through mud near a girlie picture and a sixties-moderne telephone; cars, bathing beauties, and a tank in a landscape; a grief-stricken soldier standing beside a television showing the war in a typical middle-class home. What is more "real," or at least more meaningful: the vivid scenes in the combat photographs, or the memories of home taken from advertisements? The contrast heightens the personal tragedy of Vietnam. What it expresses most of all is the sense of dislocation felt by American soldiers in country: the awful immediacy of the war compared with the jumbled memories of home, and how all these images merged in dreams to become nightmares of both.

The lingering eroticism in such images is pointed. Men at war experience the height of aggression and sexual privation, which compound each other. Love becomes a fantasy purveyed by media imagery, intimacy a distant memory perceived through the veil of time and distance and mingled with intense anxiety. *1, 2, 3, Destruction* by Bill Reis (no. 145) reveals this fear in vivid terms. The painting is in three parts, each showing a figure in a similar pose. This may be the artist in three contexts, or it may be three distinct figures: to the left is a haunting dreamscape representing all that the soldier has left behind; to the right is a ghastly demon of death, set against an inferno; and in the middle a silhouette represents the artist as physically and emotionally devastated.

Like all soldiers, we lived for mail call. Frankie Howery's preserved letters home (no. 80), with their witty little drawings, are among the reminders in the collection of how important correspondence from fam-

ily, friends, and lovers was to us, and in turn how important the ritual of writing letters home became. By the same token, the toll on families whose sons and brothers were killed in the war is alluded to in Cleveland Wright's *We Regret To Inform You* (no. 178), which conveys grief simply and eloquently, and in John Miller's small bronze, *Woman in Grief* (no. 116).

An artist who presents an explicitly black perspective on the war is Ulysses Marshall. He paints in what I regard as a classic African-American vein. His colorful style makes skillful use of abstraction, with Caribbean overtones, to make images that are symbolic rather than representational, even though their subject matter remains recognizable. The almost impenetrable, mask-like faces, flat forms, and intense color in *Blue Angels* (no. 98) serve to lift the scene out of any specific context, so that it becomes a symbol of what was a very common experience. The picture shows a wounded soldier tended by a medic and sergeant. In the background are two angels whose enigmatic presence can be equated with the two caretakers themselves, or interpreted as guardian figures or even angels of death who have come to take the soul of the warrior.

There is remarkably little direct commentary for or against the war in the art of Vietnam veterans. One reason, perhaps, is that much of this work was done well after returning Stateside. Whatever damage had been inflicted, whatever atonement had been made, whatever semblance of normality had been achieved — all this was over and done with, though coming to terms with the war in a personal sense long remained unfinished business, even in simple, everyday matters. Among the few works that seem to condemn the war directly is *Waiting for Henry Kissinger* by Charlie Shobe (no. 163), with the skeleton of a soldier whose fate has been determined by the intertwined flags of America and the two Vietnams flying like kites in the wind. The artist writes, "My paintings are of . . . butchery carried out for politicians, bureaucrats, and ambitious generals whose egos would not let them say 'enough.'" This attitude is also reflected in Scott Neistadt's *War Games* (no. 122), showing generals playing a realpolitik version of Monopoly, and Michael Kelley's *Westy and Friend* (no. 87), depicting General Westmoreland, the com-

mander of American forces in Vietnam, embraced by his buddy, the grinning figure of Death. Such sweeping condemnation is rare, however. One finds instead a pervasive sense of tragedy. Perhaps no single work captures that sorrow better than Neal Pollack's *Vietnam Service Ribbon* (no. 141), which transforms the yellow, green, and red Vietnam service badge into a bleeding face.

Because of the general unwillingness among Vietnam veteran artists to express a personal view about the political rights and wrongs of the war, the word-oriented art so common in postmodernism, juxtaposing text and image, is largely absent from their work. Those who use this approach do so very effectively, especially on an intimate scale: the greeting cards of Stephen Ham (no. 68), which are brief but eloquent personal statements, and the photographs of Jerry Kykisz (nos. 93, 94), which include longer, more assertive texts. Ham creates greeting cards, under the copyrighted name Dead Vet, for Memorial Day, Veterans' Day, and other holidays that he considers have lost their resonance. He also makes printed calendars, with significant dates marked, as well as paintings on paper.

Larger works necessarily have more immediate impact, however. The best examples incorporate images of Vietnam as emblems of the war's larger meaning. *Fascinating Vietnam* by William Hoin (no. 79) features an old, prewar tourist flier pasted onto a battlefield scene. The painting captures the GI's ironic sense of humor about our vacation in sunny Southeast Asia, but it also reflects the sharp contrast between the country as a simple paradise and as a war zone laid to waste by the machinery of modern warfare. In *Papa San* (no. 144), Robert Louis Posner enlarged a Vietnamese postage stamp and altered it to a scene of war with an old papa-san, a venerable figure who typified the country for many American soldiers. Aged, seemingly harmless peasants often turned out to be members of the Viet Cong; the problem was that one could never tell. In this case, the face is a near-portrait of Ho Chi Minh. The head of the Westerner in a cartouche at the upper left is a self-portrait and suggests how out of place Westerners – both the Americans and, before them, the French – were in Vietnam, and why they were ultimately defeated.

The most trenchant commentary is found in *Exhibition of Our Time* (no. 26), by the former South Vietnamese soldier Cao Ninh, which treats the American involvement as the final episode of a Western experiment in colonialism in Indochina (including Vietnam, Laos, and Cambodia) that began with the French in the middle of the nineteenth century. One could spend pages analyzing and deconstructing the content of this elaborate collage. Pasted together from fragments of newspaper and magazine clippings, it presents a kaleidoscopic and often conflicting overview of the war. The French downfall is signified by the *Paris Match* logo and the headline "Erreur au Cambodge" (Error in Cambodia); the American defeat likewise by the *Time* and *Life* magazine logos and the banner declaring "the end in Vietnam." A tiny element at the upper left is a fragment of headline that reads, wryly, "exhibition / the style of our times."

Kenneth Willhite's *The Vietnam War* (no. 176) condemns the lack of moral support for the troops that undermined their efforts, expresses the abiding bitterness some Vietnam veterans feel toward the radical peace activists of the era, and refers to the way the war was "sold" to the American public. The highly charged image of a wounded soldier caring for his buddy is floated like a commercial movie poster on a wall filled with antiwar graffiti.

American soldiers in Vietnam generally felt abandoned by their country. The contradictions of the situation were not lost on us: we all wanted to go home and escape a conflict that many of us did not support. The antiwar demonstrations hastened our departure – in my case by four months. During my tour of duty in 1969, at the very height of the war, the tide of American sentiment shifted so dramatically that few of us could comprehend the sea change when we returned. Yet even those most opposed to the war felt little gratitude toward the demonstrators who had taken to the streets to denounce it. Quite the opposite: we most often felt betrayed by people who did not have to participate in the conflict, because it had been our lives on the line. Worse, we were treated, by and large, like pariahs by our fellow Americans.

The consequence for many Vietnam veterans was a general sense of disillusionment with the country and the ideals that our generation had been brought up to value. Quite a few Vietnam veterans, myself included, who regard themselves as loyal Americans nevertheless had a hard time saluting the Stars and Stripes, especially before the national reconciliation movement in the mid-1980s.

That disappointment is reflected in the numerous images centering on American flags. The Stars and Stripes were elevated to iconic status by the Pop artist Jasper Johns in the early 1960s; but whereas he examined the flag's aesthetic qualities, Vietnam veterans used it to reexamine their values (nos. 10, 13, 111, 150, 153, 154). These artists are by no means anti-American. On the contrary, most would take extreme offense at the suggestion that they are in any way unpatriotic; though faith in their country was undeniably shaken, few of their flag works are intended as literal political statements. For the most part, their outlook reflects a staunch individualism that comes from having overcome often great personal difficulties and found a niche in society with very little help outside of family and other veterans – and least of all from the government and the Veterans Administration, which for years denied the consequences of exposure to the carcinogenic defoliant Agent Orange and other like problems. For them the flag is no sterile symbol; it has a power and energy that is deeply rooted in personal experience.

The Vietnam War permanently altered the mind of nearly every soldier who participated in it, especially those who saw heavy combat, and it is in self-portraits that we find the most direct attempts to come to terms with the artist's changed self-image. Farris Parker appraises his own features (no. 135) with an outward calm that belies the inner agitation conveyed by the brusque brushstrokes and olive-drab colors echoing his fatigues. He has chosen to paint himself as an active-duty soldier, in uniform. Lou Posner examines himself with equal dispassion, as a civilian after the war (no. 143). The room behind him and the medicine chest are as empty as his expression. In fact, the banal tone of the work is deceptive, for it conveys a state of alienation with great effectiveness. To me the most remarkable piece of all is the mirror assembled from jagged shards by Cao Ninh, titled *When I Look in the Mirror Each Morning* (no. 25). It cannot be reproduced properly, nor was the artist willing to appear in the photograph of its shining, fragmented surfaces. (Former South Vietnamese soldiers in the United States often prefer anonymity among other refugees.) The experience of the piece, in which not blank surfaces but a self-portrait of the viewer appears, can therefore not be duplicated on a book page. The shock of this work comes from seeing your own features reflected in it in such a cockamamie fashion. It literally reflects the shattered self-image of a veteran. For many years I myself could hardly bear to shave in a mirror in the morning, because I would often see only my broken face reflected back to me. Once, I even smashed a mirror with my fist in a rage when I could not believe that the intact image I was seeing was the real me.

The self-portraits belong to a much larger group of paintings of faces. Some, such as *This Is How It Works* by Ned Broderick (no. 17), are graphic depictions of dead or wounded soldiers. Equally unsettling is the haunted face in Richard Olsen's *Cong: Kill 'Em* (no. 129), which looks out at the viewer with a frozen terror that is riveting because it is nameless. Veterans respond strongly to these images, which illustrate their own feelings very directly. Nevertheless, Vietnam veteran artists have generally eschewed realism and turned instead to Expressionism to communicate complex emotions that cannot be represented by conventional means. Expressionism is the oldest ongoing artistic tradition of the twentieth century, to which it is unique, though its roots are considerably older. It has been updated in recent decades by Neo-Expressionists on both sides of the Atlantic as a vehicle for exposing the tensions of modern life. It is ideally suited to portray suffering, emotional as well as physical, which makes it the perfect vehicle for Vietnam veteran painters. Thus, *Physical Pain* by Theodore Gostas (no. 62), is reminiscent of Jean Dubuffet's demented clownlike figures; the shaped head by Karl Michel (no. 112) recalls Karel Appel's Burnt Face paintings, with the grotesqueness of Goya added. The difference is that these and other canvases, such as *Night Mission* by Stephen Ham (no. 67), were the outgrowth of direct experience. The

potency of these images lies in their *un*reality, which permits their makers to convey thoughts beyond words and get to the emotional heart of war.

It is but a step to paintings of entire bodies that are transformed almost beyond recognition. The destructive power of the instruments of modern warfare, such as rockets and napalm, is so stunning as to be beyond normal comprehension. Showing limbs missing and flesh seared off by heat of unbearable intensity, paintings by several artists (such as nos. 114, 127) capture not simply the physical annihilation but also the psychological devastation of combat. Contrary to what one might expect, paintings convey the shock of witnessing such carnage, and even the very feel of the charred remains, in a way that no photograph can match. Horrifying though they are at first glance, photographs of bodies blown to bits, such as *The Living Dead* and *The Dead Dead* by Arthur Dockter (nos. 36, 37), invite us to view the carnage with a curious objectivity that brings to mind the Pop artist Andy Warhol's screenprinted canvases based on newspaper photos of electric chairs and automobile wrecks. What Dockter's photos do suggest very well is the peculiar sense of humans as a kind of technological road kill. Like animals run over by cars or trucks, these fragmented bodies appear struck down at random by some awesome force. Yet that sense of vulnerability is communicated to even greater effect by the gleaming white, plucked chicken hovering like a surreal apparition out of one of Francis Bacon's canvases, which Michael Helbing painted shortly after his return from Vietnam (no. 76).

Very little Vietnam veterans' art attempts to treat the war in terms of literal narrative. Perhaps that's just as well, for it is nearly impossible to communicate the feel of actual combat in a still image. In any event, the issue for most Vietnam veteran artists is to capture what they had experienced within themselves, in order to understand the war in personal terms. By choosing to avoid the obvious, these artists arrive at a profound insight into what happened to them over there.

A large class of paintings plumbs the dark side of the human psyche in the hope of rendering the unfathomable intelligible. These works vary widely in style and content; if they have a common theme, it is that of the Beast. This was the name that grunts I knew gave to

the thing that ate away at their souls and dehumanized them in the name of survival and victory. Some openly wondered whether they could ever come back to the World, because the Beast had transformed them so completely that they had no real place anymore. An artist consciously concerned with the Beast is Michael Duffy. His paintings, such as *Facing La Guerra* (no. 40), in which War becomes a primitive totemic figure in the night, are cacophonies of clashing elements executed in an urgent, colorful Expressionist style. Thomas Gilbertson's *Night Life (Guardians of the Secret)* (no. 57) presents the kind of charred, barren landscape associated with the German Neo-Expressionists A. R. Penck and Anselm Kiefer, whose works deal with difficult unresolved issues posed by the role of Germany in World War II. The creature at the right — a fox? wolf? a dog, perhaps? — stands for the nameless Beast of war that soldiers discovered within themselves in Vietnam.

The pastel drawings of Richard Yohnka also deal with the Beast, albeit in an entirely different way. His subject is, he writes, "the depersonalized soldier, the soldier within, who has suppressed the emotion of the community of war." The "lacerated, visceral images of exposed veins and muscles . . . express an unsuspected ferocity" that exposes the fundamental nature of war itself. At one level, they describe fear and hatred in the most animal terms possible. At another level, they convey the psychological brutality of combat and its consequences for those who wage it. Yohnka's drawings are, in many respects, the most challenging works in the entire collection. Similar in style to the prints of Mauricio Lasansky, they have an emotional power that ranks them with the prints of Goya and Käthe Kollwitz, while omitting their overt commentary.

The finest paintings incorporate archetypal imagery that lifts them to a universal plane. *Falling Airman* (no. 109), by Leo McStravick, is a fantastic interpretation of what may have happened to comrades shot down during reconnaissance missions. The canvas is far from a literal description, however. What we contemplate is not so much a man plunging to his death as Icarus, the legendary figure who donned wings of wax and fell to earth because he tempted fate by disobeying

his father's admonition not to fly too close to the sun. Rather, the entire figure disintegrates in a fiery plume that, surprisingly enough, has the beauty of the veils of color painted by the great abstract painters of the 1960s, such as Morris Louis and especially Paul Jenkins.

Sculpture

The principal goal of American soldiers was to get home alive – preferably in one piece. For many, Vietnam meant an almost daily confrontation with death, including the possibility of their own. Many suffered serious wounds. It is little wonder that several veteran artists share an obsession with bones, which constitute some of the most compelling works in this collection. Stan Gillett reassembles bits of them into stick figures, strangely similar to neolithic clay figurines; their distorted anatomy and twisted poses make a mockery of life (no. 59). William Dugan collects the remnants of road kill, sometimes encasing them in mummy bandages, and places them in boxes (no. 42) that function partly as sarcophagi, partly as curio cabinets reminiscent of Joseph Cornell's peculiar boxes, but nastier in spirit. To complete the image, he sometimes constructs bizarre animals, such as *Guardian* (no. 41), with the passion of a paleontologist or archaeologist possessing a twisted mind. They nevertheless invite us to ponder the meaning of their motley company: the waste of life, its brevity, its insignificance, and, at the same time, its preciousness. The reference to interring and disinterring is clearer in Brian Maxfield's delicate *Artifact II* (no. 100), where the remains of a figure in its death anguish lie half-sunk in mud like the ancient skeletons of Pompeii and Herculaneum, buried for centuries in the ashes of Mount Vesuvius.

But bones need not only express destruction; they can also signify healing. In Michael Aschenbrenner's lyrical *Damaged Bones* series (no. 6) glass replicas of leg bones are carefully bound with wood and cloth splints. Although at first they repel, one comes to meditate on them in almost iconic fashion – exactly what the artist hopes for, but probably the last thing the viewer expects. In this way, they become moving statements in their somber, almost tender regard for the possibility of renewal amid the destruction of war.

The same desire to heal is conveyed in both the title and the work by Mary Margaret Caudill. The number of woman veterans of the Vietnam War who are also artists is, as one would expect, fairly small. Most of the women who served in Vietnam were nurses; those in combat-zone surgical units had an experience as extreme as that of most heavy-combat soldiers: they were in violent war virtually nonstop, sometimes for weeks at a time. *Healing the Wounds of War* (no. 28) is eloquent testimony to the important role they played. Caudill's set of soft, blurry faces of fragile, pale hand-cast paper are like the plaster death masks of nineteenth-century tradition. Yet death has given a semblance of peace to the trio cradled gently in the wire basket.

The work of Ned Broderick, who is both a painter and an assemblage artist, stands out for its consistent inventiveness and incisiveness. *The Wound* (no. 13), one of the signature works in the collection, acknowledges the damage done to the national fabric quite literally in a torn American flag. *Hi Mom . . . I'm Home* (no. 14) captures the strange sense of alienation that many vets felt when they returned to the World: it is the apparition of a face against a blood-colored background, hands pressed to the surface as if imprisoned behind an invisible barrier. Broderick's most startling piece is *Le Duc Tho Goes to Paris to Discuss the Shape of a Table* (no. 15). The reference, of course, is to the North Vietnamese delegate to the interminable, ineffective Paris peace talks that took place late in the war. These negotiations were characterized by insincerity and posturing on all sides: as thousands of soldiers died, the participants argued for months about whether to sit at a square or a round table. This quirky, oddly humorous piece, which features a rifle barrel emerging from a screaming face set within a cutout black suitcase, is a wonderfully ironic commentary.

As Broderick's work attests, the Surrealist tradition, which first arose in the 1920s, is alive and well. Many other Vietnam veterans have mined the same vein, and the objects they have created are often truly ingenious. Here are just a few of them: Jay Burnham-Kidwell's *Forgings – Revolutionary Furniture* (no. 21) shows a severe, quite implausible chair surmounted by

the bullet-riddled star of North Vietnam, from which dangles a Chinese Type 53 submachine gun, a weapon of the North Vietnamese and Viet Cong. It is simple, even elegant, and full of quiet menace. This kind of assemblage would be worthy of the Pop artist Robert Rauschenberg, whose early work was an outgrowth of his contact with the Dada and Surrealist artist Marcel Duchamp in New York. Equally bizarre is *Prairie Piece #14: For a Foreign Prairie* (no. 82), by Meredith Jack, which is like an inverted pungee trap that exposes its lethal sticks above ground – a witty irony in keeping with the grotesque Surrealist objects of Max Ernst and Salvador Dalí. Ernst would probably have appreciated the disjointed skeletal soldier in Michael Helbing's *One, Two, Three, Four, Let's All Go to War* (no. 77), made from bits and pieces of debris, including a spent shell. It is curiously reminiscent of the elaborately carved small-scale écorché skeletons done during the German Renaissance. One of the strangest contraptions of all is Josef Metz's *LZ Hurricane* (no. 110): it shows a barbed-wire stick figure springing from a helmet with a rocket embedded in its grinning death's head.

My personal favorite is *Dressed to Kill* (no. 53), by Joseph Fornelli, one of the very few artists to draw or paint while he was actually in Vietnam, and he carved this sculpture there, too. It was a stroke of genius to set the head bristling with shell casings in such a bold way. Thus adorned, the face, impassive as that of any drugstore Indian, is transformed into Bellona, the goddess of war. But when looked at head-on, it unmistakably becomes the head of the Statue of Liberty. Surely this must be counted as one of the classics of war imagery. I cannot think of a more sardonic critique of the American role in "defending democracy," the pretext commonly offered for our presence in Vietnam.

Fornelli is a gentle, soft-spoken person; the reference to Lady Liberty is not a conscious one. For the most part, however, such gestures are quite self-conscious. *The Pietà* by Michael Page (no. 134) is based on a photograph that reminded the artist of a Madonna and Child and a Virgin with the Dead Christ. He writes of "trying to show the pain and grief felt by young men in that situation, without missing the strength and compassion that were also present." It is the Beast, so to speak, but with a human face. What image could be more apposite than the pietà, so laden with meaning? In traditional Christian iconography the image of the Madonna and infant Christ is a premonition of his sacrifice, although the Bible makes no allusion to the pietà as such. To have compassion means "to suffer with," and is linked almost inextricably in Western art with the Passion of Christ: his torment as the Lord in human form intended to redeem humanity's sins. One need not be a Christian to be moved by Page's Everyman GI, for it reminds us that in combat the warrior can suffer as much as his victims. And without the hope of redemption, there is no possibility of forgiveness.

The Pietà is close to life-size, so that we cannot avoid it. No less confrontational are the large-scale sculptures of John McManus, which likewise use a heightened realism to bring home the plight of American prisoners of war and soldiers missing in action (POWs and MIAs), whose equivocal ghosts continue to haunt the lives of their comrades. *POW* (no. 107) is direct and potent, its emotional force arising from the contrast of raw subject and refined, beautiful craftsmanship. The title of *Abandoned* (no. 105) conveys a certain ambiguity: shrouded in a monklike habit, the beckoning figure, with his gaunt features, resembles a personification of death by the American sculptor Augustus Saint-Gaudens. But is he American or, as his Buddhist robe and face suggest, Vietnamese? These are virtuoso displays: it takes great skill to combine bronze with colored alabasters, and the technique is found in only a few periods in art history. It was first used during the Italian Renaissance, mainly for portraiture, and less commonly in Baroque art, then revived by the French Romantics, but rarely employed since then. It is remarkable to see it revived here, and in this context.

Let *Ritual Suicide Mask* (no. 72), by Randolph Harmes, end this brief overview. In this work the human face is bizarrely transmuted into a hideous yet astonishingly realistic mask in which is compressed all the guilt of survival felt by those of us who were fortunate enough to come home. I know. Two days before finishing this essay, it all came back to me. The experience has left me profoundly shaken.

1.

Art about War

The art in the collection of the National Vietnam Veterans Art Museum stands within an ancient visual tradition: the representation of war. Images of war appear in tomb paintings of dynastic Egypt and tomb sculptures of Han Chinese emperors; on temple pediments and decorations of ceramic vases of ancient Greece; on Roman triumphal columns and sarcophagi and in mosaics; in ancient Indian and Khmer temple carvings; in medieval European book illuminations, Mughal Indian miniatures, and Benin brass plaques; in Renaissance frescoes and Baroque canvases; and in every sort of painting, drawing, print, poster, and photograph of the modern era.

The art presented in this volume should be understood both within the context of its time and place and as a link to a very deep past. War has always been a central subject of art, but its purposes, its messages, the methods by which it is represented, and its effects have varied greatly. Depictions of war tend to fall into a few broad thematic categories: scenes of grandeur and triumph; scenes of pathos and lament; and records of a specific historical, mythological, or religious event, such as an important victory, a foundation myth, or an allegory of righteous conquest. Artists draw on a range of metonymies to represent the immense and grandiose subject of war – the battle piece on a vast scale, with a cast of thousands; the lone allegorical figure; the uninhabited and desolate landscape; the single, emblematic strand of barbed wire, the abstract

The Blank Space on the Gallery Wall: The Art of Vietnam Veterans in Context

Eve Sinaiko

smear of black paint – and each of these choices has its underlying rhetorical messages. Works of war art, including those by Vietnam War veterans, often contain elements of all these approaches.

Within the general categories, further distinctions may be made between public and private art; didactic and memorial art; art of mourning and art of celebration; polemical, engaged art, such as that of Francisco de Goya or certain works of Pablo Picasso, and the clinical, detached reportage of Mathew Brady or Alexander Gardner – though all these artists make related points. In surveying the historical body of war imagery, the viewer may come to see some differences between the work made by people who have been in a war and that made by more distant observers. Perhaps the most salient fact about war art is that the subject is universal, so that even the particularities of a long-past or alien war are usually readily understood by a modern viewer. The ancient Greek *Victory of Samothrace* still has the power to elate; Goya's *Disasters of War* still shock. Yet within these universals we may discover key differences in the messages war art conveys.

The Tradition of War Art

It is fitting to begin this brief survey with an art work from Southeast Asia. The great twelfth-century Khmer frieze at the temple of Angkor Wat in Cambodia depicts the Battle of Kuruksetra (fig. 2), a foundation myth (in this case a principal scene from the *Mahabarata*). It follows perhaps the most ancient tradition of war art: a battle of the gods or of a race of supermen. Battle here is heroic, deified: hierarchical rows of archers and spearmen, arranged in intricate patterns, clash on a grand scale; important personages are large, and anonymous foot soldiers are small; figures are aggregate representatives of a glorious moment of victory. Grandeur and drama are the keynotes.

Slightly older and from quite another culture is the *Bayeux Tapestry,* also monumental in scale and rich in incident. Probably made in northern France in about 1070–80, it features a sequence of embroidered scenes illustrating episodes from the Norman conquest of England. This textile belongs to the branch of war art that

Figure 2. *The Battle of Kuruksetra*, detail. Early twelfth century. Sandstone bas-relief, 159 ft. long. Temple of Angkor Wat, Cambodia

Figure 3. The Normans repulsed at the Battle of Hastings, a section of the *Bayeux Tapestry*. ca. 1070–80. Wool embroidery on linen, 20 in. x 229 ft. 8 in. Centre Guillaume le Conquérant, Bayeux, France

is explicitly historical, showing particular events and specific individuals. The *Bayeux Tapestry* is also political in that it presents its account from the perspective of the Normans. Despite a figurative style that is simple, flat, and cartoonish, reminiscent of a child's war drawings, it is convincing both as a record of events and as a visual narrative. The story is told in a central band more than two hundred feet long, captioned in places and embellished above with a strip of heraldic beasts and below with a second thin strip of detailed scenes, like footnotes. What engages the viewer most in this work is its profuse and graphic detail — the small particulars that convince us we are seeing an account of real events. In a segment in which King Harold's Saxons repulse the Norman troops (fig. 3) we have a masterful description of battle and its attendant barbarities: in the central frame horsemen engage with foot soldiers; an unarmed man dressed in cloth is killed by one in chain mail. In the lower register a corpse lies next to its severed head and archers attack, while two soldiers strip enemy bodies of their armor. The *Bayeux Tapestry* is a war narrative in the epic tradition, crafted to justify a war of conquest; but it does not fail to record even war's most intimate, bitter brutalities.

The battle painting, one of the key genres of war art, has a grand tradition in the West. The art historian Fred Licht identifies the following elements of such paintings: heroic proportions; a centered, balanced composition in which two antagonistic forces of equal weight "collide in an intricate whirl of motion and countermotion"; and an assumption of neutrality on the part of the painter and viewer.[1] Classic battle paintings are cast as contests between good and evil, and no matter how specifically historical the depicted battle may be, it is always also universal: Titans against Olympian gods, Greeks against Trojans, the armies of Philip of Spain against those of the Dutch Republic — all such scenes are equivalent, since the underlying theme is that of heroic effort, earned victory, and noble defeat.

Two important ideas are suggested here: first, the battle scene is understood to be implicated *by its nature* in ethical questions (the struggle between good

Figure 4. Albrecht Altdorfer. *The Battle of Alexander.*
1529. Oil on wood panel, 62 x 47¼ in. Alte Pinakothek,
Munich

and evil, the justification of aggression, the nobility of violent action) – albeit sometimes expressed only by their absence. Second, the place of the observer – his or her nearness to or distance from the battle – is understood to be a key element of the work itself. The battle painting is a rhetorical genre: the painter's argument is directed at the viewer, who is either excused from a deeper ethical engagement with the subject, or compelled to it. The shifting place of the viewer in relation to war scenes will warrant our closer attention.

Albrecht Altdorfer's *Battle of Alexander* (fig. 4), painted in 1529, is a fine example of a battle painting. It was commissioned by the Hapsburg duke Wilhelm of Bavaria as he was about to confront the massive armies of the invading Turks. It ostensibly represents a famous battle of antiquity, in which Alexander the Great's Greek army defeated the Persian Darius and his forces, though the soldiers all wear more-or-less contemporary dress and armor, and the landscape and background architecture are more Middle European than Middle Eastern. It is thus an allegory auguring victory to the Germans, praising heroic leadership, and promising a glorious posterity.

This is battle seen from a distance, without much pain or blood, few dead bodies, no expression of real violence or terror, and no personal identity attached to the actors. Not only the foot soldiers but even the two captains are difficult to distinguish. Indeed, the extreme minuteness of the myriad figures in the painting is startling: it looks like a battle of ant colonies. Delicate, jewellike, exquisitely painted, this scene is not intended to arouse feelings of horror or pity in us, but it is not a simple victory celebration either. Humanity is reduced to absolute anonymity; winners and losers alike swarm over a miniature terrain that we observe from a great height, like gods, indifferent. As a depiction of war *The Battle of Alexander* falls uneasily between the category of mythological or symbolic triumph and that of historical document.[2]

The ancient sculpture known as the *Dying Warrior* (fig. 5), from the pediment of a fifth-century B.C.E. temple at Aegina, in Greece, is valued as one of the canonical masterworks of Western art. This life-size figure is one of eleven that were grouped together into a large scene of the mythic Trojan War adorning the facade of the temple. The principal figures were engaged with one another in active combat stances, comprising a classic battle scene. The recumbent pose and original position of this figure in the left corner of the triangular pediment isolated him from that central action. Detached and alone, he is an eloquent personification of the tragedy of war. Now in a museum (and heavily restored

Figure 5. *Dying Warrior*, fragment from the east pediment of the Temple of Aphaia, Aegina. ca. 480 B.C.E. Marble, 72 in. long. Staatliche Antikensammlungen und Glyptothek, Munich

in the nineteenth century), he is displayed as an autonomous work of art, and thus has been removed from the genre of the battle group to that of the single, emblematic figure. Viewed as an individual, this warrior is the very archetype of classical tragic pathos: he lies dying in a posture of graceful and even elegant dignity. Leaning on his shield (he originally also held a sword) in a Homeric attitude of heroic defeat, he shows us a pure, idealized profile, a face in which the grimace of pain is smoothed into a stylized mask, and an undamaged body whose astonishing masculine beauty is perfect and unmarred, without visible wound. Dying, he sustains both poise and nobility; his body, in a turning pose, remains active but is not contorted with stress; it still symbolizes strength and self-control. This is no portrait of the destructive waste of war. The battle in which this hero is dying is one worth having fought, and he commands our admiration:

For a young man all is decorous
when he is cut down in battle and torn with the sharp
 bronze, and lies there
dead, and though dead still all that shows about him is
 beautiful.[3]

This is the early classical Greek notion of *kalos thanatos*, beautiful death. A critic notes: "The youth who dies on the battlefield is considered fortunate and beautiful, for he rises above the human condition, closer to the gods, by confronting the inevitable with courage and determination. In all ancient Greek art, *kalos thanatos* provides an appropriate opportunity to exalt the heroic ideal."[4] The artist's meaning is transparent: war is tragic, but worthy; we are moved by sorrow, but not by disgust. Twenty-five hundred years later, though its romantic view of war may seem alien to our sensibilities, we can understand this sculpture immediately.

The heroic as a tragic mode is a powerful, recurring traditional theme in art: the protagonist is handsome and young; his death is tragic but beautiful (that is, aesthetic). Shown in the intimacy of his last suffering, he is universal; and in the repose of his graceful limbs war itself lies purged of the crude particulars of politics, of right and wrong, of sides. The *Dying Warrior* appeals to what is personal in our understanding of war: sorrow at the loss of a life and recognition of the nobility of sacrifice. Many modern artists have found this notion suspect and argue against it – against the conflation of the beautiful and heroic with the tragic, and ultimately against the idea that the beautiful and heroic are capable of conveying the tragic. Nevertheless, the power of this idea has always been a driving force of both art and the national ideals that art often expresses, and remains so, even to modern eyes. At the same time, to our skeptical age, it seems deeply dishonest.

These works of art tell us that the experience of war is universal, that we have a mutual sense of what war is. And yet those who have participated in war directly, especially as soldiers, share an understanding that divides them utterly from those who have not. As makers of war art, such veterans are likely to stand apart from others in their reactions and attitudes to the subject. Can a viewer tell by looking at *The Battle of Alexander* whether Altdorfer had ever seen or been in a battle? Can one tell by looking at one of Francisco de Goya's war scenes (see figs. 1, 7) whether he had witnessed such an incident himself?

In 1633 the French engraver Jacques Callot made a portfolio of eighteen etchings called *The Miseries and Misfortunes of War* (fig. 6). These were an odd variation on a tradition of popular genre scenes – theatrical vignettes, for example – but far less lighthearted. Their grotesque, strikingly literal description of war atrocities is in its own way as rhetorical as the *Dying Warrior* or

Figure 6. Jacques Callot. *Hangman's Tree,* from *The Miseries and Misfortunes of War.* 1633. Etching, 3½ x 9 in. British Museum, London

Figure 7. Francisco de Goya. *They Avail Themselves,*
plate 16 from *The Disasters of War.* ca. 1815?, published
1863. Etching with drypoint, ca. 6 x 8 in. The Hispanic
Society of America, New York

The Battle of Alexander, but with an opposing purpose.
Callot represents a third tradition of war art: documen-
tary reportage. Acerbic and angry, he records the every-
day aspects of war in the manner suitable to the genre
artist that he is. He notes plain facts: that after the grand
army has passed with its flying banners, corpses litter
the ground and hang from trees; that when soldiers lie
dying they are not beautiful. The harsh honesty of Callot
is provocative: his method is to slough off all generali-
ties and to record instead the mean and brutish reali-
ties of war. His narrative tone is cool and critical: as he
depicts the sufferings of fallen bodies he does not show
us their faces. His war dead are as anonymous as Alt-
dorfer's minute living warriors, but do not take part in a
glorious enterprise; they are refuse and flotsam, no more.

In the 1810s and 1820s the Spanish court artist
Francisco de Goya made paintings and etchings that
infused the vision of Callot with a new intensity. Goya
marks a profound shift not only in the ways war is rep-
resented in art but also in the purposes of art itself, for
he made masterworks out of scenes of appalling, unmedi-
ated carnage, elevating them to high poetry without
aestheticizing or removing their horror. He uses the full
force of his artistic skill to indict all the civilized values
that art upholds and implicitly to condemn every artist
before him who has employed the same means to glorify
them. His many paintings and etchings of war atrocities
have a documentary value that we might judge not too

different from Callot or even the *Bayeux Tapestry,* except
that they are informed by a surpassing sense of out-
rage and protest, and made with brilliant expressiveness
and dramatic sweep. They record little of the direction
of the Napoleonic Wars themselves – the salient bat-
tles, the famous leaders. Rather, they catalogue war's
manifold horrors: marauding bands of soldiers carry out
summary executions, corpse-pickers rob the dead,
rapists and torturers commit gross assaults. These
images are fiercely particular: soldiers and civilians
wear identifiable contemporary clothing, for example,
and specific events are cited in painting titles. Like
Callot's prints, the etchings in the large cycle called *The
Disasters of War* (fig. 7) have wry captions, in the man-
ner of later political cartoons: "This always happens,"
"This is what you were born for," "Bury them and keep
quiet," and, tellingly, "This is how it happened" and "I saw
it" – statements that claim for the artist the status of
eyewitness and reporter. In these prints Goya displays
an astonishing facility with the etching medium, using
the subtlest inkings and aquatints to render shadows,
disturbances, foul smoke-filled air, an atmosphere of
uncertainty, confusion, and danger. He often uses delib-
erate crudities of technique as well – raw scratches
and marks – in the service of his polemic.

Goya utterly rejects – or lacks – the disciplined
distance of previous artists. Detailed and historically
specific these works may be, but they are not strictly
documentary, for they place us within the world of war,
drawing us away from our traditional position as dispas-
sionate onlookers, toward the artist's own ardently
partisan perspective. In his war paintings and etchings
Goya's outrage and disgust are explicit and must be
taken as an element of the art works themselves. He
records events that he has witnessed, but he declines
to interpret these experiences aesthetically. He does
not permit his art to redeem them, but calls upon the
viewer to bear witness with him to their enduring horror.

This direct appeal to the viewer is a very modern
approach: it shatters the polite pane of glass that con-
ventionally separates observer from art work, shielding
the one and universalizing the other. From this point
forward artists find it increasingly difficult to imagine
scenes of war in ennobling terms. Callot and Goya

change the paradigm of war art from the depiction of heroic themes to the expression of hard facts. They are the first war artists to conceive of themselves as witnesses rather than interpreters, and though they work in a documentary spirit, they do not pretend to objectivity.

Artists after Goya jettison some of the great themes of war art and introduce in their place a new set of questions that remain both current and complex today: What is the role of political opinion in art? What happens when we are invited to bear witness with the artist to a scene of war, and are enlisted to adopt his or her point of view about it? When is art propaganda, harboring a (presumably) hidden purpose to persuade? Can art retain its high value if it is coercive? How much must we know – or try to guess – about the artist's mind and temper in order to understand the art work? And what is the role of beauty in an art dedicated to the expression of terrible things?

Modern Art and Modern War

Historians quarrel about just when to date the beginning of the modern era. Often enough they mark it by a war – popular choices being the French Revolution and World War I. Certainly both signaled dramatic shifts in the shape of political systems, in the advancement of technology, and in the way culture reflected these

transformations. Perhaps the entire century that lay between those two extended exercises in violent change is the "moment" when modernism arrived. In one short period between the Napoleonic Wars and the American Civil War the invention of photography altered the perspective of art.

The documentary power of the photograph gave to Goya's enterprise the authority of indisputable fact. The blurry, unemotive pictures of battlefields by such artists as Mathew Brady and Alexander Gardner showed the real thing: real trenches, real bodies, real (if still anonymous) death (fig. 8). The new technology of warfare that made battles like Gettysburg so lethal was part of the same revolution that invented the camera that recorded it. In their time Brady's and Gardner's photographs horrified viewers, as they still do; but today we may also see in their low-key presentations of the aftermath of carnage something poetic, elegiac, and even gentle. These pictures of war dead mourn not the passing of generals, but the crude deaths of common soldiers. Veterans of more heavily photographed wars will recognize the impulse.

The soldier's experience of World War I can be compared in some interesting ways to that of Vietnam: the western front, with its trenches and mud, its shocking casualty rates, and its abrupt introduction to the unimagined destructive force of a new military technology has some parallels to the ground war in Vietnam. Above all, perhaps, one can compare the stasis of World War I to a similar quality in the Vietnam War. In both, futile battles were fought and refought for years, with terrible losses, over the same ground. Neither the larger motives of the war nor the tactical goals of specific battles were clear or persuasive to the soldiers in the field. Both the western front and the Vietnam War were, to use the famous phrase, wars of attrition, not of territory, fought (at least on the American side, in Vietnam) for largely abstract purposes.

The painters Horace Pippin and Otto Dix were both soldiers in World War I – Pippin an American, Dix German. The two, who were far apart in intent and temperament and worked in very different styles, are among the most eloquent artists to have survived that conflict. Both made paintings and drawings about the

A HARVEST OF DEATH, GETTYSBURG, PENNSYLVANIA.

Figure 8. Alexander Gardner. *A Harvest of Death, Gettysburg, Pennsylvania.* 1863, published 1865–66. Albumen print. New York Public Library, Rare Books and Manuscripts Division, Astor, Lenox and Tilden Foundations

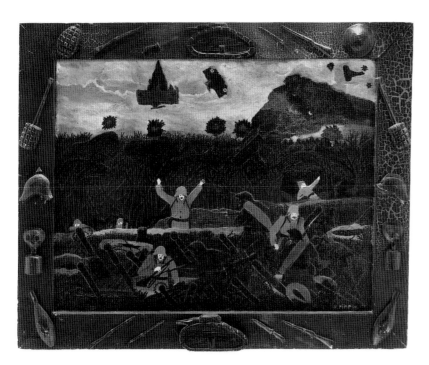

Figure 9. Horace Pippin. *The End of the War: Starting Home*. ca. 1930. Oil on canvas with painted wood elements, 25 x 32 in. Philadelphia Museum of Art, Given by Robert Carlen

war in which direct personal experience is the focus. Pippin enlisted in an infantry unit at age twenty-nine, in 1917, and fought in the trenches of France for a year, until he was wounded shortly before the Armistice. He said later that World War I "brought out all the art in [him]."[5] Though he had kept an illustrated diary in the trenches (as did numerous soldiers; World War I field art is a large genre), he did not begin painting until 1928, ten years after the war. (This pattern is repeated by many Vietnam veteran artists.) *The End of the War: Starting Home* was one of his first paintings (fig. 9).

Pippin's art is commonly discussed in the context of self-taught or folk art. As such, the subtleties of its argument about war are rarely noticed. In this work the canvas, heavily coated with thick, ridged paint, shows the moment of the war's ending: German soldiers in gray raise their hands in surrender and move toward American troops; behind them, an artillery barrage continues on the horizon and tiny planes wheel and tilt in the smoky, overcast November sky. One falls flaming into a stand of thorny, leafless trees. The palette is severely restricted to tones of gray, black, brown, and tan, with small, sharp points of red for blood, fire, and German uniform cuffs. These grim colors both describe the literal landscape of blasted mud and bare trees on the west-

ern front in November 1918 and, like Goya's dark paintings, offer a metaphor for a desolate world from which all life has been drained. Here, as in so many battle paintings, soldiers are tiny and anonymous, their faces are rendered generically – dots for eyes and mouth – they are human but not individual. The two armies move toward each other through a thicket of angular, crisscrossing black weapons, which repeat the geometric pattern of black tree branches in the background. The painting is cramped and claustrophobic; despite its optimistic title it is a scene of violence and death. The end of this war is no victory parade, nor an eloquent tragedy, but a bleak moment of tension and devastation.

The work is set in a remarkable frame carved and painted by the artist. It features small, crudely cut wooden objects representing the matériel of war: tanks are set at center top and bottom, like the heraldic cartouches on a Baroque frame. Around the sides and bottom Pippin has pinned tiny gas masks, rifles, hand grenades, and, facing each other at center left and right, a German and French helmet. These little objects are carved in the happy style of simple folk craft or Americana, with no consistent scale. They decorate the edges of the scene like whimsical little knickknacks and lend a toylike quality to the hapless soldiers and airplanes within the picture. Everything in this compressed painting, in which no home appears, denies the felicity of its title, reduces human endeavor to the stature of an ugly child's game, and prohibits the celebration of victory. Despite its unschooled means and awkward facture – or perhaps because of them – it annuls the whole vast tradition of glorious war art in one blow.

Like *The End of the War*, Otto Dix's multipanel work *The War* (fig. 10) was painted well after the Armistice, in 1929–32. Dix was in combat longer than Pippin; he enlisted at age twenty-three in 1914 and served as a machine gunner (and later an aerial observer) on the eastern and western fronts. He was already an established artist when he went to war and made drawings in the trenches. The work he produced after the war is a fierce, lurid denunciation of its gruesome viciousness. Veterans of World War I and Vietnam have often described the trenches, foxholes, and tunnels in which they found themselves as a kind of grave: half-buried, soldiers

Figure 10. Otto Dix. *The War*. 1929–32. Mixed media on wood panel, 104 x 160⅝ in. overall. Staatliche Kunst-sammlungen, Galerie Neue Meister, Dresden. Artists Rights Society (ARS), New York / Bild-Kunst, Bonn

sometimes saw themselves as already dead.[6] In the central panel of *The War* we see an open trench-grave in which living and dead hideously dwell together; at top a decaying body hangs from a lifeless tree in an explicit reference to the Crucifixion of Christ; the predella, oblong and painted to resemble the interior of a coffin full of dead soldiers, echoes an Entombment scene. Dix's painting thus takes the form of a religious polyptych – central panel, wings, and predella – and is modeled partly on one of the masterpieces of the German Renaissance, Matthias Grünewald's Isenheim Altarpiece of 1515, which also shows a tortured Crucifixion, Entombment, and, in the side panels, scenes of bestiality in devastated landscapes. Dix plays on both the history of art and the religious power of sacred paintings to produce a work of consummate irony and anger.

The War has a Grand Guignol theatricality. It looks like a vision of that other famous underground place, Hell. Yet Dix uses a clinical exactness in depicting wounds and mutilations: horribly, his scene is no theatrical exaggeration. Photographs of the shelled trenches of the Somme bear him out, but even without such evidence we trust in the artist's literal accuracy; his technical skill and the passion with which he paints persuade us. The work offers none of art's ameliorative elevation – there is no higher purpose here, no moral, no heroism, no

decency, either in the scene itself or on the part of the artist who has exposed us to it so bitterly. It is a meticulously rendered record of grotesque atrocities, painted to attest to the reality of such things and to insist upon their uncouth presence in the refined world of aesthetic experience. Dix builds upon the principle established by Goya and reiterated by Gardner: that the artist's prime obligation is to record what he knows; to bear witness and to constrain the innocent viewer to bear witness with him. Dix adds to this guiding principle a further element: he wants us to feel and smell what he felt and smelled. He wants us to know in our pores what we can never know: what it was like to be there.

So confrontational a work begs the question of artistic intent. Just what did Dix expect or want us to feel? Is this a painting of pathos? Is it designed to make us weep with sorrow, honor the dead? Is it protest art, intended so to shock us that we vow never to let such a thing happen again? Since its polemic failed to prevent the next war, should we call it a failure as a work of art? Though such questions may be asked of any work of art, they are very commonly asked of art that seems to carry an explicit polemical or political message, constraining us (or so we feel) to respond politically. Oddly, the painting's attack is directed not so much at the idea of war as at the viewer. Its grisly violence is an assault, perhaps on our romantic vision of war, or on our sense of what art is supposed to say and what, in all decency, should remain hidden from view.

Figure 11. Otto Dix. *Feeding-time in the Trench (Mealtime in the Trench, Loretto Heights)*, plate 13 from *War*, second portfolio. 1923–24. Etching with aquatint, 7½ x 11¼ in. Galerie der Stadt Stuttgart. Artists Rights Society (ARS), New York / Bild-Kunst, Bonn

Figure 12. Pablo Picasso. *Guernica.* 1937. Oil on canvas,
11 ft. 6 in. x 25 ft. 8 in. Museo Nacional, Centro de Arte
Reina Sofía, Madrid. © 1998 Succession Picasso /
Artists Rights Society (ARS), New York

Throughout its history art has drawn on war as a vehicle for the expression of private anguish and public glory, tragedy both collective and intimate, and triumph as well as pathos. The plunging horses, the melee of massed forces, the weeping women, crestfallen captives, enemies illustrious or abject – these are the traditional tools of such expression. More recently artists such as Dix, taught in the pessimistic and cynical school of two world wars, have devised a new repertory of icons: the barren field, the tangled wire, streaks of blood (literal or made of paint), the stained and abused canvas smeared with the harsh colors and broken forms of a violent abstraction.

In addition to his many war paintings and drawings, Dix produced an extraordinary suite of etchings called *War* that is a twentieth-century revisiting of Goya. In these prints subject and style are brilliantly matched: the distorted, loosely drawn figures of suffering soldiers emerge from the ink, scarred metal, and acid of the etching process as naturally as roots grow through mud. A theme of Dix's that we shall see again in the work of Vietnam War veterans is metamorphosis: radical, irreversible, fundamental transformation, from living body to corpse, from innocence to knowledge. In the etching *Feeding-time in the Trench* (fig. 11), a soldier eats his rations while worms feast on his companion, a skeleton. The transformation of the one into the other is imminent; the line between living and rotting bodies is a fine one.[7]

From the wreckage of World War I arose the greater, unimagined disaster of World War II, which made the experience of war nearly universal, nearly commonplace, no longer the specialized experience of the soldier. At the same time, the scale of destruction dwarfed art's attempts to fulfill its established role of recording, bearing witness, analyzing, commenting. Art emerged after World War II as profoundly changed as the larger world, though the artists who sought to record so great a cataclysm directly were few, as war artists have always been few. Yet for those who did, the ways of describing the war and the arguments to be made about it were extraordinarily diverse. It was after the double blow of the two world wars that art expelled from its vocabulary the ancient tradition of celebration of victory. Mourning, introspection, self-examination, and skepticism replaced the cheers.

Works by three artists – Pablo Picasso, Alberto Burri, and Robert Motherwell – represent some of the new directions World War II engendered in painting. Picasso remained committed to narrative and to the tradition of the large-scale history painting, which he had already reinvented once, in the great, epic war painting *Guernica* (fig. 12), and then revised in *Massacre in Korea* (fig. 13). Burri and Motherwell turned to abstraction, finding pictorial narrative inadequate to express the full range of emotions and ideas engendered by war.

In 1937, during the Spanish Civil War, Picasso had created *Guernica,* named for a Basque town bombed

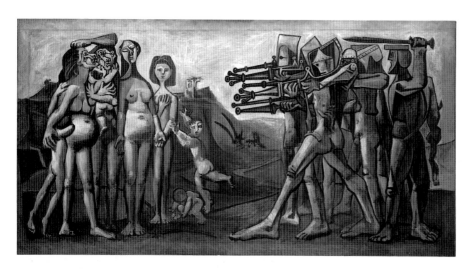

Figure 13. Pablo Picasso. *Massacre in Korea.* 1951. Oil
on plywood, 43 ¼ x 82 ⅝ in. Musée Picasso, Paris.
© 1998 Succession Picasso / Artists Rights Society
(ARS), New York

by Germans flying for General Franco in that year. Its
grand scale echoed that of the battle paintings of the
classical art tradition, while everything else about it spoke
of the modern condition. Its style was collagelike, mod-
ernist, and partly Surrealist, and its black, white, and
gray palette referred to the dispassionate reportage of
newspaper photographs and to a world in mourning.

In 1950, as Europe was beginning to recover from
the world war, the Korean War erupted as a sort of after-
shock. Reacting to it, Picasso returned to the large scale
and reduced palette of *Guernica* to paint *Massacre in
Korea,* one of the few major works to address a war that
has been largely ignored by both history and art. This
painting is in many ways more literal than *Guernica*: a
Massacre of the Innocents whose figures and composi-
tion are drawn directly from Goya's *The Third of May* (see
fig. 1). As in classical art, the figures are mostly nude, vul-
nerable women and children (at left) and armed, helmeted,
and anonymous soldiers (at right). An officer at the far
right raises a sword in the archaic gesture of the warrior.
At the time, much was made of Picasso's lapse from
pure art into politics, and his known Communist sympa-
thies led critics to read the painting as anti-American.
Yet the artist is extremely careful to present his figures
as absolutely universal and unidentified, neither Korean
nor American nor Chinese, and to set them in a land-
scape of generic war-torn destruction. The painting is an
unambiguous antiwar statement, and as such has some-
times been condemned as simplistic. Its success lies in
this directness and in the skill with which it is grounded
in a deep, nuanced art history.[8]

Picasso did not fight in World War II, unlike the
younger Burri. The latter had medical training and
served during the war as a doctor in the Italian army,
where he practiced field medicine. He was taken pris-
oner in 1944. Burri turned to art only after the war, and
from the first worked in an abstract mode. His collages
and paintings are often appreciated in purely formalist
terms: he used rough, highly textured materials such as
stitched, stained burlap, raw canvas, tar, chipped or
burned wood, and scuffed metal, exploring their tactile
beauty in delicate, gestural works without evident sub-
ject matter. Yet the soiled, damaged burlap of *Sackcloth
B.53* (fig. 14), for example, one of a series, refers to the
scavenged cloth desperate army medics used to bind
wounds, as well as the sackcloth of biblical mourning
and repentance. The holes and gaps in its patchwork,
filled with puckered brown, black, and vermillion paint,
are images of wounds — round ones, such as bullets
make — and the collage suggests the injured human
body. There are, as well, literal wounds in the fabric of
the art work. Frayed stitching just manages to hold its
rotting remnants in place: art practice is barely adequate
to knit together the damaged fragments of the world,
and must try to do so with only flotsam and discarded
rubble for paint and canvas. Burri does not employ literal
references to the human figure in his work, but he
retains the high pitch of emotion, the sense of loss and
pathos that we saw in the *Dying Warrior* from Aegina.

Equally emotional is Motherwell's series of some
150 large, purely abstract paintings entitled *Elegies to
the Spanish Republic* (fig. 15), made between 1948 and

the artist's death in 1991. These canvases have the
scale of a mural, fresco, or frieze, and the stark drama
of Zen calligraphy. They are painted mainly in black and
white and unlike Burri's abstractions have no hidden
representational references. Black ovals are pressed
between strong black vertical bars whose shapes domi-
nate and threaten both the space of the painting and
that of the viewer. The series title guides us to the
source of Motherwell's sorrow, the death of the Spanish
Republic, defeated by the Fascist army before World
War II, but the sense of oppression and tragedy con-
veyed by the immense, heavy forms is universal, not
particular. The art of mourning that he creates with the
tools of gestural abstraction remains a powerful model
and source for artists today.

In the twentieth century art with explicit political
content, a category that includes much war art, has
often been viewed with skepticism. On the one hand it
is criticized for its reliance on narrative – in particular on
the use of strong subject matter to elicit or convey
strong feeling. On the other hand, critics may refuse to
measure it by aesthetic standards at all, on the grounds
that the artist surely did not have aesthetics in mind.
Embedded in this dual critique is the implication that
political themes taint the purity of personal expression;
that if the highest standards of art criticism were applied
to such intensely felt art, it might not meet them.

Figure 15. Robert Motherwell. *Elegy to the Spanish Republic No. 55.*
1955–60. Oil on canvas, 70 x 76⅛ in. Contemporary Collection of The
Cleveland Museum of Art, 1963.583. © Estate of Robert Motherwell /
VAGA, New York, 1998

Figure 14. Alberto Burri. *Sackcloth B.53.* 1953. Burlap sewn,
patched, and glued over canvas with paint, 39⅜ x 33⅞ in.
Estate of the artist

For example, the most exciting art of the period
after World War I is usually held to be that which focuses
almost purely on the mechanics of art itself. The inven-
tors of abstraction, the visionaries who raised art to a
new, autonomous level of meaning, were the radicals;
their work is considered political not despite its rejec-
tion of all content, but because of it.

Art with a political narrative and a traditionally pic-
torial approach is easily seen as old-fashioned. When
such work depicts war, a subject often held to be too
serious and painful to criticize according to the usual
aesthetic gauges, critics tend to shift the criteria of
judgment: this is the art of memory, of a personal expe-
rience so terrible that one may forgive its perhaps
retrograde style. The work of Dix is often viewed this
way: critics have seen it as outmoded, but have hesi-
tated to condemn it as insignificant because it is so full
of feeling, and because its subject is anything but
insignificant. Those applying an equally narrow focus to
Burri's and Motherwell's much-admired work often dis-
cuss it in strictly formalist terms, without reference to its
underlying content, as if that content might weaken its
aesthetic power by appealing to emotion in a manner
thought to be facile.

American Art and the Vietnam War

After World War II, after the Korean War, came Vietnam. In the 1960s avant-garde art in the United States explored myriad new directions, of which two emerged as dominant: pure abstraction, which engendered Minimalism and some forms of Conceptual art, and Pop art. Broadly speaking, the one emphasized spiritual and intellectual issues while the other took the role of social critic and ironist. At the same time, traditional art styles and genres such as academic realism and folk art continued quietly, well out of the mainstream.

Politics permeated much of daily life in America in the sixties. The civil rights movement and the contentious Vietnam War captured headlines and were common topics of dinner-table conversations. The war was relentlessly present in nightly newscasts direct from the field, in congressional debates, and in the street demonstrations, protests, and sit-ins generically known as "bringing the war home." It was a favored subject (nearly always in an antiwar mode) of songs, posters, and other material of popular culture (though not in film or television shows, where it was virtually invisible). Not least, it was everywhere felt in the routine arrival at American airbases of returning veterans and bodies in military coffins. Artists, like other citizens, stated their positions and drew lines in the sand. In light of that intense public debate, the general absence of war imagery from visual art of the 1960s is startling.

A few oblique references may be found. The Vietnam War flickers across the canvas of a 1963 Robert Rauschenberg painting, *Tracer*, in the form of a repeated photograph of an army helicopter.[9] A few years later, at the height of the war, some Pop artists touched more directly on the subject in a handful of isolated works. But on the whole the art of that decade withdrew from the direct political commentary of earlier generations in favor of an exploration of private concerns, fundamental aesthetic problems, and in the case of Pop artists a social critique of domestic consumer culture. Exemplary of the former is the work of Ellsworth Kelly, in which the artist explores the power of pure color and shape in smoothly painted, large-scale images. Like Motherwell's black and white, Kelly's blank fields of color – blue, green, and red – are color distilled to its essential form: green, for example, reads not as an attribute of some other thing (a green plant, a green field), but as green itself, the platonic idea of a color. The artist fought in World War II with the 603d Engineers Camouflage Battalion, stationed in France in 1944; if his attentive, meticulous study of the properties of color arises from this experience, the connections are well hidden.

Why was the war – so present in daily life – so absent from art? Artists of the 1960s were much concerned with radical aesthetic issues, such as are found in Minimalism and Conceptual art, and these were sometimes understood as a metaphor for a radical political position. In the fraught climate of the war years public institutions, personal actions, and ideas easily came to be politicized and polarized, including the practice of art. In this context Kelly's investigations were understood as radical – if not politically, then aesthetically.

Parallel to the aesthetic debate was a concern with a moral or ethical dimension to art. Many artists felt that to place art in the service of a political position, no matter how righteous, was to degrade and bastardize it, to reduce it to propaganda, to commit an immoral act. The truly political in art was seen to reside strictly in the act of art-making itself. Artists made Happenings to convert art into a temporal experience; street art to question the authority of museums; Process art to undermine the material permanence of the art commodity and defy the marketplace. The political was tightly circumscribed

within the art world, though there it was hotly debated. In retrospect this seems to have been a strangely hermetic environment.

The Conceptual artist Sol LeWitt was one of many avant-garde artists who questioned art's role as a catalyst for political change. In 1968, at the height of the Vietnam War, he wrote:

The artist who is concerned with painting and sculpture just does his art and believes what he believes as a person . . . the sculptor or painter [is] asocial and apolitical. I do not think that I know of any art of painting or of sculpture that has any kind of real significance in terms of political content, and when it does try to have that, the result is pretty embarrassing. In the future maybe artists will have it, but as it is now, I do not think there is anything that particularly would qualify as great social art or great political art. . . .

The artist wonders what he can do when he sees the world going to pieces around him. But as an artist he can do nothing except to be an artist. . . .

The artist, as far as his art goes, does have the opportunity to pursue a pure line of work, as a physicist might, which disregards society. He is asocial, not only anti-social, not pro-social. If an artist thinks he is doing something that is more moral or more right or self-righteous or has any ethical meaning, that is a delusion and a sentimentality.[10]

Implied in this statement is an idealistic belief in the moral authority and redemptive virtue of art — as long as the artist remains true to art's first principles — chief among them the detached, private exploration of aesthetic concerns, a "pure line of work." Artists such as Edward Kienholz and Leon Golub, who did not adhere to this orthodoxy and infused their work with politics, were often marginalized. Only in retrospect does their work appear to represent an alternate strain of sixties style.[11]

Two striking early exceptions are worth considering together. In 1964 Norman Rockwell — often described as a sentimental upholder of traditional values, social as well as artistic — painted *The Problem We All Live With* (fig. 16) for the cover of *Look* magazine, about the racial integration of the public schools; the following year James Rosenquist created the monumental, multipanel *F-111* (fig. 17), about the connections between the military and consumer culture. Both are explicitly political in subject, to a degree rare at the

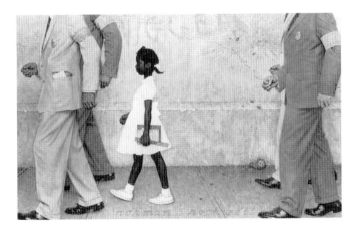

Figure 16. Norman Rockwell. *The Problem We All Live With.* 1964. Oil on canvas, 36 x 58 in. The Norman Rockwell Museum, Stockbridge, Massachusetts, © 1998 Norman Rockwell Family Trust

time. Stylistically, they could not be farther apart: Rockwell's homey, illustrational realism is light-years from Rosenquist's consciously radical Pop. One could argue that Rockwell's work is the more shocking of the two, precisely because it uses conservative, familiar means to express a fiercely passionate political opinion. It is a didactic painting, overtly promoting sympathy for integration and racial equality in the person of the small black child, surrounded by vicious graffiti and escorted by faceless, looming white men who are as much her warders as her protectors. We may take a lesson from Rockwell: it is a mistake to conflate artistic style with political meaning. Just as we must be cautious in using the artist's (perceived) intent to interpret his work, so too we should be wary of reading the politics of an art work by identifying its style. In the work of Vietnam War veterans this is a key point.

If Rockwell's painting uses a conservative style subversively, Rosenquist's extravagant painting does the same with Pop. His technique was drawn from billboard painting and his huge canvases refer directly to advertising media. *F-111* fuses images from two separate worlds: that of war and the military, and that of happy, prosperous, domestic America. A frieze of syncopated, disjointed vignettes in bright, cheerful colors dances the length of the work: a smiling blond child under a hair dryer, a big umbrella, a serving of glossy, caramelized canned spaghetti, a tire, a light bulb. These are interspersed with glimpses of the fuselage of a new F-111 strategic bomber plane, as shiny and sparkling as any consumer product. The painting itself is slightly longer than an F-111, so that the work operates virtually

in real space. Rosenquist's message is not a subtle one, but it is crafted with care, so that each element representing peacetime is converted by its context into an image of war: the hair dryer becomes a helmet; an umbrella and a splashing aqualung merge with the image of a mushroom cloud; an angel-food cake is a missile silo; slick, red-orange worms of spaghetti writhe like spilled intestines from a massive wound. The plane, blasting through a flak of household goods, transforms the objects of everyday life into its own machinery of violence.

Despite the evidence of a more complex and nuanced politics of art, in the mid-1960s radical style was commonly equated with the political left wing, opposed to the Vietnam War, and conservative techniques of representation and figuration were readily associated with the political right wing. Pop artists, who used figurative imagery, maintained an ironic, distanced, critical perspective in opposition to the sort of naive, engaged sincerity that Rockwell seemed to exemplify. Given this schematic polarization, it was nearly impossible for artists to confront directly in their work the war that was consuming America.

Nevertheless, late in the decade a few scattered examples did so, generally in the grimly humorous Pop mode: Claes Oldenburg's *Lipstick (Ascending) on Caterpillar Tracks* (1969), Red Grooms's *The Patriot's Parade* (1967), Robert Morris's *War Memorial: Trench with Chlorine Gas* (1970), Duane Hanson's *War* (fig. 18). Only a handful of artists took on the war in a consistent, extended body of work: Peter Saul, Leon Golub (fig. 19), and Edward Kienholz, whose large installations *The Portable War Memorial* (1968) and *The Eleventh Hour Final* (fig. 20) are passionate expressions of anger and sorrow. Kienholz's work has its share of cool, deadpan sixties cynicism and a macabre sense of humor that we see often in the art of Vietnam veterans.

It has been argued that few artists chose to grapple with Vietnam because art could not match the appalling, graphic images appearing daily on television and in print, directly from the war.[12] Vietnam has been called the first television war, and it was certainly the first foreign war in which American civilians at home saw uncensored battle film and photographs within hours of the events they recorded.[13] But though these

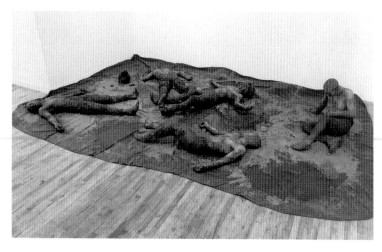

Figure 18. Duane Hanson. *War.* 1969. Oil on fiberglass, life-size. Wilhelm-Lehmbruck Museum, Duisburg, Germany. © Estate of Duane Hanson

images were, and remain, extraordinarily powerful and shocking, they are surely no more powerful than the eyewitness experience of European artists in World War I or II, and no more likely to silence art. Historically artists have not been reluctant to take on large contemporary issues in their work, as Callot, Goya, and Picasso amply demonstrate. Nor have artists in the modern era hesitated to compete with the mass media when it suited them; on the contrary, the history of art after the invention of photography suggests that paintings, sculptures, and other traditional media can still be as moving and persuasive as a photograph. It was not timidity or humility in the face of the horrors of war that restrained avant-garde artists of the 1960s. Rather it was the very notion of a moving and persuasive art that they mistrusted and ultimately rejected.

The substitution of stylistic for political radicalism, or the conflation of the two, is a salient characteristic of both 1960s art and art theory; whatever the reasons for this, the result was the critical dismissal of much art that attempted to comment on the war. The great public and private collections of avant-garde art amassed in the 1960s are thus, weirdly, an unintentional essay on the censorship of a key political and cultural event — one that altered the course of twentieth-century America, including its art, in myriad ways. This blank space on the museum wall, so to speak, may be seen in the context of a general desire in America to erase the war from history in the immediate post-Vietnam period.

It has been said that for Americans, Vietnam is a syndrome, not a country. Many cultural critics and art historians see it as a social phenomenon whose impact

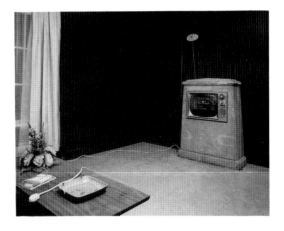

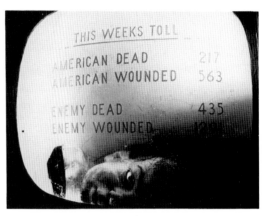

Figure 20. Edward Kienholz. *The Eleventh Hour Final.* 1968. Wood paneling, concrete, and found objects, 120 x 144 x 168 in. © Nancy Reddin Kienholz. Collection Reinhard Onnasch

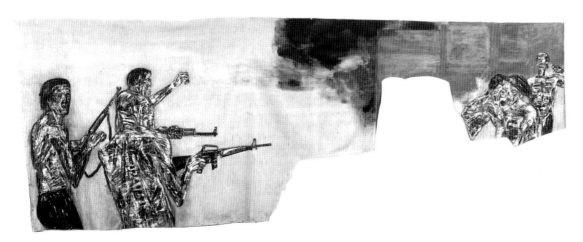

Figure 19. Leon Golub. *Vietnam I.* 1972. Acrylic on linen, 10 x 28 ft. Courtesy Ronald Feldman Gallery, New York

was profound but very general. The concrete experience of the war – who fought it, and when, and why; who supported and opposed it; who died – is not perceived to have any particular significance for art, despite the emphasis artists themselves placed on self-exploration as a primary creative source and despite the many possibilities for engaged expression the politics of the time offered.

After Vietnam

For nearly ten years after the fall of Saigon in 1975, when the North Vietnamese won the war, Americans said little about Vietnam. It was rarely taught in history classes or discussed in public forums. Just as the Korean War had all but disappeared from the national consciousness, Vietnam too seemed likely to vanish. Veterans, who might in other circumstances have been useful conveyors of the historical record, were effectively silenced by the brutal treatment they received on their homecoming. Around 1983, after the dedication of the National Vietnam Veterans Memorial, they began to emerge from limbo into the public world as advocates for veterans' benefits, research into the medical effects of exposure to the defoliant Agent Orange, and the search for soldiers missing in action during the war. By

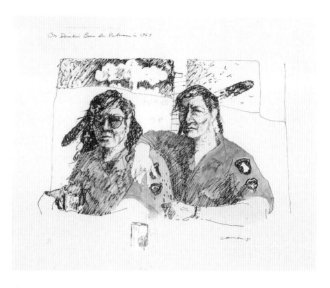

Figure 22. T. C. Cannon. *On Drinking Beer in Vietnam in 1967*. 1971. Etching, 21⅞ x 30 in. The Heard Museum, Phoenix, Courtesy Walter Cannon

the early 1980s books, films, and television programs, both fictional and documentary, had begun to examine the war – accompanied, inevitably, by new polemics about left-wing and right-wing ownership of the historical discourse.

Meanwhile, American art in these years was characterized by great eclecticism and an eager embrace of political subjects, especially the personal politics of race, gender, and identity. Though few well-known artists of the 1980s and 1990s made the Vietnam War a subject of their work, its effects were felt: in an ever-greater irony of voice, a deep sense of moral ambiguity, and a questioning of art's power to cure, ameliorate, or even analyze the ills of the world. In 1987 Eric Fischl painted an intriguing three-panel scene called *The Evacuation of Saigon* (fig. 21). Here a naked woman, vaguely Asian in aspect, stands shivering and vulnerable on a jetty by a lake. The darkening landscape around her is unidentified: it may be Vietnam, but it could easily be rural America. The title evokes the famous photographs from April 1975 of Americans and South Vietnamese being airlifted in disorder from the roof of the American embassy in Saigon, as North Vietnamese troops took the city. But war is nowhere visible in this painting; its presence is merely implied. An unmarked, army-style inflatable motorboat is tied to the dock; a Chinese-style straw hat, such as Vietnamese country people wear, floats in the water: a reductive, clichéd, equivocal image of abandonment, loss, and regret.

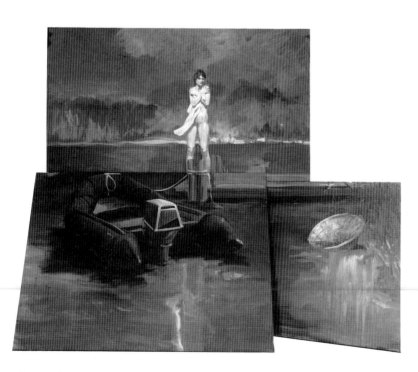

Figure 21. Eric Fischl. *The Evacuation of Saigon*. 1987. Oil on linen, three parts, 120 x 142 in. overall. Courtesy Mary Boone Gallery, New York

Fischl's visual essay on the memory of the Vietnam War was unusual among the works of established artists, but this is not to say that no art was being made about the war. Veterans, for whom the subject was not – and will never be – historical, had begun to work, turning inward with increasing confidence to their own experience and their living memories as a source for art.

Bridging these two worlds is the American Indian painter and printmaker T. C. Cannon, both a veteran and a successful mainstream artist of the 1980s. The armed forces have long been a place of opportunity for Native Americans, and they were heavily represented among the soldiery in Vietnam. Cannon enlisted in the army at age twenty and served with the 101st Airborne Division; he had begun to work as an artist before the war and returned to painting immediately after his discharge. His work is colorful and clever, with a bright Pop tone and an acerbic sense of humor. It often explores Indian identity and the relationship of the traditional Native world to the modernist world of contemporary art. *On Drinking Beer in Vietnam in 1967* (fig. 22), a relatively literal portrait of the artist with another soldier, has the deadpan, low-key touches of wit common to veterans. The two men pose with beer and cigarettes in a moment of relaxation, as if before a camera. Both are Indians, both wear army fatigues with the Airborne shoulder patch. Their hair is not GI short, however, but long and decorated with the feathers and braids of the traditional Indian warrior. Cannon is not blind to the historical ironies inherent in his position as a Native American man serving within the ranks of the United States Army; his figures stare directly at the viewer with the flat, slightly suspicious regard of experienced fighters assessing a stranger. Behind the two friends the artist has placed a sketchy landscape – no more than a simple horizon line with two cartoonish explosions, a mushroom cloud and a mortar or rocket. Boom, puff: the war proceeds in the background as Cannon and his buddy observe us observing them. He thus places himself consciously and centrally within the complex history of the representation of war in art. For the veteran, all war art is a self-portrait.

2.

Art by Vietnam Veterans

There are currently some one hundred artists with work in the National Vietnam Veterans Art Museum, and many more veterans who are making art in the United States and elsewhere. Were they artists before they went to war? Some certainly were; others would not have become artists without that experience – most American soldiers in Vietnam were no more than eighteen or nineteen years old, and had not yet chosen a career.

Just as no one political argument or perspective is discernible in this body of work, no single style or approach predominates. The variety of means, materials, and tools artists have employed to express their experiences is astonishing, from the literal narrative paintings that we expect of combat art to utterly surprising, metaphoric totems, masks, and abstractions. All the concerns of previous generations of war art surface in this collection: images of horror, pathos, humanity, and barbarism; condemnation of waste and violence; survivor's guilt; the celebration of endurance and the pain of unassuageable loss. These themes are revisited, indeed, but also converted, deconstructed, re-formed. There are not many images of triumph or glory here, but myriad works acknowledge sacrifice and praise bravery. The engagement of artist with subject is deep, personal, and intense, but the collection does not lack works that are coolly analytical and distant.

In our capsule survey of the history of war art we saw several iconographic traditions emerge: the vast battle scene, the intimate portrait, the religious allegory. Most of these recur in the present body of work, radically transformed by the ironic idiom of Vietnam.

Again and again, in memoirs and novels, and in their writing for this book, veterans have described Vietnam as a place of transformations and inversions: what was true and real in "the World" was false in "the War"; conversely, the lessons and behavior taught in the war were condemned in peacetime. The most profound value learned in childhood – that violence and killing are wrong – was replaced, as it necessarily is for all soldiers, by an opposing code. The veteran Ray Blackman states, "I watched older friends go off to Vietnam. Some

came back with severe wounds; some didn't come back at all. None were talking. They had changed; they had all changed." Kenneth Willhite, in a letter home from Vietnam, writes, "I just pray that I haven't changed when I come back." David Given sees the process of transformation in its devastating particulars: "War can easily change [compassion and aesthetics] to cynicism and pragmatism, as it can change scenery to terrain, and human beings to body counts or the enemy." These men understand that they are part of a large and complex operation: the process by which the fundamental elements of life are converted to new and alien forms. A human being becomes an enemy or a corpse; a beautiful landscape, rich in the lush green of forest and jungle, becomes military *terrain,* a booby-trapped, denatured territory filled with terrible dangers. The visible transformation of an exotic Asian country into a war zone is the material counterpart of an internal transformation of personality, character, worldview. It is a truism that war is a crucible from which no one emerges unaltered. What, then, is the effect of that transformation on a man or woman who has an artist's observing eye, an artist's sensitivity to the nature and forms of the material world? The ironies and inversions that emerge in veterans' art reflect the particularly surreal and ironic experience of the Vietnam War, in which distinctions between enemies and allies, safe and unsafe, right and wrong were so often and so easily blurred. "The world had turned upside down and inside out," Edward Emering writes. "Its colors were red and green, up and down." What is the effect, on someone with an artist's taste for close observation, of standing guard duty on the perimeter of a firebase, staring for long hours into the faceless, deadly, yet exquisite green jungle? "*Keep observing,*" Michael Helbing admonishes. "[He] was nineteen," László Kondor tells us of another soldier, "and had been in Nam for a year. He could sense from twenty-five yards what I could not see from ten feet."

And how is the artist's natural appreciation of beauty altered when beauty and horror are not opposites, but closely related? Karl Michel writes, "I can recall looking into the empty skull of an NVA sapper whose brains had been blown out. I found myself thinking of the aesthetic qualities of this image: the beautiful colors of red, purple, and violet." Ray Blackman writes, "Mountain streams and rivers ran everywhere, and waterfalls. I could hardly believe there was a war going on in such a wonderful place. Aside from occasional bomb craters, the view was spectacular: it was a dream world made of every kind of green. No artist could ever do it justice." Joseph Fornelli remembers, "These shells, the tracers on them left a beautiful yellow-orange trail after you fired them." And Michael Kelley recalls "the randomness in the scattered piles of spent shell casings that grew next to the M-60 machine gun that I was operating. There was an odd beauty in the golden, reflective heap of spent links and brass that would litter the edge of my position . . . I sometimes found myself . . . mesmerized by the haunting, abstract beauty of the battlefield."

Green in Judgment

We read in these artists' statements descriptions of the intense beauty of Vietnam. Yet in Vietnam the landscape hid terrible violence and fierce mysteries, and the color green, so predominant in that fertile land, was not the color of life, renewal, spring. It was the color soldiers were obliged to wear to erase their individual identity; it was the color of the jungle that hid snipers. If Goya, Picasso, Pippin, and Motherwell painted the colors of war as smoke black, newsprint gray, mud brown, and blood red, for artists of the Vietnam War the color of death was green. We see green used in this ironic, inverted way in paintings as cheerful as a Matisse: Randolph Evans's *Madame Sihanouk's Offspring and Their Nanny* (no. 50) and Michael Duffy's *Chi Town* (no. 38); it is lush and seductive in Ned Broderick's glowing *Round and Round* (no. 16), with its whimsical lizards swallowing one another's tails in an endless rite of cannibalism; in Frank Dahmer's *The Green Machine* (no. 31), in which a soldier's face merges with verdant leaves that are no more than the hardware of war; in Scott Neistadt's gruesome sketches *Pungee* and *What the Point Saw* (nos. 119, 121); in Richard Olsen's delicate, abstract, aerial view of Vietnam, *Blood Spots on a Rice Paddy* (no. 130). Perhaps most vivid of all is the use of green camouflage patterning in David Smith's untitled work (no. 167). One

might say that the artist here uses pure shape, rhythm, and color as Ellsworth Kelly does, studying camouflage techniques as a formalist exercise in color theory, were it not for the tiny silver- and gold-leaf bombers and helicopters scattered randomly over its mottled surface.

Other Vietnam veteran artists follow the war-art tradition that drains the world of color. Gregory Van Maanen's gray *Head Spirit* (no. 172) contains a single tiny red bullet hole. Michael Kelley's drawing *I Think We Got the Little Bastards This Time . . . !* (no. 89) is a meticulously rendered lunar landscape of lifeless bomb craters; at the edges of this desolate image streaks of yellow and red, the colors of the South Vietnamese flag, bleed, while at center a minute, triumphant North Vietnamese flag, in full color, gives the lie to the title. John Plunkett's extraordinary series of monochrome canvases reinvent the classic battle piece on a grand scale, but without a single visible human figure (nos. 138–40). These artists, like Pippin, Picasso, and Motherwell, use a restricted palette to convey a circumscribed, devastated world. And like them, they find a transcendent power and beauty within these diminished means. "I wanted the landscape to be shown for its beauty," writes Douglas Clifford. "The tropical sunsets were spectacular and with the monsoon came every shade of green, from rice stalks to the grass on the hills; and on some days the Central Highlands rose up through the low cloud cover like a panorama in a Chinese screen painting." Then he adds, "The military airplanes were beautiful but terrible. . . . Their grace and fluidity were aspects of their capacity for destruction."

Green on the outside and black within, a big green joke, the big green hell: these are the words artists use to describe Vietnam. Charlie Shobe, flying over the land, watches hundreds of bomb craters pass below, "filled with water, surreal, like the surface of some imaginary green planet"; imaginary indeed, for how could the real planet Earth express such devastation in the living color of hope?

"I love color," writes Theodore Gostas, "deep, rich, intense, and vivid color. Color is almost godlike to me. It soothes and numbs, explains, speaks, and confuses. My heart aches with frustration when I can't for some reason deepen colors to suit my aims."

Magic, Masks, and Mirrors

If inversion and conversion are common ways for veterans to think about the war, these themes recur most frequently in complex versions of the self-portrait. The majority of the works in this collection were created by artists working in isolation, both from other veterans and from other artists. The number of art works based on masks and mirrors is striking, as is the repeated use in artists' texts of the idea of the mirror or mirror image to describe the war experience (Michael Aschenbrenner: "Artists reflect what we are; we are the mirrors"; Karl Michel: "Art mirrors my desire to create and destroy"; Theodore Gostas: "I would like to hold a mirror up to war and hope that once it looks at itself, like Medusa it will begin to die"). Among the most direct self-portraits are Lou Posner's *Self-Portrait in Medicine-Chest Mirror* (no. 143) and Cao Ninh's *When I Look in the Mirror Each Morning* (no. 25). Both, using quite different idioms – realist oil on canvas and abstract collage, respectively – place the viewer in the disturbed, unnerved position of the artist regarding himself. The works record an artist who has vanished, replaced by a stranger. The latter piece is especially shocking in its manipulation of material: not only is the literal mirror broken, so that the reflected world is forever in pieces, but the edges of the collage are unprotected broken glass, as dangerous as a weapon. In both works the viewer is implicated in the artist's deadpan, affectless self-analysis.

Mirror and glass turn up in Michael Helbing's *Club of War* (no. 78), a totemic weapon that is, the artist tells us, "covered with mirror fragments, reflections of the surrounding environment, and multicolored broken glass, which makes it pretty." Aschenbrenner's *Damaged Bones* series (no. 6) comprises objects of breathtaking beauty and delicacy made of heavy spun glass in soft tints, wrapped with fragile splints made of twigs, gauze, and wire. The glass is clear and strong, yet desperately exposed and vulnerable. These too are self-portraits, for Aschenbrenner's own leg bones were badly fractured in Vietnam.

The drawings of Joseph Fornelli are among the small body of works made in Vietnam during the war. One of these, titled *Metamorphosis* (no. 55), is a simple

line sketch of a figure, head and shoulders, and its mirror image, upside down. The artist drew quickly, in the brief privacy of a hooch, using the ink and paper meant for making field maps. There is no doubt that it is in some sense a self-portrait, the equivalent in spidery thin lines of the words written by Stephen Ham: "The first time I saw men straight from combat was at night when they walked into my tent. We looked at one another without a word. It was all incomprehensible and mad but one thing I understood – this was the metamorphosis that awaited me and my friends"; and Ned Broderick's words: "[The] war was with us and with our enemy as well; whose lives I came to see as a mirror image of our own."

Four artists in the museum collection have created masks and masklike objects that may be seen as self-portraits, or as investigations of interior and exterior identities. These are Mary Margaret Caudill's *Healing the Wounds of War* (no. 28), Richard Olsen's *Cong: Kill 'Em* (no. 129), Karl Michel's *Soundless Wailing* (no. 112), and the masterful *Ritual Suicide Mask* and *Dulce Bellum Inexpertis* by Randolph Harmes (nos. 72, 73). Caudill's frail basket of paper faces is gently ambiguous: soft-featured and simplified, they are not individuals; they may be children, or multiple forms of one person's face. They may be asleep, or dead. Olsen's shaped-paper face wears a rictus of horror, like the screaming heads of ancient Greek Medusa sculptures, designed to ward off monsters. This is the imagined face of the enemy, mirror image of the self. Michel's shaped-canvas painting is of a mask-faced figure in the throes of agony; he is, perhaps, a compound of many faces, of friends and enemies as well as the face in the postwar mirror. Harmes's extraordinary masks have in common with Aschenbrenner's glass leg bones a refined sensitivity to materials – thin layers of painted and stitched gauze, finely carved bits of wood – that is both poetic and heartrending. These are the faces of the dead and their killers, anonymous, brutal, brutalized, and suffering: the faces of war itself.

Terrible Beauty

Transformation is the key operation – from living face to fabricated mask, from self-portrait to portrait of the Other, from person to body to thing, from the terrible memory of war to the art work that redeems it. Michael Rumery evokes this conversion in the figure he calls the NAM MAN; the man who *is* Vietnam, in reverse. The poet William Butler Yeats, writing during World War I, after the 1916 Easter Uprising in Ireland, saw that the alterations war makes in a landscape, a personality, a view of the world are of a peculiarly intense order. He described the change wrought in ordinary people as absolute, irrevocable, and heroic:

He, too, has resigned his part
In the casual comedy;
He, too, has been changed in his turn,
Transformed utterly:
A terrible beauty is born.[14]

Transformation and metamorphosis are alchemical, magical terms. The association of art with ritual, religion, and magic is ingrained, perhaps even inherent. Ralph Sirianni's *Crucifixion/Nam* (no. 165) links the tragedy of war with Christian allegory in the overt manner of Dix's *The War*. His fine, gestural drawing style belongs within the Expressionist tradition as well. Other artists have made works whose totemic quality is closer to the West African sculptural tradition: Josef Metz's *LZ Hurricane* (no. 110), with its death's-head top and carved stem, is a sort of scepter or speaker's staff like those of the Yoruba, conveying power and a dread authority. His painting *Cycle of Nam* (no. 111) has the stylized, formal design of a heraldic or Voudon banner. Fornelli's *Dressed to Kill* (no. 53), a carved head into which shell casings have been set, carries echoes of a Congolese *nkisi,* a sculptural spirit figure into which bristling nails are hammered as an act of empowerment or for healing. The artist made this work at age twenty-three, in Vietnam, and did not have African power figures in mind at the time; but the fierce, ritual strength of the head carries its own associations.

Vietnam veteran artists invoke a richly symbolic language. The mask and mirror, the smooth, clean bone, and the emblematic, flaglike use of color are only a handful of the ironic icons available to them. Others include the palm tree (representing, to most Americans, Vacationland, the exotic); the helicopter, that monstrous,

lethal, yet graceful dragonfly that was also the soldier's lifeline; the skull, most traditional of *vanitas* tokens – in this context reconverted from symbol to literal figure; and the innocent child, who appears over and over in this art collection. Veterans have recalled that Vietnamese children were to be seen everywhere at the firebases where they were stationed and in the hamlets and villages where they patrolled. Soldiers frequently tried to protect and comfort children and often saw them when they were frightened, hurt, or dead. Children could also be dangerous: they were sometimes used by the Viet Cong as saboteurs.[15] And it is essential to remember that the majority of servicemen and -women in Vietnam were themselves not yet out of their teens. The most charming images of childhood, therefore, such as James McJunkin's lyrical photograph of boys mugging for the camera (no. 103), may be read through the filter of an intense poignancy, and with a subtle suggestion of self-portraiture.

Themes and Variations

The inventive variety of these artists is not limited to a marvelous iconographic range. Perhaps even more arresting is the diversity of forms and metaphors through which the experience of the Vietnam War is conveyed. Grady Harp makes big ceramic vessels inscribed and incised with poems (nos. 74, 75). Richard Olsen's *Memorial to Tim Lang* (no. 126) employs the small scale, single, frontal figure, and gold leaf of the Byzantine icon tradition to remember a dead friend. Jay Burnham-Kidwell creates diminutive copper-enamel landscapes the size of a lapel brooch, one decorated with a jewellike drop of blood, another with a tiny skeleton (nos. 19, 20). Ken Hruby's memorial sculpture is a mantelpiece trophy in the form of a prosthetic leg (no. 81). Stephen Ham paints bitterly sardonic Dead Vet greeting cards (no. 68) that are a devastating mockery of the commercialism of veterans' holidays. Meredith Jack's *For a Foreign Prairie* (no. 82) is a pristine, formally severe sculpture in black steel that may represent a cluster of tiny graves surrounded by a wall of missiles standing on end; if placed on the floor it becomes an elegant pungee trap. Many of these works are executed in a miniature mode, anything but grandiose or dramatic.

They take their cue from a sense of humor – sharp, black, and bitter – that is a salient characteristic of both writing and art about Vietnam.

Some of that is the soldiers' wit typical of any war, as may be seen in titles of a number of art works: *Mail for Charlie; Hi Mom . . . I'm Home; I'm So Short, My Head Hurts.* But some reflects a brand of joke peculiar to *this* war, with its heightened, perverse, inverted sense of the comedy of tragedy. Two grim, explicit photographs of corpses by Arthur Dockter (nos. 36, 37) are titled *The Living Dead* and *The Dead Dead,* suggesting that there are stages even to the ultimate dissolution of the human being. William Dugan's *Clean White Things in a Dirty Box* (no. 42) presents a horde of small objects (including animal corpses and his high-school graduation tassel), some carefully wrapped in white bandages, displayed like precious items in a collector's case. Neal Pollack's *Vietnam Service Ribbon,* with its baleful, cartoonlike eyes (no. 141), is a grotesque rethinking of the idea of military honors. Numerous works have a toylike, joking quality reminiscent of Pippin's decorated frame: Dugan's *I'm So Short,* with its clustered toy soldiers; Steven Hanlon's painted paper-doll soldiers (no. 70); Michael Helbing's colossal warrior with a tricycle foot (no. 77); James Litz's cheerful scene of miniature infantrymen and helicopters (no. 96); David Smith's self-destructive computer-game sand sculpture *Battle Maze* (no. 168); the toy lizards on Broderick's frame. Especially compelling is Kim Jones's *War Drawing* (no. 86), whose agitated pencil marks teem like Altdorfer's ant colonies as they play out in earnest the deadly battle games that young boys so enjoy.

Bearing Witness

If a subtext of art by veterans is the examination of the self, this should not be understood as mere self-absorption, egoism, or the product of "art therapy." Much of the art in this collection was made during a period when, in the name of healing and reconciliation, Americans seemed collectively bent on obliterating the actual events and memories of the war, and above all the voices of its witnesses and participants. The art's principal argument, therefore, is the same one articulated by Goya: to bear witness, to remember. Its aim is to compel the uninitiated viewer to see and understand something fundamentally alien to him or her: what it meant to be there. Since the experience is not transferable, this is an enterprise that can never fully succeed, though to try is of vital importance to all parties. The artist's urge to

remember, to record, and to inform the viewer is the fulfillment of a promise to his or her war dead. To the dead war is always particular, never generic — a specific war, a specific bullet kills each man and woman. It should therefore be no surprise that artist veterans are rarely interested in re-creating great battle scenes, historical chronicles, or moments of high, universal rhetoric.

In the armed forces in Vietnam soldiers were routinely misled about troop strength, about strategy, about the reasons they were there. The information upon which they depended to survive was often faulty.[16] The lesson this taught them was that the only truth we can know is the truth of our own experience. Therefore, the truth they tell in their art is not the coherent narrative of well-crafted fiction or reportage; it has no story; no beginning, middle, and end; no climax; no conclusion. Instead, they describe the many small fragments of memory — emblems, objects, a child, a palm tree, a body, a piece of equipment; *a name and a place* – that together comprise an essential history, disjunctive and partial, for those with eyes to see it. Charlie Shobe paints not the terrible and famous Battle of Con Thien, but two soldiers walking on the road to Con Thien (no. 161).

The legacy of this war to art is that the details matter; that there is no such thing as a neutral or unengaged position – of artist or viewer. For a generation, since the war's end, public discourse has attempted to reconcile conflicting and ambivalent opinions about it, to justify and assign blame, ultimately to resolve the problem of Vietnam. The art resists such efforts at establishing harmony, seeing them as a mechanism, however unintentional, that silences the multitude of perspectives, personal and historical. Indifference, willful forgetting, ignorance of history – all these, in the end, are other names for a neat solution that the war would not permit during its course, and still does not permit in its aftermath.

Postscript

An artist who is one of the original members of the Vietnam Veterans Arts Group tells the following story. In early 1983, following the November 1982 dedication of the National Vietnam Veterans Memorial in Washington, D.C., the art collection was exhibited at a gallery called the Washington Project for the Arts. At that time it comprised some thirty or forty artists and perhaps one hundred art works. It was the practice of the group to hang the work salon-style, filling the walls so as to present as many works as possible. As always, art was hung in a nonhierarchical way, not favoring the most popular works and not organizing them by artist, theme, or date, but by the composition of pieces that would look best in a limited space.

The dedication of the national memorial was a profound experience for veterans. Some 150,000 of them came to Washington, spoke together publicly of the war, found old comrades, relived powerful memories, and mourned many losses. Several artists in the group met each other for the first time and discovered deep layers of shared experience. In this atmosphere of intense emotion an artist went to the gallery one day, after visiting the memorial and finding the place where many of his dead companions' names were clustered together. In great distress at his revived memories and in anger at the government for its treatment of veterans, he withdrew his painting from display, leaving a blank white space in the middle of the crowded wall. Another artist wrote in pencil there: "Dedicated to the men of the third battalion, fourth Marines, who can't be here." This small statement, laconic, ephemeral, and spontaneous, remained for the duration of the exhibition and was destroyed when the show came down. Pure in its expression and deeply attentive to context, it was an extraordinary work of art, as well as a radical curatorial act.

This simple pair of actions – the removal of one work of art and its replacement by another – is emblematic of the history of the National Vietnam Veterans Art Museum, which has always resisted the rhetoric of pristine museum walls and sought to undermine the aesthetic hierarchies of gallery practice. Installation of art works was for many years a group effort; acquisitions policy was, and remains, broad; the museum puts into practice the concept of democracy in the art world. The gap on the white wall of the gallery reminds us that at the center of any exhibition or book about this war and its art lies the empty space that can never be filled: the missing art work by the artist who did not live to make it.

1. Fred Licht, *Goya: The Origins of the Modern Temper in Art* (New York: Harper and Row, 1983), 112. Licht identifies Leonardo da Vinci's *Battle of Anghiari* (ca. 1504) as the type for such paintings.

2. On the representation of war, battle, and soldiers in Renaissance art, see J. R. Hale, *Artists and Warfare in the Renaissance* (New Haven: Yale University Press, 1990).

3. *Iliad*, xxii, ll. 71–73, trans. Richmond Lattimore (Chicago: University of Chicago Press, 1951), quoted in Jiří Frel, *Death of a Hero* (Malibu: J. Paul Getty Museum, 1984).

4. Frel, *Death of a Hero*, 13.

5. Undated letter, Horace Pippin War Memoirs, Letters, and Photographs, Archives of American Art, Smithsonian Institution, Washington, D.C., cited in Judith E. Stein, et al., *I Tell My Heart: The Art of Horace Pippin* (Philadelphia: Pennsylvania Academy of the Fine Arts and Universe, 1993), 3.

6. See Jonathan Shay, M.D., *Achilles in Vietnam: Combat Trauma and the Undoing of Character* (New York: Atheneum, 1994), 39, 50–53. The National Vietnam Veterans Memorial in Washington, D.C., is a wall of names that gradually sinks from ground-level to below the ground, and then up again. Though most veterans have come to appreciate its design, at first many objected to it. "They put us in graves in Vietnam," an ex-soldier commented to me in 1982, "and now they're doing it again." Graves, trenches, the dark, underground tunnels that housed Viet Cong cadres and that American and South Vietnamese soldiers searched during the war: veterans are alert to both the literal and the metaphoric meanings of such places.

7. For discussions of Dix, especially the idea of metamorphosis, see Matthias Eberle, *World War I and the Weimar Artists: Dix, Grosz, Beckmann, Schlemmer* (New Haven: Yale University Press, 1985), ch. 2, and Dennis Crockett, "The Most Famous Painting of the 'Golden Twenties'? Otto Dix and the *Trench Affair*," *Art Journal* 51, no. 1 (1992), 72–80.

8. For detailed discussions of *Guernica* and *Massacre in Korea,* see Ellen C. Oppler, ed., *Picasso's Guernica* (New York: W. W. Norton, 1988), and Paul Wood, Francis Frascina, et al., *Modernism in Dispute: Art Since the Forties* (New Haven: Yale University Press, 1993).

9. The photograph, by Larry Burrows, is from a magazine article on Vietnam, "We Wade Deeper into Jungle War," *Life,* Jan. 25, 1963, 26; see Roni Feinstein, *Robert Rauschenberg: The Silkscreen Paintings, 1962–64* (New York: Whitney Museum of American Art, 1990), 82, 98 n. 19, and Horst Faas and Tim Page, eds., *Requiem* (New York: Random House, 1997), 91.

10. Sol LeWitt, "La Sfida del sistema: Inchiesta sulla situazione artistica attuale negli Stati Uniti e in Francia a cura di Anna Nosei Weber e Otto Hahn," *Metro* 14 (June 1968), 44–45. It is worth noting that LeWitt was a dedicated member of an antiwar group and very politically active at the time when he made this statement. Many 1960s artists, conscious of a certain awkwardness in the association of politics and aesthetics, grappled with the relationship of their art to their political beliefs, hoping to separate or integrate the two in a consistent and ethical way. See also Irving Sandler, *American Art of the 1960s* (New York: Harper and Row, 1988), 293.

11. See Carol Duncan, *Civilizing Rituals: Inside Public Art Museums* (London: Routledge, 1995), 104, 108–9, 156 n. 3.

12. Thomas Crow writes of Edward Kienholz: "*Portable War Memorial* of 1968 . . . stood out as an exception in its ability to confront the historical moment. As in most of his comparable work of the 1960s, the fact that his eye for material was always at one with his unrelenting outrage . . . meant that no political issue registered as wilfully inserted 'content' divorced from a work's organizational logic. It is nonetheless important to recognize that the didacticism of the piece is distinctly muted; little or no direct reference to the Vietnam War of 1954 to 1975 intrudes. The artist had sense enough to realize that he could not match the searing photographs and video footage issuing from the conflict every day, images that were already doing their work to undermine public support for the war." In *The Rise of the Sixties* (New York: Harry N. Abrams, 1996), 150–51. However, Kienholz's *The Eleventh Hour Final,* also made in 1968, contains explicit references to the Vietnam War: among these are a replica of the official statistics of American and enemy war dead and wounded that were broadcast nightly on evening-news programs (called the kill ratio, or the body count, a Vietnam-era innovation in public information) and the dated *TV Guide.*

13. For an interesting and provocative discussion of war photographs, official censorship, and the effects of censored and uncensored images on American culture, see George H. Roeder, Jr., *The Censored War: American Visual Experience During World War II* (New Haven: Yale University Press, 1993), esp., on Vietnam, 147–49. See also Faas and Page, eds., *Requiem, passim.*

14. William Butler Yeats, "Easter 1916," from *The Collected Poems of W. B. Yeats* (New York: Macmillan, 1960), 178.

15. "John Vann [a senior United States military advisor in Vietnam] also made friends with a lot of the children. Their bright and eager faces moved him. Vietnamese peasant children had a winning manner, and none more so than the children of the Delta. The diet, protein-rich from fish and vegetables and fruit, made them vigorous. They laughed easily and played hard. In their bare feet and shorts and loose shirts . . . they were the children Vann and his brothers had been in their good moments in Norfolk. He learned quickly that the children could protect him. They wanted the American who handed out the candy and gum to return, and they would sometimes warn him when there were guerrillas in a hamlet or farther down a road." Neil Sheehan, *A Bright Shining Lie: John Paul Vann and America in Vietnam* (New York: Random House, 1988), 520.

16. See Shay, *Achilles in Vietnam,* ch. 1.

Glossary

of American Slang and Military Terms
from the Vietnam War Era

Agent Orange: A chemical defoliant heavily used by the American military, later found to be carcinogenic

Air strike: An attack by military aircraft

AIT: Advanced Individual Training; a level of training in the U.S. Army following basic training. Also called Advanced Infantry Training

AK-47: A Russian-designed full- and semi-automatic combat assault rifle used by North Vietnamese troops

Americal Division: The 23d Infantry Division of the U.S. Army

Ammo: Ammunition

ANZAC: Australian and New Zealand Armed Corps; ANZAC troops served in Vietnam as allies of the South Vietnamese

APC: Armored Personnel Carrier; a vehicle used for transport of troops and supplies

Arty: Artillery

ARVN: Army of the Republic of Vietnam; the South Vietnamese army

AWOL: Absent without leave; deserting or leaving a post illegally

Basic training: The initial training, in the U.S., of a military recruit

Battalion: A military unit of the U.S. Army or Marine Corps, usually comprising three or more companies (Army) or five companies (Marines) and commanded by a lieutenant colonel

Battery: An artillery company

B-52: An American bomber plane, used for high-altitude attacks

Big Red One: Nickname for the 1st Infantry Division of the U.S. Army

Bird: Aircraft

Blood: Blood brother; an African-American soldier

Blue line: A river on a map

Body bag: A plastic or rubberized canvas bag used to carry a corpse from the field

Boonie hat: A soft canvas military hat often worn in the jungle in preference to a helmet

Boonies, the: The boondocks, the wilderness; an isolated or remote outpost

Boot camp: *See* Basic training

Bouncing Betty: A trip-wire land mine that explodes in the air, at mid-body height

Brigade: An American military unit under a division, usually comprising three to five battalions and commanded by a colonel

Bronze Star: An American medal awarded for meritorious service in the U.S. Army and for bravery in the Marines

Brown-water Navy: U.S. Navy units operating on rivers and inland waters, especially in the Mekong Delta

Call in fire: In the field, to direct artillery or aerial fire or bombing on an enemy position by calling in its map coordinates by field radio to a supporting artillery post or gunship

Call in smoke: In the field, to direct the placement of colored smoke, dropped by artillery or from the air, to mark a position, such as a landing zone

CAP: Combined Action Program, or Combined Action Platoons; Marine Corps units operating

within Combined Action Groups. These were part of a U.S. military counterintelligence program in which American officers and enlisted men worked in South Vietnamese villages to interdict Viet Cong activity, train local militias, provide village security, and improve the quality of village life

Cav, Air Cav: Nickname for the 1st Air Cavalry Division of the U.S. Army; also sometimes used to refer more generally to Air Cavalry units

Central Highlands, the: A high, mountainous plateau in central South Vietnam, populated mainly by Montagnard tribal peoples; site of important strategic battles

C-4: A lightweight plastic explosive, usually carried by American infantry soldiers

Charlie, Charles, Sir Charles: Nicknames for the Viet Cong

Chicom: Chinese Communist, especially referring to weaponry and matériel manufactured in China and supplied to the North Vietnamese and Viet Cong

Chieu hoi: An informer to the Americans from the North Vietnamese or Viet Cong; also refers to the American "open arms" program that rewarded and encouraged informers and defectors

Chinook: A large cargo and transport helicopter with two rotors; officially, a CH-47

Chopper: Helicopter

Claymore: A type of American directional, command-detonated antipersonnel mine

Close air support: An air mission or strike flown in support of infantry forces on the ground, engaged in combat

Cluster bomb: Ordnance that disperses numerous explosive devices; usually small, baseball-size

American bombs released from the air in clusters of several hundred, covering a wide area

Cobra: A helicopter gunship, used for assaults; officially, an AH-1G

Commo: Communications

Company: An American military unit, usually comprising three or more platoons, commanded by a captain, often identified by a letter of the alphabet and a nickname, such as Company C or Charlie Company. An artillery company is called a battery; a cavalry company is called a troop

Concertina wire: A kind of razor wire or barbed wire, ubiquitous in base periphery defenses

Conex: A large tin box or small hut with doors, usually used for storage or transport

Contact: Engagement with the enemy

Cordite: The explosive powder in artillery rounds, which has a distinctive smell when ignited

Corps; I, II, III, IV Corps: In American military strategy, the four regions, or operational divisions, of South Vietnam

Corpsman: A medic, a member of the U.S. Navy medical corps, sometimes attached to the Marines

C-rations: Combat rations; the packaged food provided by the American military to troops in the field. Also called c-rats or c's

DASPO: Department of the Army Special Photographic Office

Delta, the: The area around the mouths of the Mekong River in southern Vietnam

DEROS: Date eligible for return from overseas; the date on which a soldier's tour of duty in Vietnam ended

Didi moi: "Hurry up," "scram," or "get out of here"; slang derived from the Vietnamese

Dink: A pejorative term for a Vietnamese, or more generally, an Asian

Dinky dau: "Crazy," or "you're crazy"; slang derived from the Vietnamese

Division: A large military unit, American or Vietnamese, usually commanded by a brigadier general

DMZ: The Demilitarized Zone; the border at the 17th Parallel, dividing North from South Vietnam, as set by the 1954 Geneva Convention, which partitioned the country in the wake of the French Indochinese war

Drag, drag position: The last position in a line of soldiers walking on a patrol, exposed to snipers and ambushes

Dust-off: Evacuation by helicopter from the field, usually for medical reasons. *See also* **Medevac**

Elephant grass: A very tall, sharp-edged, grassy plant of Vietnam

E tool: A combat shovel used by troops to dig fighting holes

Evac: Evacuation, removal from the field; also, a hospital close to the battlefield

Extraction: Evacuation or withdrawal from the field by helicopter

FAC: Forward air controller, the person who coordinates air strikes

Fall of Saigon, the: April 30, 1975, the date on which Saigon, capital of South Vietnam, was overrun and captured by North Vietnamese troops, signaling the end of the war

Fatigues: Combat uniform, usually green or camouflage-patterned

Field of fire: The area covered by a weapon or set of weapons from a given position

Firebase, fire support base: An artillery base, often temporary, usually supported by infantry

Firefight: An exchange of fire with the enemy, a battle

Fire for effect: To fire weapons in order to produce a reaction; may also mean to fire continuously on the enemy with all available ordnance, or the end result of a fire mission

Fire mission: A request, with instructions and target coordinates, for supporting fire from ground artillery or aerial bombing

Fire team: A subunit of a squad, usually composed of three or four men

FNG: Fucking new guy; an inexperienced soldier, recently arrived in Vietnam

F-111: An American supersonic fighter-bomber plane introduced in the 1960s

Forward observer: The soldier in the field who calls in map coordinates by radio to a firebase to aim fire from artillery or air support

Fragging: The killing of a fellow soldier using a fragmentation grenade; sometimes the killing of an officer by his own men

Freedom Bird: The transport plane on which a soldier left Vietnam

Friendly fire: A military term for air, artillery, or small-arms fire by Americans that mistakenly strikes an American position

General Quarters: In the U.S. Navy, the call to take up battle stations, or positions, on shipboard; a state of high combat alert

GI: Government issue; traditional military slang for an enlisted man

Glad bag: Slang for a body bag

Gook: A pejorative term for a Vietnamese, or more generally, an Asian

Green Berets: Special Forces units of the U.S. Army, so named for their distinctive caps

Grunt: Slang for a foot soldier, an infantryman. Also called a ground-pounder

Gunship: A combat helicopter mounted with weapons, usually machine guns and rockets, used for low-altitude assaults; sometimes also refers to a fixed-wing aircraft

Hanoi Hilton: Nickname for the prison in Hanoi where many American prisoners of war were held; officially, Hoa Loa Prison

Helo: Helicopter

Highway 1: The main highway from Can Tho, south of Saigon, to Hanoi in the north

Ho Chi Minh, Uncle Ho: Nguyen That Thanh (1890–1969). The Vietnamese nationalist and founder of the Indochinese Communist Party, president of the first independent Vietnam (1945), political leader of the North Vietnamese

Hooch: A house or hut, sometimes a tent or shack, referring to a Vietnamese village home or sometimes to the field quarters of an American soldier

Hot: Dangerous, receiving fire

Hot LZ: A landing zone under fire, in battle

Howitzer: A cannon that fires shells

Huey: A helicopter gunship; officially, a UH-1

Hump: To slog on foot on patrol, carrying a heavy pack and arms

Illumination: Flares used to aid vision during night action, either fired from artillery mortars or dropped by aircraft

Incoming: Receiving enemy fire, especially artillery, such as rockets or mortars

In country: In Vietnam (or in the Cambodian, Laotian, or Thai theaters of war)

Insertion: Placing troops into a forward or enemy-controlled area, usually secretly

Khmer Rouge: Cambodian Communists

KIA: Killed in action

Kit Carson Scout: A Viet Cong defector working for the U.S. and South Vietnamese armed forces, often as an interpreter or guide

Klick, click: Kilometer

KP: Kitchen police; kitchen duty

Land mine: A small, powerful explosive device, usually buried just below ground, triggered by weight and used to attack troops or vehicles

Leatherneck: A traditional slang term for a Marine

Lifer: A career member of the armed forces

Line company: An infantry company

Listening post: A forward guard position, outside the protected perimeter of a camp or firebase, usually held by two or three men

Loach: A type of small reconnaissance helicopter; officially, an LOH, or light observation helicopter

LRRP, Lurp: Long-range reconnaissance patrol; a small squad or team of men who traveled out into the jungle from base camps, often for long periods, to track enemy troops

LZ: Landing zone; a clearing in a forward or operational area, often created by bombing, where helicopters landed to transport troops or supplies

MACV: Military Assistance Command, Vietnam; American military headquarters during the war

Mama San: Generic name for an elderly Vietnamese woman

Marine Corps: A branch of the U.S. armed forces often working in close association with naval forces

MEDCAP: Medical Civil Action Program; an American military program that brought doctors and nurses to Vietnamese villages. *See also* **CAP**

Medevac: Evacuation by helicopter from the field for medical reasons. Also called a dust-off

Medic: A medical corpsman, a soldier with some basic medical training who administered emergency first aid in the field

MIA: Missing in action

MIBARS: Military Intelligence Battalion Air Reconnaissance Support

Mobile Advisory Team: An American military team used for training local South Vietnamese soldiers such as the Popular Forces. Teams usually consisted of two officers, three enlisted men, and an interpreter

Montagnard: A French term used generically to refer to numerous racially and linguistically distinct minority peoples, including the Hmong, living in the mountainous Central Highlands of South Vietnam and elsewhere in Indochina. Many Montagnards, traditionally antagonistic to Vietnamese authorities, supported the Americans

Mortar: A type of small, portable cannon, designed for transport by ground troops

MP: Military police

M-79: An American portable grenade launcher

M-16: A full- and semiautomatic 5.56mm (.223 caliber) combat assault rifle made in the U.S. and used by American and South Vietnamese troops after 1966

M-60: An American 7.62mm (.308 caliber) lightweight machine gun, often called the pig

Nam, the Nam: Slang for Vietnam, or, more generally, the war

Napalm: A sticky, flammable jellied-gasoline substance, dropped aerially in bombs or fired on the ground from flamethrowers as an incendiary weapon; made in the U.S. by Dow Chemical Corporation

NCO: A noncommissioned officer

NLF: National Liberation Front, or National Front for the Liberation of the South; the Viet Cong guerrilla movement

Number one: Slang for the best

Number ten: Slang for the worst

Nuoc mam: Vietnamese fermented fish sauce

NVA: North Vietnamese Army; the American name for North Vietnam's regular army

O-Club: Officers' club

Pacification: A term for several counterinsurgency programs, carried out by the Central Intelligence Agency, the Agency for International Development, and other U.S. agencies and military offices, intended to suppress and eradicate Vietnamese Communist guerrillas and, secondarily, encourage the cooperation of the South Vietnamese population

Papa San: Generic name for an elderly Vietnamese man

Paris peace talks: The lengthy and inconclusive official negotiations of the North Vietnamese, South Vietnamese, and U.S. governments in Paris between 1968 and 1973. Refers as well to a parallel, secret negotiation between the North Vietnamese and the Americans, also in Paris, from which the South Vietnamese were excluded

Perimeter: The fortified and guarded outer boundary of a firebase or military position

PFC: Private first class

Phoenix Program: A U.S.–sponsored counterintelligence program, notorious for assassinations and torture

Piaster: South Vietnamese currency

Pig: An M-60 machine gun

Platoon: An American military subunit of a company, comprising two or more squads (normally about forty-five men), usually commanded by a lieutenant

Point man: The first man in line on a patrol

Point, point position: The front position in a line of soldiers walking on a patrol, the riskiest position, highly exposed to snipers and booby traps

Popular Forces: South Vietnamese local militia forces

Positive identification: An informal military term, usually referring to identification of the dead

Post-traumatic stress disorder: An illness or pathology, primarily psychological but with some physical symptoms, induced by severe traumatic experience and characterized by emotional numbness and instability, repeated grief reactions, reexperiencing of the trauma, exaggerated alertness, disturbed sleep, and other features

POW: Prisoner of war

Psyops: Psychological operations, or psychological warfare; the name of an American counterintelligence program

Pungee, pungee trap: A hidden pit or deep hole in the ground at the bottom of which are set sharpened stakes, which are sometimes poisoned; the opening is masked so that an unwary patrolling soldier may fall in. A primitive but effective weapon of guerrilla warfare

Purple Heart: An American medal awarded to those wounded by the enemy in the line of duty

Quad-fifty: A weapon comprising four .50-caliber machine guns mounted on a movable platform and linked so as to fire simultaneously

R & R: Rest and recreation (or relaxation), a brief vacation from the war, usually about three days long. In the Vietnam War soldiers often went to Vung Tau, Cam Ranh Bay, or China Beach in South Vietnam; or, on longer breaks, to Thailand, Hong Kong, Australia, or Hawaii. Also called I & I: intoxication and intercourse

Ranger: A soldier with additional, specialized training in reconnaissance and combat

Recon: Reconnaissance, observation of enemy activity, on foot or from the air in a helicopter

Regiment: An American military unit usually comprising three or more battalions, typically commanded by a colonel or sometimes by a brigadier general

REMF: Rear-echelon motherfucker; a noncombat administrative soldier

Re-up: To reinlist for an additional tour of duty

Rock and roll: Firing a weapon, especially an M-16 rifle, on full automatic setting

Rocket: A self-propelled weapon with an explosive warhead, launched through a tube or on a rail

RPG: Rocket-propelled grenade, an American weapon; may also refer to a Russian antitank grenade launcher

RTO: Radio-telephone operator, or radioman; the soldier in a team or unit who carries and operates a portable field radio for communication with a base while on patrol, reconnaissance, or in a firefight

RVN: Republic of Vietnam; South Vietnam

Sapper: A Viet Cong saboteur or commando

SEALS: U.S. Navy special-warfare forces

Search and clear: A sweeping offensive military ground assault or operation on a village or area, designed to make it safe

Search and destroy: A sweeping offensive military ground assault or operation passing through a village or area, designed to attack the enemy, but not hold the territory

Shake-and-bake: Slang for a noncommissioned officer who is a product of fast Stateside training, without war experience

Shell: An explosive projectile used in a howitzer or other cannon

Short, short timer: Having less than half a tour of duty left to serve before becoming eligible to leave Vietnam. Usually refers to a soldier with less than thirty days left in Vietnam before being rotated out of the war

Short-time calendar: A hand-drawn calendar, commonly drawn by a soldier to mark off the days remaining until his tour of duty in Vietnam ended

Shotgun: On a helicopter, the doorgunner's position; in general, the passenger position in a jeep, truck, plane, or other vehicle, when armed

Silver Star: An American medal for heroic action in battle

Sin loi: See Xin loi

Slick: A Huey helicopter used for troop transport

Smoke, smoke grenade: A small explosive device that emits brightly colored smoke as a signal or marker from the ground to aircraft; smoke was usually green, purple, red, or yellow

Spec 4, Spec 5: Specialist Fourth or Fifth Class; U.S. Army ranks equivalent to corporal and sergeant, respectively

Special Forces: Soldiers in the U.S. Army with guerrilla- and irregular-warfare training. Also called Green Berets

Spook: A spy, usually referring to someone from the Central Intelligence Agency or other U.S. intelligence agencies

Squad: A small unit comprising thirteen or fewer men, usually commanded by a sergeant. A squad was usually made up of three or four fire teams

Strategic hamlet: A village that the U.S. made extra efforts to pacify, through the South Vietnamese Strategic Hamlet Program, which constructed fortified villages and resettled villagers from other, less protected areas

Street Without Joy: A section of Highway 1 in Quang Tri Province, built by the French; site of many battles

Team: A small group of soldiers with coordinated training for a specific assignment

Tet: The Vietnamese and Chinese New Year, occurring in late winter

Tet offensive: An annual offensive by the North Vietnamese and Viet Cong armed forces that occurred during the Tet holiday. Though there was more than one such offensive, the term most often refers to the January 1968 action in which North Vietnamese and Viet Cong troops attacked major cities, provincial capitals, and important military positions throughout South Vietnam, reaching central Saigon

Tho Le Duc (1911–1990): North Vietnamese envoy and chief negotiator at the Paris peace talks. Tho, together with the American secretary of state, Henry Kissinger, was awarded the Nobel Peace Prize as co-signatory to the Paris Accords in 1973, but refused it

Through-and-through: A gunshot wound that passes through the body

Tiger fatigues: Jungle camouflage uniform with a distinctive barred pattern

Tour of duty: The period of time a soldier, sailor, or Marine spent in the service; an overseas tour of duty was the time he or she spent in Vietnam; generally twelve months for enlisted personnel

Tracer: A round of ammunition that glows a bright color, making visible the direction of fire; North Vietnamese tracers were usually green, American tracers red

Track: An armored vehicle, usually for personnel transport, that moves on tracks rather than wheels

Triple canopy: The dense vegetation of the Vietnamese jungle, growing to three levels; difficult to traverse, and extremely difficult to survey from the air

Truc thang: Vietnamese term for helicopter

Tunnel rat: A soldier, usually a small man, who searched the underground tunnel system of the Viet Cong

USAF: United States Air Force

USARV: United States Army, Vietnam; a headquarters designation

USMC: United States Marine Corps

USN: United States Navy

VC: Slang for Viet Cong

Victor Charlie: An American military term for Viet Cong, used in radio communications

Viet Cong: The South Vietnamese irregular forces, usually guerrillas, fighting with the North Vietnamese; the term was coined by the Americans to signify Viet Communist

Viet Minh: The army of resistance, originally guerrilla forces, organized by Ho Chi Minh in 1941 to combat the French; predecessor of the Viet Cong

Vietnamization: An American policy, first articulated in 1967 by President Lyndon Johnson and pursued by President Richard Nixon in about 1970, to transfer combat responsibilities from U.S. military forces to the South Vietnamese army, during the very gradual withdrawal of American troops

Vietnam Service Ribbon: An American military decoration representing the Vietnam Service Medal, awarded to all troops who served in the Vietnam theater of war

Vietnik: Slang for a peace protestor

Ville: A small village or hamlet

Walking drag: *See* Drag

Walking point: *See* Point

Westmoreland, General William C. (b. 1914): Commander of American armed forces in Vietnam from 1964 to June 1968; occasionally called "Westy" by soldiers. From mid-1968 to June 1972 the commander was General Creighton W. Abrams, Jr. General Frederick C. Weyand was commander from mid-1972 to the end of the war

Willy Peter: White phosphorus, an incendiary chemical used in grenades and shells

Winning hearts and minds: A phrase referring to the need for American forces to win not only battles and territory in Vietnam but also the support of the Vietnamese people; often used ironically by both troops and critics of the war

Wood line: The line of trees edging an open area such as a rice paddy; commonly a position of cover for snipers

World, the: Home; usually, the U.S., or anywhere other than the War

Xin loi: Vietnamese for "excuse me"; as used, often ironically, by American soldiers, the phrase meant "sorry about that" or "too bad"; sometimes spelled *sin loi*

'Yard: Slang for Montagnard

Zippo: A brand of disposable cigarette lighter carried by American troops and often used to set fire to huts and villages during raids; also, slang for a flamethrower

Selected Bibliography

The bibliography on the Vietnam War is very large – over eight hundred novels about it have been published in the United States alone. The complexities of the war and its impact upon soldiers have been explored in depth by countless writers from many points of view: personal, psychological, political, strategic. The United States Department of Defense and all branches of the armed forces, for example, have issued many military studies and maintain large archives. Books, articles, and films address aspects of the war from every imaginable political and cultural perspective, and only a few may be mentioned here. The National Vietnam Veterans Art Museum does not necessarily endorse the points of view or conclusions drawn in these books. Readers are encouraged to seek a broader reading list through the bibliographies of the works listed below.

Nonfiction on and by Vietnam War veterans

Baker, Mark. *Nam: The Vietnam War in the Words of the Men and Women Who Fought There.* 1981. London: Abacus, Sphere Books, 1982.

Bryan, C. D. B. *Friendly Fire.* New York: Putnam, 1978.

Crace, Max D., and James N. McJunkin. *Visions of Vietnam.* Novato, Calif.: Presidio, 1983.

Dann, Jean Van Buren, and Jack Dann, eds. *In the Field of Fire.* New York: TOR, 1987.

Edelman, Bernard, ed. *Dear America: Letters Home from Vietnam.* New York: W. W. Norton, 1985.

Glasser, Ronald J. *365 Days.* 1971. New York: George Braziller, 1980.

Goff, Stanley. *Brothers: Black Soldiers in the Nam.* New York: Berkeley Books, 1985.

Goldman, Peter, and Tony Fuller. *Charlie Company: What Vietnam Did to Us.* New York: Ballantine, 1983.

Herzog, Tobey C. *Vietnam War Stories: Innocence Lost.* London: Routledge, 1992.

Kovic, Ron. *Born on the Fourth of July.* 1976. New York: Pocket Books, 1976.

Mason, Robert. *Chickenhawk.* 1983. London: Corgi, 1983.

Pratt, John Clark, comp. *Vietnam Voices: Perspectives on the War Years, 1941–1982.* New York: Penguin, 1984.

Santoli, Al. *Everything We Had: An Oral History of the Vietnam War by Thirty-three American Soldiers Who Fought It.* New York: Ballantine, 1984.

Shay, Jonathan, M.D. *Achilles in Vietnam: Combat Trauma and the Undoing of Character.* New York: Atheneum, 1994.

Smith, Winnie. *American Daughter Gone to War: On the Front Lines with an Army Nurse in Vietnam.* New York: William Morrow, 1992.

Terry, Wallace. *Bloods: An Oral History of the Vietnam War by Black Veterans.* New York: Random House, 1984.

Fiction, poetry, and drama on and by Vietnam War veterans

Butler, Robert Olen. *The Alleys of Eden.* New York: Horizon, 1981.

——. *A Good Scent from a Strange Mountain.* New York: Penguin, 1992.

Caputo, Philip. *A Rumor of War.* 1977. New York: Ballantine, 1984.

Del Vecchio, John M. *The Thirteenth Valley.* New York: Bantam, 1982.

Ehrhart, D. W., ed. *Carrying the Darkness: The Poetry of the Vietnam War.* Lubbock: Texas Tech University Press, 1989.

——. *Unaccustomed Mercy: Soldier-Poets of the Vietnam War.* Lubbock: Texas Tech University Press, 1989.

Heinemann, Larry. *Close Quarters.* New York: Viking, 1977.

——. *Paco's Story.* New York: Viking, 1987.

Ninh, Bao. *The Sorrow of War.* New York: Riverhead, 1993.

O'Brien, Tim. *Going after Cacciato.* New York: Delacorte, 1978.

——. *If I Die in a Combat Zone.* New York: Delacorte, 1973.

———. *The Things They Carried.* Boston: Houghton Mifflin, 1980.

Pratt, John Clark. *The Laotian Fragments.* New York: Viking, 1974.

Rabe, David. *The Vietnam Plays,* vol. 1: *The Basic Training of Pavlo Hummel, Sticks and Bones*; vol. 2: *Streamers, The Orphan.* New York: Grove, 1993.

Trinh, Minh Duc Hoai. *This Side . . . The Other Side.* Washington, D.C.: Occidental, 1980.

Van Dinh, Tran. *Blue Dragon – White Tiger: A Tet Story.* Philadelphia: TriAm, 1983.

Van Ky, Pham. *Blood Brothers.* 1947. New Haven: Council on Southeast Asian Studies, Yale University, 1987.

Wright, Stephen. *Meditations in Green.* New York: Scribner's, 1983.

General nonfiction on the Vietnam War

Braestrup, Peter. *The Big Story.* 2 vols. Boulder, Col.: Westview, 1977.

Davidson, Phillip B. *Vietnam at War: The History, 1946–1975.* New York: Oxford University Press, 1991.

Emerson, Gloria. *Winners and Losers.* New York: Harcourt, Brace, 1976.

Faas, Horst, and Tim Page, eds. *Requiem: By the Photographers Who Died in Vietnam and Indochina.* New York: Random House, 1997.

Fitzgerald, Frances. *Fire in the Lake.* New York: Vintage, 1972.

Halberstam, David. *The Best and the Brightest.* Greenwich, Conn.: Fawcett, 1969.

———. *One Very Hot Day.* Boston: Houghton Mifflin, 1967.

Herr, Michael. *Dispatches.* New York: Avon Books, 1978.

Isaacs, Arnold R. *Vietnam Shadows: The War, Its Ghosts, and Its Legacy.* Baltimore: Johns Hopkins University Press, 1997.

Karnow, Stanley. *Vietnam: A History.* New York: Viking, 1983.

Kolko, Gabriel. *Anatomy of a War: Vietnam, the United States, and the Modern Historical Experience.* New York: Pantheon, 1985.

Page, Tim. *Nam: The Vietnam Experience, 1965–75.* New York: Barnes and Noble, 1995.

Snepp, Frank. *A Decent Interval: An Insider's Account of Saigon's Indecent End.* New York: Random House, 1977.

Stanton, Shelby L. *The Rise and Fall of an American Army: U.S. Ground Forces in Vietnam, 1965–1973.* Novato, Calif.: Presidio, 1985.

Summers, Harry G., Jr. *Historical Atlas of the Vietnam War.* Boston: Houghton Mifflin, 1995.

On the Vietnam War and cultural issues

Adair, Gilbert. *Vietnam on Film.* New York: Proteus, 1981.

Allen, Terry. *Youth in Asia.* Exh. cat. Winston-Salem, N.C.: Southeastern Center for Contemporary Art, 1993.

American Arts Project, Michael G. Stephens, moderator. *Back in The World Again: Writing after Vietnam.* 2 vols., cassette tapes. New York: Holmes Cassette Group, 1984.

Anzenberger, Joseph F., Jr. *Combat Art of the Vietnam War.* Jefferson, N.C.: McFarland, 1986.

Aufderheide, Pat. "Vietnam: Good Soldiers," in Mark Crispin Miller, ed. *Seeing through Movies.* New York: Pantheon, 1990.

Fraser, John. *Violence in the Arts.* London: Cambridge University Press, 1974.

Greene, Graham. *The Quiet American.* 1955. Harmondsworth, England: Penguin, 1988.

Hallin, Daniel C. *The "Uncensored War": The Media and Vietnam.* New York: Oxford University Press, 1986.

Heinemann, Larry. *Paco's Story.* 1986. Harmondsworth, England: Penguin, 1987.

Herr, Michael. *Dispatches.* 1977. London: Picador, 1982.

Herzog, Tobey C. *Vietnam War Stories: Innocence Lost.* London: Routledge, 1992.

Lewis, Lloyd B. *The Tainted War: Culture and Identity in Vietnam War Narratives.* Westport, Conn.: Greenwood, 1985.

Lippard, Lucy R. *A Different War: Vietnam in Art.* Exh. cat. Seattle: Real Comet and Whatcom Museum of History and Art, 1990.

Loperis, Timothy, and John Clark Pratt. *Reading the Wind: The Literature of the Vietnam War.* Durham, N.C.: Duke University Press, 1987.

Louvre, Alf, and Jeffrey Walsh, eds. *Tell Me Lies about Vietnam: Cultural Battles for the Meaning of the War.* Milton Keynes: Open University Press, 1988.

Melling, Philip H. *Vietnam in American Literature.* Boston: Twayne, 1990.

Noble, Dennis L. *Forgotten Warriors: Combat Art from Vietnam.* London: Praeger, 1992.

Nhu Tang, Truong, and David Chanoff. *A Vietcong Memoir.* New York: Random House, 1986.

Rowe, John Carlos, and Rick Berg, eds. *The Vietnam War in American Culture.* New York: Columbia University Press, 1991.

Thomas, C. David. *As Seen by Both Sides: American and Vietnamese Artists Look at the War.* Boston: Indochina Arts Project and William Joiner Foundation, 1991.

Walker, Mark. *Vietnam Veteran Films.* Metuchen, N.J.: Scarecrow, 1991.

Walsh, Jeffrey, and James Aulich, eds. *Vietnam Images: War and Representation.* New York: St. Martin's, 1989.

On war, art, and culture

Ariès, Philippe. *Images of Man and Death.* Trans. Janet Lloyd. Cambridge, Mass.: Harvard University Press, 1985.

Eberle, Matthias. *World War I and the Weimar Artists: Dix, Grosz, Beckmann, Schlemmer.* New Haven: Yale University Press, 1985.

Fralin, Frances. *The Indelible Image: Photographs of War, 1846 to the Present.* New York: Harry N. Abrams, 1985.

Fussell, Paul. *The Great War and Modern Memory.* Oxford: Oxford University Press, 1975.

———. *Wartime: Understanding and Behavior in the Second World War.* Oxford: Oxford University Press, 1989.

Hale, J. R. *Artists and Warfare in the Renaissance.* New Haven: Yale University Press, 1990.

Holzer, Harold, and Mark E. Neely, Jr. *Mine Eyes Have Seen the Glory: The Civil War in American Art.* New York: Orion, 1993.

Hynes, Samuel L. *The Soldiers' Tale: Bearing Witness to Modern War.* New York: Penguin, 1997.

———. *A War Imagined: The First World War and English Culture.* New York: Atheneum, 1991.

Licht, Fred. *Goya: The Origins of the Modern Temper in Art.* New York: Harper and Row, 1979.

Roeder, George H., Jr. *The Censored War: American Visual Experience during World War Two.* New Haven: Yale University Press, 1993.

Schiff, Gert. *Images of Horror and Fantasy.* New York: Harry N. Abrams, 1978.

Stein, Judith E., ed. *I Tell My Heart: The Art of Horace Pippin.* Exh. cat. New York: Universe and Pennsylvania Academy of the Fine Arts, 1993.

Stich, Sidra. *Made in USA: An Americanization in Modern Art, the '50s & '60s.* Exh. cat. Berkeley: University of California Press and University Art Museum, 1987.

Stillings, Dennis. "Meditations on the Atom and Time: An Attempt to Define the Imagery of War and Death in the Late Twentieth Century," in Adam Parfrey, ed. *Apocalypse Culture.* 2d ed. Los Angeles: Feral House, 1990.

Wood, Paul, Francis Frascina, et al. *Modernism in Dispute: Art since the Forties.* New Haven: Yale University Press, 1993.

Films and videos on the Vietnam War

The Vietnam War and Vietnam veterans have figured in many films and a few television programs since the 1960s. Mark Walker's 1991 study, *Vietnam Veteran Films,* cited above, provides a filmography of some 250 motion pictures. Among the most interesting — and ambiguous — documents on the war are the American and European network newscasts from the years 1963 to 1975. Some of these, as well as documentaries, may be viewed at the Museum of Television and Radio, in New York; at the Vanderbilt University Television News Archive (broadcasts after Aug. 5, 1968), in Nashville, Tenn.; at the National Archives, in Washington, D.C.; and through other public libraries and archives.

Acknowledgments

The artists and staff of the National Vietnam Veterans Art Museum, and its predecessor, the Vietnam Veterans Arts Group, have many people to thank. Over the years, dozens of dedicated volunteers and supporters have helped make exhibitions around the country possible and sustained the collection. Without their contributions of time, money, and advice, the project could not have survived. We gratefully acknowledge their hard work, though they are not named here.

A very special thank-you must go to the following people, without whom the museum would not exist: Mayor and Mrs. Richard M. Daley, Commissioner Lois Weisberg of the Department of Cultural Affairs, and the City of Chicago, for making it happen; Congressman Sidney Yates, for his wonderful encouragement and support; the journalist Ann Keegan, who began writing on this collection in 1981 and diligently worked to keep it before the public; John Rainey, Patton Adams, Bud Ferillo, Murk Alexander, their fellow Vietnam veterans, and the Columbia Art Museum of South Carolina, who treasured it when we could not fully care for it; Robert W. Gersch, whose life partially inspired this journey; Sheldon Baskin, Jerry Fiat, and Rena Appel, who gave the collection its first Chicago home and facilitated construction of the museum; Richard Hackett and the Hackett family, for their generosity and continued help in myriad ways; J. Paul Beitler, for his vision and energy, and his determination that the museum be done with style; Albert Friedman and his staff, for generous hours of help and great public-spiritedness; Brian Conmy, Barry Ketter, Paul Kolpak, and Jeff Lerner, who gave us direction and countless hours of financial and legal advice; the Keeley family, who became our family and have continued to extend themselves above and beyond the call of duty; Jim Law and Wendy Willrich, for their sincere dedication and ability to make the impossible possible; William Somerville and William Moore, for their extreme generosity and continued support; Don Bell, for supplying the museum with access to historical artifacts and information; Nancee Biank, whose dedication and generous spirit always helped pull things together; Sarina Renaldi, Patricia and John White, Vincent and Philip Varco, and Andy Sztukowski, who have given unselfishly of themselves to this project for most of their lives; Ross Varco, for his generous support and interest in the success of the museum; John Doveikis and his crew of volunteers, for their great energy and countless hours of labor in finishing the construction of the museum.

Thank you to Robert and George Renaldi, Amanda and Michael White, who supplied joy.

Above all, we extend our gratitude to the families of the artists and to Vietnam veterans, whose contributions continue to make this museum unique.

S. V.

The editor would like to express her deep gratitude to Diana Murphy, an exemplar of editorial skill, judgment, and tact; to Judith Hudson, for a book design of outstanding beauty and elegance; to Herman L. Sinaiko, for much good counsel; to M-60 Mike Kelley, for unveiling the arcane mysteries of Vietnam-era military terminology and geography, not to mention those of the Internet; and to Janet Hollander, who combined the roles of critic, typist, proofreader, therapist, friend, and, on one memorable occasion in 1984, fine-art courier, from which her station wagon never quite recovered. Above all, thanks are due to the artists, who bore with patience an editing process that sometimes resembled both a B-52 strike and the Paris peace talks.

E. S.

Index

Pages on which illustrations appear are in *italic*.

Credits

All photographs of art works in the collection of the National Vietnam Veterans Art Museum are by Michael Tropea, Chicago, and all photographs of the artists are anonymous, except the following: page 28: the artist; 39: the artist; 41: the artist; 46, 47: the artist; 50, 51: the artist; 53, 54 above, below: the artist; 61: Edward J. Emering; 62 above, below: the artist; 65: the artist; 74–75: © M. Lee Fatherree, courtesy the artist, Rena Bransten Gallery, San Francisco, and Galerie Claude Samuel, Paris; 83 above, below: the artist; 92, 93: the artist; 100, photograph of the artist: Nancy Jack; 101: the artist; 102: the artist; 103: Jeff Gubbins; 108, 109: the artist; 110 above, below: the artist; 117–20: the artist; 129: the artist; 134, 135 above: Sondra Varco; 137: the artist; 139 above, below: the artist; 140, photograph of the artist: Don Schomp; 143 below: the artist; 144, 145: the artist; 163, photograph of the artist: Robert Hickman; 170, 171: the artist; 172 above, below: the artist; 174: Sondra Varco; 180: Adam Reich, courtesy P.P.O.W. Inc., New York; 191: the artist; 200: MAS, Barcelona; 210 above: Michael Freeman, London; 210 below: Giraudon, Paris; 211 above: Bayerischen Staatsgemäldesammlungen, Munich; 211 below: Staatliche Antikensammlungen und Glyptothek, Munich; 213: Hispanic Society of America, New York; 216 above: Deutsche Fotothek, courtesy Sächsische Landesbibliothek, Dresden; 217: HNA Archives; 218: RMN, Paris; 219 above: © Cleveland Museum of Art; 219 below: the artist; 220–21 above: courtesy Leo Castelli Gallery, New York; 221 below: courtesy Norman Rockwell Museum, Stockbridge, Mass.; 222: Eric Pollitzer, courtesy OK Harris Gallery, New York; 223 above, center: courtesy Nancy Reddin Kienholz; 224 above: courtesy Walter Cannon; 224 below: Zindman/Fremont, New York.

The quotation from W. B. Yeats's "Easter 1916" is reproduced by permission of A. P. Watt Ltd. on behalf of Michael Yeats and by permission of Scribner, a Division of Simon and Schuster, from *The Collected Works of W. B. Yeats*, vol. 1, *The Poems*, rev. and ed. by Richard J. Finneran, copyright © 1924 by Macmillan Publishing Company, renewed 1952 by Bertha Georgie Yeats.